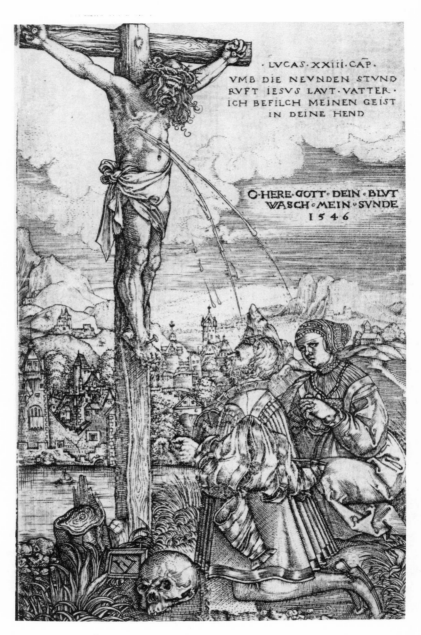

Monogrammist ⚒, *A Man and Woman Kneeling before Christ on the Cross*, engraving dated 1546 (B. IX, p. 67, no. 1). Photo courtesy of the Graphische Sammlung Albertina.

Art and the Reformation

an annotated bibliography

A
Reference Publication in

ART HISTORY

Craig Harbison, Editor
Art of Northern Europe

Art and the Reformation
an annotated bibliography

LINDA B. PARSHALL
and
PETER W. PARSHALL

REFERENCE PUBLICATIONS
I N
ART HISTORY

G. K. Hall & Co, 70 Lincoln Street, Boston, Massachusetts

Copyright © 1986 by Linda B. Parshall and Peter W. Parshall

Library of Congress Cataloging in Publication Data

Parshall, Linda B.
 Art and the Reformation.

 (A Reference publication in art history)
 Includes index
 1. Reformation and art—Bibliography. I. Parshall,
Peter W. II. Title. III. Series.
Z5934.P37 1986 016.709′02′4 85-27176
[N7862]
ISBN 0-8161-8602-2

This publication is printed on permanent/durable acid-free paper
MANUFACTURED IN THE UNITED STATES OF AMERICA

Contents

The Authors . xiii

Preface . xv

State of Research . xxi

I. Standard Reference Sources 1
 A. Bibliographies . 1
 B. Lexicons . 3

II. The Image Controversy. 5
 A. General studies . 5
 B. Reformation theologians11
 1. Anonymous .11
 2. Martin Bucer . 12
 3. Johann Bugenhagen13
 4. Heinrich Bullinger13
 5. Jean Calvin . 15
 6. Hans Denck . 18
 7. Conrad Grebel .18
 8. Ludwig Hätzer .18
 9. Cornelius van der Heyden 19
 10. Johann Honterus 19
 11. Balthasar Hübmaier 20
 12. Andreas Bodenstein von Karlstadt 20
 13. Martin Luther . 22
 14. Johann Manlius . 27
 15. Philips Marnix van St. Aldegonde 27
 16. Philip Melanchthon 28
 17. Hermann Moded . 29

18. Johannes Oecolampadius 30
19. Andreas Osiander . 30
20. Willibald Pirckheimer 31
21. Johannes Anastasius Veluanus 31
22. Pierre Viret . 31
23. Clemens Ziegler . 32
24. Huldreich Zwingli 32
C. Catholic Reform: Council of Trent35
D. Catholic Reformers and Other Apologists 36
 1. Anonymous . 36
 2. Konrad Braun . 37
 3. Johannes Cochläus 37
 4. Johannes Dietenberger 37
 5. Martinus Duncanus37
 6. Johannes Eck . 38
 7. Hieronymus Emser 38
 8. Desiderius Erasmus 39
 9. Sigmund Feyrabend 40
 10. Johann Fischart .40
 11. Franz von Sickingen 40
 12. Johannes Molanus 41
 13. Georg Newdorffer 41
 14. Gabriele Paleotti 41
 15. Louys Richeome 42
 16. Jean de Vauzèle 42

III. Iconoclasm . 43
A. General accounts and analyses 43
B. France .45
 1. contemporary accounts 45
 2. later accounts and analyses 45
C. Germany .48
 1. contemporary accounts48
 2. later accounts and analyses 50
D. Great Britain . 52
E. Lowlands .52
 1. contemporary accounts52
 2. later accounts and analyses 56
F. Switzerland . 63

1. contemporary accounts 63
2. later accounts and analyses. 66

IV. The Reformation Period and Art 67
 A. General Studies . 67
 B. Austria . 76
 C. France . 77
 D. Germany . 79
 E. Lowlands . 90
 F. Switzerland . 94
 1. General . 94
 2. Primary Documents 95
 G. Other . 96

V. Text Illustration and Printed Propaganda 99
 A. General . 99
 B. Religious text illustration: bibles, catechisms, songbooks . . 102
 C. Collections of broadsheets, pamphlets and single-leaf
 woodcuts . 113
 D. Reformation printers, pamphlets, and chronicles 119
 E. Propaganda and satire 122
 1. General . 122
 2. Anti-Catholic satire 126
 a. Anti-papal satire 126
 b. Cranach's *Passional* 129
 c. Other . 131
 3. Socio-political commentary and satire 134
 a. Peasantry & Peasants' War 134
 b. Other . 140
 4. Anti-Reformation and Intra-Reformation satire 143

VI. Reformation Religious Iconography 145
 A. General topics . 145
 B. Biblical and hagiographical subjects 148
 C. Theological and liturgical subjects 151

VII. Artists of the Reformation 155
 A. Artists' writings on the Reformation 155
 1. Jörg Breu the Elder 155

 2. Sébald Büheler . 155
 3. Dirck V. Coornhert 156
 4. David Denecker .156
 5. Albrecht Dürer .156
 6. Philip Galle .157
 7. Hans Greiffenberger157
 8. David Joris . 158
 9. Niklaus Manuel Deutsch 158
 10. Bernard Palissy .158
B. Artists and Reformation imagery 159
 1. Pieter Aertsen . 159
 2. Heinrich Aldegrever 160
 3. Albrecht Altdorfer 160
 4. Hans Asper . 160
 5. Hans Baldung Grien 161
 6. Hans Sebald Beham and Barthel Beham166
 7. Hans Bocksberger the Elder and family166
 8. Cornelis Bos . 167
 9. Jörg Breu the Elder and the Younger167
 10. Pieter Brueghel the Elder 167
 11. Antoine Caron .170
 12a. Lucas Cranach the Elder 170
 12b. Lucas Cranach the Younger177
 13. François Dubois 179
 14. Albrecht Dürer . 179
 a. General . 179
 b. Dürer's belief187
 c. Dürer's *Four Apostles* 195
 15. Jean Duvet . 198
 16. Conrad Faber .198
 17. Peter Flötner .199
 18. Jean Goujon .199
 19. Matthias Grünewald 199
 20. Maarten van Heemskerck202
 21. Lucas d'Heere .203
 22. Jan van Hemessen 203
 23. Hans Holbein the Younger 204
 24. Daniel Hopfer . 205
 25. Joos van Liere . 205

26. David Joris 206
27. Georg Lemberger 206
28. Lucas van Leyden 206
29. Niklaus Manuel Deutsch 207
30. Barent van Orley 210
31. Michael Ostendorfer 210
32. Bernard Palissy 210
33. Georg Pencz 210
34. Pieter Pourbus 211
35. Barthélemy Prieur 211
36. Jörg Ratgeb 211
37. Ligier Richier 212
38. Tilmann Riemenschneider 212
39. Bernard Salomon 212
40. Virgil Solis 213
41. Tobias Stimmer 213
42. Geofroy Tory 213
43. Heinrich Vogtherr the Elder 214
44. Martin de Vos 215

VIII. Architecture, Architectural Decoration and Furnishing 217
 A. Architecture - general 217
 1. Germany 218
 2. Other . 220
 B. Church furnishings and monuments 221
 1. General 221
 2. Chancels, pulpits and choir screen 223
 3. Epitaphs 225
 4. Glass . 227
 5. Altarpieces 228
 6. Ceiling and wall paintings 229

IX. Decorative and Minor Arts 233

X. Iconography of the Reformers 239
 A. General . 239
 B. Individual Reformers 244
 1. Gregor Brück 244

2. Johann Bugenhagen 244
3. Jean Calvin . 245
4. Joachim Camerarius245
5. Desiderius Erasmus245
6. Johann Hess . 247
7. Martin Luther 247
8. Philip Melanchthon252
9. Johannes Oecolampadius 253
10. Huldreich Zwingli253

Index of Authors, Editors and Compilers 255

Index of Exhibitions by Location 269

Index of Subjects . 271

The Authors

Linda B. Parshall has a Ph.D. from Queen Mary College, University of London. Her specialty is medieval German literature, and she is an Associate Professor of German language and literature at Portland State University.

Peter W. Parshall has a Ph.D. from the University of Chicago. His specialty is northern Renaissance art, and he is an Associate Professor of Art History and Humanities at Reed College.

Preface

This bibliography is designed to be comprehensive in scope if not in detail. We have waded through primary and secondary sources not only in the history of art and theology, but also in social, political, intellectual and institutional history. Since the literature on this cross-disciplinary topic had never before been systematically surveyed, the task seemed formidable at times. There are many individual items we chose to omit, and no doubt many we overlooked. However, we have attempted throughout to keep the larger historical (and historiographical) issues foremost, while at the same time not allowing the odd note on some eccentric but revealing subject to slip away. Our hope is that the result will prove not only useful but also stimulating.

As our outline makes clear, we have arranged the bibliographical references topically, according to our perception of the central historical problems involved and the patterns of investigation that have emerged in relevant scholarship. This is therefore a directed resource, and should be employed with that caveat in mind. We have constructed the bibliography to allow scholars to assess quickly the character and thoroughness of research in each area. However, no accumulation of studies on so broad and complex a subject as this one can hope to provide an organizational scheme that precisely fits the demands of each entry. Many items might well have fallen under different rubrics, an inevitability which we have attempted to account for through cross-referencing and the index.

The bibliography concentrates on western Europe, which has received by far the greatest scholarly attention. Those areas included in modern-day Germany, France, Belgium, Holland, and Switzerland have been given thorough coverage. In our need to draw a reasonable limit to the scope of this project, lest it never be completed, we chose to give serious but somewhat less detailed attention to Austria, Scandinavia, and the eastern European countries. England seemed to us a largely separable problem, and so we have treated it in a general way. Furthermore, the Counter

Reformation (or the Catholic reform movement as it is now often called) is included only where it figured importantly as an adversary and stimulus to Reformation controversy in the arts. Thus we consider the Catholic contribution to the debate over the use of images and to the initial propaganda campaigns, but Counter Reformation religious art is a matter that we touch on only indirectly. Although topics such as these are treated sparsely, major studies for all areas are included, and where the bibliography is less thorough, one may nevertheless expect to find a pathway into these more dimly illuminated woods.

The sequence of topics in the outline of the bibliography is meant to reflect the historical realities behind our subject. We begin, following general reference works (I), with the image question (II) and its most dramatic consequence, iconoclasm (III). It was the discussion of theory and practice in the response to religious images that first raised the question of the relation of art to the Reformation in its own time, and in many cases iconoclastic movements--violent and otherwise--were the first material consequence of the theoretical examination of this imagery. We have ordered the discussion of image theory by individual authors and of iconoclastic activity by location, because ideas travel and actions are in an important sense local.

In sections III and IV we have made sub-divisions by country. These categories correspond mainly to modern rather than sixteenth-century boundaries. An exception is the Lowlands (or, interchangeably, the Netherlands), which mainly covered the regions of present-day Holland and Belgium, but also a portion of northern France. Consequently, there are a small number of cases in which entries treating the Lowlands are placed under the modern boundaries of France. These instances have been cross-referenced in the index.

Following the section on iconoclasm are general historical and art historical studies of the Reformation period which serve as background to studies more specifically concerned with the making of images and architecture in a Reformation context (IV). We have placed a section on printing and printed propaganda next on grounds that printing was the medium through which Reformation ideas were first widely disseminated (V). Here a category treating illustrated Reformation religious texts comes first (V. B), and following that a section on satire and propaganda (V. E). Note that we have joined propaganda specifically to printing. Two points should be made clear in this regard: most but not all propaganda was printed; and our definition of propaganda is somewhat stricter than that

commonly employed in recent scholarship on this period. We have defined propaganda as adversarial imagery and rhetoric, that is to say contentious polemical attack most often with a distinct satirical intent. Therefore we have excluded from this category allegorical imagery that is directed primarily to communicating the theological tenets of the new faith. This latter topic we count as a form of Reformation religious art, and so it is placed in the following section, though we are of course aware that the distinction between these two areas is oftentimes difficult to draw. Also under printed propaganda is a section devoted to the peasantry and the Peasants' War in which much recent writing advanced from a social historical standpoint is located (V. E. 3 a). Here will be found ample representation of the Marxist school of interpretation, mainly active in the German Democratic Republic and increasingly prolific of late.

Reformation religious iconography (VI) encompasses all studies concerned with the building of a specifically Protestant form of religious art. The following section on artists of the Reformation period (VII) is an extension of Reformation iconography, including those studies in which Reformation problems are considered mainly in the context of a single master's work (rather than studies of general iconographic trends, or of the work of two or more artists). The bibliographical references included under each artist are by no means exhaustive so far as the scholarship on each is concerned, but are only intended to cover significant discussion of any artist's work specifically related to the Reformation movement. Masters such as Albrecht Dürer, Hans Baldung Grien and Lucas Cranach the Elder who are central to the topic have been covered sufficiently to include recent monographs, comprehensive catalogues and so forth, in order to bring the reader up to date independent of the Reformation question. In the case of major artists whose relation to the Reformation was more tangential (e.g. Mathias Grünewald, Hans Holbein the Younger or Lucas van Leyden), we have included only references which address the Reformation directly and substantively. This reflects our desire to remain close to the subject of the bibliography itself and to the topical scheme of organization. We should note in this context that scholarship on particular masters is relatively easy to come by via the standard bibliographical apparatus within the discipline. Furthermore, other bibliographies in the G.K. Hall series will cover Dutch, Flemish and German prints and painting during the sixteenth century and so will serve this more general need. We saw our most valuable task as generating a resource that would provide

precisely those sorts of references difficult to identify by conventional means.

Individual artists are of course dealt with in areas other than the section devoted to them alone. For example, Holbein appears in the categories of the image controversy and of printing as well as under artists of the Reformation. Mathias Gerung does not appear in the artists' section, but he is included in the sections on printed propaganda and church interiors. Thus it is particularly important to consult the index. Note also that we have regularly referred to artists by their last name and initial or last name alone. Such references designate the most prominent artist of a given family, i.e.: Cranach = Lucas Cranach the Elder, Bruegel = Pieter Bruegel the Elder, Holbein = Hans Holbein the Younger.

The sub-section given to artists' writings should be especially noted, for it lists the small number of instances in which we have the written witness of practicing artists on the events and theological issues of their times (VII. A). These are particularly valuable sources of testimony that have not previously been brought together.

Our treatment of architecture (VIII) is meant to be cursory. We have included general and selective studies on specific buildings, but not tried to be at all complete. For example, we chose not to examine the many discussions in local topographical and architectural handbooks that often deal with the fate of architecture during the Reformation period. The history of this architecture is complex and mostly technical, usually concerned with remodeling and adaptation more than new construction, and often only tangentially interesting for the broader implications of our topic. This state of affairs changes in the following century when the construction and adaptation of buildings for Protestant use becomes widespread. Note that church furnishings and decorative programs, including epitaph monuments and cycles of wall paintings *in situ*, are treated in the architecture section (VIII. B). We have also included a section here on altarpieces where these are discussed in the context of their original location (VIII. B. 5). Once again, the index should be consulted to identify other instances in which the primary concern is not the setting but the artist responsible for the work. Following architecture we have placed a mixture of studies on the minor and decorative arts which also participated in advertising the new faith (IX). And lastly, the least interesting and most over-worked topic, the iconography of the reformers, includes the multitude of identifications and mis-identifications of portraits representing the principals in this story (X).

A final note on the entries: Every item included has been examined first hand except for those marked with an asterisk. In the latter cases, books and articles are listed if we were able to confirm the essential bibliographical information from at least two separate sources. When annotations appear for these entries, they are derived from reliable secondary sources. Bibliographical information and annotations for doctoral dissertations are generally derived from *Dissertation Abstracts International,* with references to the abstracts given at the end of the annotation. The policy of this series of bibliographies is that annotations should be descriptive and not editorial (a line that is at times difficult to draw). We have generally kept to description, but occasionally an editorial comment seemed necessary, particularly in cases where a title promises much more than is delivered

In every aspect of this task from infernal tedium to the pleasures of library detective work we have been granted a vast amount of assistance. The single most valuable resource was unquestionably the Warburg Institute, University of London and its staff. We would especially like to express our gratitude to the Director J.B. Trapp, and the assistant librarian Jill Kraye. We also made extensive use of the British Library, London; the Courtauld Institute Library; the Kunstbibliothek, the Freie Universität, and the Staatsbibliothek in Berlin; the Zentralinstitut für Kunstgeschichte and the Bayerische Staatsbibliothek in Munich; the Rijksmuseum library, and University Library in Amsterdam; the University of California at Berkeley Library; and finally the staffs and library collections of our home institutions, Portland State University and Reed College. For help in compiling, typing, and proof-reading we wish to thank Anne Bender, Wesley Brenner, Karla Callaghan, Steve Harmon, David Lee, Sergiusz Michalski, Charles Rhyne, Wendy Ruppel, Gary Schlickeiser and Friederike von zur Mühlen. The offices of academic computing at Portland State University and Reed College made possible the compilation and laser printing of our computer-generated text. Part of the funding for this project was borne by grants from the National Endowment for the Humanities, the Deutscher Akademischer Austauschdienst, Portland State University, the Portland State University Foundation, and Reed College. Our final editor at G. K. Hall, Borgna Brunner, deserves special thanks for managing all arrangements with the press. Finally we would like to thank Craig Harbison, general editor of the series on Northern Renaissance art, for his patience, encouragement, and attention to detail.

State of Research

The subject of this bibliography is in one sense incongruous, for it hardly needs saying that the visual arts and the Reformation were often uncomfortable bedfellows. In contrast to the study of the later Middle Ages and the Renaissance, we are here concerned with the explanation of a conflict between religious ideology and traditional patterns of visual culture. In its most violent forms this conflict led to the wholesale destruction of works of art--iconoclasm. At the very least it meant a substantial realignment both in the structures of patronage and also in the standards of acceptable subject matter for the arts--secularization. Seen in a constructive light, the Reformation helped to refurbish the visual arts by reflecting on their social and ideological bases and by expanding their range of suitable interests. On the other side, iconoclasm and the emergence of often vicious religious and political propaganda imagery evoke a darker face of the Protestant achievement in western culture.

This perspective is important to recognize, because the scholarship on art and the Reformation has, until relatively recently, not sought an integrated view of the period which might draw together its conflicting features. Studies of iconoclasm tended to center on chronicling local events,[1] and historians of religion concerned with the image question focused their attention primarily on examining theological arguments advanced by the various reformers.[2] Discussions of Protestant religious imagery centered on the emergence of a new iconography suited to sectarian practices and beliefs.[3] In general little attempt was made to reconcile the disturbing and often destructive response to religious imagery

[1] E. van Autenboer, "Uit de geschiedenis van Turnhout in de 16e eeuw: Voorbereiding, uitbarsting en gevolgen van de Beeldenstorm (1566)," *Taxandria* n.s. 40/41 (1968-69): 1-275.

[2] Léon Wencelius, *L'esthétique de Calvin* (Paris, 1937).

[3] Friedrich Buchholz, *Protestantismus und Kunst im sechzehnten Jahrhundert* (Leipzig, 1928).

with the character and continuing development of visual culture in Protestant regions.

There were, however, notable exceptions to this pattern, most prominent among them G.G. Coulton's lengthy study of the subject published in 1928.[4] Coulton's objective was to dispute the claim that Protestantism (and Puritanism in particular), had been responsible for the demise of spirituality as the essential motivation for the creation of works of art. In his view it was the cultivation of professionalism among medieval artisans and its confirmation in the Renaissance that put sacred art out to pasture. Coulton stressed the fact that iconoclastic attitudes had a long history prior to the sixteenth century, conspicuous in the high Middle Ages and evident as well in the systematic razing of medieval monuments during the Italian Renaissance as it made way for its own spectacular vision. Thus he inclined to see the Protestant intervention as a final stage in a lengthy historical process that only came to encompass northern Europe--the last bastion of the Gothic--after having succeeded throughout the established strongholds of Catholicism. Coulton's interpretation, though it mainly concerns architecture, is comprehensive in its implications, and is meant to counter the many isolated claims for the Reformation having had revolutionary consequences for the visual arts. However much we may wish to dispute the terms of his argument, he was unusual for his time in seeking continuity between the Reformation and its past.

The question of continuity significantly resurfaced in somewhat different form during the years following World War II. Responding to Alexander Rüstow's virulent condemnation of the Reformation's effect on the arts,[5] the art historian Erwin Panofsky once again sought to challenge the notion that Protestantism had created a decisive break with the past.[6] Whereas Coulton had diminished the importance of specifically sectarian attitudes in the formulation of the visual arts altogether, Panofsky pointed to the many different points of view manifest among the Protestants themselves. He urged the following.

[4] G.G. Coulton, *Art and the Reformation* (New York, 1928).

[5] A. Rüstow, "Lutherana Tragoedia Artis," *Schweizer Monatshefte* 39 (1959): 891-906.

[6] Erwin Panofsky, "Comments on Art and Reformation," in *Symbols in Transformation,* intro. and catalogue by C. Harbison (Princeton, 1969), pp. 9-14. Panofsky's text is taken from a lecture delivered to the American Society for Reformation Research in December of 1960.

We must be careful not to think of the connection between art and the Reformation in terms of a straight cause-and-effect relationship--excepting, of course, the purely prohibitive or even destructive effect of those comparatively rare forms of Protestantism which objected to the representational arts in principle. Rather we must look for underlying affinities which at a given time, in a given place, and under given circumstances produced a kind of consubstantiality between certain types or modes of religious convictions and certain types or modes of artistic expression. (p. 9)

Panofsky went on to define the mentality of Protestant regions (in a summary and politically colored fashion) as revealing "an independent individualism in artistic, intellectual and spiritual matters which is complementary to, rather than at variance with, a tendency to submit to regimentation in the political sphere; and, second, a kind of quietism or introspectiveness..." (pp. 12-13). These observations (not published until several years after they were delivered as a lecture) demand attention first because they were made by the leading historian of northern European art, and second because they once again called for a broadly contextual view of the problem. In fact, this appeal was already beginning to be answered by the generation of scholars at work in the closing years of Panofsky's career.

The last two decades have shown a marked revitalization of Reformation studies in general, a development which can very largely be attributed to the concentrated efforts of social historians. Predictably, the study of the visual arts has reaped considerable benefits from this trend. For one thing, social history has helped break down categorical boundaries between disciplines. Historians have invaded the study of the arts, art historians have ambitiously taken up the subject of popular culture, and iconoclastic activity has been more systematically scrutinized for its underlying motives. Problems concerning the relation of culture to society have thus emerged in a more pronounced way through such cross-disciplinary investigations, a trend which makes it possible to ask certain questions that had previously been too obscure or too disturbing for treatment. Iconoclasm and propaganda imagery are presently respectable subjects for non-partisan investigation. Furthermore, in seeking to understand historical paroxisms such as these, scholars have been confronted head-on with vexing questions about our ability to measure popular responses to visual art. There has been a growing recognition that theological controversy over the efficacy of religious imagery was not a

strikingly original feature of the Reformation, and furthermore that iconoclasm took a great many different forms in different places. No longer can iconoclasm be written off simply as vandalism, as a transitory and deviant expression of social behavior.

Although it is fair to say that social history has redefined the terms with which we approach the subject of art and the Reformation, it would be a mistake to suppose that a well-rounded view of the problem has now been achieved. It hardly needs stating that a good many issues remain open, and that the trend toward social historical strategies has at many points left the investigation of art objects aside. Yet the number of important monographic studies recently published brings us to an appropriate stage for taking stock. A systematic bibliography offers a timely means of setting this topic in its historiographical context.

The Image Controversy and Iconoclasm

From the sixteenth century onward nothing has absorbed commentators on art and the Reformation so much as the image controversy itself and its destructive manifestations. Until recently these matters were mainly pursued by historians of theology and local historians respectively, the discipline of art history being understandably more concerned with surviving objects than with the forces directed against the patronage and continuing vitality of the arts.

For sound historical reasons Luther has received most attention from scholars concerned with the Reformation image controversy. A number of studies have traced the gradual emergence of his qualified position on images as it developed through his furious contest with Andreas Karlstadt up to the central arguments given in "Against the Heavenly Prophets" of 1524 and the "Letter to the Christian Nobility" of 1525. Margarete Stirm's recent comparative study of Reformation image theology, *Die Bilderfrage in der Reformation,* is the most detailed account of Luther's thought on images yet published.[7] The author pays careful attention to the contributions of other scholars such as Friedrich Buchholz, Hans von Campenhausen, and Hans Preuss. Stirm finally inclines to trim some previous claims for Luther's innovation in the realm of image theory, particularly the views expressed in Preuss' monograph, provocatively titled *Martin Luther der Künstler.*[8] Stirm stresses the consistency of Luther's

[7] Gütersloh, 1977.

[8] Gütersloh, 1931.

theological position and leaves one convinced that its general outlines are now relatively well understood. Luther was a moderate on the image question. Indeed, on some points he was simply conservative, a reluctant reformist who sought mainly to bring religious imagery in line with stricter Catholic thinking (as against the abuses of contemporary Catholic practice). However, the original genius of Luther's attack against iconoclasm rests on the clear manner in which he squares his objections to religious imagery with the principle of justification by faith, and thus with the very foundation of his entire theology. Luther held that to restrict images was to invoke the Law of Moses and thereby to doubt its having been superceded by the freedom of will allotted to man through grace. Removing images from the altar he regarded as secondary to the essential problem, removing images from the heart. Furthermore, to destroy images was to confirm a belief in their genuine power and so again to confess to a lapse of faith. For Luther this was treating the symptom rather than the disease.

Since Luther was the single major reformer actively promoting and patronizing the visual arts, his opinions on specific types of religious imagery are far more intriguing than those expressed within other Reformation ideological camps. For example, Luther's adherence to the traditional didactic justification of images led to some odd iconographic positions. As is often pointed out, Luther found the horns of Moses an acceptable attribute--even though based on a mistranslation of the Bible-- because they alert the beholder to the fearful aspect of the Law. If this remark is genuine, then he clearly contradicts his belief in the accurate rendering of scripture. Thus Luther's participation in the controversy over idolatry cannot be usefully discussed without taking account of the specifically Protestant iconography which he directly and indirectly espoused. For other reformers whose views were cleanly iconoclastic this dimension does not pertain. Furthermore, where Luther's image theology can be shown to be reasonably consistent, this must be partly attributed to his extraordinary facility in theological argument. The theological side of the image question is simply the most accessible to the historian and should not eclipse the fact that Luther's measured responses to religious images were equally directed by non-theological factors--the volatile political situation in Germany, the disposition of his immediate aristocratic patrons, his aspirations for spreading Protestant ideas through visual means, and his intense fear of provoking social upheaval by seeming to encourage iconoclastic destruction. Political motive has tended to be left out of discussions of image theology, but must ever remain prominent in

approaching the broader historical questions involved.

In comparing the positions of the Swiss reformers on the image question, Stirm is once again our most current guide. She builds on the briefer study, "Die Bilderfrage in der Reformationszeit" by H. v. Campenhausen,[9] though she inexplicably omits any reference to the work of Charles Garside Jr., whose monograph on Zwingli's attitude to the arts remains the most balanced outline to date of Zurich's stance on images as well as music.[10] As in the case of Luther, the Swiss theological debates proceed in unison from the traditional foundation of the Decalogue, then parting company over the rigidity with which the prohibition established there should be interpreted. With Zwingli and then Calvin the Reformation moved increasingly towards a complete and uncompromising ban against religious images in the churches, an inevitable progression deriving as it did from a steadily more abstract definition of Protestant worship and of the Godhead. Calvin is treated at some length by Stirm, a contribution that addresses the most glaring omission in the literature on the theology of images. Previous examinations of Calvin's relation to the arts--there were several written in the earlier part of this century--are brief, in some cases virtually inaccessible, and often unabashedly sectarian.[11]

Contributions over the last two decades have therefore set forth the essential outlines of the image controversy in an appropriately unpartisan manner. Theological distinctions among the various major reformers are further pointed up by studies of less prominent figures whose testimony recalls the importance of individual and local variation within Reformation thinking, a dimension which has become increasingly more prominent in the scholarship on the interpretation of Reformation history generally.[12] The various reformers--from conservative to moderate to radical-- separated themselves from the positions of others for a variety of different reasons. Whether such ideological breaks were mainly intellectually

9 *Zeitschrift für Kirchengeschichte* 68 (1957): 96-128.

10 *Zwingli and the Arts* (New Haven, 1966).

11 For a still more recent comparative study of the Reformation theology of images: Sergiusz Michalski, "Doktryna protestancka a problemy sztuki religijnej w Europie Srodkowej w Latach 1517-1618" (doctoral dissertation, Warsaw University, 1980).

12 See, for example, J.F. Gerhard Goeters, *Ludwig Hätzer: Eine Randfigur der frühen Taüferbewegung* (Gütersloh, 1957); Henry Vedder, *Balthasar Hübmaier* (New York, 1905); Ernst Staehelin, *Das theologische Lebenswerk Johannes Oekolampads* (Leipzig, 1939); and Gottfried Seebaß, *Das reformatorische Werk des Andreas Osiander* (Nuremberg, 1967).

inspired or inspired by perceptions of local needs within particular congregations, cities or regions, is of course important in measuring the significance of the image controversy for the spread of the Reformation altogether. Looked at for its own sake, however, the Reformation theology of images holds relatively little interest from a purely philosophical point of view. There is not a great deal that is either innovative or challenging in its contributions to the lengthy history of this debate. Rather the historical significance of the image controversy lies more in the ways it can elucidate the rhetorical dynamics of the period or the interpretation of specific iconoclastic events. The study of the image controversy must be usefully brought to bear on iconoclasm in all its manifestations, and then finally on the character of Reformation sponsored works of art.

Both iconoclasm and Reformation art have traditionally suffered from too narrow a definition. Iconoclasm is thought of primarily as image destruction per se, whereas this is only one aspect of a phenomenon that ranged from willful effacement to verbal abuse of objects, or just orderly removal and repatriation to an original donor. One also forgets that an iconoclastic habit of mind was responsible for the production of objects--the profusion of scurrilous satires and caricatures in Reformation broadsheets and pamphlets. Iconoclasm played a part in artistic and rhetorical as well as physical violence. It is this sort of issue, often involving a redefinition of terms and conventional approaches, which has lately begun to be addressed in studies seeking new social or iconological approaches to the period. Three important, broad-based analyses of the image crisis have recently appeared, each of them treating the question in distinctly separate but historically well-integrated ways: Martin Warnke's edition of essays on iconoclasm published in 1973;[13] David Freedberg's 1976 article on the image problem in the Netherlands;[14] and Michael Baxandall's discussion of idolatry in his 1980 book on sculpture in Renaissance Germany.[15]

Warnke writes the lead essay and two separate studies in a collection of articles on iconoclasm in western culture, all dedicated in one respect or another to the notion that iconoclasm is a basic, even essential cultural response that stems from the very definition of art in western society. The collection takes an assertive, though varied and undogmatic revisionist

[13] *Bildersturm: Die Zerstörung des Kunstwerks* (Munich, 1973).

[14] "The Problem of Images in Northern Europe and its Repercussions in the Netherlands" *Hafnia* (1976): 25-45.

[15] *The Limewood Sculptors of Renaissance Germany* (New Haven/London, 1980).

stance, presenting a case for iconoclasm as something other than a form of socio-pathology. Indeed in a certain sense it is understood as an unusually decisive form of art criticism. This is a useful perspective in so far as it removes a categorical stigma from the phenomenon, attempts to broaden our definition of iconoclasm, and thereby opens it up for more dispassionate consideration. On the other hand, the approaches offered in Warnke's edition are passionate in their own right as revisionist historical studies are likely to be.

Freedberg's essay is a very brief summary of essential material taken from his doctoral dissertation of 1972, a work which while centered on the Netherlands does much to place the image controversy and iconoclasm in the full perspective of Catholic thinking. Freedberg gives careful attention to both Reformation and Catholic responses to the image controversy, drawing his material from a plethora of tracts and popular pamphlets circulating in and around the Netherlands during the second half of the sixteenth century. The interplay between progressive and conservative attitudes on both sides illustrates the complexity of a region in transition much more tangibly than the Reformation debate taken by itself allows. It is important to keep in mind the fact that as Reformation thinking about religious images reached a developed stage, the Roman Church was in the midst of its own reconsideration of the matter at the Council of Trent. Furthermore, the second half of the sixteenth century in western Europe saw the crucial definition of a mature concept of art criticism, a parallel that is consistently overlooked in discussions of iconoclastic theory. Preliminary steps toward the investigation of this relationship can be found in Richard Woodfield's arguments for the importance of the Reformation in establishing what he terms a "disinterested" aesthetic.[16]

Finally, Michael Baxandall has explored an aspect of iconoclasm never before treated so perspicaciously--the role which the very production and individual character of the graven images themselves might have played in bringing about their own destruction. Baxandall penetrates behind the conventional lines of image criticism to examine the emergence of highly distinctive regional and individual styles in sculpture workshops active in southern Germany during the first quarter of the sixteenth century. His study of decorum and the challenge given to it by various styles and patronage practises carries the question of aesthetic and devotional response

16 "On the emergence of aesthetics," *The British Journal of Aesthetics* 18 (1978): 217-27.

to a new level of subtlety. By constructing a context for understanding the peculiar qualities of carved altarpieces examined from the viewpoint of particular masters, local styles, and secular patrons, he offers a fuller explanation for iconoclastic dispositions. Baxandall has succeeded in showing how quite precise stylistic and iconographic developments may have been integral to the destructive outbursts, a notion perhaps too inimical to the basic presumptions of art history to have been explored previously. Baxandall, Freedberg and Warnke stand apart in having brought the sensibilities of recent art history to bear more directly on the problem of the image debate and iconoclasm. In this respect they represent the ecumenical tendency that is increasingly characteristic of Reformation scholarship.

For many good reasons the problem of explaining iconoclasm has proven an especially compelling but vexatious one. Mob violence, individual pathology, personal vendetta, political opportunism, puritanical zealotry, class conflict, economic hardship, anti-clericalism, fear of magic, outright greed, social idealism--these and other motives have been adduced as causes for the major outbreaks of iconoclasm in Germany, Switzerland, and particularly the Netherlands. However, the accumulated studies on this subject have begun to make it increasingly clear that no general law can be readily applied to these events. Iconoclasm must continue to be studied primarily in local contexts for the sake of identifying local patterns subject to local explanation.

Original accounts of iconoclastic activity are relatively plentiful. In addition to the numerous chronicles written shortly after the events themselves, much material has been ferreted out of parish, civic, and inquisitorial archives, and no doubt more remains to be discovered. A glance at the bibliographical entries on the analysis of iconoclasm will show that the Netherlands has received most attention in the scholarship. Partly this is due to the survival of more extensive documentation. In the southern region which remained under Catholic domination (Antwerp in particular) records of investigations and trials are more plentiful than in those areas where the regime ultimately proved sympathetic to Protestant agitators. Furthermore, since the geographical sweep of these outbreaks was much wider in the Lowlands, it is possible to speak of a campaign rather than the more independent uprisings which seem to have been characteristic at earlier stages of the Reformation elsewhere. However, we still lack a sound comparative for studying iconoclasm across Europe. Much more can be

done in the way of analytical studies for towns in Germany, France, and Switzerland.

In a significant number of cases we have a reasonably reliable account of what happened. Of much greater importance of course is how and why things happened as they did. Speculations along this line tend to give priority either to socio-economic, institutional, or ideological factors, recognizing that none of these need be seen as mutually exclusive. Was wide-spread material deprivation a necessary precondition for this kind of religious violence? For this perspective, see Erich Kuttner's study of the Netherlands,[17] the debate between Natalie Davis and Janine Estebe on iconoclasm in France,[18] or Ernst Ullmann's rehearsal of events in Germany.[19] In contrast to economic explanations, the proponents of an institutional perspective concentrate on identifying a crisis of authority in the cities or regions where violent iconoclasm broke out. This argument seems particularly compelling for the Netherlands, and is supported by exception in cases of orderly image removal such as Nuremberg where the government was well in control of its citizens. Phyllis Mack Crew's recent study, entitled *Iconoclasm and Calvinist Preaching in the Netherlands,* attributes the revolt to a power vacuum resulting from the impotence of local administrations operating under Spanish occupation. Authority was usurped by people with various social, economic and religious grievances, while the Calvinist preachers played a secondary and rather disorganized part in provoking disturbances.[20]

Finally, there is the question of ideology. In what way or to what degree was the theological debate about images critical in precipitating iconoclastic outbreaks, and how should we best go about interpreting the individual and collective behavior of the image breakers from a personal or ideological perspective? Although in many ways the least susceptible to conventional methods of historical scrutiny, these questions are nonetheless among the most intriguing. Iconoclasm, or for that matter a willingness to submit to martyrdom, cannot be sufficiently accounted for by an historical theory which ascribes such cases entirely to self-interest! The phenomenon of iconoclasm by its very nature demands that we try to construct a

17 *Het Hongerjaar 1566* (Amsterdam, 1949).

18 N. Davis, "The Rites of Violence: Religious Riot in Sixteenth-Century France," *Past and Present* 59 (1973): 51-91. Following this, see the lengthy exchange between Davis and Estebe in *Past and Present* 67 (1975): 127-35.

19 "Bildersturm und bildende Kunst im 16. Jahrhundert," *Hafnia* (1976): 46-54.

20 Cambridge/New York, 1978.

psychological context for it. One may begin by examining the power of ideas alone--the effectiveness of preaching and pamphleteering for directing religious violence. But evidence of incitement by itself will not be sufficient. The real difficulty lies in explaining receptivity to these ideas, the willingness to assault objects once held in reverence. In this realm the techniques of social science have offered some recent insights. Current approaches to the function of ideology and social structure in the Reformation response to images are best exemplified by essays like Martin Warnke's on the Anabaptist take-over of Münster,[21] Natalie Z. Davis's on "The Rights of Violence,"[22] Horst Bredekamp's lengthy study of iconoclasm up through the Hussite movement,[23] and David Freedberg's "The Hidden God,"[24] among his other essays on the subject. These and other studies completed over the last decade or so offer speculations on the more subjective aspects of the image question. All point in one way or another to the strange ambivalence which western culture has repeatedly shown toward the power of images. At the very least these studies force us to realize that Reformation iconoclasm cannot be dismissed as merely random violence or a peculiarly philistine form of vandalism. Yet the more that is said, the more complex the role of ideas in this matter becomes. The thorniness of this interpretive problem is surely a reflection of the historical reality itself with its highly emotional charge and necessary confusion of motives.

The most recent, concerted study of iconoclasm is Solange Deyon and Alain Lottin's book on southern Flanders and northern France.[25] These authors weigh the questions of cause and intention carefully within the regions they have investigated. Their results are judicious and tentative. Economic conditions were conducive but not sufficient. Anti-clericalism was a factor. Although the lower classes were the main perpetrators of the destructions, they were not alone in this; the acquiescence of the nobility was probably also necessary. And most important, widespread abhorrence of the Catholic Church seems to have been heavy in the air. Iconoclasm

21 "Durchbrochene Geschichte? Die Bilderstürme der der Wiedertäufer in Münster 1534-1535," in *Bildersturm*, (see above, note 13), pp. 65-98, 159-67.

22 See above, note 18.

23 *Kunst als Medium sozialer Konflikte* (Frankfurt, 1975).

24 "The Hidden God: image and interdiction in the Netherlands in the sixteenth century," *Art History* 5 (1982): 133-53.

25 *Les 'Casseurs' de l'été 1566: L'iconoclasme dans le Nord de la France* (n.p., 1981).

here attacked symbols of power, wealth, and cultism, but was also an assault against objects thought to wield genuine power. Local studies of this kind, as well as more sweeping and speculative essays, have taken the image question in interesting directions beyond the exegesis of theological debate and the chronicling of destructions.

Printed Propaganda

Historians must now regard the printed image, much like the printed text, as an essential aspect of the Reformation phenomenon. However one may interpret its actual effect, no one can doubt that the Reformation invented mass-production of propaganda imagery. Yet it has taken some time for these polemical images to be collected and integrated into their historical context. So-called "popular prints"--often crude in content as well as form--have until this century not held even marginal status in the history of art. The illustrated broadsheets which make up the bulk of Reformation polemical and didactic images were collected mainly by those few but assiduous local historians such as Wilhelm Drugulin and Frederik Muller who, in the mid-nineteenth century, amassed huge albums (or atlasses as they were called) of topographical, journalistic and other illustrative imagery from the European past.[26]

The adoption of this rich source of visual material for social, economic and art historical studies only began in earnest shortly after the First World War. Although partly dependent upon an amateur interest in the study of local history and popular culture that stretched well back into the 19th century, this development was equally a response to contemporary politics. Karl Schottenloher declared in the introduction to his seminal study of the popular press in early modern Europe that his interest in mass communication was directly inspired by the dramatic role it had played during the War.[27] It was this perception that awakened him to the potential impact of "news media" on the flow of modern history more generally. Contemporary with Schottenloher's groundbreaking work came the legal

[26] *Drugulin's Historical Atlas: Catalogue of the Most Valuable Collection of Historical Broadsides, Allegorical and Satirical Prints, Books of Pageants etc. Serving to Elucidate the Public and Private History of all Countries during the Last Four Centuries* (Leipzig, 1867); and F.M. Muller, *De Nederlandsche Geschiedenis in Platen: Beredeneerde Beschrijving van Nederlandsche Historieplaten, Zinneprenten en Historische Kaarten.* 4 vols. (Amsterdam, 1863-82).

[27] *Flugblatt und Zeitung: Ein Wegweiser durch das Gedruckte Tagesschrifttum* (Berlin, 1922).

historian Hans Fehr's publication of broadsheets from the Wick collection,[28] as well as Hartmann Grisar and Franz Heege's compilation of Luther's "Kampfbilder."[29]

This emerging interest in various forms of propaganda and the popular press was then immediately complemented from a very different point of view by Max Geisberg's forty-three volume corpus of German single-leaf woodcuts,[30] and following shortly thereafter its Netherlandish successor compiled by Wouter Nijhoff.[31] Unlike Schottenloher, these two scholars were mainly directed by artistic motives, no doubt encouraged by the flourishing of German Expressionism with its proclivity for the woodcut medium. Both Geisberg and Nijhoff perceived the sixteenth-century woodcut to be an unrecognized dimension of fine art in need of rehabilitation. Consequently, in compiling their illustrations these scholars carefully sought out the best surviving impressions, touched up reproductions to cover flaws in the originals, and reproduced them in actual size where possible. Thus, the primary material for the study of Reformation propaganda imagery was substantially brought together over a twenty year period between the Wars, a development which accompanied the gradual legitimation (that is to say de-romanticization) of folk studies in German scholarship.[32] During the last decade or so the collecting and publication of broadsheets from the Reformation period and later has again been reinvigorated.[33]

The basic corpus of surviving images may now be nearly established. It has certainly become accessible to historians and art historians concerned with the role of the image in the dissemination of Reformation ideas. Due

[28] *Massenkunst im 16. Jahrhundert: Flugblätter aus der Sammlung Wickiana* (Berlin, 1924).

[29] *Luthers Kampfbilder*, 4 parts (Freiburg im Breisgau, 1921-23).

[30] *Der deutsche Einblattholzschnitt in der ersten Hälfte des XVI. Jahrhunderts* (Munich, 1924-30).

[31] *Nederlandsche Houtsneden 1500-1550* (The Hague, 1933-39).

[32] Wolfgang Brückner, "Expression und Formel in Massenkunst, zum Problem des Umformens in der Volkskunsttheorie," *Anzeiger des Germanischen Nationalmuseums* (Nuremberg, 1969), pp. 122-39.

[33] See, for example, the following: David Kunzle, *History of the Comic Strip* (Berkeley, 1973); Hermann Meuche, *Flugblätter der Reformation und des Bauernkrieges: 50 Blätter aus dem Schlossmuseum Gotha* (Leipzig, 1975-76); Veste Coburg, *Illustrierte Flugblätter aus den Jahrhunderten der Reformation und der Glaubenskämpfe* (Coburg, 1983). These exemplify the many recent studies, catalogues of collections and exhibitions employing broadsheets.

the character of persuasive rhetoric itself, the meaning of much of this polemical, theological, and allegorical imagery is quite transparent. Being accessible in this way, Reformation prints are often employed as direct illustrations of the events and attitudes of the period. This pattern has been particularly evident in documentary exhibitions which have pervaded museums and libraries in recent years, and were exhaustively staged in 1984 to commemorate the celebration of Luther's birth.[34]

Broadsheets and other prints of a polemical or satirical character have served the social historian well, and there are a number of important articles devoted to interpreting the vernacular iconography of certain more obscure images. Konrad Hoffmann analyzed the visual language of Reformation polemic in an important article entitled "Typologie, Exemplarik und Reformatorische Bildsatire."[35] There Hoffmann traces the evolution of structures of meaning from late medieval allegorical imagery through its transformation into Reformation polemic and a more secular frame of thinking. Most recently Hoffmann's typological approach has been adopted by Robert Scribner in his useful monograph on popular prints, *For the Sake of the Simple Folk* .[36] For the most part, it is not now the overt meaning of these images which poses problems for future scholarship, but rather the circumstances surrounding their production and the definition of their audience. These remain the most fundamental questions so far as the impact of the printed image on the Reformation is concerned.

Presently the most thorough and informative study of the circumstances of production appears in Bruno Weber's deceptively titled *Wunderzeichen und Winkeldrucker: 1543-86* . These volumes present a select group of broadsheets (all from the Johann Wick Collection in Zurich) illustrating miraculous signs, or "prodigies" as they were termed at the time.[37] In his introduction Weber marshals a vast array of detail from primary and secondary sources pertaining to everything from legal regulation to prices for prints, supplemented with an excellent

[34] For further reflection of this tendency and its pitfalls, see Peter Parshall, "The Luther Quincentenary: Prints as Illustrations of History," *Print Quarterly* 1 (1984): 60-67.
[35] In *Kontinuität und Umbruch,* edited by J. Nolte et al. (Stuttgart, 1978), pp. 189-210.
[36] Cambridge, 1981.
[37] 2 vols. (Zurich, 1972).

bibliography. Here one will discover many scattered pieces of information to be found in studies of particular designers, block-cutters, and publishers.

Additional material on the legal conditions surrounding early print publishing may be found in Theodor Hampe's corpus of archive documents from Nuremberg.[38] Hampe's publication of the Nuremberg archives has served for many decades as a foundation for speculations on the commercial and legal activities of artists and artisans active during the Reformation period. This dependence has had important consequences, in that much of what is often assumed about these matters ultimately derives from Nuremberg, by no means typical in its relation to the trades, or for that matter to the Reformation movement. Furthermore, Hampe's transcriptions are known for their frequent inaccuracies and so must be used with particular care.

Little is known about the means of disseminating broadsheets beyond the anonymous traffic at fairs and through itinerant agents.[39] The commercial relations between corner presses and their large-scale counterparts, the book publishers, remain largely obscure. Overall, the study of the commercial circumstances of early printing and of early prints have been carried on in isolation from one another. It is clear that art historians and social historians can learn much about patterns of production and audience reception from the more venerable and lovingly researched territory of the bibliophiles.

The central and in some ways most intractable historical problem for the student of Reformation art and its didactic capacity lies in defining the audience. How important were the visual arts to the conveyance and the adoption of Reformation ideas? Particularly when talking about polemic and satire, the term "popular art" has an easy and appealing resonance. Yet this is a notion which is by no means easy to specify. On the theoretical aspects of this question the reader is referred at the outset to Wolfgang Brückner's important critical essay and bibliography published in 1979, which assesses the state of research on popular imagery.[40]

There are two general lines of approach to the definition of audience. First is the examination of intent. In what way and to whom do propaganda images seem to make themselves accessible? Hoffmann, Scribner, and Fritz

[38] *Nürnberger Ratsverlässe über Kunst und Künstler* (Vienna/Leipzig, 1904).
[39] Hildegard Schnabel, "Zur historischen Beurteilung der Flugschriftenhändler," *Wissenschaftliche Zeitschrift der Humboldt-Universität zu Berlin* 14 (1965): 869-81.
[40] "Massenbilderforschung 1968-78," *Internationales Archiv für Sozialgeschichte der deutschen Literatur* 4 (1979): 130-78.

Saxl, among many others, have addressed this question.[41] These scholars seek to unveil the tradition behind Reformation polemical and allegorical imagery, explicating the meaning of specific images and unravelling iconography through interpreting images in relation to their accompanying texts. In certain instances a case can be made that an image was intended to be understood by the illiterate.[42] In most cases this is not at all evident, and at the very least one must imagine the presence of an interpreter--a lay preacher perhaps--in order to make clear the meaning of an illustrated broadsheet. Lucas Cranach's *Passional of Christ and Anti-Christ*, among the most celebrated Reformation polemical cycles, includes scriptural and other texts compiled by Philip Melanchthon along with the lawyer Johann Schwertfeger and was almost certainly intended for the educated. (A Latin edition was issued in the same year as the first vernacular edition appeared.) In any case, it seems prudent to say that in using the term "popular" in relation to Reformation allegorical and polemical prints we ought not to include the declining but nonetheless very substantial proportion of sixteenth-century society which remained unlettered. Illustrated broadsheets, with or without texts, were not likely serving as books of the unlearned.

The second problem of audience may be next to impossible to resolve. What was the actual as opposed to the intended constituency for these images? Perhaps the most direct evidence we have that printed images, like pamphlets, were effective in stirring up enthusiasm for Reformation ideas comes from cases of censorship and other forms of legal control imposed upon print publishers. Archival studies of censorship in the early history of printing have borne results pertinent to the history of images as well as books. A good summary of evidence on this question is given in Christiane Andersson's essay on "Polemical Prints during the Reformation."[43] In some cases it appears that the illustrated broadsheet was regarded, at least by the authorities, as a potentially powerful and disruptive medium. Most writing on Reformation propaganda imagery--particularly the literature

[41] F. Saxl, "Illustrated Pamphlets of the Reformation," in *Lectures* (London, 1957), vol. 1, pp. 255-66.

[42] R. Scribner, "Flugblatt und Alphabetentum: Wie Kam der gemeine Mann zu reformatorischen Ideen?" in *Flugschriften als Massenmedium*, edited by H.J. Köhler (Stuttgart, 1981), pp. 65-76.

[43] In *Censorship: 500 Years of Conflict*. Exhib. catalogue, New York Public Library, 1984, pp. 34-51; and Arnd Müller, "Zensurpolitik der Reichstadt Nürnberg," *Mitteilungen des Vereins für Geschichte der Stadt Nürnberg* 49 (1959): 66-169.

that has been flooding out of the German Democratic Republic in the past decade--presumes that it was a potent ideological force. Though this may be perfectly justified, the evidence for this presumption is very thin. There is need for further systematic study of the relation between text and image in pamphlets and illustrated broadsheets, of the independent migration of wood blocks and their use with various texts, of local and sectarian variations in religious and political propaganda, of propaganda seemingly directed towards the peasants during the 1525 uprising, and other similarly defined contexts.

It is worth asking whether images are at all well suited to the presentation of arguments. May this not be precisely a point at which texts and images importantly diverge? It is hard to imagine most broadsheet illustrations actually convincing someone of something, rather than serving to fix an idea or reinforce a prejudice already reached by other means. Satire--propaganda in its most extreme form--may not be at all effective in propagating opinion.[44] Defining the response to images in an historical setting is something that art historians tend to do more by presumption, often without much reflection on the complexity of the issue. In turning to the realm of propaganda imagery which was actually meant to provoke decisive, even violent action, the criteria for evaluating the role of images must in some ways become more explicit. This is an important and troublesome area of historical investigation that will require the attention of scholars versed in the interpretation of actions as well as images.

Reformation Art

We still lack a coherent overview of the general development of visual art in sixteenth-century northern Europe. This must be partly due to the fragmenting effect of the Reformation with its ambivalent and at times hostile response to the arts. In Protestant regions sculpture became restricted mainly to small, precious objects for private consumption or the occasional epitaph relief. Painting continued to flourish in the Netherlands where a wide range of styles and subjects were explored, though in Germany and Switzerland attention turned largely to portraiture. French patrons--chiefly Catholic--cultivated an Italianate Renaissance style in

[44] On this subject, see F. Stopp, "Reformation Satire in Germany: Nature, Conditions, and Form," *Oxford German Studies* 3 (1968): 53-68; and from a somewhat different perspective, Miriam Chrisman, "From Polemic to Propaganda: The Development of Mass Persuasion in the Late Sixteenth Century," *Archiv für Reformationsgeschichte* 73 (1982): 175-95.

painting, printmaking and architecture. The one dominant art form that seems to have thrived everywhere was the print, a flexible and inexpensive medium, commercially sensitive, and relatively unrestricted in its repertoire of subject matter. Though the detrimental effects of the Reformation may often have been exaggerated, its inhibition of artistic life, at least in certain areas of Germany and Switzerland, was surely significant.[45]

Given the potential implications of Protestantism for the visual artist, it is not surprising that a great deal of attention has been paid to its impact on the careers of individual figures. Certain of these have in fact been credited with anticipating the Lutheran challenge to established authority--Jörg Ratgeb, Mathis Grünewald, Hans Baldung, and, of course, Albrecht Dürer for example. To this group one might add Hans Holbein and Niklaus Manuel among others. This was a generation seeking to reconcile the mystical elements of a highly developed devotional art employed in the service of popular piety with an increasingly intense commitment to the imitation of the perceived world and to portraying human passions in the telling of religious narrative. Particularly in their embrace of apocalyptic as well as rational discourse, these artists concentrated on artistic problems closely parallel to the theological conflicts emerging around them. Thus it becomes possible to speak of a generation in crisis, one coming into its own at the threshhold of the Reformation outbreak and implicitly sympathetic to the Reformers' sense of their purpose.

Artists shown to have been actively drawn to the Reformation movement are relatively few. Albrecht Dürer is the most prominent among them, and by far the most discussed. Dürer's personal crisis of belief, which seems to have preoccupied him for some period from 1519 onward, is securely enough documented that it has played a major role in the interpretation of his late work. In fact much nineteenth-century German scholarship became deeply engrossed in whether Dürer remained a Catholic

[45] For an overview of the history of discussion on decline, consult the following: J. Janssen, *Art and Popular Literature to the Beginning of the Thirty Years' War* (London, 1907), chaps. 2 & 3; Georg Dehio, "Die Krisis der deutschen Kunst im sechzehnten Jahrhundert," *Archiv für Kulturgeschichte* 12 (1914): 1-16. G. Stuhlfauth, "Künstlerstimmen und Künstlernot aus der Reformationsbewegung," *Zeitschrift für Kirchengeschichte* 56 (1937): 498-514; Rüstow (see above, note 5); and most recently, Carl Christensen, "The Reformation and the Decline of German Art," *Central European History* 6 (1973): 207-32.

or turned formally to the Protestant faith.[46] The history of debate over this question consists of often impassioned sectarian claims to enlist the great master into one congregation or the other. However, as has often been pointed out, the notion of adherence to one or another church does not appropriately describe the historical situation. During the early phase of the Reformation it was rarely a question of formalized church membership, but rather degrees of sympathy for one perspective or another on certain matters of doctrine, or perhaps more commonly a preference for the style of one local preacher over another. Whether Dürer should be termed a Protestant or a Catholic is mainly a matter of historiographical interest, an aspect of Dürer's earlier scholarly reception in a highly sectarian climate of interpretation. There seems little doubt that he underwent a spiritual crisis, and that Luther's teachings played an important role in it.[47] How this crisis actually affected his art remains the more provocative and as yet unresolved issue.

There are, however, reasonably secure instances of conversion or strong allegiance to the Reformation cause among artists (for example, Hans Greiffenberger, Marinus van Reymerswaele, Jean Duvet, and Niklaus Manuel). In many cases conversion probably resulted in the abandonment of artistic production altogether, as seems to have been true of Niklaus Manuel. On the other hand, some artists can be shown to have worked for both Protestant and Catholic patrons alike throughout their careers with no indication of compromised loyalty or ambivalence towards one or the other type of patron. Of course the most glaring instance of this is Lucas Cranach the Elder: an intimate of Luther, co-resident in Wittenberg, Luther's authorized portraitist and collaborator in the production of propaganda, who nevertheless continued to execute important commissions for Cardinal Albrecht of Brandenburg throughout the period of struggle between these

[46] Typical cases are, on the side of Catholicism: Joseph Dankó, "Albrecht Dürers Glaubensbekenntnis," *Theologische Quartalschrift* 70 (1880): 244-86; and Georg Anton Weber, "Zur Streitfrage über Dürers religiöses Bekenntniß," *Der Katholik* 79 (1899): 322-33, 410-27. On the Protestant side: Moriz Thausing, "Dürer und die Reformation" in *Wiener Kunstbriefe* (Leipzig, 1884), pp. 99-117; and Markus Zucker, "Dürers Stellung zur Reformation," *Beiträge zur bayerischen Kirchengeschichte* 1 (1895): 275-80.

[47] For a balanced view of the question, see: Tim Klein, "Albrecht Dürer und die Reformation," *Zeitwende* 4 (1928): 377-79; Hans Rupprich, *Dürers Stellung zu den agnoëtischen und kunstfeindlichen Strömungen seiner Zeit* (Munich, 1959); and Gottfried Seebaß, Dürers Stellung in der reformatorischen Bewegung," in *Albrecht Dürers Umwelt* (Nuremberg, 1971), pp. 101-31.

two principal antagonists. Pieter Bruegel presents a similar though more perplexing case. These examples pose a difficult problem if we are inclined to suppose that artists' religious convictions are likely to be reflected in their work. In France, persecution may have been so intense during the period of the Religious Wars as to prohibit any workable separation between one's spiritual and commercial life. Yet we ought to assume that crossing sectarian lines for business purposes was not uncommon, at least in Germany and the Netherlands.

The question remains whether we can identify a class of works that can appropriately be termed "Reformation art". In his essay on the subject discussed above, Panofsky is quick to stress the plurality of art forms that issued from Protestant societies. He suggests that wherever Protestantism entered into the production of art, mainly it "affected iconographical subject matter rather than expressive form and intrinsic content." However, Panofsky goes on to speak of certain general proclivities in the art of Protestant regions that appear to go well beyond what would normally be termed iconographic. These qualities are summarized by what he calls the "hyperborean" outlook.[48] However much we might be inclined to agree with Panofsky's sensitive definitions of cultural ethos, his account of the problem of a Reformation art is unlikely to satisfy the more positive criteria of current social and intellectual historians.

If there is a central conviction of Protestant (and particularly Lutheran) theology that can be seen to have affected the general character of religious imagery in the sixteenth century, it is the primacy given to the scriptural Word. This aspect of the problem has been much written about generally and in relation to specific theologians, artists, and objects. Hans Preuss was the first to pursue in much depth Luther's approach to the relation of word and image. Preuss brought together all of Luther's recorded observations on the visual arts, and explored his theological and aesthetic contribution to visual expression of religious statements.[49] As one would expect, an important objective of Luther's was the employment of images in a manner literally responsive to scripture. Phillip Schmidt has

48 See above, note 6.

49 *Luther der Künstler* (see above, note 8), part 1. For qualifications and elaboration of Preuss' interpretation of Luther's notion of word and image: Stirm (see above, note 7), pp. 96ff., where the author specifically disputes Preuss in discussing the issue; and Jean Wirth, "Le dogme en image: Luther et l'iconographie," *Revue de l'art* 52 (1981): 9-23, which attempts to distinguish between Lutheran and Melanchthonian iconography.

shown in his commentary on the illustrations for Luther's Bible translation that a good deal of personal attention went into guiding the choice of episodes and their representation.[50] For Luther, these illustrations were meant to convey the meaning of the text both literally and exegetically. It seems clear then that he at least had a working knowledge and a critical sense of current biblical iconography. Luther's Bible illustrations are among the more tangible instances we have of the initial impact of Reformation principles on traditional iconographic conventions.

Allegorical construction is a conspicuous and often acknowledged feature of Protestant sponsored works of art, whether one speaks of the commissioned altarpieces that began to issue from the Cranach workshop in significant numbers during the 1540's and 1550's, or the innumerable instructive prints meant to acquaint a wider spectrum of the public with the tenets of the new faith. Allegorical religious art--more often than not heavily laden with explanatory inscriptions--illustrates most literally the importance of the Word for the Protestant employment of images. For a sample of the scholarship on allegorical art in Reformation Germany one need only survey the substantial literature treating the central icon of the new faith, the *Allegory of Law and Grace* .[51] From satirical broadsheets to intricate theological demonstrations, allegorical imagery played a major role in the rethinking of the textual basis for visual statements. Some preliminary theoretical speculation along this line is offered by Robert Scribner in the introduction to his book *For the Sake of the Simple Folk,* though it must be said that the theoretical component of this study is neither well enough developed nor adequately integrated into the author's

[50] Ph. Schmidt, *Die Illustration der Lutherbibel 1522-1700* (Basel, 1977), intro. and individual commentaries; and by the same author "Die Bibelillustration als Laienexegese," in *Festschrift Gustav Binz* (Basel, 1935), pp. 228-39.

[51] I have profited from an extremely interesting discussion of this allegory and the structure of choice in Reformation art and theology in an unpublished paper entitled "*Homo interpres in bivio* : Crisis in Lucas Cranach's Images of the Law and the Gospel," by Joseph Koerner (Art History Department, University of California, Berkeley). On the origins of this allegory, see the following article on a painting then in private hands and now in the National Gallery of Scotland, Edinburgh: Fritz Grossmann, "A Religious Allegory by Hans Holbein the Younger," *Burlington Magazine* 103 (1961): 491-94. Also Wirth (see above, note 49), pp. 17-20; and an important recent study of a different Reformation topic in the Netherlands: Karel G. Boon, " 'Patientia' dans la gravure de la Réforme aux Pays-Bas," *Revue de l'art* 56 (1982): 7-24.

discussion of the images themselves.[52] This is a rich subject which may be expected to attract more attention from those interested in the semiotic analysis of texts and images.

Seeking clarity of meaning through the use of allegory and accompanying texts is, however, importantly a feature which Protestant art shares with the art of the Counter Reformation. It is a conceptual development that reflects a concern for theological clarity and correctness on both sides of the spiritual divide. Furthermore, exploration of the text/image relationship became significant within sixteenth-century secular contexts as well. One need only recall the parallel fashion for emblems and *imprese* which are precisely concerned with complementary relations between language and image.[53] Although clarity as such is certainly not an objective in emblematic play, this literary fashion reflects a comparable obsession with complexities and interrelationships of visual and textual meaning. A case can certainly be made for the Reformation having encouraged a newly literal sort of religious image. However, this kind of image should not be taken as the peculiar mark of a Protestant art, but recognized as characteristic of the experimental art of the century as a whole.

Much the same could be said of the drift toward secular subject matter in Protestant areas, an important general trend in the sixteenth century. This tendency was no doubt enhanced by the shock which iconoclasm delivered to earlier schemes of patronage. Yet the emergence of secular subject matter, like allegorical imagery, is evident in Catholic regions as well. This has much to do with the emergence of an art market along with changing perspectives in patronage, matters often quite separate from the religious values held by artists and collectors. The Reformation may have given indirect encouragement to the evolution of non-religious art, but did Protestantism affect its character? The particular ways in which Protestantism may have directed secular interests remains very much in question. Here attention must center on what is distinctive about the treatment of secular genre subjects in northern art, as opposed, say, to the genre painting of Italy and Spain. For several decades now the prevailing tendency in the interpretation of much early secular imagery in northern

[52] Scribner (see above, note 36), intro. For a more exacting analysis of the function of texts in Lutheran art, consult Sergiusz Michalski, " 'Wiznialne slowa' sztuki protestanckiej," in *Slowo i Obraz* (Warsaw, 1982), pp.171-208.

[53] Robert Klein, "The Theory of Figurative Expression in Italian Treatises on the Impresa," in *Form and Meaning* (New York, 1979), pp. 3-24.

European painting and prints has been to see it as carrying a moral message. Several generations of scholars rethinking the art of Pieter Bruegel the Elder illustrate this point well enough. Furthermore, over the last decade the interpretation of genre subjects in much seventeenth-century Dutch art has led to similar conclusions, namely that a social or moral comment is very often embedded in the seemingly innocent representation of the everyday. This apparent need to justify an interest in the day-to-day world and its material and social complexion could be understood as an extension of a measured Protestant suspicion of the temporal. Perhaps also the forcible eclipse of so much religious art left a void of satisfaction in the didactic experience of visual art that needed to be filled in this way.

Marxist commentators have taken a different approach to the question of secularization. Following an older generation of scholars active in the post-War German Democratic Republic (J. Jahn, W. Fraenger, W. Schade), a more doctrinaire school of interpretation has since evolved largely around Friedrich Engel's definition of what he termed the "early bourgeois revolution," a phase of economic and social history in which the middle class is seen to have finally overthrown the outmoded structures of feudalism then in the process of being replaced by progressive urban capitalism.[54] Broadly speaking, this development is understood to be reflected in the emergence of a new naturalism in the visual arts, an interest in material description, and in particular a more democratized approach to subject matter. The peasantry, for example, became a common subject and are regarded as being sympathetically treated.[55] For these scholars it is the polemical imagery of the Reformation which is of most importance, and in conjunction with that comes an emphasis on the print as a popular art form adopted by the artisan class to spread revolutionary ideas among the common people. Though often redundant, this ideological approach to the issue of secularization is significant for its attempt to embed the art of the period in a socio-political context. However, relatively little primary

[54] For a sampling of this literature, see the following collections: Sibylle Badstübner et al., *Deutsche Kunst und Literatur in der frühbürgerlichen Revolution: Aspekte, Probleme, Positionen* (Berlin, 1975); and Ernst Ullmann, ed. *Kunst und Reformation* (Leipzig, 1982).

[55] See, for example, the debate over the meaning of Dürer's *Monument to the Peasants' War.*

research stands behind most of this writing.[56] One hopes that those scholars actively pursuing the social and economic aspects of the history of art will take advantage of whatever unmined resources there may be in local archives and provide more of the documentary underpinning necessary to support their interpretations. At present, however, this literature is mainly interesting as a symptom of methodological revision within orthodox Marxist historiography where Reformation studies have become a kind of ideological proving ground.

Most of what has been said so far about the identity, or lack thereof, of a Protestant art has centered on features of subject matter. There is some literature that directly broaches the question of a Protestant style, a sensitive aspect of the problem because it is the most intangible and difficult to define. Luther seems to have invited the question in the famous remark from the *Tischreden* where he compares his preaching style to Dürer's preference in painting--the choice of plain language likened to the artist's distaste for works employing too many colors.[57] One study along this line is particularly worthy of attention: Donald Kuspit's article on Dürer and the rhetorical theories of Melanchthon.[58] Melanchthon seems to have perceived Dürer's art--and possibly the print in particular--as setting a rhetorical stance and a standard of stylistic decorum that was ideal for conveying the Protestant message. Though Kuspit is convincing in his construction of a theoretical basis for thinking about Protestant art in sixteenth-century terms, he is less successful in applying this notion to the works of art themselves.[59] However, Kuspit and others who have speculated on the theological and art theoretical implications of Protestant thought provide a means of entry into one of the more vexing frustrations for those studying the art of this period. Historians have often lamented the absence of a developing art theory in sixteenth-century northern Europe, in

[56] For a critical review of the Marxist interpretation of the history of the period, see: "The Peasant War in Germany by Friedrich Engels--125 Years After," *Journal of Peasant Studies* 3 (1975), in particular the statement by Rainer Wohlfeil (pp. 98-103), and the response by Ernst Engelberg (pp. 103-107).

[57] Preuss (see above, note 8), p. 47, quotes this passage.

[58] "Melanchthon and Dürer: The Search for the Simple Style," *Journal of Medieval and Renaissance Studies* 3 (1973): 177-202.

[59] For example, "Dürer and the Lutheran Image," *Art in America* 63, no. 1 (1975): 56-61. A more successful consideration of Protestant style is: Charles Talbot, "An Interpretation of Two Paintings by Cranach in the Artist's Late Style," *National Gallery of Art: Report and Studies in the History of Art* (Washington D.C., 1967), pp. 67-88.

marked contrast to the Italian Renaissance where theoretical speculation was rampant. Though it might seem paradoxical given the uncomfortable relationship between the Reformers and the arts, Protestantism may be precisely the place to turn for reconstructing an appropriate theoretical framework for evaluating northern art. After all, it is often overlooked that Protestant sponsorship and Protestant criticism provide us with both semiotic and ethical premises for discussing works of art. It is certainly the case that we have here a more varied textual resource for exploring the response to images than is true of any other type of discourse in northern Europe prior to the seventeenth century.

If there is considerable room for developing a more refined critical framework for art in the Reformation era, it is equally the case that this must be sought in the context of Catholic patronage and the later Renaissance as a whole. Oftentimes the most precise discussions of art and the Reformation occur in thematic studies where comparisons as well as contrasts can be made between Protestant and Catholic objects and attitudes. Such studies tend to dispel easy conclusions about the distinctiveness of Protestant sponsored art, its critics, and its articulate theory. David Freedberg's discussion of iconoclastic debate has already been mentioned as an instance of this kind of contextual investigation.[60] A counterpart in the realm of iconographic and patronage studies is Craig Harbison's monograph on the Last Judgment theme in sixteenth-century art. Though mainly centered on the north, and largely the Netherlands, Harbison traces the evolution of his subject broadly and in detail, mindful of theological and formal changes taking place Europe-wide. Although Harbison draws fine distinctions in Protestant and Catholic iconography, he also shows that clear theological lines are often very difficult or impossible to identify even in the case of so potent a subject as this one. Finally, he assesses the period as one of rising individualism more than ideological polarity in religious iconography.[61] As both Freedberg's and Harbison's research implies, the Netherlands has proven to be an important arena for examining the interplay of Catholic and Protestant attitudes evolving and accomodating one another in close geographical proximity. Another manifestation of this is the persistence in the Netherlands of a liberal Erasmian viewpoint-- evident, for example, among the Rederijkers and the Family of Love.

[60] See above, note 14.

[61] *The Last Judgment in Sixteenth Century Northern Europe* (New York, 1976).

Despite a substantial body of scholarship on the topic of art and the Reformation, much still remains that has barely been studied or studied only in fragments and left unsynthesized. The significance of the Reformation image controversy and iconoclastic destruction is actively under re-evaluation. More needs to be done on the identification of audience for propaganda imagery and for the theological imagery that formed such an important part of the Reformation's self-definition. By far the greatest burden of scholarship on the topic in general has concentrated on the German-speaking regions, and within that mainly Saxony, the south from Nuremberg to Strasbourg, and northern Switzerland. The Lowlands have been extensively studied, yet the complex relation of competing Protestant sects, Catholics and independents presents an awesome problem, particularly for the art historian concerned with intellectual history and patronage in the area. France is perhaps the most understudied of all, a country with a history as volatile as the Lowlands during the sixteenth century, torn by violent religious confrontation, social and political upheaval.[62]

Considering the study of art and the Reformation over the last century, it would seem that in a certain sense the attention of scholarship has completed a cycle. The earliest work on this question often centered on the study of local events and major figures, often with a distinctly nationalistic turn. Although this latter feature has generally been eclipsed in the quest for historical objectivity, the need for detailed studies of local events has once again come to dominate scholarship. This development reflects the importance of social history with its respect for the complexity of human motives and actions. On the other hand, there has been a recognition that the early modern period cannot easily be divided into ideological factions: Protestant versus Catholic, secular versus spiritual. Rather, the Reformation and its visual context are best understood as part of larger changes that engaged the whole of European society and its art. It is these two inclinations that in the broadest terms seem to be setting current directions. We are hopeful that the bibliography offered here may be of use in furthering this enterprise.

P. W. P., October, 1985

[62] The best single study of art and the Reformation in France remains Colin Eisler's monograph *The Master of the Unicorn: The Life and Work of Jean Duvet* (New York, 1979). For a recent and provocative interpretation of the Huguenot movement in France and its social, political, and cultural implications, see: Donald Kelley, *The Beginning of Ideology* (Cambridge, 1981).

I. Standard Reference Sources

I. A. Bibliographies

1
ARCHIV FÜR REFORMATIONSGESCHICHTE / ARCHIVE FOR REFORMATION HISTORY. Gütersloh: Gerd Mohn, 1903-.
Beginning in 1972 this periodical is published with an annual, largely annotated bibliographic supplement including sections on art, music, and printing.

2
ART INDEX. New York: H.W. Wilson Co., 1933-.
Appears annually, arranged alphabetically by author/topic. Standard art bibliography before the appearance of RILA. Includes book reviews. Not annotated.

3
BAKER, DEREK. *The Bibliography of the Reform relating to the United Kingdom and Ireland for the years 1955-70*. Oxford: Blackwell, 1975, 242 pp.
Includes books, articles reviews, and theses, arranged by author. Not indexed by topic. Not annotated.

4
BIBLIOGRAPHIE DE LA REFORME 1450-1648. Leiden: E.J. Brill, 1960-.
Each issue on a specific country, initially covering scholarship from 1940-55, more recent volumes updated to 1970's. Alphabetical by author, indexed by topics, names and places. Not annotated.

5
BIBLIOGRAPHIE INTERNATIONALE DE L'HUMANISME ET DE LA RENAISSANCE. Geneva: Librairie Droz, 1966-.
Arranged by author with index of proper names and topics (vols. 1-6); thereafter arranged by categories with an index of proper names only. The section on the plastic arts is subdivided by region. The first volume includes a supplement on bibliography back to 1958. Not annotated.

1

6
BIBLIOGRAPHIE ZUR SYMBOLIK, IKONOGRAPHIE UND MYTHOLOGIE.
Baden-Baden: Verlag Librairie Heitz, 1968-.
Annual collection of mostly annotated entries. Subject and proper name indexes at the back of each volume cover some Reformation topics.

7
CHRISTENSEN, CARL. "Reformation and Art." In *Reformation Europe.* Edited by Steven Ozment. St. Louis: Center for Reformation Research, 1982, pp. 249-71.
A bibliographical essay summarizing recent research on the topic and reflecting on potential new directions.

8
HILLERBRAND, HANS JOACHIM, ed. *Bibliographie des Täufertums 1520-1630.* Quellen und Forschungen zur Reformationsgeschichte, 30. Quellen zur Geschichte der Täufer, 10. Gütersloh: Verlagshaus Gerd Mohn, 1962, xv, 283 pp., indexes.
Divided into categories, each source then chronologically listed, with each entry separately numbered. Not annotated.
Continued in: Hillerbrand. *A Bibliography of Anabaptism, 1520-1630. A Sequel 1962-1974.* Sixteenth Century Bibliography, 1. St. Louis: Center for Reformation Research, 1975.

9
LUTHERJAHRBUCH. Göttingen: Vandenhoeck & Ruprecht, 1919-.
Includes an annual bibliography ("Luther-bibliographie") divided into subject categories.

10
REPERTOIRE D'ART ET D'ARCHEOLOGIE. Paris: Morancé, etc., 1910-. Early volumes reprinted by Kraus, 1969-.
Classified and annotated bibliography on western art. Indexed annually by author and subject. An English counterpart begun in 1975 (see no. 11).

11
RILA. Répertoire international de la littérature de l'art. n.p., College Art Association of America, 1975-.
Abstracts in English of all manner of publications on the arts internationally. Indexed by author and subject. Issued annually.

12
ROOKMAKER, H.R. "Christianity and Art: A Preliminary Bibliography, 1571-1970," *Christian Scholar's Review,* 2 (1972):135-39.
About 150 titles on the general subject, with special attention given to modern, sectarian theological views.

13
SCHOTTENLOHER, KARL. *Bibliographie zur deutschen Geschichte im Zeitalter der Glaubensspaltung. 1517-1585.* 7 vols. Leipzig: Verlag Karl W. Hiersemann, 1933-66, indexes.
Essential annotated bibliography of scholarship on the Reformation period, organized by regions and topics. Vols. 1-6 cover work to 1938; vol. 7 (compiled by Ulrich Thürauf) updates to 1960. Indexes (vols. 6, no. 2 and vol. 7) cite authors and titles only.

14
WORLDWIDE ART CATALOGUE BULLETIN. International Review of Art Exhibition Catalogues. Boston: Worldwide Books, Inc., 1963-. indexes.
Annotated entries describe most major exhibition catalogues from the given year. Indexed by category (i.e. religious art), chronology, artist, etc.

I.B. Lexicons

15
BRUNOTTE, HEINZ, and WEBER, OTTO, eds. *Evangelisches Kirchenlexikon. Kirchlich-theologisches Handwörterbuch.* 4 vols. Göttingen: Vandenhoeck & Ruprecht, 1956-61.
Reference work with names, places, terminology, etc. organized alphabetically. Around 3,000 articles by various authors. Vol. 4 is a cross-reference index and an appendix with dates and identifications of persons referred to in the lexicon.

16
THE ENCYCLOPEDIA OF THE LUTHERAN CHURCH. Edited by Julius Bodensieck. 3 vols. Minneapolis: Augsburg Publishing House, 1965.
Includes various entries on the arts. See also nos. 126 and 1310.

17
KIRSCHBAUM, ENGELBERT and BRAUNFELS, WOLFGANG, eds. *Lexikon der christlichen Ikonographie.* 8 vols: Rome/Freiburg/Basel/Vienna: Herder, 1968-1976.
Vols. 1-4 contain general iconography, vols. 5-8 the iconography of the saints. Listing is alphabetical. The Reformation is mentioned rarely. Each entry is followed by bibliographical references. Vol. 8 contains extra indexes. Many illustrations.

18
RDK. Reallexikon zur deutschen Kunstgeschichte. Edited by Otto Schmidt et al. Stuttgart: Metzlersche Verlagsbuchhandlung, 1937-.
Alphabetically arranged articles by various authors on types of objects, iconographical subjects, techniques etc. The articles are illustrated and documented.

19
DIE RELIGION IN GESCHICHTE UND GEGENWART. HANDWÖRTER-BUCH FÜR THEOLOGIE UND RELIGIONSWISSENSCHAFT. Edited by Hans Freiherr von Campenhausen et al. 7 vols. Tübingen: J.C.B. Mohr, 1957-65. 1st ed. 1927-32, 6 vols. (vol. 6 indexed); 2nd ed. 7 vols. (vol. 7 indexed).

Includes essays on various topics related to art and the Reformation (i.e. Bilder und Bilderverehrung, Bilderstreitigkeiten, Cranach, Lutherbilder, Flugschriften, Reformation).

II. The Image Controversy

II. A. General studies

20

ALT, HEINRICH. *Die Heiligenbilder oder die bildende Kunst und die theologische Wissenschaft in ihrem gegenseitigen Verhältniß historisch dargestellt.* Berlin: Plahn'sche Buchhandlung, 1845, xiv, 304 pp., index.

 An early iconographic study and among the first attempts to define a Reformation iconography (pp. 241-48).

21

*BEUZART, P. "La culte des images et la Réforme dans les Pays-Bas." Bulletin de la société d'histoire du Protestantisme Belge 10 (Brussels, 1913):7-28.

22

BRÜCKNER, WOLFGANG. *Bildnis und Brauch. Studien zur Bildfunktion der Effigies.* Berlin: Eric Schmidt Verlag, 1966, 361 pp., bibliog., index, 18 illus.

 Detailed examination of effigies and their ceremonial, religious, and especially legal significance in Europe from the Middle Ages to the 19th century. An important study of popular practice regarding images, with much direct and indirect implication for Reformation satire and attitudes to religious or cult imagery.

23

CAMPENHAUSEN, HANS Freiherr von. "Die Bilderfrage in der Reformation." *Zeitschrift für Kirchengeschichte* 68 (1957):96-128.

 Examines the theological positions on images set forth in the writings of Zwingli and Luther, and briefly relates them to Karlstadt and Calvin. The conclusion reflects on the significance of the image controversy for religious art of the time.

24

COCHRANE, ARTHUR C., ed. *Reformed Confessions of the 16th Century.* Philadelphia: The Westminster Press, 1966, 336 pp.

 Gives the texts (in English translation) of Martin Bucer's *Tetrapolitan Confession* of 1530 and Heinrich Bullinger's *Second Helvetic Confession* of

1566, both including Protestant positions on images (pp. 80-81, 229-30).

25
CRAMER, S., and PIJPER, F. *Bibliotheca Reformatoria Neerlandica.* 10 vols. The Hague: M. Nijhoff, 1903-14.
Corpus of documents concerning the Reformation in the Netherlands with historical introductions, notes, and indexes. There are frequent references to religious imagery and idolatry throughout. (Those texts especially relevant to the visual arts are cited separately under their authors, see nos. 57, 58, 100 and 164).

26
CRESPIN, JEAN. *Histoire des Martyrs persecutez et mis à mort pour la verité de l'Evangile; depuis le temps des Apostres jusques à présent.* Edition of 1619. Geneva: Pierre Aubert, 1760 pp., indexes. Edited by D. Benoît. 3 vols. Toulouse: Société des Livres Religieux, 1885-89, indexes.
The first edition was published in 1554 with the title *Le Livre des Martyrs.* There is much overlapping with the *Histoire ecclésiatique* (see no. 227). The image question is discussed at numerous points. See the index "des principaux poincts de la vraye et fausse religion."

27
DELIUS, WALTER. *Geschichte der Marienverehrung.* Munich/Basel: Ernst Reinhardt Verlag, 1963, 376 pp., 4 illus., bibliog., indexes.
Chap. 12 discusses the attitude of the Renaissance and Reformation toward devotion to the Virgin, analyzing Lutheran, Zwinglian and Calvinist views (195-234). The question of images is reviewed *passim.*

28
FREEDBERG, DAVID. "The Problem of Images in Northern Europe and its Repercussions in the Netherlands." *Hafnia. Copenhagen Papers in the History of Art* (1976), pp. 25-45, 6 illus.
Lucid consideration of Protestant and Catholic positions in the debate on images. Stresses the importance of both sides in stimulating the outbreaks, and reflects on the consequences for the careers of Netherlandish artists in the latter half of the century.

29
GRÜNEISEN, CARL. *Über bildliche Darstellung der Gottheit.* Stuttgart: Gebrüder Franckh, 1828, vi, 149 pp.
A broadly-based theological discussion of the question, with the Reformation period in Germany and Switzerland reviewed pp. 113-32.

30
HOFFMANN, KONRAD. *Ohn' Ablass von Rom kann man wohl selig werden. Streitschriften und Flugblätter der frühen Reformationszeit.* Nördlingen: Alfons Uhl, 1983, 46pp. introduction and ca. 300 pp. of photo-reproduced 16th-century texts, numerous illustrations.

Facsimiles of eighteen 16th-century Reformation publications, several illustrated. Includes Karlstadt's *Von Abtuung der Bilder,* Luther's *Ein Sermon von den Bildnissen,* the *Klagrede der armen verfolgten Götzen* etc. Hoffmann's introduction discusses images pp. 28-30.

31
ISERLOH, ERWIN. "Bildfeindlichkeit des Nominalismus und Bildersturm im 16. Jahrhundert." In *Bild-Wort-Symbol in der Theologie.* Edited by W. Heinen. Würzburg: Echter-Verlag, 1969, pp. 119-38.

Ties the Reformation attack on images to Nominalist theology of the 14th and 15th centuries which, according to the author, undercut the worth of images precisely at a time when they were proliferating alongside the diversification of forms of popular devotion.

32
KITZINGER, ERNST. "The Cult of Images in the Age before Iconoclasm." *Dumbarton Oaks Papers* 8 (1954):83-150.

Though concerned exclusively with the early church and Byzantium, this is an essential study of Christian theology, the practice of image worship and early opposition to the cult of images. It is regularly cited in studies of Reformation attitudes to images and discussions of iconoclasm.

33
KOTTMEIER, DAVID. *Die Darstellung des Heiligen durch die Kunst, vornehmlich in ihrer Anwendung auf den evangelischen Kultus.* Bremen: Schünemann, 1857, vi, 142 pp.

A general theological consideration of the image question in the Reformation, followed by an overview of the development of a Protestant religious art and architecture.

33a
MICHALSKI, SERGIUSZ. "Aspekte der protestantischen Bilderfrage." *Idea* 3 (1984):65-85.

Discusses the historical, philosophical and theological bases for iconoclasm. Based on the author's dissertation (see. no. 34). Footnotes include extensive bibliographical references.

34
MICHALSKI, SERGIUSZ. "Doktryna protestancka a problemy sztuki religijnej w Europie Srodkowej w Latach 1517-1618." [Protestant Doctrine and the Problem of religious art in central Europe in the years 1517-1618]. Ph.D. dissertation, Warsaw University, 1980, 2 vols., 416 pp.

In Polish. Analyzes the theological positions of Luther, Karlstadt, Calvin and Zwingli on the question of images, and examines the significance of the issue for the relations between Protestantism and the Eastern Churches. Chap. 3 surveys this question for Russia and Constantinople as well.

35
MOXEY, KEITH P.F. "Image Criticism in the Netherlands before the Iconoclasm of 1566." *Nederlands Archief voor Kerkgeschiedenis* 57 (1977):148-62.

Discusses contemporary published documents engaged in the debate over images prior to iconoclastic outbreaks. The documents include tracts and rederijker plays. The distinction between Lutheran and Calvinist treatment of the issue is identified in certain sources.

36
PARSHALL, PETER W. "Some Visual Paradoxes in Northern Renaissance Art." *Wascana Review,* Spring 1974, pp. 97-104.

Reviews the image question raised as a strategy of self-contradiction within works of art themselves: Holbein's *Ambassadors* (London, National Gallery), Lucas van Leyden's *Dance around the Golden Calf* (Amsterdam, Rijksmuseum), and P. Bruegel's *Nemo*.

37
REICKE, BO. *Die zehn Worte in Geschichte und Gegenwart. Zählung und Bedeutung der Gebote in den verschiedenen Konfessionen.* Beiträge zur Geschichte der biblischen Exegese, 13. Tübingen: J.C.B. Mohr (Paul Siebeck), 1973, vi, 73 pp., indexes.

In analyzing the history of arguments for varying divisions and numberings of the Ten Commandments, discusses the roles of Luther, Zwingli and other Reformers in isolating the ban on images as a separate commandment (see esp. pp. 14, 19, 27-32).

38
SEGUY, JEAN. "Images et 'religion populaire'." *Archives de Sciences sociales des Religions* 44 (1977):25-43.

Argues that religious images should not be too narrowly defined as didactic tools but should be seen as part of power relationships within society. This is apparent in Reformation attitudes towards images.

39
SENN, MATTHIAS. "Bilder und Götzen: Die Zürcher Reformatoren zur Bilderfrage." In Tavel, *Zürcher Kunst nach der Reformation* (see no. 490), pp. 33-8, 2 illus.

Summarizes the history of the image question in Zurich by reviewing the positions of the major Reformers (Zwingli, Jud, Bullinger) on idolatry, the distinction between narrative picture and idol, etc.

40
SÖRRIES, REINER. *Die Evangelischen und die Bilder. Reflexionen einer Geschichte.* Erlangen: Verlag der Ev.-Luth. Mission, 1983, 235 pp., numerous illus.

Written for an exhibition in Nuremberg. Contains short, general essays on the image question.

41

STEINMETZ, MAX. "Reformation und Kunst. Bemerkungen zur Stellung der frühen Reformation zur Kunst, besonders zu den Bildern (1521-1525)." In E. Ullmann, *Von der Macht der Bilder* (see no. 386), pp. 250-58.
 Surveys the views of Münster, Grebel and Karlstadt on art and music.

42

STIRM, MARGARETE. *Die Bilderfrage der Reformation.* Gütersloh: Verlagshaus Gerd Mohn, 1977, 246 pp., bibliog.
 Reviews: Walther von Loewenich, *Zeitschrift für Kirchengeschichte* 89 (1978):193-95.
 H. G. Koenigsberger, *Journal of Ecclesiastical History* 29 (1978):488-89.
 A detailed, fully documented study of the image question in the 16th century from a theological perspective. Concentrates on a comparative analysis of Luther and Calvin but covers Zwingli, Karlstadt and others as well. Contains an extended criticism of H. Preuss, *Luther der Künstler* (see no. 139) regarding the basis for Luther's defense of images.

43

STIRM, MARGARETE. "Kleine Theologie der Kunst." *Theologia viatorum* 13 (1975-76):235-42.
 Analyzes Heinrich Vogel's modern theological interpretation of the image question (*Der Christ und das Schöne*, Berlin, 1955) and compares it in detail with Luther's and Calvin's.

44

STUHLFAUTH, GEORG. "Das Bild als Kampflosung und als Kampfmittel in der Kirchengeschichte." *Wege und Ziele* 2 (1918):458-72, 2 illus.
 Contrasts Byzantine and Reformation iconoclasm on grounds that in the latter case images were enlisted as an essential means of propaganda on behalf of both pro and anti-religious image parties. Discusses Cochläus' *Seven-headed Luther* (1529), and H. Sachs' *Seven-headed Papal-animal* (1543) broadsheets.

45

STUMPF, JOHANN. *Gemeiner loblicher Eydgnoschafft. Stetten, Landen und Völckeren Chronick wirdiger thaaten beschreybung.* 2 vols. Zurich: Christoffel Froschauer, 1548, 3917 illus., indexes.
 A Swiss chronical relating attitudes to the image controversy and commenting on the "image war" between Pope and Emperor.

46

TAPPOLET, WALTER, ed. *Das Marienlob der Reformatoren. Martin Luther, Johannes Calvin, Huldrych Zwingli, Heinrich Bullinger.* Tübingen: Katzmann, 1962, 365 pp., 8 illus.
 A collection of texts (rendered in modern German) excerpted from many sources recording the reformers' views on aspects of mariolatry. Includes commentary on images by Luther (pp. 145-52) and Calvin (214-18), with

additional references (p. 364).

47
THULIN, OSKAR. "Bilderfrage." In *RDK* (see no.18), vol. II, cols. 561-71.

A concise discussion of questions concerning art and the Reformation in part IV (the Tridentine decrees) and part VI (the Protestant position), including bibliography.

48
ULLMANN, ERNST. "Reformation und Bilderfrage." *Bildende Kunst,* 1983, pp. 212-17, 13 illus.

Only a brief summary of the image question in the Reformation period.

49
WANDERSLEB, MARTIN. "Luthertum und Bilderfrage im Fürstentum Braunschweig-Wolfenbüttel und in der Stadt Braunschweig im Reformationsjahrhundert." *Jahrbuch der Gesellschaft für Niedersächsische Kirchengeschichte* 66 (1968):18-80 and 67 (1969):24-90.

Reviews Luther's attitude to art (via Campenhausen and Preuß; vol. 66, pp. 35-41), then local ordinances regarding art in the churches (vol. 66, pp. 41-62). Concludes that the Braunschweig area church was not iconoclastic but only against the misuse of images, though there was excessive destruction beginning in 1528 (vol. 67). Numerous lists of things lost. Overview of all art works from the area that are still extant, listed according to their location in the 16th century with present locations given in footnotes.

50
WEERDA, JAN. "Die Bilderfrage in der Geschichte und Theologie der Reformierten Kirche." In *Evangelische Kirchenbautagung, Erfurt 1954, Karlsruhe 1956.* Edited by Walter Heyer. Berlin (n.p.), pp. 289-322.

Beginning with the example of peaceful image-removal followed by continued flourishing of the arts in 16th-century Emden, the author argues that the Reformation's attitude was a complex one, certainly not simply "anti art" (Réau, see no. 766, is specifically condemned). The subtleties of Reformation thought are explicated by analyzing statements in works by Bullinger, Calvin, and other 16th-century theological texts.

51
WENCELIUS, LEON. "Les réformateurs et l'art," *Bulletin de la Société de l'histoire du Protestantisme Français* 117 (1971):11-37.

Summary of Zwingli's, Luther's and Calvin's views on the visual arts from a theological perspective. All agree on the beauty of creation and the danger of idolatry in worldly art, but Luther differs in granting didactic potential to sensory experience. Two schools of thought are defined: one allows only pictures that reflect the glory of God, the other allows illustrations of religious histories.

52
WILLIAMS, GEORGE H., ed. *Spiritual and Anabaptist Writers: Documents*

Illustrative of the Radical Reformation. The Library of Christian Classics, 25. Philadelphia: Westminster Press, 1957, 421 pp., bibliog., indexes.

A useful source book of Anabaptist texts in English. For material pertinent to the image controversy, see index under image of God, idolatry.

53

WOODFIELD, RICHARD. "On the emergence of aesthetics." *British Journal of Aesthetics* 18 (1978):217-27.

Argues that the Protestant attack on the efficacy of religious imagery was an essential stage in setting the foundations for the development of modern aesthetic theory.

II. B. Reformation Theologians

II. B. 1. Anonymous

54

ANONYMOUS. *Eyn gesprech auff das kurtzt zwuschen eynem Christen und Juden, auch eynem Wyrthe sampt seynem Haussknecht, den Eckstein Christum betreffendt.* Jena: M. Buchführer, 1524. Reprinted in O. Clemen, Flugschriften (see no. 589), I, pp. 387-422.

A pamphlet in which a Christian and a Jew discuss the misuse of images by the Catholic church.

55

ANONYMOUS. *Recueil des choses advenues en Anvers, touchant la fait de la Religion, en l'an M.D. LXVI.* n.p., n.d., 96 pp. (second ed. Strassbourg, 1566).

A Protestant polemic against Catholic practices of image worship and the cult of saints.

56

ANONYMOUS. "Een schoon Tafelspel van een Prochiaen, een Coster en een Wever", n.p., 1565. Reprinted in Leendert M. van Dis, *Reformatorische Rederijkerspelen uit de eerste helft van de zestiende eeuw.* Haarlem: Drukkerij Villbrief [1937], pp. 150-221.

A Netherlandish rederijker play in which three characters debate a series of Reformation theological issues, including a lengthy dispute over the misuse of religious images (lines 1638-1836). Though not printed until 1565, the play was likely written c. 1538-40.

57

ANONYMOUS. *Den Val der Roomscher Kercken.* Emden: Steven Mierdman, 1556. Reprinted in Cramer & Pijper, *Bibliotheca Reformatoria Neerlandica* (see no. 25), vol. 1, pp. 399-420.

A tract of disputed authorship (Jan Utenhoven and Marten Micron have been proposed). Attacks the Roman church for its idolatry, citing in particular Old Testament prohibitions against image worship. Appeared first in London in 1553. The edition of 1556 was the first of several issued in the Netherlands.

58

ANONYMOUS. *Vanden Propheet Baruch.* np., nd. Reprinted in Cramer & Pijper, *Bibliotheca Reformatoria Neerlandica* (see no. 25) vol. 1, pp. 259-72.

A pamphlet published in the Netherlands probably in the 1520's, and reissued at Wesel in 1558. It is an attack on the misuse of religious images, and reflects knowledge of Luther's writings on this question. A copy of the early edition bound with other Protestant writings is in the library of the Maatschappij der Nederlandsche Letterkunde, Leiden.

II. B. 2. Martin Bucer

59

BUCER, MARTIN. *Confessio Religionis Christianae.* Strasbourg: Georgio Ulrichero Andlano, 1531, vii, 43 pp.

Arguments against images in chap. 22: "De Statuis & imaginibus." English translation (*Tetrapolitan Confession*) in Cochrane, *Reformed Confessions* (see no. 24).

60

[BUCER, MARTIN]. *Das einigerlei Bild bei den Gotglæubigen an orten da sie verehrt nit mægen geduldet werden.* [Strasbourg] 1530. Reprinted in *Martin Bucers Deutsche Schriften* (see no. 63), vol. 4, pp. 161-81.

Treatise published by Bucer in support of the Strasbourg city council's order of February 1530 to remove all images from the churches. His argument is based on Old Testament passages: images can lead the weak to idolatry and must be abolished. Published in Latin translation the same year: *Non esse ferendas in templis Christianorum imagines et statues.*

61

[MARTIN BUCER]. Gesprechbiechlin neüw Karsthans. Strasbourg: n.p., 1521, 28 pp. Reprinted in *Martin Bucers Deutsche Schriften* (see no. 63), vol. 1, pp. 406-44, introduction 385-43.

Text argues for criticism and reform of the church, including condemnation of altarpieces and portraits for their costliness and their evil seductiveness (pp. D4b and E1a).

62

BUCER, MARTIN. *Grund und ursach auß gotlicher schrifft der neüwerungen an dem nachtmal des herren...zu Straßburg fürgenomen.* Strasbourg: n.p., 1524, 60 pp. Reprinted in Martin Bucers deutsche Schriften, (see no. 63), vol. 1, pp. 194-278, introduction pp. 187-93.

Explanation of the Reformation in the Strasbourg church. One of the nine sections devoted to the image question: "Ursach darumb die bilder sollen abgestelt werden," pp. O2a-P2a. His arguments follow those of the Second Zurich Disputation.

63

BUCER, MARTIN. *Martin Bucers Deutsche Schriften.* Edited by Robert Stupperich. Martini Buceri Opera Omnia, ser. 1. Gütersloh: Verlagshaus Gerd Mohn, 1960-, and Paris: Presses Universitaires de France, 1960-. Vols. 1-7, 17 etc., bibliog., indexes.

The definitive edition of Bucer's German works, still in progress. Texts are accompanied by comprehensive and well-documented introductions and up-to-date bibliographies.

64

BUCER, MARTIN. *Ordnung, die ain Ersamer Rath der Statt Ulm in abstellung hergeprachter etlicher mißpreuch in jrer Stat und gepietten zu halten fürgenommen....* Ulm: n.p., 1531, 34 pp., 1 illus. Reprinted in *Martin Bucers Deutsche Schriften* (see no. 63), vol. 1., pp. 212-72, introduction pp. 185-211.

Bucer's reforming of the Protestant church in Ulm, containing a condemnation of images (pp. A6B).

II. B. 3. Johann Bugenhagen

65

RAUTENBERG, WERNER, ed. *Johann Bugenhagen - Beiträge zu seinem 400. Todestag.* Berlin: Evangelische Verlagsanstalt, 1958.

See articles by Schmidt (see no. 1229) and Thulin (see no. 1269).

II. B. 4. Heinrich Bullinger

66

BULLINGER, HEINRICH. *Confessio et Expositio simplex orthodoxae Fidei...* Zurich: Christopher Froschauer, 1566, viii, 96 pp.

Arguments against images in chap. 4: "De Idolis vel Imaginibus." English translation (*Second Helvetic Confession.*) in Cochrane, *Reformed Confessions* (see no. 24),

67

BULLINGER, HEINRICH. *Heinrich Bullingers Reformationsgeschichte.* Edited by J.J. Hottinger and H.H. Vögeli. 3 vols. Frauenfeld: Ch. Beyel, 1838-40. Index volume appeared separately: Zurich: Zürcher & Furrer, 1913.

Contemporary history of the Swiss reformation, especially in Zurich, from a

Zwinglian perspective. Written from 1567-74 with much material drawn from earlier chronicles.

68

BULLINGER, HEINRICH. *De origine erroris, in divorum ac simulachrorum cultu.* Basel: Thomas Wolff, 1529, 110 pp., 1 illus.

A learned argument against images, also describing the origins of the cult of images.

69

BULLINGER, HEINRICH. *Heinrich Bullinger Werke.* Edited by Fritz Büsser. Zurich: Theologischer Verlag, 1972-.

To be published in 4 sections: Bibliographies, Correspondence, Theological Works, and Historiographical Works. Each section will contain several volumes with separate editors. (For bibliography volumes published, see Staedtke no. 75; Herkenrath, no. 72).

70

BULLINGER, HEINRICH. *Von dem unverschampten fräfel, ergerlichem verwyrren, unnd unwarhafftem leeren, der selbs-gesandten widertöuffern.* Zurich: Christopher Froschauer, 1531, 178 pp.

A polemic against the "Libertines" (in this case the Anabaptists), including a discussion of idolatry. The image question is argued largely on the basis of biblical citations. Published in German (1531), Latin (1535), and Dutch (1569). The Dutch edition is reprinted in Cramer-Pijper, 7, pp. 298-407 (see no. 25).

71

FRIEDLAENDER, GOTTLIEB, ed. *Beiträge zur Reformationsgeschichte. Sammlung ungedruckter Briefe des Reuchlin, Beza und Bullinger nebst einem Anhange zur Geschichte der Jesuiten. Aus den handschriftlichen Schätzen der Königlichen Bibliothek zu Berlin mit Einleitungen und Anmerkungen herausgegeben.* Berlin: Enslin (Müller), 1837, viii, 286 pp.

The image question is discussed in the 10 letters published here written by Bullinger to Count Ludwig von Sayn-Witgenstein (pp. 220-68), especially nos. 4,6,7, and 9.

72

HERKENRATH, ERLAND, et al, compilers. *Heinrich Bullinger. Bibliographie.* Vol. 2. Beschreibendes Verzeichnis der Literatur über Heinrich Bullinger. Section 1, vol. 2 of *H.B.Werke* (see no. 69), 1977, viii, 263 pp., indexes.

All works written about Bullinger from 1534 to 1976 are listed (numbered 1001-2006) with short annotations. Index includes numerous references to images.

73

KOCH, ERNST. *Die Theologie der Confessio Helvetica Posterior.* Beiträge zur Geschichte und Lehre der Reformierten Kirche, 27. Neukirchen: Verlag des Erziehungsvereins, 1968, 455 pp., bibliog.

14

The section "Die Bilderfrage als Exemplifikation des Problems des Gottesdienstes" (pp. 350-57) closely analyzes the text of the Confession dealing with images.

74
ROTH, ERIC. *Die Reformation in Siebenbürgen. Ihr Verhältnis zu Wittenberg und der Schweiz*. 2 vols. Cologne/Graz: Böhlau, 1962/64, bibliog., indexes.
The question of images was a focus of a letter that Bullinger wrote to Johannes Honterus in 1522, instructing him on how best to bring the Reformation to Siebenbürgen. The text of the letter is printed here (on images vol. 1, pp. 211-13, and the removal of images described pp. 149-55, 160-66).

75
STAEDTKE, JOACHIM. *Heinrich Bullinger. Bibliographie*. Vol. 1. Beschreibendes Verzeichnis der gedruckten Werke von Heinrich Bullinger. Section 1, vol. 1 of *H.B.Werke* (see no. 69), 1922, xxiv, 322 pp., (index in vol. 2).
Includes all works (numbered 1-772) written or edited by Bullinger that he himself or others published. Arranged chronologically according to the first edition. Title pages given in full. Description of each followed by bibliographical references.

II. B. 5. Jean Calvin

76
"Calvin et les briseurs d'images. Note rectificative d'une assertion de M. Rosseeuw Saint-Hilaire." *Bulletin de la Société d'histoire du Protestantisme français* 14 (1865):127-31.
Quotes from Calvin's writings to show that he was firmly against the excesses of the iconoclasts.

77
CALVIN, JEAN. *Calvin: Institutes of the Christian Religion*. Edited by John T. McNeill, translated by Ford Lewis Battles. Library of Christian Classics, vols. 20-21. Philadelphia: Westminster Press, 1960, bibliog., indexes.
The current standard English translation of the 1559 Latin edition. On images see esp. Book I., chaps. 11-12, pp. 99-120. Calvin bases much of his case against images on the writings of the church fathers, especially Augustine.

78
CALVIN, JEAN. *Christianae religionis institutio*. Basel: Platter and Lasius, 1536.
The first Latin edition, followed by 12 other editions in the 16th century (8 Latin and 4 French), published in Strasbourg and Geneva. 16th century translations appeared in Italian (1557), Dutch (1560), German (1572), Spanish (1540), and English (1561).

79

CALVIN, JEAN. *Institution de la religion chrestienne*. Geneva: Jean Crespin, 1560. Recent edition in 5 volumes, edited by Jean-Daniel Benoit. Paris: Librairie Philosophique J. Vrin, 1957-63. Vol. 5 contains indexes and a glossary.

Chapter XI, "Qu'il n'est licite d'attribuer à Dieu aucune figure visible, et que tous ceux qui se dressent des images se révoltent du vray Dieu," argues against images on the basis of the Old Testament command against idols. In earlier editions (beginning in 1541) the same arguments occur in other sections also.

80

CALVIN, JEAN. *Ioannis Calvini. Opera.* 59 vols. Corpus reformatorum, vols. 29-87. 1863-1900. Reprint. New York and London: Johnson Reprint Corp., 1964.

The basic corpus of Calvin's works.

81

DOUMERGUE, EMILE. *L'art et le sentiment dans l'oeuvre de Calvin.* Geneva: Atar, 1902. Reprint. Geneva: Slatkine, 1970, 85 pp., 4 illus.

A collection of 3 lectures, the second on painting (pp. 31-56). The positive results of Calvin's program for the visual arts are sought in Dutch painting of the 17th century, particularly Rembrandt. The history of the later 16th century is reviewed as background to the developments that distinguish Dutch art from Flemish.

82

*DUBOSE, LUCIUS BEDDINGER. "The transcendent vision. Christianity and the visual arts in the thought of John Calvin." Thesis, Louisville, Presbyterian Theological Seminary, 1965.

83

*GRAU, MARTA. "Calvins Stellung zur Kunst." Ph.D. dissertation, Munich, 1917. Printed Würzburg: Staudenrauss, 1917, 83 pp.

84

KUYPER, A. *Calvinism.* London/New York, 1899. New ed. London: Sovereign Grace Union, 1932, 298 pp.

Lecture 5 (pp. 216-57) on Calvinism and art. A broad, sectarian meditation on the implications of Calvin's view for responses to the artistic tradition generally. Stresses his influence on music more than the plastic arts.

85

LASCH, GUSTAV. "Calvin und die Kunst." *Christliches Kunstblatt für Kirche, Schule und Haus* 51 (1909):132-49, 2 illus.

An investigation of Calvin's attitude towards each of the arts. On the visual arts pp. 133-40.

86

NIESEL, WILHELM. *Calvin Bibliographie.* 1901-1959. Munich: Chr. Kaiser, 1961, 120 pp., index.

Topically arranged. Includes sections on Portraits of Calvin and Calvin and Art.

87

OLBRICH, HARALD. "Calvinistische Vorstellungen vom Sinn der Bilder." In E. Ullmann, *Von der Macht der Bilder* (see no. 386), pp. 361-66.

Calls for a sociological approach to the study of images in the 16th century, centering particularly on Calvin's views of mankind.

88

POLLMANN, JOP. [Jos. Casp. Maria]. *Calvijns Aesthetica. Een Daad van eevoudige rechtvaardigheid.* Studiën-Reeks no. 4. 's-Hertogenbosch: L.C.G. Malmberg, n.d., 63 pp.

A brief analysis of various aspects of aesthetics in Calvin's work, his attitude to the visual arts considered in chap. 5, pp. 37-45. Stresses the consistency and dogmatic rigor of Calvin's approach to art.

89

SAXER, ERNST. *Aberglaube, Heuchelei, und Frömmigkeit. Eine Untersuchung zu Calvins reformatorischer Eigenart.* Studien zur Dogmengeschichte und systematischen Theologie, 28. Zurich: Zwingli Verlag, 1970, 290 pp., bibliog.

Briefly discusses and analyzes Calvin's views on idolatry and superstition, pp. 25-28, 63-64.

90

SPELMAN, LESLIE P. "Calvin and the Arts." *Journal of Aesthetics and Art Criticism* 6 (1947/48):246-52.

Brief discussion of Calvin's views on the arts and their theological basis.

91

SPRENGER, PAUL. *Das Rätsel um die Bekehrung Calvins.* Beiträge zur Geschichte und Lehre der Reformierten Kirche, 11. Neukirchen: Neukirchener Verlag, 1960, 100 pp.

Reviews Calvin's attitude towards relgious images as "superstitio," a concept he applied to relics and the mass (pp. 42-44). The discussion is based on the relevant passages from the *Institutes.*

92

WENCELIUS, LEON. *L'esthétique de Calvin.* Paris: Société d'Edition "Les Belles Lettres" [1937], 428 pp.

The theological aspects of Calvins notion of beauty are examined, in Part 1 the aesthetic nature of Christianity, Part 2 its manifestations (architecture pp. 153-60, painting and sculpture pp. 161-88). Calvin was not against the visual arts per se, but against the attempt to represent God. Rather he encouraged

attention to nature in all her aspects, making possible the golden age of 17th-century Dutch painting.

II. B. 6. Hans Denck

93

COUTTS, ALFRED. *Hans Denck 1495-1527. Humanist and heretic.* Edinburgh: MacNiven & Wallace, 1927, 262 pp., bibliog.

The biography concentrates on Denck's theological development from his confession at Nuremberg through his association with Anabaptism. His relation to the three artists banned from Nuremberg in the same year is not considered, but the short monograph provides an outline of his thought.

94

DENCK, HANS. *Schriften.* Part 3, *Exegetische Schriften, Gedichte und Briefe.* Quellen und Forschungen zur Reformationsgeschichte, 24. Edited by Walter Fellmann. Gütersloh: Gerd Mohn, 1960, 146 pp., index.

The Anabaptist Denck's commentary *Der Prophet Mica* (1532) discusses the problem of idolatry (pp. 24-25, 76, 83).

II. B. 7. Conrad Grebel

95

BENDER, HAROLD S. *Conrad Grebel c. 1498-1526. The Founder of the Swiss Brethren Sometimes Called Anabaptists.* Studies in Anabaptist and Mennonite History, 6. Goshen, Indiana: Mennonite Historical Society, 1950, xvi, 326 pp., 8 illus., bibliog., index.

A thorough biography which treats Grebel's position on the image question briefly in relation to Zwingli. During the early stages of Zwinglian reform in Zurich Grebel agreed with his condoning of iconoclasm (1523). Grebel seems to have maintained this view after splitting from Zwingli who himself retracted his early position (pp. 83-97 *passim).*

II. B. 8 Ludwig Hätzer

96

GARSIDE, CHARLES, Jr. "Ludwig Haetzer's Pamphlet against Images: A Critical Study." *The Mennonite Quarterly Review* 34 (1960):20-36.

Includes a translation of the second part of Hätzer's pamphlet (consisting of four arguments for images and Hätzer's answers). Commentary shows a close relationship to Karlstadt's "Von Abtuhung der Bilder." Argues that Hätzer's popular pamphlet was significant in bringing Karlstadt's ideas to Zurich and to

Zwingli. Translation also in Garside, *Zwingli and the Arts,* see no. 172.

97
GOETERS, J.F. GERHARD. *Ludwig Hätzer (ca. 1500 bis 1529). Spiritualist und Antitrinitarier. Eine Randfigur der frühen Täuferbewegung.* Quellen und Forschungen zur Reformationsgeschichte, 25. Gütersloh: C. Bertelsmann, 1957, 162 pp., bibliog.
Discusses Hätzer's pamphlet against images (pp. 17-23) concluding it is not based on Karlstadt (p. 19), but is an independent call to remove images and perhaps a kind of apology for the iconoclasts (p. 23).

98
HÄTZER, LUDWIG. *Ein Urteil Gottes.* Zurich: Christopher Froschauer, 1523. 19 pp., 1 illus.
Original text includes 2 sections: 33 Old Testament passages against images; four arguments for images and Hätzer's answers.

99
WEIS, FREDERICK LEWIS. *The Life and Teachings of Ludwig Hetzer: A Leader and Martyr of the Anabaptists 1500-1529.* Dorchester, Mass.: Underhill Press, 1930, 239 pp.
A "detailed, sympathetic" life of Hätzer. Chapter 4 focuses on his pamphlet condemning images, and chapters 5-7 on his related role in the second Zurich disputation. Significant passages given in English translation.

II. B. 9. Cornelius van der Heyden

100
HEYDEN, CORNELIUS van der. *Corte Instruccye / ende onderwijs / hoe een ieghelic mensche met God / ende zynen even naesten / schuldigh es / ende behoord te leven.* Ghent: Joos Lamprecht, 1545. Reprinted in Cramer & Pijper, *Bibliotheca Reformatoria Neerlandica,* vol. 4, pp. 15-77 (see no. 25).
Expresses a relatively moderate Protestant position on the image question, and criticizes excesses committed on pilgrimages and in the cult of saints generally (see esp. pp. 19-21). The original edition is illustrated with 65 woodcuts (not reproduced in Cramer & Pijper).

II. B. 10. Johannes Honterus

101
BINDER, LUDWIG. "Johannes Honterus und die Reformation im Süden Siebenbürgens mit besonderer Berücksichtigung der Schweizer und Wittenberger Einflüsse." *Zwingliana* 13 (1972):645-87.
Reviews scholarly opinion on Honterus, especially the question of Swiss

influence on his Protestant views. Bullinger's letter concerning images cannot be shown to have had demonstrable effect. On images see pp. 653, 661-63, 669-72, 674-75, 685-87.

II. B. 11. Balthasar Hübmaier

102

VEDDER, HENRY C. *Balthasar Hübmaier. The leader of the Anabaptists.* New York: G.P. Putnam's Sons, 1905, xxiv, 333 pp., bibliog., index.

Recounts the image controversy during the Reformation, and specifically Hübmaier's attitude. His anti-image statement at the Zurich disputation in 1523 is given in English translation (pp. 58-62).

II. B. 12. Andreas Bodenstein von Karlstadt

103

BARGE, HERMANN. *Andreas Bodenstein von Karlstadt.* 2 vols. Vol. 1. *Karlstadt und die Anfänge der Reformation.* Leipzig: Friedrich Brandstetter, xii, 500 pp., 1 illus., index of names in vol. 2. Reprint Nieuwkoop, 1968.

Detailed study of Karlstadt, controversial in the significance it ascribes to him relative to Luther. Karlstadt's publication of a satirical anti-scholastic woodcut by Cranach, *Der Fuhrwagen (Karlstadt's Cars of Heaven and Hell,* 1519) is discussed pp. 146-47 and in Excursus II. Pages 386-91 analyze Karlstadt's arguments against images in *Von abtuhung der Bylder* and pp. 394-98 discuss Emser's response (see no. 200).

104

BARGE, HERMANN. *Frühprotestantisches Gemeindechristentum in Wittenberg und Orlamünden.* Leipzig: M. Heinsius Nachfolger, 1909, xxvi, 366 pp.

Essentially a response to Karl Müller's book *Luther und Karlstadt* (see no. 113). For iconoclasm in Wittenberg and Karlstadt's views on the subject, see especially pp. 95-101.

105

BARGE, HERMANN, and FREYS, E. "Verzeichnis der gedruckten Schriften des Andreas Bodenstein von Karlstadt." *Zentralblatt für Bibliothekswesen* 21 (1904):153-79, 209-43, 305-23.

Chronological list of Karlstadt's printed works (total 156) with descriptions and some commentary. *Von abtuhung der Bylder* = nos. 87-89.

106

BUBENHEIMER, ULRICH. "Andreas Rudolff Bodenstein von Karlstadt. Sein Leben, seine Herkunft und seine innere Entwicklung." In Merklein, *Karlstadt* (see no. 112), pp. 5-58, 12 illus.

Part V (pp. 19-28) reviews Karlstadt's part in planning and producing Cranach's *Himmel-und Höllenwagen* (1519), identifies several of the figures in the print, and interprets its polemical nature and its quick success. Part VI. (32-35) deals briefly with Karlstadt's banning of images in Wittenberg.

107

BUBENHEIMER, ULRICH. *Consonantia Theologiae et Iurisprudentiae. Andreas Bodenstein von Karlstadt als Theologe und Jurist zwischen Scholastik und Reformation.* Jus ecclesiasticum, 24. Tübingen: J.C.B. Mohr (Paul Siebeck), 1977, xv, 335 pp., bibliog., indexes.

Fully documented biography of Karlstadt, focusing on legal aspects of his theology. The Wittenberg period (1521-22) and his position on images is discussed especially pp. 243-81.

108

HASSE, HELLMUT. "Karlstadt als Prediger in der Stadtkirche zu Wittenberg." In Merklein, *Karlstadt* (see no. 112), pp. 59-83, 5 illus.

On Karlstadt's attitude to images in his *Von Abtuhung der Bilder* (see no. 110) and his sermons, pp. 71-75.

109

KARLSTADT, ANDREAS BODENSTEIN von. *Ob man gemach faren und des ergernüssen der schwachen verschonen soll in sachen so gottis willen angehn.* n.p., 1524, 32 pp., 1 illus.

A strong denunciation of images as the devil's work, calling for their destruction.

110

KARLSTADT, ANDREAS BODENSTEIN von. *Von abtuhung der Bylder Vnd das keyn Betdler unther den Christen seyn soll.* Wittenberg: Nicolaus Schirlentz, 1522, 39 pp., 1 illus. Reprinted in *Von Abtuhung der Bilder und das keyn Bedtler unther den Christen seyn sollen 1522 und die Wittenberger Beutelordnung.* Edited by Hans Lietzmann. Kleine Texte für theologische und philologische Vorlesungen und Übungen, no. 74. Bonn: A. Marcus & E. Weber, 1911.

Influential tract calling on the Wittenberg city council to remove images from churches. Argues that the commandment against images is explicit and that the popular attitude toward them has become idolatrous.

111

LOEWEN, HARRY. *Luther and the Radicals. Another Look at some Aspects of the Struggle between Luther and the Radical Reformers.* Waterloo, Ontario: Wilfrid Laurier Univ., 1974, 208 pp., bibliog., index.

Briefly summarizes events surrounding Karlstadt and the image controversy in Wittenberg, pp. 33-45.

112

MERKLEIN, WOLFGANG et al, eds. *Andreas Bodenstein von Karlstadt:*

1480-1541. Festschrift der Stadt Karlstadt zum Jubiläumsjahr 1980. Karlstadt: Michel, 1980, 126 pp., 19 illus.

Includes articles by various scholars, see Bubenheimer (no. 106) and Hasse (no. 108).

113
MÜLLER, KARL. *Luther und Karlstadt. Stücke aus ihrem gegenseitigen Verhältnis.* Tübingen: J.C.B. Mohr, 1907, xvi, 243 pp. Detailed, chronological review of the theology of the two reformers from 1521-28.

Aims to disprove what Müller sees as careless reasoning in the strongly pro-Karlstadt thesis of Barge's two-volume study (see no. 103).

114
PREUS, JAMES S. *Carlstadt's "Ordinaciones" and Luther's Liberty: A Study of the Wittenberg Movement 1521-1522.* Cambridge: Harvard University Press, 1974, 88 pp.

A lucid analysis of Karlstadt's theological principles during this period, with his views on images and the related events discussed pp. 33-50.

115
SIDER, RONALD J. *Andreas Bodenstein von Karlstadt: The Development of his Thought, 1517-1525.* Leiden: E.J. Brill, 1974, xii, 318 pp., bibliog. indexes.

Recounts and analyzes Karlstadt's views on images (esp. pp. 166-69, 279-80) within a careful and well-annotated study of his theology.

116
SIDER, RONALD J., ed. and trans. *Karlstadt's Battle with Luther. Documents in a Liberal-Radical Debate.* Philadelphia: Fortress Press, 1978, 161 pp., selected bibliog., index.

A clear overview of the main points in the reformers' debate on images, including the relevant passages in English translation.

II. B. 13. Martin Luther

117
BANGS, JEREMY D. *Cornelis Engebrechtsz.'s Leiden. Studies in Cultural History.* Assen: Van Gorcum, 1979, 259 pp., indexes, 97 illus.

Discusses in passing the evidence for the early availability of Luther's works in Leiden (p. 64), and more extensively Luther's response to pagan antiquities as this affected his theology (pp. 72-76). Relation to contemporary visual art is not developed.

118
BENZING, JOSEPH. *Lutherbibliographie. Verzeichnis der gedruckten Schriften Martin Luthers bis zu dessen Tod.* Baden-Baden: Heitz, 1966, 512 pp., indexes.

A complete bibliography of Luther's publications during his lifetime, noting present locations of surviving editions. Indexes: printers and publishers; their locations; titles; other authors edited or translated by Luther. Bibliography of 3704 entries.

119

BERGMANN, ROSEMARIE. "A 'tröstlich pictura': Luther's Attitude in the Question of Images." *Renaissance and Reformation* 5 (1981):15-25, 2 illus.
Cursory review of Protestant positions on images followed by brief remarks about Luther's influence on religious art.

120

BOSSERT, GUSTAV. "Die Maler in Luthers Wartburgpostille." *Christliches Kunstblatt,* 1897, pp. 110-11.
Quotes some of Luther's comments on art to show his evaluation of artists as prophets, capable of revealing divine truth.

121

CAMPENHAUSEN, HANS Freiherr von. "Luthers Stellung zur bildenden Kunst." *Kunst und Kirche* 17 (1940):2-5, 3 illus.
A general review of Luther's views regarding art and architecture.

122

*CHRISTENSEN, CARL C. "Luther's Theology and the Uses of Religious Art." *The Lutheran Quarterly* 22 (1970):147-65.
Republished with revisions in the author's book (see no. 416, chap. 2).

123

DÜFEL, HANS. "Luther und die Marienbilder." *Kirche und Kunst* 39 (1961):21-24, 3 illus., 29-31 1 illus.; 40 (1962):2-5, 2 illus.
An earlier presentation of the material in the author's 1968 publication (see no. 124).

124

DÜFEL, HANS. *Luthers Stellung zur Marienverehrung.* Kirche und Konfession. Veröffentlichungen des Konfessionskundlichen Instituts des Evangelischen Bundes, 13. Göttingen: Vandenhoeck und Ruprecht, 1968, 288 pp., 4 pls., bibliog., index.
Luther's attitude to painted images of the Virgin is discussed pp. 233-46. This includes a review of the types of images he probably saw, and then numerous quotations from his works. The extent to which Reformation notions are expressed in Dürer's and Cranach's works is analyzed.

125

EDWARDS, MARK U., Jr. *Luther and the False Brethren.* Stanford: Stanford University Press, 1975, ix, 242 pp., index.
Luther's comments on images are given (in English translation) at several

points in this study of the disputes between Luther and his evangelical opponents from 1522 to 1546.

126
HARTMANN, OLOV. "Art (Lutheran Concept)." In *The Encyclopedia of the Lutheran Church*, 1, pp. 107-9 (see no. 16).
General discussion of Luther's views on art and their significance for the developing church.

127
IHLENFELD, KURT. "Martin Luther und Lucas Cranach," *Luther. Zeitschrift der Luthergesellschaft* 44 (1973):42-44.
Reflections on a 1521 letter from Luther to Cranach and on two Luther portraits by Cranach.

128
KREßEL, H. "Das Problem des Altars in der Lutherischen Kirche." *Monatsschrift für Gottesdienst und kirchliche Kunst* 41 (1936):204-7.
Reviews Luther's position on altars, altarpiece retables and the placing of the crucifix on the altar.

129
LEHFELDT, PAUL. *Luthers Verhältniss zu Kunst und Künstlern.* Berlin: Wilhelm Hertz, 1892, 130 pp.
Reviews the Reformation's effect on art by studying Luther's references to the architecture, objets d'art, paintings and artists he encountered at home and abroad, as well as his views on iconoclasm and related issues. Finds that the reformer did not appreciate art for purely aesthetic reasons but always looked for a more practical value.

130
LOEWENICH, WALTER von. "Bilder VI: Reformatorische und nachreformatorische Zeit." In *Theologische Realenzyclopädie* , vol. 6, pp. 546-57. Berlin: Walter de Gruyter, 1976-.
Concise review of Luther's position on images, of iconoclastic arguments in the Reformation, and the Catholic response.

131
LUTHER, MARTIN. "Abbildung des Papsttums." In *Luthers Werke* (see no. 133), *Werke*, vol. 54, pp. 346-73.
Ten woodcut images mocking the Pope with rhyming texts by Luther appeared separately between 1538-45. Their history is discussed and their texts reprinted in the Weimar edition, with the plates appended at the back of the volume.

132
LUTHER, MARTIN. *An den Christlichen Adel deutscher Nation: von des Christlichen standes besserung.* Wittenberg: Melchior Lotther, 1520, 48 pp.

Reprinted in *Luthers Werke* (see no. 133), *Werke,* vol. 6, pp. 404-69, commentary and notes pp. 381-403, 631-32.
Luther's major statement on the question of images and the church.

133

LUTHER, MARTIN. *D. Martin Luthers Werke. Kritische Gesamtausgabe.* Weimar: Hermann Böhlau und Nachfolger, 1883-1980. Reprint including some additions begun in 1964.

The standard edition of Luther's works, in four parts. References to the visual arts occur frequently in his writings, sermons and table talks. Major sources are separately annotated.
1. *Werke.* 60 vols. 1883-1980 (index, vol. 58);
2. *Briefwechsel.* 16 vols. 1930-80 (indexes, vols. 15-16);
3. *Tischreden.* 6 vols. 1912-21 (index, vol. 6);
4. *Die deutsche Bibel.* 12 vols. 1906-61.

134

LUTHER, MARTIN. *Luther und die Bilderstürmer, in seinen und seiner Zeitgenossen Aussagen.* Flugschrift der Luthergesellschaft. Edited by Theodor Knolle. Wittenberg: Verlag der Luther-Gesellschaft, 1922, 19 pp., 5 illus. Published also in *Luther. Mitteilungen der Luther-Gesellschaft* 4 (1922):1-17, 5 illus.

A collection of Luther's comments (all given in modern German translation) on iconoclasm with short explanatory introductions. Included are Luther's letters concerning Karlstadt and Wittenberg in 1521-22, excerpts from his sermons during the first week of lent 1522, and passages from letters by Luther and others recording reactions to the sermons.

135

LUTHER, MARTIN. *Luther's Works.* American Edition. Edited by Jaroslav J. Pelikan (vols. 1-30) and Helmut T. Lehmann (vols. 31-55). 55 vols. St. Louis: Concordia Publishing House and Philadelphia: Fortress Press, 1955-.
Standard edition of Luther's works in English translation.

136

LUTHER, MARTIN. *Ein Sermon...Von den Bildtnussen (12 March 1522).* Augsburg: Melchior Ramminger, 1522, 4 pp. Reprinted in *Luthers Werke* (see no. 133), *Werke,* vol. 10,3, pp. 30-40, introduction and commentary to this and 7 other sermons pp. XLVI-LXXXV.

One of Luther's sermons following his return to Wittenberg in which he disagrees with the extreme measures taken by Karlstadt. Luther opposes the worship of images but recognizes their value as pious inspiration and memory aids. Published separately several times.

137

LUTHER, MARTIN. *Von beyder gestalt des Sacraments zu nehmen und ander newrung.* Wittenberg: Joh. Grunenberg, 1522, 16 pp. Reprinted in *Luthers Werke* (see no. 133), *Werke,* vol. 10, pp. 11-41, commentary and notes pp.

1-10, 502-3., 507-8.
Luther argues that pictures are allowable, though not "ferlich," and it is better not to have any on the altars in a church.

138
LUTHER, MARTIN. *Widder die hymelischen propheten von den bildern und Sacrament*. Part 1. Wittenberg: Cranach and Döring, 1525, 44 pp. Reprinted in *Luthers Werke* (see no. 133), *Werke*, vol. 18, pp. 62-125, commentary pp. 37-61.
A biting attack on Karlstadt, Müntzer and the Zwickau prophets. Here Luther stresses his functional definition of suitable and unsuitable images, and he appeals to artists not to make images that might lead to idolatry.

139
PREUSS, HANS. *Martin Luther der Künstler*. Gütersloh: C. Bertelsmann, 1931. 319 pp., indexes.
Part 1 on "Luther and Images" first reviews Luther's own handwriting and marginalia. He then culls references from various documents to establish what artists and specific works of art Luther might have known. Luther's views on the image question are similarly investigated. Parts 2 and 3 discuss music and poetry.

140
ROGGE, CHRISTIAN. *Luther und die Kirchenbilder seiner Zeit*. Schriften des Vereins für Reformationsgeschichte, 108, Jahrgang 29. Leipzig: Verein für Reformationsgeschichte, 1912, 29 pp.
Shows how visual traditions and even specific works of art affected Luther by analyzing references to art in Luther's writings. Argues that often Luther's image of a scene, of a saint's attribute, etc., reflected traditional representations in the visual arts, not biblical descriptions. Also reviews Luther's views on the image controversy.

141
SPELMAN, LESLIE P. "Luther and the Arts." *Journal of Aesthetics and Art Criticism* 10 (1951/52):166-75.
Brief discussion of Luther's attitudes and their effect on the arts.

142
STARKE, ELFRIEDE. "Luthers Beziehungen zu Kunst und Künstlern." In *Leben und Werk Martin Luthers von 1526 bis 1546*. Edited by Helmar Junghans. 2 vols. Göttingen: Vandenhoeck & Ruprecht, 1983. Text vol. 1, pp. 531-48, notes and 60 plates, vol. 2, pp. 905-15 and plates interspersed in vols. 1 & 2, pp. 981-1012.
A detailed survey (with 330 footnotes) of Luther's views on art, his connections with Dürer, Cranach, Bible illustration etc. Gives a history of major Protestant pictorial religious themes and of satirical imagery in broadsheets and pamphlets.

143

THULIN, OSKAR. "Der Altar in reformatorischer Sicht." In *Reich Gottes und Wirklichkeit. Festgabe für Alfred Dedo Müller zum 70. Geburtstag.* Berlin: Evangelische Verlagsanstalt, 1961, 193-204.

Luther's opinions on retable altars and the development of a Protestant altar with new pictorial content are reviewed (pp. 199-204).

144

*WALTER, GOTTFRIED. "Luthers Würdigung kirchlicher Bau- und Bildkunst." *Blätter für christliche Archäologie und Kunst* 2 (1926):5-9.

145

WIRTH, JEAN. "Le dogme en image: Luther et l'iconographie." *Revue de l'art* 52 (1981):9-23, 20 illus.

Detailed study of Lutheran iconography in light of Luther's own views on art (extensive references from H. Preuss, see no. 139, and others). Finds him sensitive to the potential of the visual arts as propaganda, but essentially conservative, making use of established iconographical patterns. This traditionalism is particularly true of Cranach. The numerous panels of the *Fall and Redemption* are seen to separate into two groups, reflecting different stages of Luther's antinomian convictions and the theological positions of Melanchthon.

146

WIRTH, JEAN. *Luther, Etude d'histoire religieuse.* Geneva: Librairie Droz, 1981, 158 pp., 2 illus., bibliog., index.

Luther's use and interpretation of images are treated in a discussion of his sermons on limbo and resurrection (pp. 105-16).

II. B. 14. Johann Manlius

147

MANLIUS, JOHANN. *Locorum communium collectanea.* 4 vols. Basel: Joannes Oporinus, 1563.

German translation printed in Frankfurt, 1565. Vol. 2 contains a section of anecdotes related to the commandment against idolatry (pp. 24-30). Included is the story of a Madonna and Child painting in Eisenach--seen by Luther and others--that was so manipulated as to turn the faces toward a worshipper offering money, and away if none was offered.

II. B. 15. Philips Marnix van St. Aldegonde

148

KOSSMAN, E.H. and MELLINK, A.F. *Texts Concerning the Revolt of the Netherlands.* Cambridge: Cambridge University Press, 1974, xii, 295 pp.,

bibliog., index.

A collection of primary documents given in English translation, including part of the important text of an apology written by Philips Marnix van St. Aldegonde (pp. 78-81) reflecting on the iconoclasm of 1566 (for the complete original text, see Marnix no. 149). Other brief references to iconoclasm given in the index.

149

MARNIX, PHILIPS van ST. ALDEGONDE. *Philips van Marnix van St. Aldegonde. Godsdienstige en keerkelijke Geschriften.* Edited by J.J. van Toorenenbergen. 3 vols. The Hague: Martinus Nijhoff, 1871-91, 2 illus.

An edition of the writings of one of the major Netherlandish theologians concerned with the image controversy. Critical introduction for each volume gives historical background for Marnix's writing.

150

MARNIX, PHILIPS van ST. ALDEGONDE. *Van de Beelden afgheworpen in de Nederlanden in Augusto 1566* [Breda, 1566]. Reprinted in Philips van Marnix, edited by J.J. van Toorenenbergen, vol. 1, pp. 1-34 (see no. 149).

Severe critique of the moderate Lutheran position on images, issued in print as a response to one of the followers of the Augsburg Confession. Marnix condemns all manner of religious imagery and disputes any claim to its constructive use for the worshipper.

151

MARNIX, PHILIPS van ST. ALDEGONDE. *Vraye narration et apologie des choses passées au Pays-Bas, touchant le Fait de la Religion en l'An MDLXVI par ceus qui font profession de la religion Réformée au-dit pays.* n.p. [1567]. Reprinted in Marnix, *Philips van Marnix* , edited by J.J. van Toorenenbergen (see no. 149), vol. 1, pp. 35-133.

A lengthy tract supporting Protestant criticism of image worship and the cult of saints. Views iconoclasts as instruments of God's providence in the cleansing of faith. The pamphlet appeared without the author's name, though the attribution seems secure (see Toorenenbergen edition, p. xx).

II. B. 16. Philip Melanchthon

152

CARO, JAKOB. "Anekdotisches zu Melanchthon." *Theologische Studien und Kritiken* 70 (1897):801-11.

Publishes a letter from the reformer to Veit Dietrich in 1536 which is interpreted as making reference to drawings of Sts. George and Christopher done by Melanchthon himself. For a contrary interpretation see O. Clemen (no. 153).

153

CLEMEN, OTTO. "Hat Melanchthon gezeichnet?" *Theologische Studien und*

Kritiken 80 (1907):137-43.

The author disputes a claim by Caro (see no. 152) that a passage in Melanchthon's letters shows that he drew religious images. The passage speaks of images, Dürer's in particular, but only figuratively in reference to Melanchthon's own descriptive poetry.

154

HAMMER, WILHELM. *Die Melanchthon-forschung im Wandel der Jahrhunderte. Ein beschreibendes Verzeichnis.* 2 vols. Quellen und Forschungen zur Reformationsgeschichte, 35 & 36. Vol. 1, 1519-1799; vol. 2, 1800-1965. Gütersloh: Gerd Mohn, 1967-68.

Massive bibliography (4136 entries) of works by and about Melanchthon from 1519 to 1965. The entries are listed chronologically and are annotated, but with no index or cross-references.

155

MELANCHTHON, PHILLIP and LUTHER, MARTIN. *Deuttung der zwo grewlichen figuren Bapstesels zu Rom und Munchkalbs zu Freyberg in Meyssen funden.* Wittenberg: J. Rhau, 1523, 15 pp., 2 illus. Reprinted in *Luthers Werke* (see no. 133), *Werke,* vol. 11, pp. 369-85, commentary and notes pp. 357-68, 486-87.

A satirical pamphlet containing an interpretation by Melanchthon of the woodcut the *Papstesel* (pp. 4-8) and by Luther of the *Mönchskalb* (pp. 9-15).

156

THIMME, WILHELM. "Melanchthon und die kirchliche Kunst." *Monatschrift für Gottesdienst und kirchliche Kunst* 30 (1925):174-75.

Reflects on the meaning of a passage from Melanchthon's *Augustana* and its implications for the aesthetic dimension of evangelical church ceremony. The importance of instruction for music and church decoration is discussed briefly.

II. B. 17. Hermann Moded

157

BRUTEL DE LA RIVERE, G.J. "Het leven van Hermannus Moded, een der eerste Calvinistische predikers in ons vaderland." Ph. D. dissertation, Rijksuniversiteit Leiden. Haarlem: De Erven F. Bohn, 1879. vi, 146 pp., plus appendix.

A biography of a Reform minister who became an important spokesman for the Calvinist position on images. His career in Flanders and later in Utrecht is traced.

158

MODED, HERMANN. *Apologie ofte verantwoordinghe Hermanni Modedt, teghens de Calumnien ende valsche beschuldinghen ghestroeyet, tot lasteringhe des H. Evangelij, ende zijnen Persoon door de vianden der Christelijcker Religie.* n.p.,

1567, 91 fols. Reprinted in: Brutel de la Riviere, "Het Leven" (see no. 157), appendix.

A tract addressed to William of Orange, defending the purposes of Protestant preaching and attacking the abuses, idolatry and other faults of the papists. Moded's apologia for the iconoclasm of 1566 is an important early statement in the Netherlandish debate on this issue (fols. 35-7).

II. B. 18. Johannes Oecolampadius

159

*OECOLAMPADIUS, JOHANNES. *In Danielem prophetam Joannis Oecolampadii libri duo, omnigena et abstrusiore cum Hebraeorum tum Graecorum scriptorum doctrina referti.* Basel: Johann Babel, 1530.

Commentary on Daniel, chap. 3, contains an extensive discussion of scriptural prohibitions against idolatry and an indictment of the practices of the Catholic church.

159a

STAEHELIN, ERNST, ed. *Briefe und Akten zum Leben Oekolampads.* 2 vols. Quellen und Forschungen zur Reformationsgeschichte, 10 & 19. Basel: M. Heinsius, 1927 & 1934, indexes.

Includes several discussions of images. See vol. 1, no. 396; vol. 2 no. 636 (a long letter to Wolfgang Capito) and no. 729.

160

STAEHELIN, ERNST. *Das theologische Lebenswerk Johannes Oekolampads.* Quellen und Forschungen zur Reformationsgeschichte, 21. Leipzig: M. Heinsius Nachfolger, 1939, xxiv, 652 pp., indexes.

Reviews the development of the reformer's thought through careful scrutiny of his sermons, treatises etc. His position on images put forth especially on pp. 344-45, 417-18, 559-60.

II. B.19. Andreas Osiander

161

OSIANDER, ANDREAS. *Gesamtausgabe.* Edited by Gerhard Müller. Gütersloh: Gütersloher Verlagshaus, 1975-.

The complete edition of Osiander's works (in progress: vol. 5, writings and letters through 1534, appeared in 1983). Each volume contains indexes of names, places and subjects. Images, iconoclasm and image worship are discussed *passim*.

162

SEEBAß, GOTTFRIED. *Das reformatorische Werk des Andreas Osiander.*

Einzelarbeiten aus der Kirchengeschichte Bayerns, 44. Nuremberg: Selbstverlag des Vereins für Bayerische Kirchengeschichte, 1967, xxii, 308 pp., 1 color illus., 8 b&w illus., bibliog., indexes.

A detailed, thoroughly documented biography of Osiander with examination of his position on various theological issues. The topic of images is raised via Greiffenberger and the three "godless painters" (pp. 111-14). Dürer's *Four Apostles* is interpreted as critical of Osiander and the evangelical church in Nuremberg. Includes an appendix of Osiander portraits.

II. B. 20. Willibald Pirckheimer

163

ECKERT, WILLEHAD PAUL, and IMHOFF, CHRISTOPH von. *Willibald Pirckheimer. Dürers Freund im Spiegel seines Lebens, seiner Werke und seiner Umwelt.* Cologne: Wienand Verlag, 1971, 390 pp., 108 illus., index, bibliog.

A biographical study which treats Pirckheimer's changing relation to the Reformation (pp. 69-118, 305-21). Reprints his protest over the damages done by iconoclasts to his sister's convent (pp. 320-21), and his important testimony regarding Dürer's piety in a letter to Johannes Tschertte of ca. 1529-30 (pp. 362-67).

II. B. 21. Johannes Anastasius Veluanus

164

VELUANUS, JOHANNES ANASTASIUS. *Der Leken Wechwyser.* Strasbourg: Balthasar von Klarenbach, 1554. Reprinted in Cramer & Pijper, *Bibliotheca Reformatoria Neerlandica,* vol. 4, pp. 123-376 (see no. 25).

The most extensive and theologically intricate contemporary discussion of the image question from the Protestant viewpoint. (see esp. pp. 284-90, 328-35, 357-64). Widely circulated in the Netherlands. Appeared in several editions.

II. B. 22. Pierre Viret

165

VIRET, PIERRE. *De la vraye et fausse religion, touchant les voeus & les sermens licites & illicites.* Geneva: Jean Rivery, 1560, 864 pp., index.

A stong adversary of Catholic "superstitions", Viret argues vehemently against idolatry and images at many points (pp. 198, 203, 221, 262, 493-94, 503-4).

II. B. 23. Clemens Ziegler

166
*ZIEGLER, CLEMENS. *Ein Kurtz Register vnd auszzug der Bibel in welchem man findet was abgötterey sey vnd wo man yedes suchen sol.* Strasbourg: Johannes Schwan, 1524.
 A pamphlet by the vegetable gardener Ziegler citing the biblical passages against images. Sections reprinted in Krebs, Quellen (see no. 399), vol 7, pp. 8-10.

II. B. 24. Huldreich Zwingli

167
CAMPENHAUSEN, HANS Freiherr von. "Zwingli und Luther zur Bilderfrage." In *Das Gottesbild im Abendland.* Edited by Günter Howe. Glaube und Forschung, 14. Witten/Berlin: Eckhart-Verlag, 1957, pp. 139-72.
 A shorter version of his essay "Die Bilderfrage in der Reformationszeit" (see no. 23).

168
FARNER, OSKAR. *Huldrych Zwingli.* 4 vols. Zürich: Zwingli Verlag, 1943-60, vii, 488 pp., 22 illus. 2 out of 4 vols. published with separate titles.
 1. *Seine Jugend, Schulzeit und Studentenjahre. 1484-1506.* 1943, 340 pp., 22 illus.
 2. *Seine Entwicklung zum Reformator 1506-1520.* 1946, vii, 488 pp., 22 illus.
 Includes in the appendix (pp. 425-36) an essay by Hans Hoffmann, "Zu Dürers Bildnis eines jungen Mannes in der Galerie Czernin in Wien."
 3. *Seine Verkündigung und ihre ersten Früchte 1520-1525.* 1954, vii, 615 pp., 1 illus.
 Discusses the image question (pp. 438-47) and iconoclasm (pp. 483-500).
 4. *Reformatorische Erneuerung von Kirche und Volk in Zürich und in der Eidgenossenschaft 1525-1531.* 1960, xi, 574 pp., 1 illus.
 "Die Stellung zu Kunst", pp. 63-66, insists that Zwingli was very appreciative of the visual arts, as long as they were not intended for "cultic" purposes.

169
FINSLER, GEORG. *Zwingli-Bibliograpghie.* Zürich: Institut Orell Füßli, 1897, 187 pp., indexes.
 Part "A" lists and describes all known editions of Zwingli's published works from the 16th century. They are arranged in chronological order according to the date of composition. Part "B" lists secondary literature, arranged alphabetically, and includes post-1600 printings of Zwingli's works.

170

GÄBLER, ULRICH. *Huldrych Zwingli im 20. Jahrhundert. Forschungsbericht und annotierte Bibliographie 1897-1972.* Zürich: Theologischer Verlag, 1975, 473 pp.

Briefly annotated bibliographical references arranged chronologically with indexes of names and selected subjects.

171

*GARSIDE, CHARLES Jr. "Huldrich Zwingli's Attitude toward the Visual Arts and Music." Ph.D. dissertation, Yale University, 1957.

172

GARSIDE, CHARLES Jr. *Zwingli and the Arts.* New Haven and London: Yale University Press, 1966, xiv, 190 pp., bibliog. note, index.

Reviews: K.H. Dannenfeld in *Renaissance Quarterly* 20 (1967):47-49.

E.G. Rüsch in *Zwingliana* 12 (1968):725-26.

R. Stupperich in *Archiv für Reformationsgeschichte* 58 (1967):264-65.

On Zwingli's attitude toward music and the visual arts with close attention to arguments about images in the Zürich area 1523-1524. Sees basis for Zwingli's moderate iconoclastic views in relation to Erasmian rejection of the cult of saints and ideals of biblical humanism. The most extensive available study of Zwingli's position.

173

HUMBEL, FRIDA. *Ulrich Zwingli und seine Reformation im Spiegel der gleichzeitigen, schweizerischen volkstümlichen Literatur.* Quellen und Abhandlungen zur schweizerischen Reformationsgeschichte, 1. Leipzig: M. Heinsius Nachfolger, 1912, viii, 299 pp., bibliog., index of names.

Surveys the broadsheet literature from 1521-32 in Switzerland, giving an historical account of several aspects of the Reformation and its reception. Attitudes toward images are documented and discussed pp. 102-4 and 250-56.

174

KÖHLER, WALTHER. *Das Buch der Reformation Huldrych Zwinglis. Von ihm selbst und gleichzeitigen Quellen erzählt.* Munich: Ernst Reinhardt, 1926, 373 pp., 96 illus., index of persons.

Chronological and topical survey of Zwingli's life by means of excerpts from contemporary documents, letters, pamphlets etc. Includes discussions of image worship (pp. 106-115) and the iconoclasm of 1524 (pp. 121-31), with the relevant portions of Hätzer's pamphlet.

175

*KOOIMAN, WILLEM JAN. "Profetie en Symbool. Zwingli en de Kerkelijke Kunst." *Wending. maandblad voor evangelie en cultuur* 8 (1953/54):683-93.

176

LEHMANN, HANS. "Zwingli und die züricherische Kunst im Zeitalter der

Reformation." In *Ulrich Zwingli. Zum Gedächtnis der Zürcher Reformation 1519-1919.* Zürich: Berichthaus, 1919, xiv, ca., 160 pp., 11 color plates, 172 b&w plates, index, appendix with letters in Latin and in German translation.

Discusses Zwingli's moderate views on the image question in relation to general Swiss attitudes of the time. Considers the Reformation's liberating effect on Zurich artists, glasspainters in particular (pp. 221-28), and the growth of portraiture. The numerous portraits of Zurich reformers (paintings from Hans Asper's workshop, prints and medallions) are illustrated with commentary (pp. 228-46 and *passim*).

177
PIPKIN, H. WAYNE. *A Zwingli Bibliography.* Pittsburgh: The Clifford E. Barbour Library. Pittsburgh Theological Seminary, 1972, 157 pp.

Updates Finsler's 1897 bibliography (see no. 169). Ordered alphabetically, not annotated. Index includes references to the arts and images.

178
RÜEGG, WALTER. "Zwinglis Stellung zur Kunst." *Reformatio* 6 (1957):271-82.

Lucid review of Zwingli's thoughts on images, based mainly on his "Answer to Valentin Compar."

179
SPÖRRI, HERMANN. *Zwingli-Studien.* Leipzig: S. Hirzel, 1866, 131 pp.

Chap. 5 on Zwingli and Christian art deals with the reformer's attitudes to the visual arts (pp. 111-31), quoting from his answer to Valentine Compar and elsewhere to show the moderation of his view.

180
STAEHELIN, RUDOLPH. *Huldreich Zwingli: Sein Leben und Wirken nach den Quellen dargestellt.* 2 vols. Basel: Benno Schwabe Verlagsbuchhandlung, vol. 1, 1895, viii, 535 pp. vol. 2, 1897, 540 pp.

Detailed survey, quoting original sources, of Zwingli's life. The discussion of images is reviewed from p. 330, and iconoclastic events recounted, pp. 368-88.

182
ZWINGLI, HULDREICH. *Acta oder geschicht wie es uff dem gesprech d' 26. 27. unnd 28. tagen Wynmonadts in der Christenlichen Statt Zürich... ergangen ist.* Zurich: C. Froschauer, 1523, 144 pp. Reprinted in *Zwinglis Sämtliche Werke,* vol. 2, pp. 671-803, intro. pp. 664-70 (see no. 184).

Also known as the Second Zurich Disputation (26 - 28 Oct. 1523). On the question of images, and their removal from churches. Considers two special topics: image worship and the celebration of the mass. The first day of the disputation was devoted to images.

183
ZWINGLI, HULDREICH. *Ein Antwurt Huldrychen Zwinglis Valentino Compar alten landt schrybern zuo Ore ggeben über die. iiij. artickel...* Zurich: J. Hager,

1525, 120 pp. Reprinted in *Zwinglis Sämtliche Werke* (see no. 184), vol. 4, pp. 48-159, introduction pp. 35-47.

Part 3, "Von den bilden, unnd wie an denen die schirmer und stürmer mißlerend" demonstrates Zwingli's relatively moderate attitude toward images. He saw the danger of idolatry in paintings but not in statues. Zwingli viewed this essay as a full statement of his opinion on the subject.

184

ZWINGLI, HULDREICH. *Huldreich Zwinglis Sämtliche Werke*. Edited by Emil Egli, Georg Finsler et al. 14 vols. (Corpus Reformatorum, vols. 88-101). Berlin/Leipzig/ Zurich, 1905-68.

Authoritative edition of Zwingli's complete works. References to the image question occur throughout, i.e. in vol. 2, *Vorschlag wegen der Bilder und der Messe* (1524), and in vol. 10, the *Decree of May 1524*. Major sources are separately annotated (see nos. 183, 185, & 186).

185

ZWINGLI, HULDREICH. *Ein Kurtze und Christeliche inleitung...1523*. Zurich: C. Froschauer, 1523, 44 pp. Reprinted in *Zwinglis Sämtliche Werke* (see no. 184), vol. 2, pp. 626-63.

The section on imagery ("Von den bilden") outlines the biblical bases for abolishing images.

186

ZWINGLI, HULDREICH. *Von der bilden wegen ist dis ein einhallige meinung aller zugesatzten Xin*. Dec., 1523. Exists in the original manuscript. Reprinted in *Zwinglis Sämtliche Werke* (see no. 184), vol. 2, pp. 814-15, introduction pp. 804-7.

A summary of the conclusions reached by the disputation on images.

II. C. Catholic Reform: Council of Trent

187

*ASCHENBRENNER, TH. "Die tridentinischen Bildervorschriften." Ph.D. dissertation, Freiburg University, 1925.

A study of synod statutes and literary material reflecting the attitude of the church to images before and after the Council of Trent.

188

JEDIN, HUBERT. "Entstehung und Tragweite des Treinter Dekrets über die Bilderverehrung." *Tübinger Theologische Quartalschrift* 116 (1935):143-88, 404-29. Reprinted in Hubert Jedin, *Kirche des Glaubens, Kirche der Geschichte. Ausgewählte Aufsätze und Vorträge*. 2 vols. Freiburg/Basel/Vienna: Herder, 1966, vol. 2, pp. 460-98.

Surveys the history of the image question with emphasis on Catholic positions leading up to the Council of Trent. Part II deals with the controversy in

France from 1561 to 1562, showing that the Paris *Sentenz* of 1562 served as a model for the Tridentine decree on images. Parts III and IV focus on the council's approach to the question, concluding the purpose was not to define the direction of art. The basic study of the Tridentine position on the visual arts.

189
JEDIN, HUBERT. "Das Tridentinum und die bildenden Künste. Bemerkungen zu Paolo Prodi, Richerche sulla teorica delle arti figurative nella Riforma Cattolica (1962)." *Zeitschrift für Kirchengeschichte,* ser. 4, 12, vol. 74 (1963):321-39.
 Summarizes and expands Jedin's earlier article (see no. 188), then focuses on Paleotti (see no. 215) and his discussion of images and the Tridentine decrees. Recounts much of Prodi's study (see no. 216).

190
TRENT, COUNCIL OF. "De invocatione, veneratione et reliquiis sanctorum, et de sacris imaginibus (3-4 Dec. 1563). In *Conciliorum Oecumenicorum Decreta.* Edited by Centro di Documentazione, Istituto per le Scienze Religiose (Freiburg im Breisgau, 1962), pp. 750-52. 3rd ed. (Bologna, 1972), pp. 774-76.
English translation in Elizabeth G. Holt, ed., *Literary Sources of Art History.* Princeton: Princeton University Press, 1947, pp. 242-44.
 The brief decree of the Council which treats images and the cult of saints. This is the essential Catholic position on reforming the arts.

II. D. Catholic Reformers and Other Apologists

II. D. 1. Anonymous

191
BUGGE, RAGNE. "Effigiem Christi, qui transis semper honora. Verses condemning the cult of sacred images in art and literature." *Acta ad archaeologiam et artium historiam pertinentia* 6 (1975):127-40, 15 illus.
 Traces the history of this Latin distich in debates over the use of holy images. The text appears in relation to images of Christ in particular and was quoted both by Catholic apologists and in Protestant attacks on images. It translates: "The image teaches of God, but is not itself God. You should revere the image, but worship with your mind Him whom you recognize in it."

192
KLAGREDE DER ARMEN VERFOLGTEN GÖTZEN UND TEMPELPILDER / ÜBER SO UNGLEICH URTAYL UND STRAFFE [ca. 1530]. Broadsheet, 1 woodcut, 6 cols. of text.
 Reproduced in Max Geisberg, *The German Single-Leaf Woodcut.* Edited by W. Strauss (see no. 597), vol. 3, p. 1092, cat. no. G. 1145. Also in Hoffmann, see no. 30. The woodcut is attributed to Erhard Schoen. The text is a satirical verse spoken in the first person plural by the "idols", i.e. saints'

images who are glad to sacrifice themselves if it will better the state of the world. An indirect defense of images probing the motives of the iconoclasts. Another version once attributed to Niklaus Manuel, but no longer. See Bern, Kunstmuseum, *N. Manuel* (no. 1088), p. 86.

II. D. 2. Konrad Braun

193

BRAUN, KONRAD [Brunus, Conradus]. *De imaginibus liberunus. In D. Conradi Bruni...opera tria.* Ex officiana F. Behem, Moguntiae 1548, 145 pp., preceded by an index (7 pp.).

The period's most extensive Catholic treatment of the image question. Discusses the iconography of particular subjects, the Trinity for example, and closes (chaps. 21 and 22) by dealing with Protestant positions against image worship. Defends religious but not secular images.

II. D. 3. Johannes Cochläus

194

COCHLÄUS, JOANNES [Dobneck, Johann]. *De sanctorum invocatione & interceßione, deque imaginibus & religuiis eorum pie riteque colendis.* Ingolstadt: A. Weissenhorn, 1544, 101 pp., 1 illus.

Catholic tract in favor of images, directed specifically against Bullinger.

II. D. 4. Johannes Dietenberger

195

DIETENBERGER, JOHANNES. *Fragstuck an alle Christglaubigen.* Cologne, n.p., 1530, ca. 275 pp.

Chapter 22 (15 pages numbered y-aa) poses the question of what one should think of images in churches. The short Protestant answer is given first, then the "Christian" answer, defending images in detail.

II. D. 5. Martinus Duncanus

196

DUNCANUS, MARTINUS [Donk, Martin]. *Een cort onderscheyt tusschen Godlyke ende Afgodissche Beelden.* Antwerp: Peeter van Keerberge, 1567, 72 pp.

Argues that the Bible forbids misuse of images but not images altogether.

God himself made images. Defines "oprechte beelden" as opposed to idols and defends the correctness of burning candles before them.

II. D. 6. Johannes Eck

197
ECK, JOHANNES. *De non tollendis Christi & sanctorum Imaginibus, contra haeresim Faelicianam sub Carolo magno damnatum, & iam sub Carolo V renascentem decisio.* Ingolstadt: n.p., 1522, 27 pp., 1 illus. (title p.).

Catholic tract in favor of images. Sees initial justification in the fact of the incarnation (Christ as first image); surveys the history of image controversy, then (chap. 15) deals with arguments put forth by 16th-century "iconomachists".

198
ECK, JOHANNES. *Enchiridion locorum communium adversus Lutherum et alios hostes ecclesiae.* Ingolstadt: Alexander Weißenhorn, 1543, 254 pp. Recent edition by Pierre Fraenkel. Münster: Aschendorffsche Verlagsbuchhandlung, 1979.

First edition 1525. This is the last revised edition by Eck. Chapter 16, "De imaginibus crucifixi et sanctorum" provides a defense of images based on his own earlier work (*De non tollendis*, see no. 197) and Emser's (see no. 200), directed against Karlstadt (see no. 110).

199
ISERLOH, ERWIN. "Die Verteidigung der Bilder durch Johannes Eck zu Beginn des reformatorischen Bildersturms." *Würzburger Diözesangeschichtsblätter,* vols. 35/36, 1974. Published as: *Aus Reformation und Gegenreformation. Festschrift für Theobald Freudenberger.* Würzburg: Bischöfliches Ordinariatsarchiv, 1974, pp. 75-85.

Eck's treatise *De non Tollendis* (see no. 197) is analyzed in detail, demonstrating that Catholic justification of images in this case shows a learned understanding of the history of the controversy and an awareness of the potential abuse of images.

II. D. 7. Hieronymus Emser

200
EMSER, HIERONYMUS. *Das man der heyligen bilder yn den kirchen nit abthon/noch unehren soll/ Unnd das sie yn der schrifft nyndert verbotten seyn.* Dresden: 1522, 63 pp., 1 illus.

A sharp attack, from a Catholic perspective, on Karlstadt's *Von abtuhung der Bylder* (see no. 110). He defends the presence of images in churches, responding to each of Karlstadt's points separately.

201

SMOLINSKY, HERIBERT. "Reformation und Bildersturm. Hieronymus Emsers Schrift gegen Karlstadt über die Bildverehrung." In *Reformatio Ecclesiae,* edited by Remigius Bäumer. Paderborn/Munich/Vienna/Zurich: Ferdinand Schöningh, 1980, pp. 427-40.

Provides a well-documented survey of the Catholic side of the Reformation image controversy, focusing on Emser's tract (see no. 200). Detailed comparison of Emser's and Karlstadt's arguments.

II. D. 8. Desiderius Erasmus

202

ERASMUS, DESIDERIUS. *The Correspondence of Erasmus.* Translated by R.A.B. Mynors and D.F.S. Thompson. Toronto: University of Toronto Press, 1974-.

Allen's edition and ordering are followed (see no. 204). The volumes are separately indexed, mostly restricted to citing proper names and places. For topics, correlate Allen's edition with indexes. To date 5 vols. complete (letters up to 1518).

203

ERASMUS, DESIDERIUS. *Desiderii Erasmi Roterodami Opera Omnia.* Leiden, 1703. 10 vols. Reprinted in facsimile. Hildesheim: Georg Olms Verlag, 1961-62.

Complete works indexed by volume.

204

ERASMUS, DESIDERIUS. *Opus Epistolarum Des. Erasmi Roterdami.* 12 vols. Edited by P.S. Allen. Oxford: Clarendon Press, 1906-58.

The authoritative Latin edition of Erasmus' letters chronologically arranged. Vol. 12 indexes the letters by: correspondents, references to Erasmus's writings, and general listing of names and topics. See especially s.v. images.

205

GIESE, RACHEL. "Erasmus and the Fine Arts." *Journal of Modern History* 7 (1935):257-79.

An overview of Erasmus's remarks on the arts, concluding that he was sympathetic to religious art for its educational value and so felt bound to defend it given the hostile attitudes of reformers.

206

MARLIER, GEORGES. *Erasme et la peinture flamande de son temps.* Damme: Editions du Musée van Maerlant, 1954, xvi, 329 pp., bibliog., index, 60 illus.

Considers Erasmus's writings in relation to several topics bearing on Protestant discussion of the arts: abuses of the cult of saints, iconoclasm, and accurate representations of scripture (chap. 4); representations of St. Jerome in

relation to Erasmus's and Luther's views of the Saint (chap. 6); and the relation of works by the Protestant artist and iconoclast M. van Reymerswael to Erasmus and his school (chaps. 7-8).

207
NAUWELAERTS, M.A. "Erasmus en de Kunst." *Revue belge d'archéologie et d'histoire de l'art* 42 (1973):3-30, 8 illus.
 Discusses Erasmus's aesthetic response to the visual arts in relation to the liberal arts, his position on idolatry, and his own marginal drawings.

208
PANOFSKY, ERWIN. "Erasmus and the Visual Arts." *Journal of the Warburg and Courtauld Institutes* 32 (1969):200-27, 15 illus.
 Detailed discussion of the topic. Specific attention given to the issues of idolatry and decorum in religious art (see pp. 207-14).

II. D. 9. Sigmund Feyrabend

209
FEYRABEND, SIGMUND. "Vorrede." In Jost Amman, *Künstliche und wohlgerissene figuren der fürnembsten Evangelien durchs gantze Jar...* Frankfurt: Petrus Fabricius impensis S. Feyrabendii, 1579, 86 pp., 83 illus.
 This preface by the publisher defends images for their role in teaching the Bible and their ability to reach a large public as book illustrations.

II. D. 10. Johann Fischart

210
FISCHART, JOHANN. "Vorrede." In Tobias Stimmer, *Neue Künstliche Figuren Biblischer Historien, grüntlich von Tobia Stimmer gerissen.* Basel: Thomas Gwarin, 1576, 182 pp., 170 illus.
 Fischart's preface of 8 pages is an imaginative and learned defense, partly in verse, of the visual arts. Fischart was a Protestant.

II. D. 11. Franz von Sickingen

211
OELSCHLÄGER, ULRICH. "Der Sendbrief Franz von Sickingens an seinen Verwandten Dieter von Handschuchsheim." *Ebernburg-Hefte* 4 (1970):71-85.
 A letter (written 1521, published 1522; here transcribed into modern German) illustrates the reception of Reformation doctrines by the knightly class. The letter's author defends Lutheran practices with the exception of the negative

attitude towards images. He defends the positive use of images and disapproves of iconoclasm.

II. D. 12. Johannes Molanus

212
FREEDBERG, DAVID. "Johannes Molanus on Provocative Paintings. De historia sanctarum imaginum et picturarum, Book II., Chapter 42." *Journal of the Warburg and Courtauld Institutes* 34 (1971):229-45.
 An analysis of those portions of Molanus' interpretation of the Tridentine decrees relevant to matters of proper decorum in treating the nude. A contribution to the very limited literature on this important commentator.

213
MOLANUS, JOANNES. *De Picturis et Imaginibus Sacris, Liber unus.* Louvain: Hieronymus Wellaeus, 1570, xii, 184 pp., index. Title of subsequent editions: *De Historia Sanctarum. Imaginum et Picturarum.*
 The first thorough application of the Tridentine decrees to the visual arts. A lengthy discussion of decorum and iconography for religious images from the Catholic viewpoint. A widely-read treatise frequently reprinted.

II. D. 13. Georg Newdorffer

214
NEWDORFFER, GEORG. *Von der heiligen erung unnd anrueffen sampt ettlicher einred wider der heiligen bild...* Tübingen: Ulrich Moihart, 1528, 48 pp., 1 illus.
 A sober Catholic (Dominican) defense of images in question and response form.

II. D. 14. Gabriele Paleotti

215
PALEOTTI, GABRIELE. *De imaginibus sacris, et profanis...libri quinque.* Ingolstadt: David Saratorius, 1594, xxvii, 382 pp., index.
 First published in Italian (Bologna, 1582), this lengthy tract by the Cardinal Paleotti (adviser to the papal legates at the Council of Trent) discusses the Tridentine decrees on images, analyzing them and their proper application.

216
PRODI, PAOLO. "Ricerche sulla teorica delle arti figurative nella Riforma cattolica." *Archivio italiano per la Storia della pietà* 4 (1962):121-212.
 Analyzes the effect of the Tridentine decree on art through close study of

Paleotti's writings on images (see no. 215), including previously unpublished tracts (pp. 194-208) on the continued abuse of images. Prodi believes to have found a "Tridentine" style in certain artists influenced by Paleotti's writings.

II. D. 15. Louys Richeome

217

RICHEOME, LOUYS. *L'idolatrie huguenote*. Lyon: Pierre Rigaud, 1608, 736 pp., index.

A Catholic polemic against the Protestant position on images and the conduct of iconoclasm, supported by a defense of religious images in the church.

II. D. 16. Jean de Vauzèle

218

VAUZELE, JEAN de. *Les simulacres & historiees faces de la mort*. Lyon: Melchior and Gaspar Trechsel, 1538, 104 pp., 41 illus. Reprinted as *The Dance of Death by Hans Holbein the Younger*. Introduction by Werner L. Gundersheimer. New York: Dover, 1971, xiv, 146 pp., 82 illus.

Though Holbein's cycle has been shown to be traditional in religious attitude (see Davis, no. 738), the dedication by Jean de Vauzèle (pp. iiir-iiiv) to this first, Catholic-sponsored edition touches on the image controversy. It justifies the use of images in several ways.

III. Iconoclasm

III. A. General accounts and analyses

219

BREDEKAMP, HORST. *Kunst als Medium sozialer Konflikte. Bilderkämpfe von der Spätantike bis zur Hussitenrevolution.* Frankfurt: Suhrkamp, 1975, 406 pp., 34 illus., bibliog.

A wide-ranging theoretical investigation of the status of images in Western culture, stressing the dynamic relation of image-making to iconoclastic theory at specific historical stages. Though concerned with pre-16th-century events, the implications of the interpretation are projected beyond its chronological scope.

220

CHASTEL, ANDRE. "L'iconoclasme." In E. Ullmann, *Von der Macht der Bilder* (see no. 386), pp. 264-77.

Iconoclasm from the time of the Hussites is viewed as a rebellion against both secular and religious authority. The role of various artists, of prints, and of popular preachers is assessed. Polemical imagery directed against the iconoclasts is also discussed.

221

FREEDBERG, DAVID. "The Structure of Byzantine and European Iconoclasm." In *Iconoclasm.* Edited by Anthony Bryer and Judith Herrin. Birmingham: Center for Byzantine Studies, 1977, pp. 165-77.

An essay analyzing the theories, motivations and procedures of iconoclastic activity in its Byzantine and later western European occurences. These events, and the Catholic church's responses to them, are taken to demonstrate the exceptional power imputed to images by these cultures.

222

KRETZENBACHER, LEOPOLD. *Das verletzte Kultbild. Voraussetzungen, Zeitschichten und Aussagewandel eines abendländischen Legendentypus.* Sitzungsberichte, Bayerische Akademie der Wissenschaften, Philos.-hist. Klasse, Munich 1977, no. 1, 124 pp., 12 illus., indexes.

Concerned mainly with Baroque legends about damaged cult images that miraculously survive and thereafter bleed. One chapter (pp. 94-105) reviews

43

legends surrounding damage due to Protestant iconoclasm, finding continuities with earlier legends relating to Jews, Turks, and Saracens.

223

NIGG, WALTER. *Maler des Ewigen. Meditationen über religiöse Kunst.* Zurich/Stuttgart: Artemis, 1951, 318 pp., 48 illus.

The introductory essay, "Bildersprache" (pp. 11-25), focuses on Reformation iconoclasm, seeing this violence against religious images as a special category, different from violence against political institutions, the castles of overlords, etc. in having an intense psychological aspect. Reformation iconoclasm, an expression of ethical-religious outrage over church corruption and artistic excess, is lamented as the destroyer of a long-standing symbolic language.

224

VEGH, JULIUS v. *Die Bilderstürmer. Eine kulturgeschichtliche Studie.* Strasbourg: J.H. Ed. Heitz (Heitz & Mündel), 1915, xvi, 140 pp.

Brief review of iconoclasm from the Old Testament to the modern era according to chronological and geographical categories, including the Reformation in Germany (pp. 20-29), Switzerland (pp. 30-46), the Netherlands (pp. 47-56).

225

WARNKE, MARTIN, ed. *Bildersturm. Die Zerstörung des Kunstwerks.* Kunst-wissenschaftliche Untersuchungen des Ulmer Vereins für Kunstwissenschaft, 1. Munich: Carl Hanser, 1973, 179 pp., 14 illus. Reprinted. Frankfurt/Main: Syndikat-Reprise, 1977. See also nos. 226 and 265.

A collection of 7 studies by various authors on the topic of iconoclasm from antiquity to the 20th century. The editor's introductory essay (pp. 7-13), establishes a broad conception of iconoclasm (ranging from mere criticism to destruction), as the common subject of the volume. Iconoclasm is understood in the widest sense as a response to the valuation of aesthetic objects. Pertinent articles cited individually.

226

WARNKE, MARTIN. "Von der Gewalt gegen Kunst zur Gewalt der Kunst. Die Stellungnahmen von Schiller und Kleist zum Bildersturm." In M. Warnke, ed., *Bildersturm* (see no. 225), pp. 99-107, notes pp. 167-69.

Schiller's "Geschichte des Abfalls der Niederlande" of 1788 is interpreted as expressing a classic bourgeois ambivalence toward iconoclasm. Schiller elevates art to the plane of morality and religion, and presumes that iconoclasm must be attributed exclusively to the lower social orders. Kleist's *Heilige Cäcilie,* on the other hand, portrays the middle class as iconoclastic, but in a context where art is deemed distant and coersive.

III. B. France

III. B. 1. contemporary accounts

227

[BEZA, THEODORE]. *Histoire ecclésiastique des églises réformées au royaume de France*. 3 vols. Antwerp: Jean Remy, 1580, indexes. Revised edition by G. Baum and Ed. Cunitz. Paris: Librairie Fischbacher, 1883-89.

Contemporary account of the Reformation in French churches, formerly ascribed to Theodore Beza. The image question is discussed in numerous places. See esp. vol. I, pp. 777-99, 887-88.

228

BOURRILLY, V.-L., ed. *Le Journal d'un bourgeois de Paris sous le règne de François Ier (1515-1536)*. Paris: Librairie Alphonse Picard et Fils, 1910, 471 pp., index.

New edition of a unique manuscript from the late 16th century (Paris, Bibliotheque Nationale) by an unknown author. Destruction of images discussed pp. 290-94, 366, 432-33.

229

HASAK, MAXIMILIAN. *Das Münster Unserer Lieben Frau zu Straßburg im Elsaß*. Berlin: Guido Hackebeil, 1927, 224 pp., many illus., index.

Pages 198-200 report on the Reformation period with quotations from contemporary accounts of iconoclasm etc. This is preceded (pp. 196-98) by an account of Bernhard von Heidelberg who was the cathedral's Baumeister from 1519 to 1551.

230

SAINCTES, CLAUDE DE. *Discours sur le saccagement des Eglises Catholiques par les Heretiques anciens, et nouveaux Calvinistes, en l'an 1562*. Paris: Fremy, 1562, xxii, 200 pp.

A Catholic expression of outrage at iconoclastic destruction. On the Reformation period see chapters 11 (iconoclasts), 12 (the Hussites in Bohemia) and 14 (a long chapter, pp. 45v-81r, omitted in the table of contents, on specific destruction involving churches in France).

III. B. 2. later accounts and analyses

231

BLIN, JEAN BAPTISTE NICOLAS. *Petit Tableau des Ravages faits par les Huguenots de 1562 à 1574 dans l'ancien et le nouveau Diocèse de Séez*. Avignon: Sequin Frères, 1888, 178 pp.

A Catholic view of Huguenot destruction including some accounts of iconoclasm.

232

CARRIERE, VICTOR. "Les Epreuves de l'Eglise de France au XVIe siècle." *Revue d'histoire de l'église de France* 11 (1925):167-201, 332-62.

Detailed history of the effects of Protestantism on the church in France, with sections on the pillaging of churches (pp. 186-91), the destruction of images (pp. 191-96) and of church buildings (pp. 196-201).

233

CHRISTENSEN, CARL C. " Patterns of iconoclasm in the early Reformation: Strasbourg and Basel." In *The Image and the Word -- Confrontations in Judaism, Christianity and Islam.* Edited by Joseph Gutmann. American Academy of Religion and Society of Biblical Literature, Religion and the Arts, no. 4, 1977, pp. 107-48.

Surveys iconoclastic events in the 1520's in both cities (Strasbourg pp. 108-19; Basel pp. 119-29) and shows that though inspired by Zurich reforms, each developed differently. The text is a slightly altered version of a chapter in his book *Art and the Reformation in Germany* (see no. 416).

234

DAVIS, NATALIE ZEMON. "The Rites of Violence: Religious Riot in Sixteenth-Century France." *Past and Present* 59 (May 1973):51-91. Reprinted as "The Rites of Violence" in N.Z. Davis, *Society and Culture in Early Modern France.* Stanford: Stanford University Press, 1975, pp. 152-88, and notes pp. 315-26.

Analyzes the religious riots and iconoclasm of this era through study of primary sources, seeking its motives and legitimation in ritual, drama, and politics. Denies that urban violence can be systematically correlated to socioeconomic conflict, and recognizes the horrors of the period as more normal than pathological.

235

DEYON, SOLANGE, and LOTTIN, ALAIN. *Les "Casseurs" de l'été 1566. L'iconoclasme dans le Nord de la France.* N.p., Hachette, 1981, 255 pp., appendix, bibliog.

A study of patterns of iconoclastic activity in northern France and the southern Netherlands. Examines the motives behind the destructions: the theological debates, the economic and social circumstances. Concludes with a discourse on the "ritualistic" aspect of image breaking and its symbolic implications. Appendix includes transcriptions of a number of primary documents.

236

ESTEBE, JANINE, and DAVIS, NATALIE ZEMON. "Debate. The Rites of Violence: Religious Riot in Sixteenth-Century France." *Past and Present* 67 (1975):127-35.

Estebe's "A Comment" (pp. 127-30) on Davis' earlier article (see no. 234) argues for more stress on economic and social factors and for a clearer distinction between Protestant and Catholic violence. Protestant iconoclasm was a

demonstration of the powerlessness in images, not a destruction of "pollution." Davis defends herself in "A Rejoinder" (pp. 131-35).

237

FYOT, EUGENE. "Les Spoilations commises par les Calivinistes en 1562 dans la cathédrale Saint-Vincent de Chalon." *Mémoires de la Société d'Histoire et d'Archéologie de Chalon-sur-Saône* 26, n.s. 18 (1934-35):124-40.

Describes destruction, then (pp. 126-38) quotes archival account of the *procès-verbal* from seven months later which gives detailed descriptions of the damage.

238

JUNG, A[NDRE]. *Geschichte der Reformation der Kirche in Straßburg und der Ausbreitung derselben in den Gemeinden des Elsasses.* Beiträge zu der Geschichte der Reformation, 2. Strasbourg & Leipzig: F.G. Levrault, 1830, xv, 387 pp.

Recounts the city council's position on images, the removal of images from churches, and iconoclasm in Strasbourg in 1524-25 (pp. 331-36).

239

KINGDON, ROBERT M. *Geneva and the Coming of the Wars of Religion in France 1555-1563.* Geneva: Librairie E. Droz, 1956, 161 pp., appendixes, bibliog., index.

Studies the role of missionaries from the Geneva Company of Pastors in the outbreak of religious war in France. Part I gives the background of the 88 men involved. Part II examines their involvement. Iconoclastic events are described *passim..*

240

REAU, LOUIS. *Les monuments détruits de l'art français. Histoire du vandalisme.* Vol. 1: Du haut Moyen Age au XIXe siècle. Paris: Librairie Hachette, 1959, 420 pp., 62 illus., bibliog.

Pages 65-106 investigate the vandalism during the wars of religion. Protestant (Huguenot) iconoclasm is described according to regional categories. Quotations from contemporary documents are integrated into a sparsely footnoted narrative.

241

REGNAULT, J.-M., and VERMANDER, P. "La crise iconoclaste de 1566 dans la région d'Armentières, essai de description et d' interprétation." *Revue du Nord* (Univ. de Lille) 59 (1977):221-31, 1 illus.

Studies a local instance of iconoclasm in the southern Netherlands (now northern France). Shows that here iconoclasm was supported by a significant portion of the population (including some Anabaptists) as part of pressure for broad social changes.

242

SAUZET, ROBERT. "L'iconoclasme dans le diocèse de Nîmes au XVIe et au debut

du XVIIe siècle." *Revue d'Histoire de l'Eglise de France* 66 (1980):5-15.

Studies iconoclastic outbreaks in Nîmes in 1561, 1567 and 1621, locating the impetus in popular responses to sacred objects. The Protestant leaders were generally moderate and did not encourage violence, though Pierre Viret, who began preaching in Nîmes in 1561, was vehemently iconoclastic.

III. C. Germany

III. C. 1. contemporary accounts

243

BARACK, K.A. ed. *Zimmerische Chronik.* 4 vols. Bibliothek des Literarischen Vereins in Stuttgart, 91-94. Tübingen: H.Laupp, 1869. Complete index in vol. 4. New revised edition. *Die Chronik der Grafen von Zimmern.* Edited by Hansmartin Decker-Hauff, Vol. 1. Constance/Stuttgart: Jan Thorbecke, 1964.

This wide-ranging family chronicle from the latter half of the 16th century (first vol. dated 1566) includes some descriptions of iconoclasm (vol. 2, 168; vol. 3, 276-77) including an account of the destruction of an altarpiece by Cranach at Torgau in 1547 (vol. 4, 19).

244

BARGE, HERMANN. *Aktenstücke zur Wittenberger Bewegung. Anfang 1522.* Leipzig: J.C. Hinrichs'sche Buchhandlung 1912, vi, 52 pp.

The 23 documents include two of the very few contemporary references to iconoclasm in Wittenberg (pp. 27-32), these reflecting a generally moderate attitude toward images.

245

COHAUSZ, ALFRED. "Anmerkungen zum Herforder Bildersturm im Jahre 1532." In *Paderbornensis Ecclesia. Beiträge zur Geschichte des Erzbistums Paderborn. Festschrift für Lorenz Kardinal Jaeger zum 80. Geburtstag am 23. September 1972.* Munich/Paderborn/Vienna: Ferdinand Schöningh, 1972, pp. 207-21.

Describes what is known of the unrest in Paderborn in 1531-2. Includes passages from contemporary documents.

246

DISTEL, THEODOR. "Spruch des Leipziger Schöppen gegen eine Bilderstürmerin (vor 1546)." *Neues Archiv für Sächsische Geschichte und Alterthumskunde* 10 (1889):151.

Extract from archival records of an iconoclastic event in Merseburg where a teacher sent her pupil to remove images from the church (St. Maxim's) and then burned them in her own oven. She had not received permission and was thus fired.

247

DORPIUS, HEINRICH. *Warhafftige Historie, wie das Evangelium zu Münster angefangen, und darnach durch die Widderteuffer verstöret, widder aufgehört hat.* N.p., 1536, 33 pp. New edition. *Die Wiedertäufer in Münster von Heinrich Dorpius.* Edited by Friedrich Merschmann. Magdeburg: Heinrichshofen'sche Buchhandlung, 1847.

An eye-witness account of the Anabaptist disturbances in Münster from 1532-35. Tells of plundering monasteries and churches, fol. Cii verso.

248

GEISBERG, MAX. *Die Stadt Münster.* Bau und Kunstdenkmäler von Westfalen, 41. 7 vols. Münster: Aschendorff, 1931-62.

Vol. 5 on the Münster cathedral includes contemporary documents relating to the Anabaptist iconoclasm of 1534-35 (pp. 22-28), descriptions of damage (p. 67) etc. Vol. 7 contains a series of indexes to the preceding 6 volumes.

249

KERSSENBROCH, HERMANN von. *Anabaptistici Furoris. Monasterium inclitam Westphaliae metropolim evertentis historica narratio.* Edited by H. Detmer. 2 parts. Geschichtsquellen des Bisthums Münster, 5 and 6. Münster: Theissing'sche Buchhandlung, 1899 (part 2) & 1900 (part 1), indexes in part 2. German translation: *Geschichte der Wiedertäufer zu Münster in Westfalen. Aus einer lateinischen Handschrift des Hermann von Kerssenbroick übersetzt.* N.p., 1771, v, 272 pp., 6 illus.

A contemporary Catholic account (1573) of the Anabaptist riots in Münster. Publication of the original manuscript was supressed but survives in several copies. This edition is based on a 1574 copy in the Münster library. It describes the city's churches, their altars, paintings and statues (see for instance the Cathedral, pp. 29-45) and their destruction (pp. 521 & *passim*).

250

KERSSENBROCH, HERMANN von. *Belli Monasteriensis contra anabaptistica monstra gesti brevis atque succincta descriptio, nunc primum et impressa et edita.* Cologne: Martin Gymnicus (Gymnich), 1545, 69 pp., 1 illus.

Latin poem giving a supposed eye-witness account of the Anabaptist disturbances in Münster in 1534.

251

LANGER, OTTO. "Der Kampf des Pfarrers Joh. Petrejus gegen den Wohlgemutschen Altar in der Marienkirche." *Mitteilungen des Altertumsvereins für Zwickau und Umgegend* 11 (1914):31-49.

Traces in detail the ultimately frustrated attempt of the new pastor in Zwickau to replace an old carved stone altarpiece with a new one of an appropriate Protestant type. The series of discussions recorded in the city council proceedings from 1564-70 is recounted with substantial quotation from the original documents.

252
SCHILDHAUER, JOHANNES. "Der Stralsunder Kirchensturm des Jahres 1525." *Wissenschaftliche Zeitschrift der Ernst Moritz Arndt-Universität Greifswald* 8 (1958/1959):113-19.
Includes accounts of the iconoclasm against churches and monasteries.

253
SCHULTZE, VICTOR. "'Bildersturm' in Waldeck." *Geschichtsblätter für Waldeck und Pyrmont* 33 (1933):15-21.
The removal of images from the church is documented on the basis of visitation records from the years 1532, 1556, and 1563.

254
SPECHT, REINHOLD. "Wittenberger Bilderstürmer in Zerbst 1522." *Zeitschrift des Vereins für Kirchengeschichte der Provinz Sachsen* 31/32 (1936):66-8.
Publishes proceedings of the Zerbst city council from 1522, documenting that there was iconoclasm in the town and that it broke out under the direct influence of Wittenberg iconoclasts.

255
TÜCHLE, HERMANN. "Die Münsteraltäre des Spätmittelalters: Stifter, Heilige, Patrone und Kapläne." In Specker, *600 Jahre Ulmer Münster* (see no. 1162), pp. 126-82.
Compiles details of 52 altars that were in the Ulm Cathedral at the time of iconoclasm in 1531. The city council's ruling that paintings should be removed by their donors came too late, and most were destroyed. The extant information here assembled about each altar includes the saints depicted, the donors, the location within the church, etc.

III. C. 2. later accounts and analyses

256
BREDEKAMP, HORST. "Bildpropaganda und Bildersturm in der Hussitenbewegung." *Bildende Kunst*, 1975, pp. 111-16, 6 illus.
Describes the Hussite movement as an anticipation of radical tendencies in the 16th-century Reformation, in particular T. Münster. Hussite iconoclasm is characterized, and an intense anti-Catholic pictorial tradition reconstructed on the basis of an illuminated Hussite manuscript, the *Jena Codex* of ca. 1490-1510. These illustrations are taken to reflect a visual culture consciously developed by an oppressed class in opposition to the Catholic feudal tradition of religious art.

257
CHRISTENSEN, CARL C. "Iconoclasm and the Preservation of Ecclesiastical Art in Reformation Nuernberg." *Archiv für Reformationsgeschichte* 61 (1970):205-21.
Uses city records and other contemporary accounts to show moderate attitude

toward religious art in Nuremberg. Some iconoclasm (church windows) occurred, but the city council acted quickly to discourage it. Reiterated in the author's book (see no. 419).

258

HEIMPEL, HERMANN. "Das Wesen des deutschen Spätmittelalters." In *Der Mensch in seiner Gegenwart. Sieben historische Essais.* Göttingen: Vandenhoeck & Ruprecht, 1954, pp. 109-35.

A broadly cast essay defining the pre-Reformation period as one of social and cultural crisis, a characterization which the author concludes by formulating the much-discussed and often misquoted phrase: The image breakers were the image donors, "die Bilderstürmer waren die Bilderstifter."

259

HOFFMANN, KONRAD. "Das Ulmer Münster als Pfarrkirche in der Zeit von 1531 bis 1803." In Specker, *600 Jahre Ulmer Münster* (see no. 1162), pp. 377-404.

Pages 383-90 analyze the events of the Reformation years in Ulm, the removal and destruction of images from the Cathedral, the establishment of Protestant services there, and the replacement of two altars for the visit of Charles V.

260

*NIEMEYER, GERLINDE. "Die Entstehung und Zerstörung der Liesborner Altartafeln [Meister von Liesborn]," *Westfalen* 52 (1974):126-34.

261

RASMUSSEN, JÖRG. "Bildersturm und Restauratio." In *Augsburg, Welt im Umbruch* (see no. 407), pp. 95-114, 7 illus.

Recounts iconoclastic activity in Augsburg from 1524 on, setting it in relation to contemporary documents concerning the early Reformation in the city. Patterns of destruction and the final restoration of images are analyzed.

262

ROTT, HANS. "Kirchen- und Bildersturm bei der Einführung der Reformation in der Pfalz." *Neues Archiv für die Geschichte der Stadt Heidelberg und der rheinischen Pfalz* 6 (1905):229-54.

Investigates the records of Ottheinrich's and Friedrich III's attempts to have images removed from churches in Neuburg, Heidelberg and the surrounding area from 1556-66. The ordinances reflect moderation and a concern for the dangers of popular idolatry, but not a hatred of art *an sich*. On the contrary, Ottheinrich was an important patron.

263

SCHARFE, MARTIN. *Evangelische Andachtsbilder. Studien zu Intention und Funktion des Bildes in der Frömmigkeitsgeschichte vornehmlich des schwäbischen Raumes.* Veröffentlichungen des Staatlichen Amtes für Denkmalpflege Stuttgart, Reihe C, vol. 5. Stuttgart: Müller und Gräff, 1968, 366 pp., 161 illus., indexes.

Surveys the Reformation period in Swabia, especially Ulm (pp. 7-15). Only

limited sources exist, but they show that iconoclasm in this region was not extreme.

264

ULLMANN, ERNST. "Bildersturm und bildende Kunst im 16. Jahrhundert." *Hafnia: Copenhagen Papers in the History of Art,* 1976, pp. 46-54.

Karlstadt urged iconoclasm as a means of asserting the economic rights of the peasantry over Catholic luxuriance. Cites other spokesmen critical of religious imagery: Dürer, H. Greiffenberger, T. Münzer, etc. Iconoclasm seen as a radical expression of a more general change in the purpose of visual images.

265

WARNKE, MARTIN. "Durchbrochene Geschichte? Die Bilderstürme der Wiedertäufer in Münster 1534-1535." In M. Warnke, ed., *Bildersturm* (see no. 225), pp. 65-98, 159-67, 11 illus.

A view of the Anabaptist iconoclasm in Münster as an expression of social/economic strife. The various historical interpretations of the events are given as an introduction, as is a survey of the image controversy in Germany and Switzerland. The destruction and deformation in Münster (including confiscation of precious metals, the use of statues in fortifications, etc.) are shown to be focused on symbols of social and political domination.

III. D. Great Britain

266

PHILLIPS, JOHN. *The Reformation of Images: Destruction of Art in England, 1535-1660.* Berkeley: University of California Press, 1973, xiii, 228 pp., 38 illus., bibliog., index.

An analysis of iconoclastic attitudes and actions in the English Reformation, tracing the history of image destruction and the ultimate resolution of Anglican views toward religious art and architecture.

III. E. Lowlands

III. E. 1. contemporary accounts

267

AUTENBOER, E. van. "Een Pamflet over de Mechelse Beeldenstorm." *Mechelsche Bijdragen* 11 (Malines, 1949):21-29.

Reprints a Catholic satirical account of the iconoclasm in Mecheln (Malines) and a call for a united response. Written under a pseudonym and purportedly published in 1567, the year of the events. The historical context for the document is outlined in some detail.

268
AUTENBOER, E. van. "Uit de geschiedenis van Turnhout in de 16e eeuw: Voorbereiding, uitbarsting en gevolgen van de Beeldenstorm (1566)." *Taxandria* n.s., 40/41 (1968-69):1-275.

Presentation of the most extensive and detailed documentation available on iconoclastic activity in the Netherlands, apart from Antwerp. The evidence of destruction recounted by witnesses, identification of participants, reparation charges etc. are recorded.

269
BRANDT, GEERAERT the Elder. *Historie der Reformatie en andere kerkelyke geschiedenissen, in en ontrent de Nederlanden.* 4 vols. 2nd ed. Amsterdam: J. Rieuwertsz, H. & D. Boom, 1677-1704, indexes.

Exhaustive history of the Reformation in the Netherlands. Images and iconoclasm are discussed repeatedly, primarily in vol. I., Book 7, pp. 341-96.

270
BRANDT, GEERAERT the Elder. *Verhaal van de Reformatie, In en ontrent de Nederlanden.* Amsterdam: Jan Rieuwertsz, 1663, xxix, 722 pp., notes and index. English translation, London, 1720.

A separate publication of the first 10 books of vol. 1 of Brandt's *Historie der Reformatie* (see no. 269) including the major discussions of images and iconoclasm (pp. 419-500).

271
BREEN, JOH. C. "Uittreksel uit de Amsterdamsche gedenkschriften van Laurens Jacobsz. Reael, 1542-1567." *Bijdragen en Mededeelingen van het Historische Genootschap te Utrecht* 17 (1896):1-60.

Reconstructs from later printed sources a contemporary account of the uprising given by an Amsterdam merchant. Iconoclasm described briefly (pp. 32-35).

272
DES MAREZ, G. "Documents relatifs aux excès commis à Ypres par les iconoclastes (le 15 et le 16 Août 1566)." Part 1 in *Compte rendu de séances de la Commission Royale d'Histoire,* 5th ser., 7 (1897):547-82. Part 2 in *Bulletin de la Commission Royale d'Histoire* 89 (1925):95-127.

Publishes depositions of witnesses, interrogations of the accused, and one judgment against an iconoclast. The documents are pertinent to destructions in several religious establishments. The second publication supplements the first with additional depositions.

273
DUKE, A.C. "An Enquiry into the Troubles in Asperen, 1566-1567." *Bijdragen en Mededeelingen van het Historisch Genootschap te Utrecht* 82 (1968):207-27.

A description of the relatively orderly iconoclasm in this town. Transcribes a contemporary and previously unknown account by J. de Jong surviving in manuscript (Brussels, Rijksarchief) providing details of the iconoclasm.

274
HAECHT, GODEVAERT van. *De Kroniek over de Troebelen van 1565 tot 1574 te Antwerpen en elders.* 2 vols. Edited by Rob. van Roosbroeck. Antwerp: De Sikkel, 1929-30.

Publishes (with introduction and notes) a transcription of this contemporary account. The chronicle proceeds month by month with some gaps, and includes an account of the activities of iconoclasts in Antwerp (vol. 1, pp. 98 & *passim*). Godevaert was a painter by profession, though nothing is known of his artistic activities.

275
[KLEIJNTJENS, J.C.J.] KLEYNTJENS, JOS. "Bijdrage tot den Beeldenstorm. Beeldenstorm te Wessem." *De Navorscher* 84 (1935):145-90, and 193-99.

Transcribes legal documents pertinent to iconoclastic outbreaks in northern Holland between 1565-75: instructions to the Inquisition and lists of persons to be interviewed, persons accused (often mentioning their professions), judgments passed, confiscations of property, with some extended accounts of particular cases.

276
KLEIJNTJENS, J.C.J. and CAMPEN, J.W.C. van. "Bescheiden betreffende den beeldenstorm van 1566 in de stad Utrecht." *Bijdragen en Mededeelingen van het Historisch Genootschap te Utrecht* 53 (1932): 63-245.

Historical introduction and transcription of documents concerning iconoclasm in Utrecht: legal proceedings against two rebels, reports of the destruction, and other relevant materials.

277
KLEIJNTJENS, J.C.J., and HUIJBERS, H.F.M., eds. *Corpus Iconoclasticum. Documenten over de Beeldenstorm van 1566 in de Boergondische Monarchie.* 2 vols. Tilburg: Henri Bergmans & Cie, n.d., xi, 536 pp., indexes.

Extensive compilation of primary documents: legal proceedings, letters, official reports etc. Vol. 1 for Haarlem, vol. 2 for Nijmegen, each with a brief historical introduction. Of particular interest is the extensive treatment of the case of D.V. Coornhert, artist, humanist, and secretary of Haarlem (vol. 1, pp. 1-121).

278
KOLFF, D.H.A. "Libertatis Ergo. De beroerten binnen Leiden in de jaren 1566 en 1567." *Jaarboekje voor Geschiedenis en Oudheidkunde van Leiden en Omstreken* 58 (1966):118-148.

A brief account of iconoclasm in Leiden (pp. 127-29) with a list of those prosecuted for heretical activities (pp. 142-45). The role of the *Schutters* (the archer's guild), in enforcing regulations is given special attention.

279
LE PETIT, JEAN FRANÇOIS. *A Generall Historie of the Netherlands.* Translated and supplemented by Edward Grimeston. London: A. Islip and G. Eld, 1608,

pp. xxvi, 1415 pp., index, 57 illus.

An early, though brief historical account of iconoclasm, with attention given mainly to the destruction in Antwerp: the treatment of particular images and religious establishments and references to specific officials involved (pp. 399-404), and the aftermath (p. 409). The illustrations are 57 engraved portraits of rulers.

280

SMIT, J. "Hagepreeken en Beeldenstorm te Delft, 1566-67." *Bijdragen en Mededeelingen van het Historisch Genootschap te Utrecht* 45 (1924):206-50.

Transcribes a contemporary account chronicling the upheaval and iconoclasm: "Een corte deductie van (den) anvanck van (de) predicatie van (de) nieuwe religie..." (Delft, Gemeentearchief).

281

SOUTENDAM, J. "Beeldstormerij te Delft in Augustus en October 1566." *Bijdragen voor vaderlandsche geschiedenis en oudheidkunde,* n.s. 9 (1877):173-221.

Publishes the official report of the Court of Holland on the unusually violent iconoclasm at the Cloister of the Minor Brothers in Delft, and the subsequent protest of the city magistrates.

282

VAERNEWIJCK, MARC van. *Troubles religieux en Flandre et dans les Pays-Bas au XVIe siècle. Mémoires d'un patricien Gantois du XVIe siècle.* Translated by H. van Duyse. 2 vols. Ghent: Maison d'éditions d'art, N. Heins, 1905-6.

Translation of a lengthy contemporary account of the troubles, including extensive reports of iconoclasm. This edition is embellished by the publisher with over 600 unnumbered illus., some in color. The original Flemish text survives in manuscript (Ghent, Univ. Lib. Ms. G. 2469). It remains the major primary source for much historical study of the uprisings in this area. See esp. Bk. I, chap. 15; II; III, chaps. 6-7, 14, 19.

283

VAERNEWIJCK, MARC van. *Van die beroerlicke Tijden in de Nederlanden en voornamelick in Ghendt, 1566-1568.* 5 vols. Edited by Ferd. Vanderhaeghen. Maatschappij der Vlaamsche Bibliophilen, series 4, no. 1. Ghent, 1872-81.

For annotation see the French edition, no. 282.

284

*VERHEYDEN, A.L.E. *Le Conseil des Troubles. Liste des condamnés (1567-1573).* Brussels: Palais des Académies, 1961, xii, 596 pp.

An extensive, detailed compilation of those condemned in the uprisings in the Lowlands, culled from various archives there and in Spain. Includes an alphabetical list of 12,203 condemned, noting their parentage, social status, and place of judgment. See review, no. 318.

285

VERMASEREN, B. A. "De Antwerpse Graveur Filips Galle en zijn Kroniekje over

de Opstand (1579)." *De Gulden Passer* 35 (1957):139-47.

Galle published a short Latin chronicle of the Netherlands revolt appended to a map. The text was quickly translated and published in French and Dutch as well. It conclusively shows that Galle was active in promoting Orangist propaganda against the Spanish.

286

VLOTEN, J. van. *Onderzoek van's Koningswege ingesteld omtrent de Middelburgsche Beroerten van 1566-67.* Werken, Historisch Genootschap te Utrecht, n.s., vol. 18. Utrecht: Kemink en Zoon, 1873, 267 pp.

Publishes the official investigation of the uprising in this region, largely records of testimony. A. de Jonghe's letter to Margaret of Parma recounting the iconoclasm of 21-22 Aug. 1566 included in the appendex (pp. 252-56).

287

WILS, I.M.P.A. "Beeldenstorm te Heenvliet." *Haarlemsche Bijdragen* 54 (1937):464-65.

Publishes a document (Brussels, Rijksarchief) describing destructions in the church at Heenvliet and identifying the perpetrators.

288

WILS, I.M.P.A. "De Reformatie en Beeldenstorm in Den Briel." *Haarlemsche Bijdragen* 56 (1938):398-434.

Presents documentation concerning those accused of iconoclasm (including their professions). Based on investigation reports of the Council of the Court of Holland in 1567.

III. E. 2. later accounts and analyses

289

BACKHOUSE, M. "Beeldenstorm en Bosgeuzen in het Westkwartier (1566-1568)." *Handelingen van de koninklijke geschied- en oudheidkundige kring van Kortrijk,* n.s. 38 (1971):7-173, bibliog., index.

A monographic study of the socio-economic, spiritual and political context of the movement, the nature and procedure of iconoclasm, and finally its political consequences in this area of the southern Netherlands. The study is based partly on archival research and partly on published historical accounts. The discussion of iconoclasm provides details on the participants and organization, but very little on the objects removed or destroyed. Good bibliography.

290

BECKER, JOCHEN. "Hochmut kommt vor dem Fall. Zum Standbild Albas in der Zitadelle von Antwerpen 1571-1574." *Simiolus* 5 (1971):75-115, 15 illus.

A statue of Alba, erected by himself in his honor (1571) after his conquest of the Netherlands, was protested both by the Netherlanders and Philip II as unduly prideful. It was dismantled in 1574 and destroyed. The allegorical program of

the statue is interpreted, and a number of satirical texts and images responding to the event are reproduced. Certain of the broadsheets contain specific reference to Alba's persecution of the Protestants. See also, Smolderen, no. 320.

291
BEENAKKER, A.J.M. "Breda in de eerste storm van de opstand. Van Ketterij tot Beeldenstorm 1545-1569." Ph. D. dissertation, Rijksuniversiteit Leiden. Tilburg: Stichting zuidelijk historisch contact, 1971, xxviii, 187 pp., bibliog., index, 1 illus.
Studies in detail the rise of Protestantism in Breda, including chapters on iconoclasm and its consequences (pp. 56-84. *passim*). The precedents, patterns, and motives for local image breaking are examined, and the apparent effect on the social and religious attitude of the population synthesized. Appendices 3-4 transcribe documents pertaining to iconoclasm in Breda in 1566-67.

292
BLENK, C. "Hagepreek en beeldenstorm in 1566. Een historische analyse." In *Hagepreek en beeldenstorm.* Edited by C. Blenk. Kampen: Civitas Studiosorum in Fundamento Reformato, 1966, pp. 16-36.
Discussion of the events relating to hedge preaching and iconoclasm in 1566.

293
BRAND, P.J. "De beeldenstorm der religietroebelen in Hulst in augustus 1566." *Jaarboek van de Oudheidkundige Kring. "De Vier Ambachten",* Hulst, 1966/1967, pp. 37-69.
Attempts to account for the violent iconoclastic outbreak in Hulst by analyzing the economic situation in general and by culling the records of the city archive for information about those involved: their depositions, the courts' verdicts, etc.

294
BRUYN KOPS, C.J. de. "De Zeven Werken van Barmhartigheid van de Meester van Alkmaar gerestaureerd." *Bulletin van het Rijksmuseum* 23 (1975):203-26, 26 illus.
A report on the restoration of this polyptych of 1504 which was severely damaged apparently during the iconoclastic campaigns of 1566 or 1572 in Alkmaar. Photographs of the original damage uncovered in the process of restoration are published.

295
CREW, PHYLLIS MACK. *Calvinist Preaching and Iconoclasm in the Netherlands, 1544-1569.* Cambridge/New York: Cambridge University Press, 1978, 221 pp., bibliog., index.
Reviews: J.S. Bromley. *Historical Journal* 22 (1979):985-95.
Goeffrey Parker. *Times Literary Supplement* 3984 (Aug.11, 1978):916.
Guy Wells. *Sixteenth Century Journal* 12 (1981):126.
Examines backgrounds and attitudes of preachers to clarify their role in the

Netherlands reform movement, which reached its crisis in the "troubles" of 1566. Detailed, well-documented study based largely on original source material. Interprets Calvinist popularity and iconoclastic activity as reflections of already wide-spread religious and social discontent. On image breaking, see especially chapters 1 and 6.

296
DIERICKX, M. "De Beeldenstorm en Frans-Vlaanderen," *Ons Erfdeei. Algemeen-Nederlands kultureel tijdschrift* 10, no. 2 (1966):12-20, 5 illus.
Raises the question of the origins of iconoclasm in the Netherlands, reviewing the spread of riots in 1566 with special reference to Coussemaker, Charles Edmond H. de. *Troubles reliqieux du XVIe siècle dans la Flandre maritime, 1560-1570. Documents originaux.* 4 vols. Bruges: Aimé de Zuttère, successeur de van de Casteele-Werbrouck, 1876.

297
DIERICKX, M. "Beeldenstorm in de Nederlanden in 1566." *Streven* 19 (1966):1040-48.
Summarizes the views presented in several papers by various scholars delivered at a conference in Louvain in 1966. The discussions center on questions of the uprising's spontaneity and the importance of socio-economic factors. A general conclusion was that the political vacuum in Brussels and the obstreperousness of the Protestants were primary causes.

298
DRIESSCHE, ROGER van. "Een treurige Bladzijde uit de oostvlaamse Kunstgeschiedenis." *Cultureel Jaarboek voor de provincie Oostvlaanderen* 7 (1958):94-144, 1 illus.
Traces iconoclasm in Ghent (1578-) conducted under the rule of a commission of 18 members, mainly of Calvinist persuasion. The relinquishing of church property and iconoclastic forays in and around Ghent resulted in the melting down and sale of vast quantities of precious objects. Early records (including a detailed inventory from 1579 of goods collected and their provenance, and the first secretary of the commission's report on the iconoclasm of 1578) are printed in the appendices.

299
DUKE, A.C. and KOLFF, D.H.A. "The time of troubles in the county of Holland, 1566-1567." *Tijdschrift voor Geschiedenis* 82 (1969):316-37.
An overview of iconoclastic activity in this area, stressing the distinction between violent outbreaks and orderly removal of images.

300
EEGHEN, I.H. van. "Een Kettersche Schilderij in 1534." *Oud Holland* 57 (1940):108.
Publishes a document sentencing Peter Rippensz. to a pilgrimage to Rome as punishment for having painted an anti-monastic satire on the outer wall of a house.

301
FREEDBERG, DAVID. "The hidden god: image and interdiction in the Netherlands in the sixteenth century." *Art History* 5 (1982):133-53, 25 illus.
 Examines both Catholic and Protestant controversy over matters of decorum in religious imagery, the likely objects of this controversy, and evidence for the actual effects of theological interdiction on art. Discusses specific instances of censorship, and also the emergence of secular elements around religious subjects. Speculates on the broader sociological and philosophical implications.

302
FREEDBERG, DAVID. "Iconoclasm and Painting in the Netherlands, 1566-1609." Ph.D. dissertation, Oxford University, 1972, x, 295 pp., bibliog., 27 illus.
 Examines the contemporary writings on imagery for both Protestant critics and Catholic apologists. The modification and elaboration of Catholic attitudes, particularly after the Council of Trent, provides an important dimension to the Reformation debate. The effects of iconoclasm on the careers of artists are traced through primary documents, especially in Antwerp.

303
FRIS, VICTOR. "Les chefs de l'iconoclastie gantoise en 1566." *Bulletijn der Maatschappij van Geschied- en Oudheidkunde te Gent* (= *Bulletin de la Société d'Histoire et d'Archéologie de Gand*) 16 (1908):263-68.
 Relation of Calvinist ministers to the iconoclasm in Ghent is discussed.

304
*FRIS, VICTOR, ed. *Notes pour servir à l'Histoire des Iconoclastes et des Calvinistes à Gand de 1566 à 1568*. Société de l'histoire et d'archéologie de Gand. Ghent: V. van Dosselaire, 1909. (Handelingen der maatschappij voor geschied- en oudheidkunde te Gent, 9, 1909).

305
*GELDER, H.A.E. van [Herman Arend Enno van]. *Van beeldenstorm tot pacificatie: Acht opstellen over de Nederlandse revolutie der zestiende eeuw*. Amsterdam/Brussels: Agon Elsevier, 1964.

306
JONG, OTTO JAN de. *Beeldenstormen in de Nederlanden*. Groningen: J.B. Wolters, 1964, 16 pp.
 Surveys the spread of Calvinism and iconoclastic activity from the southern provinces to the northern Netherlands from 1566-80, reflecting primarily on the religious motives for iconoclasm.

307
KAUFMANN, JOSEPH. "Über die Anfänge des Bundes der Adelichen und des Bildersturmes. Beiträge zur Geschichte des niederländischen Aufstandes." Ph.D. dissertation, Friedrich-Wilhelms-University, Bonn, 1889. Bonn: Hauptmannische Buchdruckerei, 1889, 69 pp.

Part II seeks to identify the causes and perpetrators of iconoclasm in the Netherlands. Concludes that preachers and some of the nobility were responsible for considerable incitement to rebellion.

308
KNAPPERT, LAURENTIUS. *De Opkomst van het protestantisme in eene Noord-Nederlandsche Stad.* Leiden: Van Doesburgh, 1908, 290 pp., index, 5 illus.
Study of the rise of Protestantism in Leiden. Iconoclastic activities are described briefly (pp. 228-33).

309
KUTTNER, ERICH. *Het Hongerjaar 1566.* Amsterdam: N. V. Amsterdamsche Boek- en Courantmaatschappij, 1949, 454 pp., bibliog.
A socio-economic analysis of the Netherlands revolt of 1566. The motives, objectives, and effects of iconoclasm are examined (pp. 300-24). Stresses economic hardship and social conflict above religious issues in accounting for the destructions.

310
MALTBY, WILLIAM S. "Iconoclasm and Politics in the Netherlands, 1566." *In The Image and the Word. Confrontations in Judaism, Christianity and Islam.* Edited by Joseph Gutmann. Missoula, Montana: Scholars Press, 1977, pp. 149-64.
Overview of the state of research on the topic, stressing difficulties with the assumption that Calvinism and iconoclasm are inextricably linked or that iconoclasm can be accounted for in terms of strictly socio-economic conflict. Concludes with Crew (see no. 295) that it was a largely spontaneous outbreak due to a general "crisis of authority."

311
MOTLEY, JOHN L. *The Rise of the Dutch Republic: A History.* 3 vols. London: Bickers and Son, 1884, index.
Classic history of the revolt. Iconoclastic movement surveyed briefly (vol. 1, chap. 7).

312
NIEROP, HENK F.K. van. *Beeldenstorm en burgerlijk verzet in Amsterdam 1566-1567.* Nijmegen: Socialistiese Uitgeverij, 1978, 150 pp., bibliog., index, 10 illus.
General examination of iconoclasm in Amsterdam and the surrounding area, focusing on participants in the revolt and their social or professional positions. Appendix includes statistical profiles identifying the status of persons convicted for participating in the revolt.

313
PARKER, GEOFFREY. *The Dutch Revolt.* Harmondsworth, Middlesex: Penguin Books, 1979, 327 pp., bibliog., indexes, 11 maps and diagrams.

A recent history of the uprising, including an overview of iconoclastic activity and a map tracing the patterns of iconoclastic outbreaks. See esp. chap. 2, and fig. 5 (p. 77).

314
PRIMS, FLORIS. *Het Wonderjaar (1566-1567)*. 2nd rev. ed. Antwerp: Bijdragen tot de Geschiedenis, 1941, 397 pp.
 A narrative account of the time of troubles in Antwerp, arranged chronologically and particularly concerned with religious developments. The outbreak of iconoclasm is treated pp. 153-56. Primary sources are quoted liberally, but there is no system of reference to these sources.

315
ROOSBROECK, ROB. van. *Het wonderjaar te Antwerpen (1566-1567)*. Université de Louvain, Recueil de travaux, 2nd ser., 19. Antwerp/Louvain: De Sikkel, 1930, xxvi, 527 pp., bibliog., index.
 Treats the conflicts of reformers and Catholics primarily in Antwerp. A detailed and well-documented study of the political and religious events surrounding and stimulated by the iconoclastic outbreaks. Less concerned with specific acts of image breaking than with its implications and consequences. Good bibliography.

316
*RYCKAERT, M. "Een beeldenstorm in de kerk van Oostwinkel op 23 Augustus 1566." *Appeltjes van het Meetjesland. Jaarboek van het heemkundig genootschap van het Meetjesland* 8 (1957):109-12.

317
SCHEERDER, J. *De Beeldenstorm*. 2nd ed. Bussum: De Haan, 1974, 132 pp., 32 illus., bibliog.
 An interpretive overview of iconoclasm in the Netherlands during 1566, its economic and social setting, the character of iconoclastic actions, and analysis of the causes. Iconoclasm is finally viewed as essentially motivated by religious fanaticism rather than socio-economic or political circumstances.

318
SCHEERDER, J. "Les condamnés du Conseil des Troubles." *Revue d'Histoire Ecclésiastique* 59 (Louvain, 1964):90-100.
 A review of A. Verheyden's extensive correlation of documents listing those condemned for the uprising in the Lowlands from 1567-73, (see no. 284). Points out statistical errors and adjusts the lists in several categories, thus qualifying certain of Verheyden's conclusions. Alba's role is argued to have been overstated.

319

SCHEERDER, J. "Le mouvement iconoclaste en 1566 fut-il spontané ou prémédité?" *Annales de la Fédération archéologique et historique de Belgique* 2 (Tournai, 1952):67-74. (Previously published in: *Miscellanea Tornacensia*, Congrès de Tournai, 1949, vol. 1, Brussels, 1951, pp. 297-304).

Reviews the various opinions on the motivation behind the 1566 iconoclasm (without offering any bibliographical references beyond authors' names). Summarizes the relevant events and concludes the movement was neither entirely spontaneous, nor part of a large organized plan.

320

SMOLDEREN, L. "La statue du duc d'Albe a-t-elle été mise en pièces par la population anversoise en 1577?" *Jaarboek van het Koninklijk Museum voor schone Kunsten, Antwerpen,* 1980, pp. 113-36, 8 illus.

Investigates the disappearance of this statue, erected in 1571 and thought to have been destroyed by the Antwerp populace in 1577. The contemporary accounts and early histories examined by the author, however, reveal this implication of iconoclasm as a fabrication. It is instead likely that the statue was melted down to be made into munitions or a crucifix. (See also Becker, no. 290).

321

U[LLENS], F.G. *Antwerpsch chronykje, in het welk zeer veele en elderste te vergeefsch gezogte geschiedenissen, sedert den jare 1500 tot het jaar 1574 ... F. G. U.* Leiden: Pieter van der Eyck, 1743, ix, 260 pp.

An early history of Antwerp focusing on the revolt and its consequences. The author takes a strong anti-Spanish and anti-Catholic position. Iconoclasm and surrounding events are treated pp. 86-89.

322

VERHEYDEN, ALPHONSE L.E. *Anabaptism in Flanders 1530-1650. A Century of Struggle.* Scottsdale, Pa.: Herald Press, 1961, xvi, 136 pp., 2 maps.

Considers the Anabaptists' relation to the iconoclasm of 1566, arguing their aloofness from the movement and stressing attempts of other reformers to implicate them in the destructions (see pp. 58ff.).

323

VERLINDEN, C.; CRAEYBECKX, J.; and SCHOLLIERS, E. "Mouvements des prix et des salaires en Belgique au XVIe siècle." *Annales. Economies, Sociétés, Civilisations* 10 (1955):173-98. English translation in *Economy and Society in Early Modern Europe, Essays from Annales.* Edited by P.Burke. London: Routledge & Kegan Paul, 1972. pp. 55-84.

The iconoclastic outbreaks of 1565-66 in Belgium are related to fluctuations in the price of grain.

324

WITTMANN, TIBOR. *Les gueux dans les "bonnes villes" de Flandre (1577-1584).*

Translated by András Semjén. Budapest: Akadémiai Kiadó, 1969, 422 pp.
A Marxist interpretation of the Netherlands revolt, stressing social and economic class conflict as the basis for the "Beggars" movement. Iconoclasm is analyzed in this context (pp. 113-39), with a review of scholarship on the question.

325
WOLTJER, J.J. "De Beeldenstorm in Leeuwarden," *Spiegel Historiael, Maandblad voor geschiedenis en archeologie* 4 (1969):170-175, 9 illus.
Reviews the introduction of Protestantism in Friesland, noting its sudden but orderly institution in Leeuwarden in 1566. First precious objects and shortly thereafter images were removed from churches (the guilds reclaiming their own donations). Yet through negotiations with the city administration the new faith was gradually suppressed and Catholic services reintroduced in 1567.

III. F. Switzerland

III. F. 1. contemporary accounts

326
FECHTER, D.A., ed. *Thomas Platter und Felix Platter, zwei Autobiographien.* Basel: Seul & Mast, 1840, viii, 208 pp. English translation by Elizabeth Ann McCaul [Mrs. Finn]. London, 1847.
Thomas Platter, a school-master and scholar of Hebrew, describes how, as a schoolboy in Zurich, he burned a statue of St. John. Shortly thereafter he was converted by Zwingli.

327
FISCHER, FRIEDRICH. "Der Bildersturm in der Schweiz und in Basel insbesondere." *Basler Taschenbuch* 1 (1850):1-43, 1 illus.
Introduction (pp. 3-16) gives an overview of iconoclasm in Zurich, Bern, and St. Gall. The events in Basel are described in a contemporary account, the "Chronicle of Fridolin Ryff," extracts of which are published here with commentary (pp. 17-37). A short discussion on iconoclasm in Neuenburg and Valangin (pp. 40-43).

328
FROMMENT, ANTHOINE. *Les actes et gestes merveilleux de la cité de Genève, nouvellement convertie à l'Evangille...Geneva.* Edited by Gustave Revilliod. Geneva: Fick, 1854, xxxi, 249 pp., appendix ccix pp., some illus.
Written 1548-51 but banned from publication, this chronicle by the Protestant Fromment reports on the period of religious unrest in Geneva, describing the removal and destruction of images (chapters 32-35) and an

anti-papal caricature (chap. 36). The lengthy appendix contains relevant archival material.

329
KESSLER, JOHANNES. *Sabbata*. Reprinted in *Johannes Kesslers Sabbata. Mit kleineren Schriften und Briefen*. Edited by Emil Egli and Rudolf Schoch. St. Gall: Fehr'sche Buchhandlung, 1902, xxx, 719 pp., glossary, index of names, commentary, 1 illus.
　　Chronicle of the Reformation years in St. Gall (1519-39) by the Protestant theologian and schoolteacher Kessler. Many descriptions of iconoclasm in St. Gall and elsewhere (esp. pp. 309-14 and see detailed Table of Contents).

330
MÖSCH, JOHANN. "Bildersturm und Reconciliationen auf solothurnischem Gebiet." *Jahrbuch für Solothurnische Geschichte* 22 (1949):101-114.
　　Follows his earlier article (see no. 331) with another account of iconoclastic destruction in Solothurn churches, this one based on a record drawn up in 1534 at a meeting of local church officials (pp.101-4).

331
MÖSCH, JOHANN. "Die Reconciliation der in den Jahren 1525 bis 1533 auf solothurnischem Gebiet verwüsteten Kirchen und Altäre." *Jahrbuch für Solothurnische Geschichte* 15 (1942):73-92.
　　The iconoclasm in the canton of Solothurn from 1525 to 1533 (a contemporary account survives) is reflected in documents relating to the re-consecration of churches and altarpieces during the Catholic Reconciliation (1559, 1581, 1590 etc.).

332
MÜLLER, THEODOR. *Die St. Gallische Glaubensbewegung zur Zeit der Fürstäbte Franz und Kilian (1520-1530)*. St. Gall: Zollikofer and Cie., 1910, viii, 239 pp.
　　The iconoclasm in St. Gall is described (pp. 57-63), and a contemporary complaint by Abbot Kilian is included as appendix III. (pp. 219-26).

333
NÄF, WERNER. *Vadian und seine Stadt St. Gallen*. 2 vols. St. Gall: Fehr'sche Buchhandlung, 1944 and 1957.
　　Vol. 2 on Vadian's career as Protestant mayor of St. Gall, 1518-1551, relates the iconoclasm and its effects, pp. 238, 269-70, 292-97.

334
OECOLAMPADIUS, JOHANNES. *Was sich zuo Basel uff den achten tag des Hornungs/der Mess und goetzen halb zuo tragen hat*. Strassburg, n.p., 1529.
　　An anonymously published German translation of Oekolampadius's letter to Capito (see Stachelin, no. 160a) describing the storming of the churches and subsequent burning of images in Basel in early February 1529.

335

ROTH, PAUL. *Durchbruch und Festsetzung der Reformation in Basel*. Basler Beiträge zur Geschichtswissenschaft, 8. Basel: Helbing & Lichtenhahn, 1942, 111 pp., bibliog.

Narrates the political events in Basel around 1529. Culled mostly from published documents (see Dürr, no. 493). Describes the removal of images in Basel (pp. 31-32), in Kleinbasel (pp. 33-36), and the appropriation of treasures from several churches and monasteries in the area (pp. 71-79).

336

ROTH, PAUL. "Eine Elegie zum Bildersturm in Basel." *Basler Zeitschrift für Geschichte und Altertumskunde* 42 (1943): 131-38.

Discusses and reprints the Latin original and a modern German translation of an anonymous Counter-Reformation pamphlet from ca. 1595. The text is in the form of an elegy bemoaning the suppression of the Catholic church in Basel and describing the iconoclasm of 1529.

337

SOMWEBER, ERICH. "Die Zerstörung der Werke Heinrich Dieffolts in Zürich im Jahre 1587." *Jahrbuch des Voralberger Landesmuseumsvereins*, 1958, pp. 9-18.

Reports on an unusual iconoclastic event wherein a wagonload of carved altarpieces was destroyed by a group of youths who claimed the figures were idols. The court investigation is recounted.

338

STREUBER, WILH. THEOD. "Zur Geschichte des Bildersturms von 1529." *Basler Taschenbuch* 5/6 (1855): 193-96.

Contains the text of a contemporary Catholic account of the iconoclasm in Basel February 8-10, 1529, written by a Dominican monk, Johann Stolz von Gebweiler, abhorring the destruction, but with few specifics.

339

WYSS, BERNHARD. *Die Chronik des Bernhard Wyss.1519-1530*. Edited by Georg Finsler. Quellen zur schweizerischen Reformations- geschichte, 1. Basel: Basler Buch- und Antiquariats-Handlung, 1901, xxv, 167 pp., indexes of places and names.

Chronicle of an ardent Protestant in Zurich (original manuscript in Zurich, Stadtbibliothek), containing brief accounts of iconoclasm there and in surrounding areas.

III. F. 2. later accounts and analyses

340

HOBI, URS. "Zum Bildverständnis im reformierten Zürich." In E. Ullmann, *Von der Macht der Bilder* (see no. 386), pp. 231-35.

Summarizes well-organized removal of images in Zurich with comments on Zwingli's moderate views. Sees the sobriety of subsequent portraits as a reflection of Reformation discipline and suspicion about art.

IV. The Reformation Period and Art

IV. A. General Studies

341

ANTAL, FREDERICK. "Introduction à la peinture du temps de la Réforme."
Histoire et Critique des arts, no. 1, 1977, 9 pp. (this first number is
unpaginated).

Originally written in 1932 in Germany and published here posthumously,
this essay discusses the economic, social and spiritual tensions of the
Reformation era (identified as 1485-1535), leading not to an art of the
Reformation but to a "deformalization" and nationalization of art that in fact
destroyed art. The author sees a parallel with his contemporary society.

342

ARENS, FRANZ. "Reformation und bildende Kunst." *Die Kunst für Alle* 45
(1929-30):385-87, 2 illus.

A plea for a wider look at the topic than that offered by Buchholz (see no.
349), who is praised for his insights but criticized for focusing on Dürer and
Cranach and overlooking broader sociological implications.

343

BATTISTI, EUGENIO. "Reformation and Counter-Reformation," in *Encyclopedia
of World Art.* New York: McGraw Hill, 1966, XI, col. 894-916, 2 maps,
bibliog., 14 illus.

Condensed overview of the topic art and the Reformation, including
architecture, iconoclasm, Protestant sacred art, and developments in secular art.
The Reformation as a reaction against Renaissance culture is given particular
stress.

344

BENESCH, OTTO. *The Art of the Renaissance in Northern Europe. Its Relation to
the Contemporary Spiritual and Intellectual Movements.* 1945. Revised ed.
London: Phaidon, 1965.

Religious and artistic "extremism" in German Catholicism taken as an
anticipation of Reformation zealousness (chap. 2). Reformation Humanism also

discussed in general terms (chap. 4).

345

BERLIN, STAATLICHE MUSEEN. Das alte Museum. *Kunst der Reformations-zeit.* Exhib. cat. 26 Aug.-13 Nov. 1983, 448 pp., ca. 350 b&w illus., 80 color illus.

Major commemorative exhibition, topically organized (the image cult, secularization, Protestant themes in art). Includes works of art, decorative and liturgical objects, medals, books etc. Well illustrated. Includes many unusual and previously unillustrated objects, most well described and documented in the entries.

346

BREDEKAMP, HORST. "Autonomie und Askese." In *Autonomie der Kunst, zur Genese und Kritik einer bürgerlichen Kategorie.* Frankfurt: Suhrkamp, 1972, pp. 88-172, 11 illus.

A theoretical analysis of the changing relationship of art and society from the 14th to the 16th century. This period is interpreted as one of emerging autonomy in the arts, rejecting the feudal structure of the Middle Ages. Iconoclasm is discussed as an aspect of social conflict.

347

*BIALOSTOCKI, JAN, ed. *Symbole i obrazy w swiecie sztuki.* [Symbols and Pictures in the World of Art]. 2 vols. Warsaw, 1982, 524 pp., 320 illus.

In Polish. A collection of essays including a general discussion of art and the Reformation (pp. 230-34), and on Dürer and the Reformation (pp. 234-68).

348

BUCHHOLZ, FRIEDRICH. "Protestantismus und Kunst im sechzehnten Jahrhundert." Ph.D. dissertation, Halle-Wittenberg, 1927. (Halle/S., n.p. 1928, 57 pp.).

349

BUCHHOLZ, FRIEDRICH. *Protestantismus und Kunst im sechzehnten Jahrhundert.* Studien über christliche Denkmäler, n.s. 17. Leipzig: Dieterich'sche Verlagsbuchhandlung, 1928, 88 pp., 4 illus.

Review: R. Berliner in *Die christliche Kunst* 27 (1931):94-95, 1 illus.

Surveys Luther's attitude toward art, followed by a cursory overview of architecture, painting (Dürer, Cranach), Bible illustration and sculpture. The roots of Protestant art are seen already in "pre-Reformation" works. Brief descriptions of Reformation effects on iconography and style are given.

350

COULTON, GEORGE GORDON. *Art and the Reformation.* New York: Alfred A. Knopf, 1928, vi, 622 pp., 109 illus., appendixes, index. Reprints: Hamden, Conn., 1969. Part II reprinted as *The Fate of Medieval Art in the Renaissance and Reformation.* New York: Harper, 1958.

This book is broadly concerned with the overthrow of the spiritual character of medieval art and architecture. It contests the view that secular notions of craftsmanship and the puritanical attitudes of the Protestant Reformation should be credited with this historical change, since such attitudes were alive throughout the Middle Ages as well. The systematic rejection of 'medievalism' occured first and most fully in Catholic regions (Italy, Spain, and France) with the emergence of Renaissance rationalism. Indeed, Protestants and Catholics largely agreed on the uses and abuses of religious art and architecture, and Protestant artists (eg. Rembrandt) have been responsible for creating profound works of Christian art. Coulton's study is mainly devoted to architectural history.

351

CROUCH, JOSEPH. *Puritanism and Art. An Inquiry into a Popular Fallacy.* London and New York: Cassell, 1910, xiv, 381 pp., 18 illus., index.

An overview from the medieval period to the 19th century intending to counter the opinion that Puritanism and art are antagonistic to one another. Concerns literature and music as well as the visual arts and architecture, primarily in England. Chap. 11 treats Protestant art on the continent.

352

ECKERT, WILLEHAD. "Reformation." In Kirschbaum, *Lexikon der christlichen Ikonographie* (see no. 17). Vol. 3, cols. 516-19, 3 illus.

A brief classification of types of imagery emanating from the Reformation: portraits of reformers, theological subjects, historical subjects and polemics. Concludes with summary observations on the significance of the Reformation for religious imagery and architecture.

353

*EIRE, CARLOS M.N. "Idolatry and the Reformation: A Study of the Protestant Attack on Catholic Worship in Germany, Switzerland and France, 1500-1580." Ph.D. dissertation, Yale University, 1979, 456 pp.

A study of the attack on material aspects of Catholic worship. Along with Luther, Zwingli and others, the writings of Calvin are given special attention. The means by which Catholic practices were abolished, iconoclasm (particularly in Switzerland), and the role of Nicodemism (crypto-Protestants openly attending Catholic rites) are examined. See *Dissertation Abstracts International* 40, no. 6 (1979) 3365A.

354

FRIESEN, ABRAHAM. *Reformation and Utopia. The Marxist Interpretation of the Reformation and its Antecendents.* Veröffentlichungen des Instituts für Europäische Geschichte Mainz, 71. Wiesbaden: Franz Steiner Verlag, 1974, xv, 271 pp., bibliog., index.

Though not specifically concerned with visual culture, this study provides historiographical background relevant to recent East European Marxist interpretations of Reformation art.

355
GELDER, H.A. ENNO van. *The Two Reformations of the 16th Century. A Study of the Religious Aspects and Consequences of Renaissance and Humanism.* The Hague: Martinus Nijhoff, 1961, x, 406 pp., index.
Study of major thinkers of the 16th century and their relation to the Reformation. Brief essays on the place of the visual arts, 220ff., 323ff.

356
GERTZ, ULRICH. "Die Bedeutung der Malerei für die Evangeliumsverkündigung in der evangelischen Kirche des XVI. Jahrhunderts." Ph.D. dissertation: Badische Ruprecht Karls-Universität, Heidelberg. Berlin: Rudolph Pfau, 1936, 75 pp., indexes, bibliog.
Examines the role of religious paintings in the early Reformation church in contrast to Catholicism. Various types of imagery (allegorical, sacramental, devotional) are treated separately, and iconoclasm discussed briefly. The Cranach workshop is treated more extensively than others.

357
HAENDCKE, BERTHOLD. "Das Reformationszeitalter Deutschlands im Spiegel der bildenden Künste des 16. Jahrhunderts." *Internationale Monatsschrift für Wissenschaft, Kunst und Technik* 6 (1912):1153-68.
A general description of changing artistic trends during and due to the Reformation. Sees minor innovations in architecture, and in painting the emergence of new categories: peasant scenes, portraits, landscape and nudes.

358
HAENDCKE, BERTHOLD. "Die wirtschaftliche Lage der bildenden Künstler in der Reformationszeit und die Entwicklung der Künste." *Monatshefte für Kunstwissenschaft* 4 (1911):368-70.
Discusses the Reformation as a stimulus to secularization in the visual arts -- the development of genre, landscape, and portraiture. This change is attributed to the altered economic circumstances of artists no longer dependent on the church for patronage.

359
HAMBURG, KUNSTHALLE. *Luther und die Folgen für die Kunst.* Exhib. Cat. Edited by Werner Hofmann. Essay by Peter-Klaus Schuster. Hamburg, Kunsthalle, 11 November 1983 - 8 January 1984. Munich: Prestel-Verlag, 1983, 164 entries, 1132 b&w illus., 40 color illus., bibliog., indexes.
Traces Luther's impact on the visual arts into the 20th century. Entries arranged topically: cult of images, iconoclasm, *Kampfbilder,* Protestant subject matter, etc.

360
HOLL, KARL. "Die Kulturbedeutung der Reformation." In *Gesammelte Aufsätze zur Kirchengeschichte.* Vol. 1, *Luther.* Tübingen: J.C.B. Mohr (Paul Siebeck), 1921, 3rd ed. 1923, pp. 468-543. English translation by Karl and Barbara Hertz

and John H. Lichtblau. *The Cultural Significance of the Reformation.* New York: Meridian Books, 1959.

Discusses the Reformation's effect on aspects of political, social, economic and cultural life, coming to focus briefly on art at the end (pp. 540-43).

361
*JONES, WILLIAM PAUL. "Art as a Problem in the Theology of Culture: Toward an Understanding of Aesthetics within a Protestant Context." Ph.D. dissertation, Yale University, 1960, 169 pp.

362
KIDD, Rev. B.J. *Documents illustrative of the Continental Reformation.* Oxford: Clarendon Press, 1911, xix, 742 pp., index.

Includes 351 texts and excerpts sometimes in Latin but often in English or French. Sources for each are noted in the introductory remarks to each chapter. Index lists numerous references under "iconoclasm" and "image".

363
KUNST DER REFORMATIONSZEIT. Berlin: Henschelverlag Kunst und Gesellschaft, 1983, 96 pp., numerous illus. (some color).

Includes an introduction and commentary on works from several East German museums.

364
[LIEBMANN, MICHAEL J.] LIBMAN, M.J. *Djurer i ego epocha* [Dürer and his Epoch]. Iz istorii mirovogo iskusstva. Moscow: Iskusstvo, 1972, 239 pp., 228 b&w illus., 26 color illus., summary in German (p. 211).

In Russian. Survey of Swiss and German art of the 15th and 16th centuries. Chapters on the artist and society, prints, and popular culture discuss the relationship between art and the religious movements of the time.

365
LIEBMANN, MICHAEL J. "Reformationszeitalter und Spätrenaissance." In E. Ullmann, *Von der Macht der Bilder* (see no. 386), pp. 277-85.

Mainly a discussion of the decline of art under Reformation influence, placing this in the context of the Renaissance period generally which the author sees as the close of a cycle.

366
LILJE, HANNS. *Luther. Anbruch und Krise der Neuzeit.* Nuremberg: Laetare Verlag, 1946, 261 pp.

"Der Wandel des Weltbildes" (pp. 51-62) sets the Reformation in a broad perspective of the changing economic and social realities of an expanding world. Sees the visual arts reflecting renewal most clearly, abandoning the hieratic for a fresh view of nature.

IV. The Reformation Period and Art

367

MALE, EMILE. *L'art religieux après le concile de Trente. Etude sur l'iconographie de la fin du XVIe siècle, du XVIIe, du XVIIIe siècle.* Paris: Librairie Armand Colin, 1932, ix, 532 pp., 294 illus., index.

Classic study of post-tridentine, Counter-Reformation art in Italy, France, Spain, and Flanders. Chapter 2 considers the direct response of Catholic art to Protestantism (iconographic responses to Protestant iconoclasm, attacks on the cult of images and on the celebration of the Virgin Mary and the cult of saints).

368

MÜNTZ, EUGENE. "Le protestantisme et l'art." *Revue des Revues* 32 (1900):476-95 and 34 (1900):135-43.

Criticizes contemporary art in French churches through a history of views on art, specifically the Protestant practices of the 16th century, contrasting Germany and France (vol. 32, pp. 483-93). Vol. 34 argues that Protestantism had deleterious effects on art in France as opposed to Germany and Switzerland.

369

OSTEN, GERT von der. *Deutsche und niederländische Kunst der Reformationszeit.* Cologne: M. DuMont Schauberg, 1973, 354 pp., indexes, 247 illus.

This text is the German version (with some additions) of von der Osten's survey (see no. 370) published in English in 1969. The German text excludes those portions contributed to the English version by Vey (specifically chaps. 32-35, 37-40).

370

OSTEN, GERT von der, and VEY, HORST. *Painting and Sculpture in Germany and the Netherlands 1500 to 1600.* Harmondsworth, Middlesex: Penguin Books, 1969, xxii, 403 pp., index, 1 color illus., 307 b&w illus.

General survey ordered by local schools and particular artists. References to Reformation issues made in passing where specifically relevant, but no overall analysis.

371

OZMENT, STEVEN E. *The Reformation in the Cities. The Appeal of Protestantism to Sixteenth-Century Germany and Switzerland.* New Haven/London: Yale University Press, 1975, xi, 237 pp., index.

Studies in particular the Catholic church's attitude to religious practice among the laity and the resulting stress. Iconoclasm is interpreted as a violent rejection of these demands (pp. 42ff. and *passim*).

372

PANOFSKY, ERWIN. "Comments on Art and Reformation." In Princeton Art Museum, *Symbols in Transformation* (see no. 375), pp. 9-14. Previously unpublished lecture given in 1960.

The author disagrees with Rüstow (see no. 376), arguing that Protestant art was not simply a result of the Reformation but part of more general trends in the

period as well. Reformation doctrine affected mainly iconography, not "expressive form and intrinsic content." Protestant art is taken to be expressive of "hyperborean" views, including a tendency to quietism and introspection, thus the rejection of Baroque style in Protestant areas.

373

PIANZOLA, MAURICE. *Peintres et Vilains. Les artistes de la Renaissance et la grande guerre des paysans de 1525.* Paris: Editions Cercle d'Art, 1962, 133 pp., 117 b&w illus., 10 color illus., bibliog. German translation by T. Bergner: *Bauern und Künstler. Die Künstler der Renaissance und der Bauernkrieg von 1525.* Berlin, 1961.

Undocumented narrative of the major artists of the period. Connections with the Reformation touched upon in passing.

374

PREUSS, HANS. *Die deutsche Frömmigkeit im Spiegel der bildenden Kunst. Von ihren Anfängen bis zur Gegenwart dargestellt.* Berlin: Furche-Kunstverlag, 1926, xv, 328 pp., 157 illus., index.

Interprets Dürer as a forerunner of the Reformation in his return to sacred texts and the direct recreation of their meaning. Reviews images of explicit Reformation iconography and the emergence of portraiture intended to honor individual piety. Brief consideration of architecture. Concludes that Reformation art formed a distinctive "Seelenbild" in western art (see pp. 155-203).

375

PRINCETON, ART MUSEUM. *Symbols in Transformation. Iconographic Themes at the Time of the Reformation.* Exhib. cat., 15 March-13 April 1969. Princeton: Art Museum, 1969, 110 pp., 85 illus., bibliog.

Introductory essay by Craig Harbison (pp. 15-34) discusses the exhibited prints in topical categories including Spirit and Flesh, Self-conscious Man, etc., relating them to the conflicting attitudes expressed on these matters during the early Reformation period. (See also Panofsky, no. 372).

376

RÜSTOW, ALEXANDER. "Lutherana Tragoedia Artis. Zur geistesgeschichtlichen Einordnung von Hans Baldung Grien angesichts der erstmaligen Ausstellung seines Gesamtwerkes in Karlsruhe." *Schweizer Monatshefte* 39 (1959):891-906.

Argues that Protestantism ruined German art (with the exception of portraiture) from the mid-16th to mid-17th century. Sees Dürer's *Four Apostles* as only superficially Protestant. Perceives a degeneration in the art of Grünewald, Holbein, Cranach ("der Abstieg ins Hausbackene") and Baldung. (See Panofsky's response, no. 372)

377

*ROMANE-MUSCULUS, PAUL. *La prière des mains, l'église réformée et l'art.* Paris: Editions "Je sers," 1938, 247 pp., 20 illus.

378
ROTT, HANS. *Quellen und Forschungen zur südwestdeutschen und schweizerischen Kunstgeschichte im XV. und XVI. Jahrhundert.* 6 vols. Stuttgart: Strecker & Schröder, 1933-38, 232 illus., indexes.
 Vol. I A -Bodenseegebiet, sources, index.
 I B -Bodenseegebiet, text, index, 86 illus.
 II -Altschwaben und die Reichstädte, sources and text, 41 illus., index.
 III A -Baden, Pfalz, Elsaß - sources (no illus. or index).
 III B -Schweiz - sources - index.
 III C -Text for III A and III B and index to all vols., 105 illus.
 Indexes of artists and craftsmen are divided according to professions. The source volumes are clearly organized by geographic localities. The text volumes discuss the Reformation *passim*.

379
SAXL, FRITZ. *Lectures.* 2 vols. London: Warburg Institute, 1957, 390 pp., bibliog., index. Vol. 2: 26 pp., 243 plates. Partly reprinted in F. Saxl, *A Heritage of Images*. Edited by Hugh Honour and John Fleming. Harmondsworth, Middlesex: Penguin Books Ltd., 1970.
 A collection of lectures written mostly between 1933 and 1948, dealing with various topics in art history. For relevant lectures, see nos. 646, 960 and 1077.

380
SCHLICHTER, RUDOLF. *Das Abenteuer der Kunst.* Stuttgart/Hamburg: Rowohlt, 1949, 86 pp.
 Offers a "panorama" of artistic trends from the Renaissance to the present. The Reformation era is criticized for its attention to naturalism and the resulting loss of spirituality (pp. 13-20).

381
*SPELMAN, LESLIE P. "Art and the Reformation. A Critical study of the Effects of the Protestant Reformation on the Continental Arts of the Sixteenth and Seventeenth Centuries, and in Particular on Organ Music of France and Germany up to the Time of J.S. Bach." Ph.D. dissertation, Claremont Graduate School, 1946, 284 pp.

382
STECHOW, WOLFGANG, ed. *Northern Renaissance Art 1400-1600: Sources and Documents*. Englewood Cliffs, N.J.: Prentice-Hall, 1966, 187 pp., index, 1 illus.
 Almost all new English translations of source material (van Mander, legal documents, etc.) on major artists in the Netherlands, Germany, France and England. A brief introduction to each artist is followed by the entries, several of which reflect the Reformation's religious and economic impact on the arts.
 Includes Luther's remarks on art from Against the Heavenly Prophets (pp. 129-30).

383
STUHLFAUTH, GEORG. "Künstlerstimmen und Künstlernot aus der
Reformationsbewegung." *Zeitschrift für Kirchengeschichte* 56 (1937):498-514.
A view of the financial plight of artists in the 16th century caused by the
Reformation's antipathy to art. Includes quotations from contemporary
documents.

384
THULIN, OSKAR, ed. *Illustrated History of the Reformation.* St. Louis:
Concordia Publishing House, n.d., 327 pp., 301 illus., index of persons,
bibliog. Original edition: *Reformation in Europe.* Leipzig: Edition Leipzig,
1967.
General historical surveys of the Reformation in western and eastern Europe.
The many illustrations are not discussed or integrated with the texts but presented
merely as background to each geographical area.

385
ULLMANN, ERNST, ed. *Kunst und Reformation.* Leipzig: E.A. Seemann, 1982,
171 pp., 43 b&w illus., 6 color illus.
Collection of previously published articles (see nos. 695, 710, 722, 725,
887, and 919).

386
ULLMANN, ERNST, ed. *Von der Macht der Bilder. Beiträge des
C.I.H.A.- Kolloquiums "Kunst und Reformation."* Leipzig: E.A. Seemann,
1983, 483 pp.
A collection of the 48 presentations delivered at the 1983 conference of the
Comité International d'Histoire de l'Art. Some essays have been expanded in the
printed version. See separate entries under authors for the most relevant (nos.
41, 87, 220, 340, 365, 508, 629, 635, 694, 709, 716, 776, 1097, 1157, 1199,
1207, and 1227).

387
*VAHANIAN, GABRIEL. "Protestantism and the Arts." Ph.D. dissertation,
Princeton Theological Seminary, 1958, 293 pp.
Disputes the notion that Protestantism (in contrast to Catholicism) is
inherently hostile to the arts. Develops a concept of the "Protestant Symbol" in
Reformation theology to show that images are an essential feature of Protestant
ideology. See *Dissertation Abstracts International* 32, no. 12 (1972): 7081A.

388
WEST, ROBERT. *Nordische Reformationskunst 1500-1600.* Vol. 6 of West,
Entwicklungsgeschichte des Stils. Munich: Hyperion, 1922, 165 pp., 24 illus.
General history of 16th-century art, very little concerned with the
significance of the Reformation as such.

389

WILLIAMS, GEORGE HUNTSTON. *The Radical Reformation.* London: Weidenfeld and Nicolson, 1962, xxxi, 924 pp., indexes.

Study of various radical sects with remarks on their respective views of idolatry and iconoclasm throughout (see index).

IV. B. Austria

390

KRENN, PETER. "Zur Malerei in Steiermark um 1550 bis 1630." *Alte und moderne Kunst* 12, 90 (1967):12-20, 13 illus.

Reviews this period with an eye to the impact of the Reformation on art and artists under the reigns of successive monarchs. The footnotes provide a basic bibliography on Austrian art of the Reformation period.

391

REINGRABNER, GUSTAV. "Zur 'Kunst der Reformation' in Österreich," *Jahrbuch der Gesellschaft für die Geschichte des Protestantismus in Österreich* 94 (1978):7-66.

Approaches the question of Reformation art in Austria from several viewpoints. Section 1 (pp. 8-17) gives a history of Luther and art; 2 (pp. 18-22) discusses Austrian Renaissance art; 3 (pp. 22-6) reviews Protestant art in Austria; 4 (pp. 26-40) surveys the extant monuments. The conclusion is that Austria produced no artistic tradition that could be properly characterized as "Protestant", though the Reformation provided an important influence.

392

STEINBÖCK, WILHELM. "Kunst der Reformation in Österreich." In *Renaissance in Österreich. Geschichte-Wissenschaft-Kunst.* Edited by Rupert Feuchtmüller et al. Horn: Ferdinand Berger und Söhne, 1974, pp. 223-29.

Reviews Reformation works of art produced in Austria during the second half of the 16th century, finding a significant innovation in the emphasis on the Bible as text, which led to the illustration of new subjects.

393

STEINBÖCK, WILHELM. "Kunstwerke der Reformationszeit in der Steiermark. Ein Beitrag zur protestantischen Ikonographie and zur Kunstgeschichte der Steiermark des 16. Jahrhunderts." In *Johannes Kepler 1571-1971. Gedenkschrift der Universität Graz.* Edited by Paul Urban et al. Graz: Leykam Verlag, 1975, pp. 407-73, 50 illus. (plates 37-64 at rear of volume).

Discusses a number of Protestant works from this part of Austria done from 1550 to 1600, including epitaph monuments, altarpieces, and church frescoes. Changes in iconography and a more didactic content are identified.

394
WOISETSCHLÄGER-MAYER, INGE. *Die Kunstdenkmäler des Gerichtsbezirkes Murau.* Österreichische Kunsttopographie, 35. Vienna: Anton Schroll und Co., 1964, 490 pp., 588 illus., bibliog., indexes.

A detailed study of art and architecture in and around Murau, Austria, from the Middle Ages to the 18th century. Works from the Reformation period are discussed *passim,* see especially the Protestant frescoes on the exterior walls of the Pfarrkirche in Ranten.

IV. C. France

395
BORNERT, RENE. *La réforme protestante du culte à Strasbourg au XVIe siècle (1523-1598). Approche sociologique et interprétation théologique.* Studies in Medieval and Reformation Thought, 28. Leiden: E.J. Brill, 1981, xviii, 654 pp., bibliog., indexes.

Studies the liturgy of the Strasbourg reform movement as it evolved in the 16th century, touching on the image question in passing (pp. 133-34, 336-37, 486-89). Good bibliography.

396
BOURGUET, P.; SCHLEMMER, A.; RABINEL, A.; and ROMANE-MUSCULUS, P. *Protestantisme et Beaux-arts.* Collection "Protestantisme," 7. Paris: Editions "Je sers," 1945, 117 pp., 5 illus., bibliog.

Essays by the compilers and others on various aspects of the question, some relating to the 16th century. Gives a "lexicon" (undocumented) of the principal Protestant artists in France, from the 16th to the 20th century (pp. 91-114).

397
BRADY, THOMAS A. Jr. *Ruling Class, Regime and Reformation at Strasbourg 1520-1555.* Studies in Medieval and Reformation Thought, 22. Leiden: E.J. Brill. 1978, xxi, 458 pp., bibliog., indexes.

A detailed study of the political and economic effects of the Reformation on Strasbourg's patricians, privy councillors, merchants, guilds, churches etc. The question of iconoclasm is discussed pp. 217-21.

398
CHRISMAN, MIRIAM USHER. *Lay Culture, Learned Culture. Books and Social Change in Strassburg, 1480-1599.* New Haven: Yale University Press, 1982, xxx, 401 pp., 15 illus., bibliog., index.

Contains a thorough account and analysis of printers in this city (chap. 1) and later a discussion of propaganda, with special attention to the illustrated broadsheets produced by the Protestant trio Johann Fischart, Tobias Stimmer, and Bernard Jobin (chap. 13). Their publication of Huguenot tracts against the papacy and Jesuits discussed.

399
KREBS, MANFRED, and ROTT, HANS GEORG, eds. *Quellen zur Geschichte der Täufer*. Vols. 7 & 8. *Elsass*. Quellen und Forschung zur Reformationsgeschichte, 26 & 27. Gütersloh: Verlagshaus Gerd Mohn, 1959 & 1960, indexes in vol. 8.

Vol. 7 covers the city of Strasbourg from 1522-32, vol. 8 from 1533-35. The entries are arranged chronologically with brief descriptions and footnotes explaining difficult readings. The index lists many references under Bilder, Bildersturm.

400
LESTOCQUOY, [JEAN]. "Notes pour servir à l'histoire de l'art en Artois, III. Quelques documents et oeuvres d'art." *Bulletin de la Commission Départementale des Monuments Historiques du Pas-de-Calais*. n.s. 7 (1941-1949):368-414.

Part IV on 16th-century religious art in Artois devotes pp. 382-97 to the topic art and the Reformation, reviewing various works of art and Catholic attitudes in the 16th and 17th centuries.

401
PARIS, ARCHIVES NATIONALES. *Coligny. Protestants et Catholiques en France au XVIe siècle*. Exhib. cat., Oct. 1972-Jan. 1973. Paris: Hôtel de Rohan, n.d., 144 pp., numerous illus., bibliog.

An exhibition centered on Admiral Coligny, an important political figure during the period of religious wars in France. Includes portraits of contemporaries, visual records of religious violence, and (part V) allegories of religious strife.

402
PARIS, BIBLIOTHEQUE NATIONALE. *Calvin et la Réforme française*. Exhib. cat., March 1935. Compiled by Jean Cordey and Jacques Pannier. Paris: Société de l'histoire du protestantisme français, 1935, vii, 122 pp., 12 illus., 482 entries.

An exhibition of printed books, works of art and artifacts illustrating Calvin's career and influence in France. Special sections given to portraiture, propaganda, and Huguenot artists.

403
ROY, MAURICE. *Artistes et monuments de la Renaissance en France. Recherches nouvelles et documents inédits*. 2 vols. Paris: Librairie Ancienne Honoré Champion, 1929 & 1934, 624 pp., 23 illus., index.

Chapter 4 (pp. 391-417) is devoted to the sculptor Pierre Bontemps who had to leave Paris from 1561-66 because of his Protestant sympathies. Other Protestant artists are discussed as well: Jean Goujon, Jehan Cousin the Elder and Younger, etc.

404
VIRCK, HANS (vol.1), & OTTO WINCKELMANN (vol. 2). *Politische Correspondenz der Stadt Strassburg im Zeitalter der Reformation 1517-1539.* 2 vols. Strasbourg: Karl J. Trübner, 1882 & 1887.

Material concerning the Reformation in Strasbourg culled mainly from the Strasbourg archives but also from Marburg, Ulm, Basel and a few other cities. Indexed.

405
WEISS, N. "L'art et le protestantisme." *Bulletin de la Société de l'histoire du protestantisme français* 49 (1900):505-35.

In defending his views against Müntz (see no. 368), the author discusses the attitude of the French Reformation to art, concluding that it followed the intentions of the original reformers to do away only with cult objects. Suggests that iconoclastic damage in France was relatively light.

406
WILDENSTEIN, GEORGES. "Le goût pour la peinture dans la bourgeoisie parisienne entre 1550 et 1610." *Gazette des Beaux-Arts,* ser. 6, 38(1951):8-343, 71 illus., indexes.

Analyzes patterns of taste with special attention to preferences for subject matter. A large number of household inventories were surveyed (listed chronologically, noting names, addresses and professions). The predominance of Counter-Reformation imagery is emphasized in relation to the writings of Gabriele Paleotti, and secular subjects in context of the period. Though the Reformation as such is considered only briefly, this article is an exceptional study of patronage and covers precisely the period of the religious wars in France.

IV.D. Germany

407
AUGSBURG, ZEUGHAUS AND RATHAUS. *Welt im Umbruch. Augsburg zwischen Renaissance and Barock.* 2 vols. Exhib. cat., 28 June-28 Sept., 1980. Augsburg, n.p., 1980, numerous b&w illus., 24 color illus., bibliog., indexes.

Introductory essays for each volume by various authors, followed by a descriptive catalogue (not all objects are illustrated). Vol. 1, pp. 145-215 is devoted to documents and artifacts pertaining to religious history including a section on the Augsburg Confession of 1530.

408
AUSTIN, ARCHER M. HUNTINGTON ART GALLERY. *Nuremberg - A Renaissance City, 1500-1618.* Exhib. cat., by Jeffrey Chipps Smith. Austin: University of Texas Press, 1983, xiv, 322 pp., 213 catalogue entries, ca. 275 illus., bibliog., index.

A brief catalogue essay (pp. 30-36) reviews certain of the artistic

ramifications of the Reformation in Nuremberg: Dürer and Luther, iconoclasm, propaganda, etc.

409
BAADER, J. *Beiträge zur Kunstgeschichte Nürnbergs*. 2 vols. Nördlingen: Beck'sche Buchhandlung, 1860-62.
 Paraphrases information from documents in the city archives, including references to the removal of precious objects from the churches (vol. 1, pp. 91-2), and the trial of the Beham's and Pencz for heretical beliefs (vol. 2, pp. 51ff., 74ff.).

410
BERLIN, MUSEUM FÜR DEUTSCHE GESCHICHTE. *Martin Luther und seine Zeit*. Exhib. cat., 15 June-20 Nov. 1983. Berlin: Museum für Deutsche Geschichte, 1983, 95 pp., 64 b&w illus., 33 color illus.
 Summary catalogue including works of art, artifacts, books and documents pertinent to Luther and his context.

411
BERLIN, SCHLOß CHARLOTTENBURG. *Von der Freiheit eines Christenmenschen. Kunstwerke und Dokumente aus dem Jahrhundert der Reformation*. Exhib. cat., 13 October-26 November 1967. Berlin: Verlag Bruno Hessling, 1967, 173 pp., 150 b&w illus., 4 color illus.
 Paintings, drawings, prints, manuscripts, book illustrations and other documents are grouped under general topics: Luther's development as reformer (pp. 13-50); his struggle with the Pope and Emperor (pp. 50-78); spiritual aspects of the Reformation (pp. 78-112); social aspects (pp. 112-23); the establishment of local churches (pp. 124-35); the Reformation in Mark Brandenburg (pp. 135-40). Each of the 232 entries, including many works of art, is described and its relation to the Reformation discussed.

412
BLASCHKE, KARLHEINZ. *Sachsen im Zeitalter der Reformation*. Schriften des Vereins für Reformationsgeschichte, 185. Gütersloh: Verlagshaus Gerd Mohn, 1970, 136 pp., indexes, 1 map.
 Brief historical perspective on artistic growth in Saxony during Reformation period. See pp. 79-87 on "Kunstpflege."

413
BLASCHKE, KARLHEINZ. *Wittenberg - die Lutherstadt*. Berlin: Evangelische Verlagsanstalt, 1983, 50 pp., 1 color illus., 61 b&w illus.
 Relates the history of the city before, during and after Luther's life. Includes many illustrations of architecture and works of art from the Reformation period.

414
BRAUNSCHWEIG, STÄDTISCHES MUSEUM. *Dokumente zur Reformation. Bugenhagen 1528 in Braunschweig*. Exhib. cat., 17 Sept.-15 Oct. 1978.

Braunschweig: Evangelisch-lutherisches Stadtkirchenamt, 1978, 116 pp., 58 illus.

The illustrations (Bible illustrations, portraits, epitaphs) are accompanied by short texts relating them to the Reformation in Braunschweig.

415

BRUCK, ROBERT. *Friedrich der Weise als Förderer der Kunst.* Studien zur deutschen Kunstgeschichte, 45. Strasbourg: J.H.Ed. Heitz, 1903, 336 pp., 47 illus., index.

Studies Friedrich's patronage of art and architecture. The story is arranged according to various media, and includes a collection of documents in an appendix. Friedrich was Cranach's major patron.

416

CHRISTENSEN, CARL C. *Art and the Reformation in Germany.* Studies in the Reformation, 2. Athens, Ohio and Detroit, Michigan: Ohio University Press and Wayne State University Press, 1979, 269 pp., 15 illus., appendix, bibliog., index.

Reviews: Carlos Eire. *Sixteenth Century Journal* 12 (1981):100-101.
Charles Garside, Jr. *Renaissance Quarterly* 34 (1981):256-57.
Craig Harbison. *American Historical Review* 86 (1981):154-55.
Robert Scribner. *Religious Studies* 18 (1982):274-75.

A topical examination of the subject, treating iconoclasm (in Zurich, Strasbourg and Basel), Luther's theology of images, the early development of Lutheran art, and the general effect of the Reformation on German art. Local variations in the attitude to religious art and differing theological positions are analyzed. Substantial portions of this study were published earlier in articles by the author (see nos. 122, 233, 257, 419, and 1028).

417

CHRISTENSEN, CARL C. "Municipal Patronage and the Crisis of the Arts in Reformation Nuernberg." *Church History* 36 (1967):140-50.

Financial strain on artists due to the decline in church patronage during the Reformation was alleviated by the Nuremberg city government. Specific commissions by the city and donations of works to it are cited.

418

*CHRISTENSEN, CARL C. "The Nuernberg City Council as a Patron of the Fine Arts, 1500-1550". Ph.D. dissertation, Ohio State University, 1965.

Studies the role of the council in promoting and controlling artistic and architectural activity in context of Nuremberg's non-restrictive guild structure. The council's custodianship of religious art during the Reformation period is given special attention (chap. 7). See *Dissertation Abstracts International* 26, no. 5 (1965):2706-07A.

419

CHRISTENSEN, CARL C. "The Reformation and the Decline of German Art." *Central European History* 6 (1973):207-32.

Considers evidence for the claim that the Reformation led to such a decline. Cites instances of financial hardship among artists, and notes changing subject matter preferences. Tables listing numbers of artists documented in select towns, and breakdowns of subjects portrayed by various artists. This article is substantially reiterated in the author's book (see no. 416).

420

COBURG, KUNSTSAMMLUNGEN DER VESTE COBURG. *Martin Luther Ausstellung zur Erinnerung an die 95 Thesen.* Exhib. cat., July-October 1967. Edited by Heino Maedebach, et al. Coburg: n.p., 1967, 71 pp., 37 b&w illus., 1 color illus.

An exhibition of artifacts and documents (267 entries) from the 16th-19th century concerning Luther and his contemporaries. An introductory essay recounts Luther's contact with Coburg.

421

COLOGNE, OBERSTOLZENHAUS. *Reformatio. 400 Jahre Evangelisches Leben im Rheinland.* Exhib. cat., 11 July-12 Sept. 1965. Cologne, n.p., 1965, 214 pp., 63 b&w illus., bibliog., indexes.

An exhibition of works of art, artifacts, liturgical furnishing, printed works and written documents illustrating the history of the church from the 16th - 20th century.

422

DEHIO, GEORG. *Geschichte der deutschen Kunst.* Vol. 3. Berlin/Leipzig: Walter de Gruyter, 1926, 424 pp., 683 illus. (bound separately), indexes.

The introductory essay to Book 7 discusses the Reformation and art (pp. 1-27), accounting for the richness of graphic art and painting in the early 16th century as the expression of a vital reforming spirit that died out with the establishment of Protestantism. The significance of a changing public and changing patronage is also considered.

423

DEHIO, GEORG. "Die Krisis der deutschen Kunst im sechzehnten Jahrhundert." *Archiv für Kulturgeschichte* 12 (1914):1-16.

The rapid decline of German art after its high point around 1500 is seen partly as a result of the Reformation, but also of a German failure to assimilate the artistic accomplishments of the Italian Renaissance.

424

DEHIO, GEORG. "Die Lage der deutschen Kunst nach der Reformation." *Deutsche Rundschau* 197 (1923):71-75.

Reprints the introduction to vol. 8 of *Geschichte der deutschen Kunst* (see no. 422). A lament on the decline of art after 1530, arguing that the Reformation

destroyed artistic traditions but replaced them with nothing new. Sees the bond between art and religion as essential; without it art became itself a shell reflecting the superficialities of post-reform Germany.

425

DETROIT, INSTITUTE OF ARTS. *From a Mighty Fortress. Prints, Drawings, and Books in the Age of Luther. 1483-1546.* Exhib. cat., Detroit Institute of Arts, Oct. 3-Nov. 22, 1981; Ottawa, National Gallery of Canada, Dec. 4, 1981- Jan. 31, 1982; Coburg, Kunstsammlungen der Veste Coburg, July 18-Aug. 5, 1982. By Christiane Andersson and Charles Talbot. Detroit: Detroit Institute of Arts, 1983, 411 pp., 11 color illus., 244 b&w illus., bibliog.

An elaborately produced and detailed catalogue of an exhibition from the Coburg collections. Certain of the catalogue entries, and certain of the essays (by various authors) touch on the question of art and the Reformation. See esp. Ellen Sharp, "Germany in the Age of Luther" (pp. 28-39); Lewis Spitz, "Luther at Coburg" (pp. 40-48); and Charles Talbot, "Prints and Illustrated Books at Coburg," (pp. 169-175).

426

ENGELHARDT, ADOLF. " Die Reformation in Nürnberg." *Mitteilungen des Vereins für Geschichte der Stadt Nürnberg* 33 (1936):1-258; 34 (1937):1-402; 36 (1939):1-184, index.

A detailed study of the subject, organized by topics. See especially the chapter on the suppression of the monasteries (part 1, chap. 9), and index references to artists. The study was also issued separately (Nuremberg: J.L.Schrag Verlag, 1936-).

427

GEISBERG, MAX. "Zwei zeitgenössische Darstellungen der Belagerung Münsters 1534/35." *Westfalen* 5 (1913):74-89, 4 illus.

Discusses the historical circumstance of the siege to depose the Anabaptist regime in Münster. The two representations of the campaign are a woodcut broadsheet attributed to Pseudo-Beham (1534), and the background of a portrait by Konrad Faber of *Justinian von Holzhausen and Wife* (1535).

428

GERKE, FRIEDERICH. *Reformatio. Beiträge zur Theologie und Kunst der Dürerzeit. Berlin/Rom 1930-1935.* Kleine Schriften der Gesellschaft für bildende Kunst in Mainz, 27. Mainz: Druckerei Krach, 1965, 68 pp., 2 illus.

Collection of five essays written from 1930-35 and already published (no indication of where or when), here presented unchanged: *ars moriendi* and Luther, Veit Stoss, Dürer's and Luther's images of Christ (see no. 985).

429

HAMPE, THEODOR, ed. *Nürnberger Ratsverlässe über Kunst und Künstler im Zeitalter der Spätgotik und Renaissance.* 3 vols. Vienna & Leipzig: K. Gräser & Co., 1904.

Documents from the city council organized chronologically and indexed for persons, places and subjects. Contains important material about censorship: restrictions on writings of the reformers and extensive legal records concerning artists and craftsmen.

430
HÜBENER, P. "Der Protestantismus in der Kunst des alten Nürnberg." *Der alte Glaube* 14 (1913):897-900; 920-24.
Recognizes a Protestant spirit of "piety and inwardness" in Nuremberg's 16th-century architecture, sculpture and painting.

431
HÜTT, WOLFGANG. *Deutsche Malerei und Graphik der frühbürgerlichen Revolution.* Leipzig: E.A. Seemann Verlag, 1973, 595 pp., 218 b&w illus., 51 color illus., bibliog., index.
A general survey from the mid-15th to the mid-16th century, concentrating on the political and social implications of the visual arts. The arts are taken to illustrate the conventional Marxist interpretation of the period, references to Reformation attitudes occuring throughout.

432
HÜTT, WOLFGANG. *Wir und die Kunst.* Berlin, 1959. 3rd rev. ed., Berlin: Henschelverlag, 1977, 463 pp., 626 b&w illus., 32 color illus.
Surveys the art of the "early bourgeois revolution" in Germany (pp. 217-28), touching on artists' role in the Reformation.

433
JANSSEN, JOHANNES. *Art and Popular Literature to the Beginning of the Thirty Years' War.* Vol. 11 of Janssen, *History of the German People at the Close of the Middle Ages.* Translated by A.M. Christie. London: K. Paul, Trench, Trübner, 1907. Reprint. New York: Ams Press, Inc., 1966, xii, 410 pp., indexes.
Chapters 2 and 3 devoted to the decay of art brought on by the Reformation. Iconoclasm is surveyed, as are Luther's ideas about the visual arts and the negative effect on artists who lost their livelihood. A critical view of art in the service of sectarian polemics. This text was originally published in 1888 as vol. 6 of *Geschichte des deutschen Volkes.*

434
JUNGHANS, HELMAR, ed. *Die Reformation in Augenzeugenberichten.* Düsseldorf: Karl Rauch, 1967, 541 pp., 37 illus., index, list of original sources.
History of the Reformation in Germany and Switzerland recounted through excerpts from published contemporary accounts (chronicles, broadsheets, letters, etc.), here translated into modern German and arranged chronologically and topically. The image problem is treated pp. 211, 267-70, 336-43.

435
JUNGHANS, HELMAR. *Wittenberg als Lutherstadt.* Göttingen: Vandenhoeck & Ruprecht, 1979, 224 pp., 104 plates, 18 text illus., indexes.
Reviews the historical development of Wittenberg specifically in relation to Luther. A description of the city prior to Luther's arrival (chapters 1 & 2) is followed by an investigation of the effect of the Reformer's teachings on its cultural, intellectual, social and economic life (chapters 3 & 4). This includes topics such as painting, publishing, the university reforms, and architecture. The final two chapters trace the continued implementation of Lutheran practices by later followers.

436
KALKOFF, PAUL. *Ablaß und Reliquienverehrung an der Schloßkirche zu Wittenberg unter Friedrich dem Weisen.* Gotha: Friedrich Andreas Perthes, 1907, 116 pp.
A detailed study of the acquisition and presentation of relics in the period leading up to the Reformation and during the early 1520's. The implications of this for Reformation attitudes to religious imagery not discussed, but implicit.

437
KREUßLER, HEINRICH GOTTLIEB. *Dr. Martin Luthers Andenken in Münzen. Part 2, Abbildung und Lebensbeschreibung merkwürdiger Zeitgenossen Dr. Luther's.* Leipzig, n.p., 1818. Published separately, Leipzig: F.A. Serig, 1822, 152 pp., 7 illus.
Biographical sketches of various contemporaries of Luther including Cranach (pp. 1-12), Dürer (pp. 13-16), and Karlstadt (pp. 65-128).

438
LIESKE, REINHARD. *Protestantische Frömmigkeit im Spiegel der kirchlichen Kunst des Herzogtums Württemberg.* Forschungen und Berichte der Bau- und Kunstdenkmalpflege in Baden-Württemberg, 2. Munich/Berlin: Deutscher Kunstverlag, 1973, 274 pp., 98 illus., bibliog., indexes.
In spite of official legislation against images in this area, a Protestant art developed that was in many ways a continuation of existing visual traditions. Decorative programs in several Protestant buildings are reviewed, the earliest known only from written descriptions, the majority from the 17th and 18th centuries.

439
MARSCH, ANGELIKA. *Bilder zur Augsburger Konfession und ihren Jubiläen.* Weißenhorn, Bavaria: Anton H. Konrad Verlag, 1980, 174 pp., 19 color illus., 108 b&w illus., bibliog., index.
A brief history of the Augsburg Confession of 1530 (pp. 10-32) is followed by a discussion of Lutheran attitudes toward images (pp. 33-40) and a survey of early depictions (late 16th-early 17th century) of the Confession as well as images produced for the centennials in 1630 and 1730.

440
MÜLLER, NIKOLAUS. *Die Wittenberger Bewegung 1521 und 1522. Die Vorgänge in und um Wittenberg während Luthers Wartburgaufenthalt.* 2nd ed. Leipzig: M. Heinsius Nachfolger, 1911, ii, 422, index.

Revised edition of articles appearing in vols. 6, 7 & 8 of *Archiv für Reformationsgeschichte*. Part I publishes important letters and documents from these years, arranged chronologically with explanatory notes. Part II discusses individuals in alphabetical order, 28 from Wittenberg itself, 14 from elsewhere. Cranach and Karlstadt mentioned repeatedly (see index). Contemporary reports on image destruction pp. 191-95.

441
MÜNSTER, STADTMUSEUM. *Die Wiedertäufer in Münster.* Exhib. cat., 1 Oct. 1982 - 27 Feb. 1983. Münster: Aschendorff, 1982, 240 pp., many illus., bibliog.

Contains essays on various aspects of the Anabaptist rule in Münster and many examples of the art of this period.

442
MUNICH, RESIDENZ. *Wittelsbach und Bayern.* Exhib. cat., 12 June - 4 Oct. 1980. Vols. II, 1 & 2: *Um Glauben und Reich.* Edited by Hubert Glaser. Munich/Zurich: R. Piper & Co., 1980.

These two massive volumes contain considerable information about and illustrations of art relating to the Reformation, especially vol. II/2 pages 1-30; and II/1, Wolfgang Braunfels' essay, "Cuius Regio Eius Ars," pp. 133-40.

443
NUREMBERG, GERMANISCHES NATIONALMUSEUM. *Anfang der Neuzeit. Deutsche Kunst und Kultur von Dürers Tod bis zum Dreissigjährigen Kriege 1530-1650.* Exhib. cat., 15 July-15 Oct. 1952. Nuremberg: Germanisches National Museum, 1952, 222 pp., 84 illus.

Includes a section on broadsheets and art of the Reformation. None of these objects is illustrated, and the catalogue entries are very brief, often only identifications.

443a
NUREMBERG, GERMANISCHES NATIONALMUSEUM. *Martin Luther und die Reformation in Deutschland. Ausstellung zum 500. Geburtstag Martin Luthers.* Exhib. cat. 25 June - 25 September 1983. Frankfurt: Insel, 1983, 491 pp., 652 entries, numerous b&w illus., 18 color illus., glossary, bibliog., indexes. Review: P.W. Parshall, see no.518.

A comprehensive overview of the German Reformation, arranged according to major topics. Introductory essays by various scholars precede each section. The catalogue includes works of art in all media, books, pamphlets, documents, and various artifacts pertinent to the Reformation in Germany and its religious, political, and social context.

444
NUREMBERG, GERMANISCHES NATIONALMUSEUM. *Reformation in Nürnberg - Umbruch und Bewahrung 1490-1580.* Exhib. cat., 12 June - 2 Sept. 1979. Schriften des Kunstpädagogischen Zentrums im Germanischen Nationalmuseum Nürnberg, 9. Nuremberg: Medien und Kultur, 1979, 250 pp., 8 color illus., numerous b&w illus., index.

A rich collection of works of art and literature relating to the Reformation in Nuremberg, with sections on the image question (pp. 130- 33), the task of Reformation art (pp. 140-44), the use of pamphlets (pp. 145-52), etc.

445
PFEIFFER, GERHARD, ed. *Nürnberg -- Geschichte einer europäischen Stadt.*
2 vols. Munich: C.H. Beck, 1971, xxiv, 619 pp., 40 illus., bibliog., indexes. (Second volume entitled *Geschichte Nürnbergs in Bilddokumenten,* 120 pp., 359 illus.)

Eighty short articles by various authors on the history and culture of the city: popular culture, politics and art, crafts, trade etc. Bibliog. of 1307 items. The second volume contains illustrations supplementing the articles.

446
*QUINN, ROBERT MACLEAN. "German Art in Reference to the Protestant Reformation." Ph.D. diss. Baltimore, John Hopkins University, 1957, 376 pp.

447
RETTBERG, R. von. *Nürnbergs Kunstleben in seinen Denkmalen dargestellt.*
Stuttgart: Ebner & Seubert, 1854, xii, 232 pp., 87 illus., index.

Revision of the author's *Nürnberger Briefe* (1846). Pages 99-177 provide a brief chronological guide through the artistic world of 16th-century Nuremberg. Argues that the Reformation elevated art to a more noble sphere.

448
ROEPKE, CLAUS-JÜRGEN. *Die Protestanten in Bayern.* Munich: Süddeutscher Verlag, 1972, 474 pp., numerous illus.

A richly illustrated history of the evangelical Lutheran church in Bavaria from its beginnings to the present including sections on Dürer (pp. 77-84) and on the debate about art in the churches (pp. 128-47).

449
ROTHKRUG, LIONEL. "Popular Religion and Holy Shrines. Their Influence on the Origins of the German Reformation and their Role in German Cultural Development." In *Religion and the People, 800-1700.* Edited by James Obelkevich. Chapel Hill: University of North Carolina Press, 1979, pp. 20-86, 1 map.

Condensed presentation of material treated in the author's book (see no. 450).

450

ROTHKRUG, LIONEL. *Religious Practices and Collective Perceptions: Hidden Homologies in the Renaissance and Reformation.* In *Historical Reflections* 7, no. 1 (1980): xiii, 266 pp., bibliog., 1 map.

A controversial reinterpretation of the causes of the Reformation, from early Frankish cults of the dead to medieval witchcraft, heresy, mariology, and particularly pilgrimage shrines (over 1000 located). Argues that the presence or absence of local saints was decisive for the attitude of any particular cultural region to the Reformation.

451

ROTT, HANS. *Mitteilung zur Geschichte des Heidelberger Schlosses.* Vol. 5, *Ott Heinrich und die Kunst.* Heidelberg: Karl Groos, 1905, 232 pp., 26 illus., index.

Ott Heinrich, a friend of Bucer and a convinced Protestant, was also an important patron of the arts. Contains an appendix with archival documents and an index of names, but no table of contents.

452

ROTT, HANS. "Zu Kunstbestrebungen des Pfalzgrafen Ott Heinrichs." In *Mitteilungen zur Geschichte des Heidelberger Schlosses.* Vol. 6. Heidelberg: Karl Groos, 1912, pp. 191-240, 6 illus.

Adds sources and documents to the same author's earlier study of this Protestant patron (see no. 451). Effects of the Reformation are discussed pp. 207, 216-18.

453

SAUER, J. "Reformation und Kunst im Bereich des heutigen Baden." *Freiburger Diözesan-Archiv,* n.s. 19 (1919):323-506.

The image question is reviewed by surveying the architecture, sculpture and painting produced prior to the Reformation (including lists of contracts for altars and wallpaintings and their iconographic programs) and then examing the consequences of iconoclasm and image removal.

454

SCHNELBÖGL, FRITZ. "Sankt Sebald in Nürnberg nach der Reformation." *Zeitschrift für bayerische Kirchengeschichte* 32 (1963):155-72, 2 illus.

Though Nuremberg had banned images of saints by 1528, St. Sebald continued to be honored and his grave monument (erected 1519) was left intact and in place in the church of his name.

455

SCHULZE, INGRID. "Zum Problem der Verweltlichung religiöser Bildformen in der deutschen Kunst des 16. Jahrhunderts und der Folgezeit." In *Renaissance und Humanismus in Mittel- und Osteuropa.* Edited by Johannes Irmscher. Vol. 1. Deutsche Akademie für Altertumswissenschaft, 32. Berlin: Akademie

Verlag, 1962, pp. 249-60, 23 illus.

An interpretation which distinguishes between a reactionary turn in Cranach's late workshop style and a progressive tendency in the allegories and satires of other Reformation art. Matthias Gerung's *Roundtable of Vice* (1546), and the *Michelfeldt Tapestry* (1524) woodcuts are analyzed, the latter related to imagery of the Hussite wars in the previous century.

456

SEHLING, EMIL, ed. *Die evangelischen Kirchenordnungen des XVI. Jahrhunderts.* 15 vols. Leipzig, 1902 - Tübingen: J.C.B. Mohr, 1977-.

These weighty volumes (still in progress) contain all the evangelical church regulations for Germany, grouped according to geographical area. Each volume includes a chronological index and indexes of names, places, and topics. The more recent volumes have indexes of Bible passages and songs as well. Contains a variety of material revealing attitudes and policies regarding the visual arts.

457

SPECKER, HANS E., and WEIG, GEBHARD. *Die Einführung der Reformation in Ulm. Geschichte eines Bürgerentscheids.* Vortragveranstaltungen, Ausstellungskatalog und Beiträge zum 450. Jahrestag der Ulmer Reformationsabstimmung. Forschungen zur Geschichte der Stadt Ulm, 2. Reihe Dokumentation. Ulm: Stadtarchiv Ulm, 1981, 387 pp., 91 b&w illus., 4 color illus.

Commemorative series of lectures and exhibition catalogue including numerous visual and written documents described and occasionally illustrated.

458

STEPHAN, BERND. "Kulturpolitische Maßnahmen des Kurfürsten Friedrich III., des Weisen, von Sachsen." *Lutherjahrbuch* 49 (1982):50-95.

This study (part of a 1980 Leipzig dissertation) investigates Friedrich's activities as patron of the arts, as donor, as founder and supporter of wide-ranging cultural institutions. Although his involvement was often indirect, he played an important role--not least in his support of Luther--in the cultural achievements of the Reformation.

459

THULIN, OSKAR. "Bildanschauung zur Confessio Augustana und den Jahrhundertfeiern." *Luther. Vierteljahresschrift der Luthergesellschaft* 12 (1930):114-27, 28 illus.

Reviews the depictions of the Augsburg Confession in works of art (prints and medals) produced for jubilees celebrating the event from 1530 to 1830.

460

ULLMANN, ERNST. "Die Reformation im Spiegel der bildenden Kunst, vornehmlich am Beispiel Albrecht Dürers." In *Weltwirkung der Reformation.* Edited by Max Steinmetz and Gerhard Brendler. Vol. 2. Berlin, 1969, pp. 438-48.

Sees the national crisis of the period 1476-1517 reflected in the visual arts, in new subject matter and style.

461

WERNER, JOHANNES. *Die Passion des armen Mannes. Soziale Motive in der spätmittelalterlichen Kunst am Oberrhein.* Freiburg: Verlag Rombach, 1980, 112 pp., 21 illus.

A cursory interpretation of the economic, social, and cultural "revolution" expressed in attitudes toward the common man from the late 15th century through the Peasants' War.

462

WINKLER, GERHARD B. "Die Regensburger Wallfahrt zur Schönen Maria (1519) als reformatorisches Problem." In *Albrecht Altdorfer und seine Zeit.* Edited by Dieter Heinrich. Schriftenreihe der Universität Regensburg, 5. Regensburg: Mittelbayerische Druckerei und Verlagsgesellschaft, 1981, pp. 103-21, 8 illus.

The pilgrimage and its cult imagery have traditionally been taken as symptomatic of medieval practices against which the Reformation reacted. Here they are considered new phenomena, reflecting popular religious undercurrents and thus parallel to and a model for especially extremist Reformation movements. The career of Balthasar Hübmaier who turned from promoting the Regensburg pilgrimage to Anabaptism is taken as a case in point.

463

WOLTMAN, ALFRED. *Die deutsche Kunst und die Reformation.* Sammlung gemeinverständlicher wissenschaftlicher Vorträge. Series 2, vol. 31. Berlin: C.G. Lüderitz, 1867, 40 pp., 2 illus.

Sees the Reformation as a positive influence on German art, culminating in the masterpieces of Dürer and his generation.

IV. E. Lowlands

464

AXTERS, STEPHANUS. *Geschiedenis van de Vroomheid in de Nederlanden.* 4 vols. Antwerp: De Sikkel N.V., 1950-60, indexes, bibliog.

Basic overview of religious life in the Netherlands. Vol. 3 treats the Modern Devotion up to 1550. No extensive discussion of the visual arts, though devotional practice in general treated throughout.

465

BANGS, JEREMY D. "Book and Art Collections of the Low Countries in the Later Sixteenth Century: Evidence from Leiden." *Sixteenth Century Journal* 13 (1982):25-39.

A recounting of works of art and books recorded in four Dutch household inventories spanning the period in which the Reformation was introduced into the

region. Unhappily, the author concludes that nothing can be said on such bases about patterns of ownership and patronage at the time.

466
BRANDEN, F. JOS. van den. *Geschiedenis der Antwerpsche Schilderschool.* 3 vols. Antwerp: Drukkerij J.E. Buschmann, 1883.
General history, mentions the effects of religious and political strife at points in passing (see vol. 1, chaps. X-XI).

467
BROM, GERARD. *Schilderkunst en Litteratuur in de 16e en 17e Eeuw.* Utrecht / Antwerp: Uitgeverij Het Spectrum, 1957, 295 pp., index.
Overview of Netherlandish devotional literature and drama in relation to Erasmian and Lutheran ideas. These Humanist and Protestant trends are associated with the proliferation of moralizing themes and modifications of more traditional religious subjects in the visual arts (see especially chap. 6).

468
DEVOGHELAERE, HUB. *De Zuidnederlandsche Schilders in het buitenland, van 1450-1600.* Antwerp: De Nederlandsche Boekhandel, 1944, 103 pp., 8 plates.
On painters who left the Netherlands because of religious belief.

469
DUVERGER, J. "Lutherse predicatie te Brussel en het proces tegen een aantal kunstenaars (april - juni 1527)." *Wetenschappelijke Tijdingen* 36 (1977):cols. 222-28.
Describes the prosecution and punishment of several artists for having attended a Lutheran sermon delivered by Nicolaas van der Elst in Brussels. Chief among those involved were the tapestry makers Pieter de Pannemaker and Valentin van Orley, and the painters Bernard van Orley, Jan van Coninxloo, Jan Tons, and Jan Tseraerts. A document listing the essential points in the Lutheran sermon is appended.

470
DVORAK, MAX. "Über die geschichtlichen Voraussetzungen des niederlandischen Romanismus. In *Kunstgeschichte als Geistesgeschichte: Studien zur abendländischen Kunstentwicklung.* Edited by Karl Swoboda and Johannes Wilde. Munich: R. Piper & Co., 1924, pp. 203-15.
Interprets the wave of Italian style in the Netherlands during the mid-sixteenth century as an interruption of the inherent character of the region's art, this being expressed by the Reformation movement directed against the Catholic and the classical traditions.

471
GELDER, H. A. ENNO van. "Erasmus, schilders en rederijkers." *Tijdschrift voor Geschiedenis* 71 (1958):1-15, 206-42, 289-331.
Published in monograph form in the following year (see no. 472).

472
GELDER, H. A. ENNO van. *Erasmus, Schilders en Rederijkers. De religieuze Crisis der 16e eeuw weerspiegeld in toneel- en schilderkunst.* Groningen: P. Noordhoff N. V., 1959, 128 pp., index, 32 illus.

Detailed study of the interrelation of art, rhetorician drama, and the emergence of Protestantism in the Netherlands from 1520-1600. Examines parallel changes of subject matter, the effects of the Reformation on artists' biographies, and the progressive role of the arts generally in this period.

473
GELDER, H. A. ENNO van. *Gegevens betreffende roerend en unroerend bezit in de Nederlanden in de 16e eeuw.* Rijks Geschiedkundige Publicatien, no. 140. Vol. 1, Adel, Boeren, Handel en Verkeer. The Hague: Martinus Nijhoff, 1972, xx, 636 pp.

Compilation of household inventories and commercial stocks from archival material in the second half of the century. The inventories are of goods confiscated by local authorities on account of heretical activities. Many references to works of art.

474
KLIJN, M. de. *De invloed van het Calvinisme op de Noord-Nederlandse Landschapschilderkunst 1570-1630.* Apeldoorn: Willem de Zwijger-Stichting, 1982, 63 pp., 4 illus.

The author reviews methodological approaches taken to the issue of Dutch landscape and ideology, follows with a discussion of Calvinism, and then its relation to landscape painting of the late 16th century (Gillis van Conincxloo, Esias van de Velde) and later. The sobriety, directness, and self-confidence of Dutch landscapes are taken to be Calvinist features.

475
KNIPPING, JOHN B. *De Iconografie van de Contra-Reformatie in de Nederlanden.* 2 vols. Hilversum: N.V. Paul Brand's Uitgeversbedrijf, 1939-40. Vol. I: vii, 333 pp., 210 illus., bibliog., index; Vol. II: vii, 342 pp., 222 illus., bibliog., index. English translation: *Iconography of the Counter Reformation in the Netherlands. Heaven on Earth.* 2 vols. Nieuwkoop/Leiden: B. de Graaf/A. W. Sijthoff, 1974, xi, 539 pp., 472 illus., bibliog., index.

This work is included as the single major iconographic study of the Catholic response to the Reformation in northern Europe. The text and notes provide the basis for further research done in this field for the Netherlands. The English translation is revised and updated with substantial additions to the bibliography.

476
LARSEN, ERIK (with the collaboration of Jane P. Davidson). *Calvinistic Economy and 17th Century Dutch Art.* University of Kansas Humanistic Studies, 51. Lawrence: University of Kansas Press, 1979, 74 pp., bibliog.

Stresses Max Weber's thesis (*The Protestant Ethic and the Spirit of*

Capitalism. Translated by Talcott Parsons. New York, 1958) regarding the relation of capitalism and Protestantism, seeing this conjunction as essential to the formation of Dutch art in the 17th century. Discusses Calvin's position on the visual arts, emphasizing his constructive attitude and encouragement of secular subject matter.

477
MANDER, KAREL van. *Het Leven der doorluchtighe Nederlandtsche / en Hooghduytsche schilders.* Haarlem, 1604. 2nd ed. 1617. English translation by Constant van de Wall: Carel van Mander, *Dutch and Flemish Painters.* New York: McFarlane, Warde, McFarlane, 1936.

The major, early biographical source for the lives of Netherlandish painters of the 15th and 16th centuries. Includes frequent references to iconoclasm, occasional remarks on artists' religious affiliations as these affected their careers, and other reflections on the destructive effects of the Reformation on the visual arts.

478
MOREAU, EDOUARD de. *Histoire de l'Eglise en Belgique.* 5 vols. 2nd rev. ed. Brussels: l'Edition Universelle, 1945-52, indexes, bibliog.

Overview of church history. Vol. 4 treats the period 1378-1559 with a section on the arts (pp. 399-462) and 35 illus. Vol. 5 treats the period 1559-1633, also with a section on the arts (pp. 443-89) and 28 illus.

479
RIEGL, ALOIS. *Das holländische Gruppenporträt.* 2 vols. Vienna: Verlag der Österreichischen Staatsdruckerei, 1931, viii, 302 pp., bibliog., index. Vol. 2: 88 illus. First published in *Jahrbuch der Kunsthistorischen Sammlungen des allerhöchsten Kaiserhauses* 23 (1902):71-278, 83 illus.

Major study of the portrait genre and the cultural context of its development in the Netherlands. The thesis of this study bears generally on the division between Catholics and Protestants and its consequences for secular art (see esp. pp. 104ff.).

480
ROEY, J. van. "De Antwerpse schilders in 1584-1585. Poging tot sociaal-religieus onderzoek." *Jaarboek van het koninklijk Museum voor Schone Kunsten te Antwerpen,* 1966, pp. 107-132, 1 illus.

Study based on documents in Antwerp archives for the years 1584-85 when the city was besieged by the Spanish. Religious affiliations are cited in the "registers of purification," overseen by the Catholic magistrate after the city's capitulation in August of 1585. 108 painters are recorded as Catholic, Calvinist, Lutheran, or undecided. The proportions of each correspond to records for other professions, varying comparably in the relation of faith to wealth.

481
SLIVE, SEYMOUR. "Notes on the Relationship of Protestantism to Seventeenth Century Dutch Painting." *Art Quarterly* 19 (1956):2-15, 3 illus.

Fundamental consideration of the methodological questions posed by the relation of Protestantism and art in the Northern Netherlands.

482

VERWEY, HERMAN de la FONTAINE. "The Family of Love." *Quaerendo* 6 (1976):219-71, 11 illus.
 Discusses this sect of libertine Humanists, devoting a section to those artists associated with the group and its publications: Johan Ladenspelder, Willem J. and Gerard J. van Campen. Bruegel's *Misanthrope* and a series of prints by H. Goltzius (inspired by Coornhert) are interpreted as satirical attacks on the Family and its beliefs.

483

WEGG, JERVIS. *The Decline of Antwerp under Philip of Spain*. London: Methuen & Co., 1924, xv, 352 pp., bibliog., index, 14 illus.
 History of the city. Chapter 3 devoted to iconoclasm.

IV. F. Switzerland

IV. F. 1. General

484

DEONNA, W[ALDEMAR]. "Artistes à Genève au temps de la Réformation." *Genava* 15 (1937):127-30.
 Briefly discusses 3 Protestant artists: Ligier Richier, Jean Duvet, and Jean Goujon, who worked in Geneva during the Reformation period, and speculates on Bruegel the Elder's presence there.

485

DEONNA, W[ALDEMAR] . *Les arts à Genève des origines à la fin du XVIIIe siècle*. Geneva: Musée d'art et d'histoire, 1942, 499 pp., 328 illus.
 The art and architecture of the Reformation period in Geneva are discussed (pp. 283-378), with a list of artists and short biographies (pp. 378-79).

486

GANZ, PAUL LEONHARD. *Die Malerei des Mittelalters und des XVI. Jahrhunderts in der Schweiz*. Basel: Verlag Birkhäuser, 1950, 102 b&w illus., 4 color illus., bibliog.
 Reviews the changes in Swiss art brought about by the Reformation's tendency to expel art not only from the church but from public life in general (pp. 133-34, 143-60), leading to an increase in other kinds of two-dimensional art forms besides painting, and to innovations in subject matter and style.

487

HUGELSHOFER, WALTER. *Die Zürcher Malerei bis zum Ausgang der Spätgotik*.

2 parts. Mitteilungen der Antiquarischen Gesellschaft in Zürich, 30, 1 & 2. Zurich: A.-G. Gebr. Leemann & Co., 1928, 109 pp., 100 illus.
The iconoclasm in Zurich in 1523 is described pp. 20-21. The status of artists after the Reformation (especially the work of Hans Asper) is discussed pp. 82-108.

488

MULLER-DUMAS, JANINE. "Catalogue de la Collection d'estampes du Musée historique de la Réformation." Geneva: Travail de diplôme, Ecole de Bibliothécaires, 1970, 46 pp.
A history of the collection, an explanation of the catalogue system, and a guide to the collection.

489

OCHS, PETER. *Geschichte der Stadt und Landschaft Basel.* 8 vols. Berlin/Leipzig: Georg Jakob Decker; Basel: Schweighauser'sche Buchhandlung, 1786-1822.
Vol. 5 covers the Reformation period and includes descriptions of iconoclasm and unrest. See the index in vol. 8.

490

TAVEL, HANS CHRISTOPH von. "Einleitung." In Zurich, Helmhaus, *Zürcher Kunst nach der Reformation* (see no. 492), pp. 5-8, 2 illus.
Summarizes the Reformation's positive and negative effects on Zurich painting, book illustration, etc.

491

ZÜRCHER, RICHARD. *Die Künstlerische Kultur im Kanton Zürich. Ein geschichtlicher Überblick.* Zurich: Atlantis, 1943, 268 pp., 78 illus., bibliog.
Overview of the developments in Zurich art of the early 16th century (pp. 39-76) and the decline after 1531, even of a momentarily strong landscape tradition. Argues that the Reformation compelled local artists to turn to book illustration, portraits and cabinet pieces (pp. 81-86).

492

ZURICH, HELMHAUS. *Zürcher Kunst nach der Reformation. Hans Asper und seine Zeit.* Exhib. cat., 9 May - 28 June 1981. Zurich: Schweizer Institut für Kunstwissenschaft, 1981, 253 pp., 291 b&w illus., 8 color illus., bibliog., index.
Contains essays on various topics relating to art and the Reformation. See especially Tavel (no. 490), Wüthrich (no. 826), Geiger (no. 1218), and Senn (no. 39).

IV. F. 2. Primary Documents

493

DÜRR, EMIL, and ROTH, PAUL, eds. *Aktensammlung zur Geschichte der Basler*

Reformation in den Jahren 1519 bis Anfang 1534. 6 vols. Basel: Verlag der Historischen und Antiquarischen Gesellschaft, 1921-1950, indexes.

Texts of all documents from the Basel archives relating to the Reformation, arranged chronologically. Subject and name indexes begin in vol. 3 (for first 3 vols.) and continue in each subsequent volume. Vol. 1 edited by Dürr. Vol. 2 by Dürr and Roth. Vols. 3-6 by Roth.

494
EGLI, EMIL, ed. *Actensammlung zur Geschichte der Zürcher Reformation in den Jahren 1519-1533.* Zurich: J. Schabelitz, 1879, 947 pp., indexes of names, places, subjects. Reprinted Nieuwkoop: B. de Graaf, 1973.

Texts of all documents from the Zurich archives relating to the Reformation arranged chronologically. Indexes not always complete. On images see numbers 436, 456, 458, 460, 544ff.

495
STECK, R., and TOBLER, G., eds. *Aktensammlung zur Geschichte der Berner-Reformation 1521-1532.* Bern: K.J. Wyss Erben, 1918-1923, 1551 pp., indexes.

Contains archival records relating to the Reformation in Bern.

496
STRICKLER, JOH., ed. *Actensammlung zur Schweizerischen Reformationsgeschichte in den Jahren 1521-1532.* Zurich: Meyer & Zeller, I 1878; II 1879; III 1880; IV 1881; V 1884.

Contains material relevant to the Reformation archives throughout Switzerland. Extensive indexes in Vol. 5.

497
VISCHER, WILHELM, and STERN, ALFRED, eds. *Basler Chroniken.* Vol. 1. Leipzig: S. Hirzel, 1872, xxvi, 591 pp., index.

This volume contains several texts of importance to the Swiss Reformation, including the "Chronicle of Fridolin Ryff" from 1514-41 (pp. 1-229), and chronicles of the Carthusian monastery in Klein-Basel (pp. 233-490).

IV. G. Other

498
*BENDE, J. "Reformácio és képzömüvészet." [Reformation and the Fine Arts]. *Protestáns Szemle* 51 (1942):295-304.

In Hungarian.

499
BIALOSTOCKI, JAN. "The Baltic Area as an Artistic Region in the Sixteenth Century." *Hafnia: Copenhagen Papers in the History of Art* (1976):11-23, 4 illus.

Briefly considers the impact of the Reformation as a unifying element in the adoption and development of foreign styles by 16th-century central European patrons. Centers particularly on the transmission of Netherlandish models for architecture, tombs, and the decorative arts.

500

BOBROVSZKY, IDA. "A XVI. századi magyar református zsinatok végzéseinek müvészeti vonatkozásai." [Artistic Aspects of the Prescription of 16th-century Hungarian Reformed Synods.] *Ars Hungarica* 4 (1976):65-71, English summary.

In Hungarian. Analyzes the Reformation attitude to images in Hungary by examining the prescriptions for art (in and outside the churches) as set down in the synod records, especially those of the great constituent synod of 1567 in Debrecen. The attitude was largely directed against Catholic practice, and was relatively moderate.

501

BUGGE, RAGNE. "Holdninger til bilder i kirkene i Norge: Reformasjons-arhundret." [The Post-Reformation Attitude to Paintings and Images in Churches in Norway]. In *Fra Olav til Martin Luther*. Edited by Martin Blindheim. Oslo: Universitetets Oldsaksamling, 1975, pp. 195-206, English summary.

In Norwegian. Demonstrates the survival of the cult of images despite the Reformation in Norway. The one surviving Norwegian text on images in this period is a dialogue written in 1572 by Jens Skielderup, and shows a critical but tolerant attitude.

503

CUST, LIONEL. "Foreign Artists of the Reformed Religion Working in London from about 1560-1660." *Proceedings of the Huguenot Society* 20 (1903):45-82, 3 illus.

Documents culled mainly from the registers of the Dutch Reformed Church in London. The material is arranged according to the following: 1. Nether-landish artists taking refuge from religious persecution; 2. Netherlandish artists of the reformed religion though not necessarily fleeing persecution; 3. French artists of the reformed religion. Among the artists treated are L. d'Heere, M. Gheeraerts, J. Hoefnagel, Richard Stevens, Cornelis Janssen, Hieronymus Custodis, Woudneel, and Renold Elstracke. The information supplied is mainly family history.

504

DAVIES, HORTON. *Worship and Theology in England.* 5 vols. Princeton: Princeton University Press, 1961-75, indexes and bibliog.

Vol. 1 treats the period 1534-1603, and includes a chapter on the arts (pp. 349-76, 11 illus.). The image question and church art and architecture in England are surveyed.

505

DORSTEN, J[AN] A[DRIANUS] van. *The Radical Arts. First Decade of an*

Elizabethan Renaissance. Leiden/Oxford: Leiden and Oxford University Presses, 1970, xi, 146 pp., 13 illus., appendixes, index.

A study of the effects mainly of Dutch and French culture on Reformation England. The "Family of Love" was an active group among Dutch exiles. Artistic connections with the Netherlands, and the importance of political and religious immigrant artists discussed (Marcus Gheeraerts, Lucas d'Heere, Joris Hoefnagel). The problem of religious and political affiliation and its relation to artistic expression considered *passim*.

506
EDSMAN, CARL-MARTIN. "Nademedlen i reformationstidens bildkonst." [Means of Grace in Reformation Art]. *Kyrkohistorisk Arsskrift* 56 (Uppsala, 1956):73-100, 17 illus., summary in German, p. 100.

In Swedish. Discusses 16th-century Protestant images in Sweden, mostly of German origin, representing the Protestant means of attaining grace through sacraments: baptism, and communion. Early examples are seen to reflect actual church services, but this connection is lost as the tradition develops.

507
HELSINKI, TUOMIOKIRKON KRYPTA. *Martin Luther 500*. Exhib. cat., 16 Aug. - 28 Sept. 1983, 5 color illus., 58 b&w illus.

In Finnish, Swedish and some German. English summary. A commemorative exhibition of art, printed books and documents, mainly German but with a section devoted to the Reformation in Finland.

508
THEODORESCU, RAZVAN. "Art princier et art patricien en Transylvanie au temps de la Réforme." In E. Ullmann, *Von der Macht der Bilder* (see no. 386), pp. 383-95.

Reviews some works of art (book illustration, sarcophagi) reflecting Protestant views in 16th-century Transylvania.

V. Text Illustration and Printed Propaganda

V. A. General

509
BASEL, UNIVERSITÄTSBIBLIOTHEK. *Basler Buchillustration 1500-1545.*
Oberrheinische Buchillustration, 2. Publikationen der Universitätsbibliothek
Basel, 5. Exhib. cat. 31 March - 30 June 1984, lxiii, 813 pp., many illus.,
bibliog., indexes.
 A massive study (488 catalogue entries) of book illustration in Basel during
the Reformation period. Indexes of author, artist, printer and subject.

510
BRÜCKNER, WOLFGANG. "Massenbilderforschung 1968-1978." *Internationales
Archiv für Sozialgeschichte der deutschen Literatur* 4 (1979):130-78.
 An essay on relevant scholarship (including a section on the single-leaf
woodcut) prefaces a bibliography of 249 entries, not annotated, and organized by
topics.

511
BRÜCKNER, WOLFGANG. *Populäre Druckgraphik Europas. Deutschland vom
15. bis zum 20. Jahrhundert.* Munich: Georg D.W. Callwey, 1969, 248 pp.,
153 b&w illus., 46 color illus., bibliog. First published as *Stampe popolari
tedeschi.* Milan, Electra.
 On the Reformation period (pp. 41-68). A brief essay discussing the satirical
and didactic character of popular imagery in this context.

512
CHOJECKA, EWA. "Zur Stellung des gedruckten Bildes im 15. und 16.
Jahrhundert: Zwischen Kunstwerk und 'Massenmedium.'" In *Reform,
Reformation, Revolution.* Edited by Siegfried Hoyer. Leipzig: Karl Marx
Universität, 1980, pp. 123-27.
 Investigates the reception of printed images in the Reformation period
considering questions of audience, thematic range, and interpretive method.
Prints are seen as very different from paintings, valued especially for their
didactic and mnemonic functions and their topical nature.

513

ECKER, GISELA. *Einblattdrucke von den Anfängen bis 1555. Untersuchungen zu einer Publikationsform literarischer Texte.* 2 vols. Göppinger Arbeiten zur Germanistik, 34. Edited by Ulrich Müller et al. Göppingen: Kümmerle Verlag, 1981, 342 pp., cat., bibliog., 78 illus.

Discusses various aspects of German broadsheets: production, censorship, distribution, reception. The primary concern is with the texts, many of which are examples of religious propaganda and frequently illustrated. Extensive bibliography on broadsheets and popular literary forms.

514

GEISBERG, MAX. *Die deutsche Buchillustration in der ersten Hälfte des 16. Jahrhunderts.* 2 vols. Munich: Hugo Schmidt, 1930-31, introductory texts, 450 plates with 1212 illus.

Reproduces several satirical images for and against the Reformation, Bible illustrations, and popular literature illustrations (H. Weiditz, Thomas Murner and others). A basic resource for book illustrations.

515

KLOSS, HILDEGARD. "Publizistische Mittel in Einblattdrucken bis 1550." Ph.D. dissertation, Friedrich-Wilhelms-Universität, Berlin, 1942, 96 pp., 42 illus.

Surveys woodcut images according to various subjects, including Reformation satire (pp. 52ff.).

516

KÖHLER, HANS JOACHIM, ed. *Flugschriften als Massenmedium der Reformationszeit. Beiträge zum Tübinger Symposium 1980.* Spätmittelalter und Frühe Neuzeit. Tübinger Beiträge zur Geschichtsforschung, 13. Stuttgart: Klett-Cotta, 1981, xii, 636 pp., 34 illus., index.

Nineteen essays on various topics having to do with mass media in the Reformation, various of them relevant to propaganda, and indirectly to popular images. See also Scribner "Flugblatt und Alphabetentum" (see no. 522), and Vogler, "Täuferreich zu Münster" (see no. 627).

517

LEEMANN-van ELCK, PAUL. *Die zürcherische Buchillustration von den Anfängen bis um 1850.* Zurich: Schweizerische Bibliophilen- Gesellschaft, 1952, 251 pp., 230 illus., index, bibliog.

The second chapter deals with book illustration in Switzerland from 1520-1600, divided further according to publisher (Froschauer etc.). The Reformation and its effects on printed illustration are discussed *passim*.

518

PARSHALL, PETER W. "The Luther Quincentenary: Prints as Illustrations of History," *Print Quarterly* 1 (1984):60-67, 1 illus.

A review article treating the commemorative exhibits in Hamburg and Nuremberg (see nos. 1249 and 443a), with special attention to the issue of

employing prints as historical documents. The function of popular prints in the Reformation is discussed.

519
RÖTTINGER, HEINRICH. *Beiträge zur Geschichte des sächsischen Holzschnittes. Cranach, Brosamer, der Meister MS, Jakob Lucius aus Kronstadt.* Studien zur deutschen Kunstgeschichte, 213. Strasbourg: J.H.Ed. Heitz, 1921, 104 pp., 12 illus., index.
The relation of these artists (Cranach only briefly discussed) to the Reformation is mentioned in discussing their lives and works. All produced Protestant works, Brosamer and Master MS Lutheran Bible illustrations. Includes descriptive catalogues of woodcuts by the last three artists.

520
SCHOTTENLOHER, KARL. *Flugblatt und Zeitung. Ein Wegweiser durch das Gedruckte Tagesschrifttum.* Berlin: Richard Carl Schmidt & Co., 1922, 555 pp., 88 illus.
Fundamental study of early broadsheets and news-sheets. Extensive consideration given to the Reformation period (chaps. 2 and 6) and to illustrated sheets (chap. 3).

521
SCHNABEL, HILDEGARD. "Zur historischen Beurteilung der Flugschriftenhändler in der Zeit der frühen Reformation und des Bauernkrieges." *Wissenschaftliche Zeitschrift der Humboldt-Universität zu Berlin,* Gesellschafts- und sprachwissenschaftliche Reihe 14 (1965):869-81.
On the basis of fragmentary documentation, seeks to determine as much as possible about the likely origins and activities of pamphlet and broadsheet sellers. Stresses the predominance of Lutherans among 16th-century printers, and the independent activities of small-time printers and dealers in pamphlets.

522
SCRIBNER, ROBERT W. "Flugblatt und Alphabetentum. Wie kam der gemeine Mann zu reformatorischen Ideen?" In *Flugschriften als Massenmedium.* Edited by H.J. Köhler (see no. 516), pp. 65-76.
Considers the means whereby Reformation ideas might have been communicated to the illiterate. Images, including broadsheets, picture books and other forms of visual propaganda are cited (pp. 71-73).

523
SCRIBNER, ROBERT W. *For the Sake of Simple Folk. Popular Propaganda for the German Reformation.* Cambridge Studies in Oral and Literate Culture, 2. Cambridge: Cambridge University Press, 1981, xi, 299 pp., 194 illus., bibliog., index.
Explicates major themes in the imagery of Lutheran propaganda: principally depictions of Luther (an appendix lists these from the 1520's), anti-papal and anti-monastic propaganda, the Antichrist, and various pedagogical allegories. Concerned with the symbolic structure of visual propaganda as related to popular

culture and belief, and how propaganda might be studied to explain the appeal of the Reformation to the "common man."

524
UTRECHT, CATHARIJNE-CONVENT. *Geloof en Satire Anno 1600*. Utrecht: Van Rossum bv, 1981, 64 pp., 41 illus.

Catalogues several Netherlandish works in Utrecht (Rijksmuseum, Catharijne-convent) from the late 16th to the 17th century portraying moral and theological allegories related to the reform in the Netherlands and to the Spanish oppression. The works are interpreted and prototypes identified. Examples of Protestant, Catholic, and non-sectarian allegories discussed.

525
WEBER, BRUNO. *Wunderzeichen und Winkeldrucker. 1543-1586. Einblattdrucke aus der Sammlung Wikiana in der Zentralbibliothek Zürich*. Zurich: Urs Graf-Verlag Dietikon, 1972, 153 pp., 26 illus., bibliog.

The introduction reviews in detail the evidence for the circumstances surrounding the manufacture and publication of popular prints during this period. The selection of "miraculous sign" broadsheets includes a number pertinent to the Reformation. All are accompanied by extensive historical commentary.

V. B. Religious text illustration: bibles, catechisms, songbooks

526
BAUMGART, FRITZ. "Holbein als Bibelillustrator." Ph.D. dissertation. Friedrich-Wilhelm Universität, Berlin, 1927, 90 pp.

Short discussion of Old and New Testament illustrations designed by Holbein the Younger, including those employed to illustrate Luther's translation.

527
DODGSON, CAMPBELL. "Eine Holzschnittfolge Matthias Gerungs." *Jahrbuch der königlich preuszischen Kunstsammlungen* 29 (1908):195-216, 8 illus.

Publishes a group of woodcuts dated from 1536-58, including a cycle of *Apocalypse* illustrations. Gerung worked for both Protestant and Catholic patrons, executed a number of anti-papal satires, and some designs reflecting a critical attitude towards Luther as well.

528
FARNER, OSKAR, ed. *Katechismen*. Zurich: Max Niehans, 1955, 376 pp.

An edition of catechisms including Heinrich Bullinger's *Large Catechism* (1534) and *Short Catechism* (1541), which discuss the commandments and articulate the official position of the Zurich reformers on images (see pp. 37-43; 262-64).

529
FICKER, JOHANNES. "Bibelbildstudien." *Zeitschrift für Buchkunde* 2

(1925):89-98, 9 illus.

Discusses the early stages of illustrated Reformation texts, stressing their importance for the development of Bible illustration in general. A set of woodcut historiated initials and two title pages for Latin Psalters published between 1518-27 in Leipzig (attributed to Cranach the Elder), reflect the migration of Lutheran illustration into orthodox publications.

530

FICKER, JOHANNES. "Das größte Prachtwerk des Straßburger Buchdrucks. Zur Geschichte und Gestaltung des großen Straßburger Gesangbuches 1541." *Archiv für Reformationsgeschichte* 38 (1941)198-230.

Discusses a richly decorated Protestant hymnal published in Strasbourg in 1541 and reprints Bucer's preface to this edition. The hand of Baldung is associated with some of the ornament. Reviews other hymnals and their illustration from the second half of the 16th century.

531

GASSEN, RICHARD W. "Die Leienbibel des Strassburger Druckers Wendelin Rihel." In Boerlin, *Hans Baldung Grien im Kunstmuseum Basel* (see no. 829), pp. 85-91.

Discusses a 1541/42 edition of the Bible (Basel, Kupferstichkabinett) with 188 woodcut illustrations. Ascribes 27 to Baldung and his circle, the majority of the rest to H. Vogtherr the Elder. Reviews the history of Bible production in the 16th century, arguing that such a "picture book" appearing in Strasbourg reflects the relatively active role of the citizenry in the Reformation's success there, where most local artists turned to Bible illustration after the period of iconoclasm.

532

*GASSEN, RICHARD W. *Die Leien Bibel des Strassburger Druckers Wendelin Rihel. Kunst, Religion, Pädagogik und Buchdruck in der Reformation.* Memminger Geschichtsblätter. Memmingen, 1984.

The author's Ph.D. dissertation.

533

GEFFCKEN, JOHANNES. *Der Bildercatechismus des fünfzehnten Jahrhunderts und die catechetischen Hauptstücke in dieser Zeit bis auf Luther.* Vol. I. Die Zehn Gebote. Leipzig: T.O. Weigel, 1855, ix, 114 pp. and 218 cols. of appendixes, 12 illus.

Argues that much of the popular art and literature credited to the Reformation had its foundation in the 15th century, which was already rich in vernacular sermons, illustrated catechisms etc. These are reviewed in relation to Luther. On the Second Commandment pp. 58-63.

534

GEISBERG, MAX. "Cranach's Illustrations to the Lord's Prayer and the Editions of Luther's Catechism." *Burlington Magazine* 43 (1923):85-87, 8 illus.

Cranach's woodcuts are related to a commentary by Melanchthon. Since copies of the woodcuts appear in later publications of Luther's catechisms, it is

likely that Luther personally sanctioned this cycle of images.

535
*GRÜNEISEN, ERNST. "Evangelische Katechismusillustration in der ersten Hälfte des 16. Jahrhunderts." Ph. D. dissertation, Martin Luther-Universität, Halle, 1937.
Part of this dissertation appeared as an article (see no. 536).

536
GRÜNEISEN, ERNST. "Grundlegendes für die Bilder in Luthers Katechismen." *Luther-Jahrbuch* 20 (1938):1-44, 10 illus.
Traces the recension of these illustrations and their use in the publication of Melanchthon's interpretations for the Lord's Prayer and Ten Commandments. The iconography of these illustrations (cycles by H. Holbein the Younger and L. Cranach the Elder) discussed in relation to the instructional texts.

537
HEIDELBERG, UNIVERSITÄTSBIBLIOTHEK. *Biblia. Deutsche Bibeln vor und nach Martin Luther.* Exhib. cat., 15 Dec. 1982 - 26 Feb. 1983. Catalogue by Joachim-Felix Leonhard. Heidelberg: Universitäts- bibliothek Heidelberg, 1982, 272 pp., 146 illus., bibliog.
A survey of German Bible production with some discussion of the effects of the Reformation.

538
HEYDENREICH, LUDWIG H. "Der Apokalypsen-Zyklus im Athosgebiet und seine Beziehungen zur deutschen Bibelillustration der Reformation," *Zeitschrift für Kunstgeschichte* 8 (1939):1-40, 39 illus.
Studies the apocalypse recensions from which the Athos cycle derives. Dürer, Cranach workshop, and Holbein treatments, their interrelationship, and their relation to Reformation political polemic are examined, the apocalypse cycle in Luther's September Testament (1522) in particular.

539
HOBERG, MARTIN. *Die Gesangbuchillustration des 16. Jahrhunderts: Ein Beitrag zum Problem Reformation und Kunst.* Strasbourg: J.H. Ed. Heitz, 1933. Reprint. Baden-Baden: Valentin Koerner, 1973, 139 pp., 42 illus., bibliog.
General questions about the relationship of the Reformation and art are raised in this focused study of 16th-century Protestant hymnal illustration. Topics concern the relation of text to image, iconographic innovation and tradition, Luther's changing attitude to images, etc. Reformation art, even when iconographically creative, did not depart significantly from the artistic traditions of the Middle Ages. A descriptive catalogue of 16th-century illustrated hymnals is included (pp. 83-118).

540
HOBERG, MARTIN. "Eine verfolgte Kirche schmückt ihr Gesangbuch." *Kunst und Kirche* 15,3 (1938):11-14, 9 illus.

The historiated initials in the songbooks (1540's-60's, especially the 1564 edition) of a defiant Bohemian sect are strongly Protestant and unusually close reflections of the text.

541
HOFMANN, HANS-ULRICH. *Luther und die Johannes-Apokalypse. Dargestellt im Rahmen der Auslegungsgeschichte des letzten Buches der Bibel und im Zusammenhang der theologischen Entwicklung des Reformators.* Beiträge zur Geschichte der biblischen Exegese, 24. Tübingen: J.C.B. Mohr (Paul Siebeck), 1982, xiv, 745 pp., bibliog.

Discusses the illustrations for the *Septembertestament* (pp. 314-29): why only Revelations was illustrated and Luther's role in determining the character of the cycle. The influence of the illustrations and how they changed in later versions is discussed pp. 501-7.

542
HÜTT, WOLFGANG. "Lucas Cranach d. Ä. und die Illustrationen zu Luthers Septembertestament von 1522." *Bildende Kunst* 6 (1972):298-300, 5 illus.

Argues that Cranach himself was responsible for at least the choice of motif if not also the sketch for all but the last two illustrations to the *Septembertestament.*

543
HUGGLER, MAX. "Tobias Stimmers Bibelbüchlein (1576)." *Schweizerisches Gutenbergmuseum* 39 (1953):3-16, 3 illus.

The Reformation era introduced the popular *Bibelbüchlein,* books containing Bible illustrations with short accompanying verses. In the example described here, *Neue Künstliche Figuren* (see no. 210), both the texts by Fischart and the images by Stimmer are shown to reflect a consciously Protestant attitude.

544
JAHN, JOHANNES, ed. *Zerbster Prunkbibel. "Cranachbibel". Die Apokalypse.* Witten and Berlin: von Consteinsche Bibelanstalt, 1973, 49 pp., 26 illus.

Facsimile edition of a special printing on parchment (original in the Zerbst City Hall) of Luther's translation of the *Apocalypse* published by Hans Lufft in Wittenberg (1541) and including 26 hand-colored woodcuts from Cranach's workshop. The introductory text reviews the history of Bible illustration and compares the images with Dürer's *Apocalypse* series.

545
JENNY, MARKUS. "Ein frühes Zeugnis für die kirchenverbindende Bedeutung des evangelischen Kirchenliedes. *Jahrbuch für Liturgik und Hymnologie* 8 (1963):123-28, 3 illus.

Identifies the Lutheran hymnal in Holbein's *Ambassadors* as the second edition printed in Worms, 1525. That the formulaic closings ("Halleluja" and "Kyrieleison") are omitted is seen as an attempt to disguise the spiritual nature of the songbook. Similarly its presence with song texts represents a plea for church unity, partly disguised by the use of German instead of Latin.

546

JÜRGENS, WALTHER. *Erhard Altdorfer. Seine Werke und seine Bedeutung für die Bibelillustration des 16. Jahrhunderts.* Lübeck: O. Quitzow, 1931, 87 pp., 91 illus., bibliog.

Catalogues and briefly discusses the content of Altdorfer's illustrations for editions of Luther's Bible translation (Lubeck 1533-34).

547

KOHLS, ERNST-WILHELM. "Holzschnitte von Hans Baldung in Martin Bucers 'Kürtzer Catechismus'." *Theologische Zeitschrift* 23 (1967): 267-84, 24 illus.

Bucer's shortest catechism of 1527 includes 24 woodcuts here illustrated and ascribed to Baldung on the basis of similarities with other works by the artist. Kohls denies a distinctly Protestant tone in some images (pp. 281-82) but suggests a specific reference to Bucer (note 32).

548

KOHLS, ERNST-WILHELM, ed. *Die "Leien Bibel" des Strassburger Druckers Wendelin Rihel vom Jahre 1540 mit Holzschnitten von Hans Baldung Grien.* Quellen und Untersuchungen zur Druckgeschichte des 15. und 16. Jahrhunderts, 1. Marburg: Erich Mauersberger, 1971, 28 pp. intro. and 194 pp., Bible facsimile with 186 illus., bibliog.

A photo reproduction of a 1540 Protestant Bible with woodcuts by Baldung (only copy known is in Memmingen, Stadtbibliothek). The introduction discusses the role of such illustration in interpreting the Reformation for the broad public, and interprets Baldung's works here as a strong evangelical statement. Rihel's own preface defends the use of images.

549

KOHLS, ERNST-WILHELM. "Die neu gefundene 'Leien Bibel' des Straßburger Druckers Wendelin Rihel vom Jahre 1540 mit 200 unbekannten Holzschnitten von Hans Baldung Grien und seiner Schule. Ein Beitrag zur Schule Albrecht Dürers." *Zeitschrift für Kirchengeschichte* 83 (1972):351-64, 8 illus.

Ascribes all woodcuts in this rare Bible (Memmingen, Stadtbibliothek) to Baldung and his workshop (Mende, see no. 844, accepts many fewer).

550

LANCKORONSKA, MARIA. *Die christlich-humanistische Symbolsprache und deren Bedeutung in zwei Gebetbüchern des frühen 16. Jahrhunderts.* Baden-Baden/Strasbourg: Heitz, 1958, 135 pp., 58 illus.

Regards the illustrations in the *Prayerbook of Maximilian* and the *Grimani Breviary* as anticipations of Reformation thought. Identifies instances of anti-clerical satire etc.

551

LUTHER, JOHANNES. *Die Titeleinfassungen der Reformationszeit.* 3 parts. Leipzig, 1909-13. Corrected and expanded version edited by Josef Benzing,

Helmut Claus and Martin von Hase. Hildesheim/New York: Georg Olms, 1973, xxi, over 125 illus.

A 3-page introduction on the importance of such a compendium is followed by a list of all plates and their printers and dates (8 pp.) and then the title pages themselves.

552
LUTHER, MARTIN. *Das Newe Testament Deutzsch. Vuittemberg.* Wittenberg: C. Döring and L. Cranach, 1522, 222 pp., 21 illus. Reprinted in *Luthers Werke,* (see no. 133), *Deutsche Bibel,* vol. 7. The 21 Cranach illustrations pp. 483-523.

Luther's first published translation of the New Testament, known as the *September Testament,* containing 21 woodcut illustrations by Cranach. The 1530 edition includes an additional 7 woodcuts.

553
*LUTHER, MARTIN. *Ein seer gut und nützlichs Bettbüchleyn.* Nuremberg: Hieronymus Formschneider, 1527, 408 pp., 24 illus. Facsimile edition: *Ein sehr gut und nützliches Bet-Büchlein 1527.* Edited by Elfriede Starke. Heidelberg: Freidrich Wittig, 1983, 472 pp., 12 b&w illus., 12 color illus.

Extant in a simple example (Wittenberg, Lutherhalle). The full-page woodcuts by Sebald Beham are related to the accompanying biblical texts.

554
MARTIN, PETER. *Martin Luther und die Bilder zur Apokalypse. Die Ikonographie der Illustrationen zur Offenbarung des Johannes in der Lutherbibel 1522 bis 1546.* Vestigia Bibliae. Jahrbuch des Deutschen Bibel-Archivs Hamburg, 5. Hamburg: Friedrich Wittig Verlag, 1983, 207 pp., 93 illus., bibliog.

A thorough analysis of the origins, context, and later history of the Apocalypse illustrations for Luther's *September Testament.* The author's central concern is to clarify Luther's relation to the iconography of this cycle and to explicate the cycle in terms of Luther's theology.

555
MEYER, KARL. " Die Bibelillustration in der zweiten Hälfte des 16. Jahrhunderts." *Zeitschrift für allgemeine Geschichte, Kultur, und Kunstgeschichte* 4 (1887):161-87.

Describes and characterizes the style of the main Protestant Bible illustrators from ca. 1540-1600. Their quality is judged against their model (Holbein), and generally found wanting.

556
NESSELSTRAUß, CÄCILIA G. "Die Holzschnitte von Lucas Cranach zur ersten Ausgabe des Neuen Testaments von Luther und die Traditionen der deutschen Wiegendrucke." In Feist, *Lucas Cranach,* (see no. 887), pp. 98-101.

Discusses Cranach's part in the publication and illustration of Luther's New Testament translation.

557
NETTER, MARIA. "Freiheit und Bindung in der Bibelillustration der Renaissance. Eine ikonographische Studie zu Hans Holbein des Jüngern 'Icones'." *Schweizerisches Gutenberg-Museum Bern* 39 (1953): 155-89, 16 illus.

Holbein's 91 woodcut illustrations for the Old Testament (published 1538 in Lyons but designed more than a decade earlier in Basel) show that he enjoyed the new "freedom" of the Reformation period, which allowed and even encouraged artists to diverge from traditional representations and formulate an individual approach. Reviews the etymology of creation images: from the mathematical abstraction in Nicholas of Lyra's *Postilla* to a naturalistic landscape in Holbein's 1525 Bible and in his *Scenes of Death*. Shows the concern of Reformers, especially Luther, for pictorial as well as verbal formulation.

558
*NETTER, MARIA. "Die Postille des Nicolaus von Lyra in ihrer Wirkung auf die Bibelillustration des 15. und 16. Jahrhunderts unter besonderer Berücksichtigung der 'Icones' Hans Holbein d. J." Ph. D. dissertation, Basel, 1943, 215 pp.

The thesis is summarized in her 1953 article (see no. 557).

559
NUREMBERG, GERMANISCHES NATIONALMUSEUM. *Bibel und Gesangbuch im Zeitalter der Reformation.* Exhib. cat., 8 July - 27 August 1967, Nuremberg: n. p., 1967, 99 pp., 36 b&w illus., 2 color illus.

Pages 14-16 of the introductory essay (by Bernhard Klaus) discuss the role of Bible illustrations along with more specific examples of Lutheran imagery.

560
OERTEL, HERMANN. "Das Bild in Bibeldrucken vom 15. bis zum 18. Jahrhundert (Die Wolfenbütteler Bibelsammlung)." *Jahrbuch der Gesellschaft für niedersächsische Kirchengeschichte* 75 (1977):9-37, bibliog.

Reviews the illustrated Bibles of the Reformation period in Germany, the Netherlands, and France.

561
OLDENBOURG, M[ARIA] CONSUELO. "Eine unbeschriebene Titeleinfassung von Hans Baldung Grien." *Philobiblon* 4 (1960):195-98, 2 illus.

Publishes a title page frame from 1519 showing the mass of St. Gregory and records its re-use in a Lutheran publication ("XII. Predigt") in 1524. The printer/publisher Johann Schott was a convinced Lutheran, thus his use of the image must attest to the broad popularity of St. Gregory outside the church in Alsace and Sundgau.

562
PUC-BIJELIC, BREDA. "Ilustracije v slovenskih protestantskih Knjigah." (Illustrated Protestant Books in Slovenia) *Zbornik za umetnostno zgodovino* 4 (1957):183-210, 11 illus. (German summary pp. 209-10).

In Polish. Surveys 10 printed Protestant texts from the 16th century, all illustrated. The illustrations are localized and traced to German prototypes.

563
REINHARDT, HANS. "Ein unbekannter Holzschnitt Hans Holbeins d.J. von 1536 und Holbeins Melanchthon-Bildnis." *Zeitschrift für Schweizerische Archäologie und Kunstgeschichte* 32 (1975):135-40, 7 illus.

Discusses the re-use of Holbein woodcuts for title pages of the English *Coverdale Bible* (ca. 1535) and a work by Melanchthon (1536). These and Holbein's portrait of Melanchthon are associated with the English reformer Thomas Cranmer, who may have commissioned all of them.

564
SCHMIDT, PHILIPP. "Die Bibelillustration als Laienexegese." In *Festschrift Gustav Binz*. Basel: Benno Schwabe & Co., 1935, pp. 228-39, 5 illus.

Argues that in the Reformation period Bible illustration acquired significant new value as exegesis, as opposed to the tradition of medieval illuminations or the *Biblia pauperum*.

565
SCHMIDT, PHILIPP. "Fusstapfen der Geschichte in der Illustration von Luthers deutscher Bibel." *Luther. Zeitschrift der Luther-Gesellschaft* 36 (1965):31-40, 5 illus.

Identifies references to contemporary political events and figures in Cranach's eschatological illustrations for Revelations in the *September Testament*. Reviews opinions on the Lutheran content of illustrations in several Bible editions.

566
SCHMIDT, PH[ILIPP]. *Die Illustration der Lutherbibel. 1522-1700. Ein Stück abendländische Kultur- und Kirchengeschichte.* Basel: Friedrich Reinhardt, 1962, 496 pp., 398 illus., bibliog.

Surveys pre-Reformation illuminated Bibles and early German and Swiss editions of Luther's translation. Focuses on the content of the illustrations and their closeness to Luther's text. A comparative section (pp. 401-78) examines the pictorial treatment of eleven selected topics in various Bibles.

567
SCHRAMM, [JOHANNES] ALBERT. *Luther und die Bibel. I. Die Illustration der Lutherbibel.* Festschrift zum Lutherischen Weltkonvent, Eisenach, August 1923. Leipzig: K.W. Hiersemann, (1923), viii & 43 pp., 554 illus.

Describes and illustrates the illuminated initials and all woodcuts from the 75 Luther Bibles and sections thereof published in Wittenberg from 1522 until Luther's death in 1546.

568
*SCHUBART, HERTA. "Die Bibelillustration des Bernhard Salomon." Ph.D. dissertation, University of Hamburg, 1929. Partial printing: Amorbach: Gottlob Volkhardtsche Druckerei, 1932.

The printed version contains the introduction, conclusion, and a short

summary of the rest. The influence of the Reformation on Bible illustrations is discussed, as well as the fact that Salomon remained Catholic, though working for a Protestant printer.

569

SCHWARZ, KARL. *Augustin Hirschvogel. Ein deutscher Meister der Renaissance.* Berlin: Julius Bard, 1917, bibliog., 182 plates. Reprint. New York: Collectors Editions Ltd., n.d.

In 1550 Hirschvogel published the illustrated *Concordantz und Vergleichung des alten und neuen Testaments* with the Hungarian Peter Perényi who was an early adherent of Luther and later of Calvin. The *Concordantz,* begun by Perényi, was completed and published by Hirschvogel after the reformer's death in 1548. The question of possible Protestant features in the iconography of the illustrations is not discussed.

570

SEIDLITZ, W. von. "Die gedruckten illustrierten Gebetbücher des XV. und XVI. Jahrhunderts in Deutschland." *Jahrbuch der königlich preussischen Kunstsammlungen* 6 (1885):29-38, 4 illus.

As the Reformation eclipsed the cult of the Virgin, traditional prayerbooks were replaced by Luther's *Gebetbüchlein* of 1522 illustrated by H. Schäufelein. Also traces the history of the *Hortulus Animae,* reissued in German under Reformation auspices beginning in 1547.

571

STENGEL, WALTER. "Drei neu entdeckte Grünewald-Zeichnungen." Berliner Museen n.s. 2 (1952):30-31, 4 illus.

First publication of three Grünewald drawings found in the 1541 Lutheran Bible of Hans Plock (East Berlin, Märkisches Museum). The drawing of a *Pharisee* (West Berlin, Kupferstichkabinett) is identified as coming from the same source.

572

STENGEL, WALTER. "Der neue Grünewald-Fund." *Zeitschrift für Kunstwissenschaft* 6 (1952):65-78, 14 illus.

Discusses the Grünewald drawings found in Hans Plock's Bible (see no. 571), suggesting that they along with the *Pharisee* were preliminary studies for Grünewald's lost painting of the *Transfiguration of Christ.* Recounts what is known of Hans Plock and speculates on his motivation for cutting out the drawings and gluing them and many other graphic works into his Lutheran Bible.

573

STRACHAN, JAMES. *Early Bible Illustrations. A short study based on some fifteenth and early sixteenth century printed Texts.* Cambridge: University Press, 1957, viii, 170 pp., 127 illus., bibliog., index.

Chapters on Luther's Bibles (pp. 42-507) German and Swiss (51-8) French and Dutch Bibles (59-68) offer a survey of Protestant Bible production and illustration in the 16th century.

574
THIEL, HEINRICH. "Zum Verhältnis von Reformation und Kunst." *Kirche und Kunst* 31 (1952):8-11, 3 illus.

The representations (circle of Virgil Solis) of the prophets Joel, Micha and Malachi in the 1567 Bible printed by Sigismund Feyerabend are shown to demonstrate an active relationship between Protestantism and art.

575
THULIN, OSKAR. "Die Gestalt der Lutherbibel in Druck und Bild. Jubiläumsausstellung der Lutherhalle 1534-1934." *Luther. Vierteljahresschrift der Luthergesellschaft* 16 (1934):58-70, 7 illus.

Stresses Luther's involvement with the illustration of his Bible translations, reviewing the history of different printings and their illustrations.

576
TIMM, W. "Die Einklebungen der Lutherbibel mit den Grünewaldzeichnungen." In *Forschungen und Berichte. Staatliches Museen zu Berlin.* Edited by H.W. Grohn, et al. Berlin: Akademie-Verlag, 1957, pp. 105-21 (11 illus.).

Concerns a 1541 Lutheran Bible (East Berlin, Märkisches Museum) owned by a Protestant, Hans Plock, who was expelled from Mainz in 1525 and moved to Halle. Plock pasted into his Bible 52 items, including prints, drawings (3 by Grünewald), and broadsheets. Many of these are accompanied by commentary.

577
VOLZ, HANS. *Hundert Jahre Wittenberger Bibeldruck. 1522-1626.* Göttingen: Ludwig Häntzschel, 1954, 168 pp.

A history of Bible printing in Wittenberg with illustrations and related questions discussed in passing.

578
VOLZ, HANS. *Martin Luthers deutsche Bibel. Entstehung und Geschichte der Lutherbibel.* Introduction by Friedrich W. Kantzenbach, edited by Henning Wendland. Hamburg: Friedrich Wittig Verlag, 1978, 260 pp., 406 b&w illus., 10 color illus., bibliog., indexes.

An illustrated history of Luther's translation with a wide selection of reproductions taken from its various editions. This is a lavish pictorial overview of the topic with brief text outlining the publishing process and the history of the editions.

579
WALTHER, CHRISTOFF. *Von unterscheid der Deudschen Biblien und anderer Büchern des Ehrnwirdigen und seligen Herrn Doct. Martinus Lutheri/so zu Wittenberg gedruckt/und an andern enden nachgedruckt werden.* Wittenberg, 1563, 16 pp.

A pamphlet by the proof-reader *(corrector)* for Hans Lufft, addressing corruptions in the text of later editions of Luther's Bible translation. A section is

devoted to the Bible illustrations, stressing Luther's direct concern with their original formulation (fols. Bijf.).

580
WENDLAND, HENNING. "Gibt es eine noch unbekannte Buchausgabe der Cranach-Passion?" *Philobiblon* 23 (1979):44-53, 4 illus.

Publishes a previously unknown 16th-century printing of Cranach's woodcut Passion (10 of the original 14 with portraits of reformers printed on the reverse side of each), and speculates the cycle may have been bound originally as a book.

581
WOLFENBÜTTEL, HERZOG AUGUST BIBLIOTHEK. *Biblia deutsch. Luthers Bibelübersetzung und ihre Tradition.* Compiled by Heimo Reinitzer. Exhib. cat. Wolfenbüttel, Zeughaushalle, 7 May - 13 Nov. 1983; Hamburg, Staats- und Universitätsbibliothek, 21 Nov. - 25 Feb. 1984. Hamburg: Friedrich Wittig, 1983, 333 pp., 202 entries, 5 color illus. and over 200 b&w illus., bibliog., index.

A lengthy and detailed catalogue surveying the history of Luther's Bible translation, its precedents, its proponents and critics, and the history of its illustration. Examples of Bibles from the 16th and partly the 17th century, illustrated broadsheets, pamphlets, portraits and other artifacts are included. Introductory essays by the compiler preface each of 5 chapters.

582
ZIMMERMANN, HILDEGARD. *Beiträge zur Bibelillustration des 16. Jahrhunderts. Illustrationen und Illustratoren des ersten Luther-Testamentes und der Oktav-Ausgaben des Neuen Testamentes in Mittel-, Nord- und Westdeutschland.* Studien zur deutschen Kunstgeschichte, 226. Strasbourg: J.H. Heitz, 1924, iv, 184 pp., 39 illus. Reprint. Baden-Baden: Koerner, 1973.

Study of the illustrated German editions of Luther's *September-Testament* and the octave editions of the New Testament up to 1576, focusing on the artists and their contributions. Pages 120-79 provide a chronological list and descriptions of the many editions. No bibliography but informative notes.

583
ZIMMERMANN, HILDEGARD. "Kunstgeschichtliches und Ikonographisches zur Bilderfolge in Luthers Septembertestament." In *Luthers Werke,* (see no. 133), *Die deutsche Bibel,* 7, pp. 525-28, 21 illus. (pp. 483-523).

Attributes all of the woodcut designs to Cranach, in spite of the hasty style of several, identifying the hands of assistants at places. Discusses the specifically Lutheran iconography of the images by contrasting them with versions by Dürer.

584
ZIMMERMANN, HILDEGARD. *Lukas Cranach d. Ä. Folgen der Wittenberger Heiligtümer und die Illustrati des Rhau'schen "Hortulus animae."* Schriften der Gesellschaft der Freunde der Universität Halle-Wittenberg, 1. Halle: Gebauer-Schwetschke, 1929, 59 pp., 43 illus.

Demonstrates how the medieval cult of images continued under Protestantism, but with a complete revaluation of its contents. The case here shows how some of Cranach's illustrations to the 1509 printing of Friedrich the Wise's reliquary collection were used again in 1547-48 to illustrate the evangelical *Hortulus animae,* the first lay beviary of the Wittenberg reformation.

585
ZIMMERMANN, HILDEGARD. "Luthers Betbüchlein. Ein Schatzkästlein deutscher Andacht und reformationszeitlicher Buchkunst." *Luther. Vierteljahresschrift der Luthergesellschaft* 13 (1931):79-90, 4 illus.

The important didactic role of art in Protestant publications is shown in an analysis of the 50 woodcut illustrations from the 1529 printing of Luther's *Betbüchlein.* Elucidates the Protestant theological program in this cycle.

586
ZÜLCH, WALTER KARL. "Die Grünewaldfunde in Donaueschingen und Berlin." *Aschaffenburger Jahrbuch* 2 (1955):190-206, 10 illus.

The Bible of Hans Plock (East Berlin, Märkisches Museum), with its wealth of pasted-in engravings and drawings by Grünewald and others, is discussed as a document of Protestant response to art. Certain of Plock's inscriptions added as commentary to the images are transcribed, and the document related to contemporary political and religious events.

587
ZÜLCH, WALTER KARL. "Die Lutherbibel des Grünewaldfreundes." *Bildende Kunst* 5 (1953):21-27, 7 illus.

Recounts the history of the discovery of the drawings and their subsequent publication by Stengel (see nos. 571 and 572). The details of Plock's life, his friendship with Grünewald, his Lutheran connections and his professional interests are discussed.

V. C. Collections of broadsheets, pamphlets and single-leaf woodcuts

588
BECKER, RUDOLF ZACHARIAS. *Bildnisse der Urheber und Beförderer, auch einiger Gegner der Religions- und Kirchenverbesserung im sechzehnten Jahrhundert, nebst andern darauf Bezug habenden Bildern in gleichzeitigen Holzschnitten.* Gotha: Becker'sche Buchhandlung, 1817, iv, 23 plates.

Facsimile reproductions of portraits, allegories, and other Reformation images and reproductions of coins, all woodcuts. A traditional "iconography" for the Reformation period, published in luxurious format. The author's caption for the broadsheet *Der arm gemein Esel* (pl. 18) is among the earliest recorded attempts to interpret this allegory.

589
CLEMEN, OTTO. *Flugschriften aus den ersten Jahren der Reformation.* 4 vols.

Leipzig & New York: Rudolf Haupt, 1907-11, 8 illus., index.

A basic edition of pamphlets with brief introductions and index (of proper names only). Bibliographical information on each of the reprinted texts includes an account of illustrations appearing in the original publication, though only rarely illustrated here.

590

COUPE, WILLIAM A. *The German Illustrated Broadsheet in the Seventeenth Century.* Bibliotheca Bibliographica Aureliana, 17 & 20. 2 vols. Baden-Baden: Verlag Heitz, 1966-67, 285 pp., 145 illus., bibliog., index.

Though concerned with a later period, the lack of extensive monographic studies on illustrated broadsheets renders this a useful resource. For a discussion of earlier broadsheet production and the tradition of religious broadsheets, chaps.1-2.

591

DRUGULIN, WILHELM E. *Drugulin's Historical Atlas. Catalogue of the Most Valuable Collection of Pictorial Broadsides, Allegorical and Satyrical Prints, Books of Pageants etc. Serving to Elucidate the Public and Private History of all Countries during the Last Four Centuries.* Leipzig: Leipziger Kunst-Comptoir, 1867, 500pp. Reprint. Historisches Bildatlas, Hildesheim, 1964.

One of earliest catalogues of illustrated broadsheets, pamphlets, and intaglio prints, including over 1000 items from the 16th century, briefly described. Many are pertinent to the Reformation. As this is a sale catalogue, the title page appears in various languages.

592

FEHR, HANS. *Massenkunst im 16. Jahrhundert. Flugblätter aus der Sammlung Wickiana.* Denkmale der Volkskunst, 1. Edited by W. Fraenger. Berlin: Herbert Stubenrauch, 1924, 121 pp., 111 illus.

A selection of broadsheets from the Wick Collection, Zurich, on various topics. For Reformation broadsheets see pp. 66-74. Transcriptions of the texts are given for many of the illustrations (pp. 84-116).

593

FLUGSCHRIFTENSAMMLUNG GUSTAV FREYTAG. Catalogue by Paul Hohenemser. Frankfurt am Main: Stadt- und Universitätsbibliothek, 1980/81, 746 microfiches.

Complete reproduction of 6,265 pamphlets from the 15th through the 17th century (over half from the 16th century), divided topically. See especially Group XVII: Reformers and Opponents (pamphlets 2767-3870).

594

GEISBERG, MAX. *Bilderkatalog zu Max Geisberg, Der deutsche Einblatt-Holzschnitt der ersten Hälfte des 16. Jahrhunderts.* Edited by Hugo Schmidt. Munich: Hugo Schmidt, 1930, 299 pp., 1600 illus.

Postage stamp illustrations of Geisberg's entire corpus (see no. 595) prefaced by brief biographical information on the artists, and select bibliography.

Establishes a consistent numbering scheme for the portfolios and an index by artist.

595
GEISBERG, MAX. *Der deutsche Einblattholzschnitt in der ersten Hälfte des XVI. Jahrhunderts.* 43 portfolios. Munich: Hugo Schmidt, n.d. [1924-30], ca. 1600 illus., many in color.
The basic corpus of single-leaf woodcuts for Germany, excluding book illustrations. Alphabetical by artist (but with many additions in later vols.), labeled with the subject, location of the impression reproduced, and other catalogue references (Bartsch, Dodgson etc.). Many examples of Reformation theological and polemical allegory, portraits, etc.

596
GEISBERG, MAX. *Der deutsche Einblatt-Holzschnitt in der ersten Hälfte des 16. Jahrhunderts. Übersicht über die in der ersten Hälfte des Werkes veröffentlichten Holzschnitte.* Munich: Hugo Schmidt, 1926, 89 pp., 1 illus.
An interim report noting some changes of attribution, giving a list of artists and works, and a useful breakdown by subject matter. Covers portfolios 1-21 (see no. 595). See especially subject heading: Konfessionelle Kampfbilder (p. 78).

597
GEISBERG, MAX. *The German Single-Leaf Woodcut: 1500-1550.* Revised and edited by Walter L. Strauss. 4 vols. New York: Hacker Art Books, 1974, bibliog., index.
Review: Wolfgang Harms, *Beiträge zur Geschichte der deutschen Sprache und Literatur* 102 (1980):479-85.
English revised edition of no. 595. Over 1600 illustrations including many not in the original corpus. There are additional alterations accommodating changes in attribution since Geisberg's publication. The illustrations, apart from Strauss's additions, are taken from Geisberg.

598
GROTE, LUDWIG; ZINK, FRITZ; HUBER, RUDOLF. *Der deutsche Holzschnitt. 1420-1570. Einblattdrucke aus dem Besitz des Germanischen National Museums in Nürnberg.* Exhib. cat., Tübingen, 1959, 59 pp., 15 illus., bibliog.
Includes a number of illustrated broadsheets from the Nuremberg collection which do not appear in Geisberg (see no. 595). A short section of the exhibit concerns the woodcut as forerunner of the news-sheet and includes broadsheets with 6 Reformation and anti-Reformation polemics (4 not in Geisberg).

599
HARMS, WOLFGANG, et al, eds. *Deutsche illustrierte Flugblätter des 16. und 17. Jahrhunderts. Die Sammlung der Herzog August Bibliothek in Wolfenbüttel.* 3 vols. *Historica,* vol. 2. Munich: Kraus International Publications, 1980, 648 pp., 385 illus. (Vols. 1 and 3 in preparation).
Historical broadsheets, including contemporary religious satires. All

examples illustrated, most described and interpreted; the texts only partially transcribed. Contains unprinted sheets as well (pen drawings with texts etc.). Many instances of Reformation polemic.

600
HOLLÄNDER, EUGEN. *Wunder, Wundergeburt und Wundergestalt in Einblattdrucken des 15.-16. Jahrhunderts.* Stuttgart: Ferdinand Enke, 1921, xvi, 373 pp., 202 illus., bibliog.

The classic study and corpus of prodigy broadsheets. A brief section devoted to this theme in relation to religious polemic of the Reformation period (pp. 320-26).

601
KUCZYNSKI, ARNOLD. *Thesaurus libellorum historiam reformationis illustrantium. Verzeichnis einer Sammlung von nahezu 3000 Flugschriften Luthers und seiner Zeitgenossen.* Leipzig: Weigel, 1870, iv, 272 pp., (2920 entries), supplement 1874.

A handlist of a collection of 16th-century broadsheets belonging to the Leipzig book dealer and publisher T.O. Weigel. Arranged alphabetically according to author, then chronologically.

602
LAUBE, ADOLF, and SEIFFERT, HANS W., eds. *Flugschriften der Bauernkriegszeit.* 2nd ed. Cologne/Vienna: Böhlau Verlag, 1978, 662 pp., indexes, 16 illus.

A compilation of printed pamphlets concerning the Peasants' War of 1525. Many of these were illustrated, though the information is not included in this anthology which reprints the texts with bibliographical information (in appendix) but no indication of illustrated title pages or text illustrations.

603
MEUCHE, HERMANN, ed. *Flugblätter der Reformation und des Bauernkrieges. 50 Blätter aus dem Schlossmuseum Gotha.* Catalogue by Ingeburg Neumeister. Leipzig: Insel, 1975-1976, 144 pp., 25 text illus., bibliog. Accompanied by a portfolio of 50 color plates.

An introductory chapter on broadsheets and their social significance is followed by a catalogue of the sheets reproduced and a section of bibliographical information on the relevant artists. Included are many broadsheets of importance for Reformation polemic. Excellent bibliography. All sheets are illustrated with their accompanying texts where intact. Very high standard of reproduction.

604
MULLER, FREDERIK. *De Nederlandsche Geschiedenis in Platen. Beredeneerde Beschrijving van Nederlandsche Historieplaten, Zinneprenten en Historische Kaarten.* 4 vols. Amsterdam: Frederik Muller, 1863-82.

Historical prints grouped chronologically and topically. Indexed by volume. First volume covers 16th century. Not illustrated.

605

NIJHOFF, WOUTER. *Nederlandsche Houtsneden 1500-1550.* The Hague: Martinus Nijhoff, 1933-39, portfolio of 334 illus., 2 text vols., bibliog., indexes.

The basic corpus of Netherlandish single-leaf woodcuts (including broadsheets with texts), the second half of the portfolio giving full commentary on the condition of the blocks.

606

NUREMBERG, STADTGESCHICHTLICHE MUSEEN. *Die Welt des Hans Sachs. 400 Holzschnitte des 16. Jahrhunderts.* Exhib. cat. Nuremberg: Verlag Hans Carl, 1976, xxxiv, 321 pp., over 400 illus., index.

A brief, general introduction (including an essay on Sachs and the Reformation) is followed by a catalogue of 343 items. The Illustrations are chosen for their relationship to Sachs' writings, often as illustrations of specific texts. Includes a wide range of satirical imagery, much of it pertinent to the Reformation. The illustrations are referenced to catalogue numbers, but oddly enough not vice versa.

607

RIJN, G. van. *Katalogus der Historie-, Spot- en Zinneprenten betrekkelijk de Geschiedenis van Nederland verzameld door A. van Stolk Cz.* 10 vols. plus index. Amsterdam: Frederik Muller & Co., 1895-1933.

Catalogues a substantial collection of popular historical prints ranging from the 16th to the 19th century. Unillustrated and chronologically arranged. Vol. 1 covers the 16th century. Alphabetical index integrating topics, names and places.

608

RIJN, G. van, and KERNKAMP, G. W. *Nederlandsche Historieprenten (1555-1900). Platenatlas.* Amsterdam: S.L. van Looy, 1910, xvi, 192 pp., many plates (unnumbered).

Primarily topographical and historical. Occasional prints bearing on the Protestant uprisings and Catholic response.

609

RÖTTINGER, HEINRICH. *Die Bilderbogen des Hans Sachs.* Studien zur deutschen Kunstgeschichte, 247. Strasbourg: J.H.Ed. Heitz, 1927, vii, 103 pp., 17 illus., index.

An introduction examining the history of Sachs' publications is followed by a catalogue of broadsheets organized chronologically, noting but not describing their illustrations. Only a small number of the illustrations are reproduced, though references are given to published reproductions.

610

SCHADE, OSKAR, ed. *Satiren und Pasquille aus der Reformationszeit.* 3 vols. Hannover, 1856-58. 2nd ed. Hannover: Carl Rümpler, 1863, index.

Basic edition of 50 texts of satirical broadsheets and pamphlets from ca. 1517-24. The texts are transcribed as originally printed, with annotations on the

orthography. Their arrangement is roughly chronological. The bibliographical information for each includes descriptions of accompanying illustrations, though none reproduced.

611
SCHEIBLE, JOSEF. *Die fliegenden Blätter des XVI. und XVII. Jahrhunderts, in sogenannten Einblatt-Drucken mit Kupferstichen und Holzschnitten; zunächst aus dem Gebiete der politischen und religiösen Caricatur.* Stuttgart: J. Scheible, 1850, 344 pp., 88 illus.
An edition of broadsheet texts with illustrations (engraved after the originals). Includes some items of Reformation polemic.

612
SENN, MATTHIAS. *Johann Jakob Wick (1522-1588) und seine Sammlung von Nachrichten zur Zeitgeschichte.* Mitteilungen der Antiquarischen Gesellschaft in Zürich, 46, Heft 2. Zürich: Leemann, 1974, 120 pp., 1 b&w illus., 8 color illus., bibliog.
A discussion of the contents of Wick's collection (pp. 53-65) records his interest in reports of Reformation tensions both in Switzerland and abroad, especially France and the Netherlands. A section on the St. Bartholomew's Day massacre (pp. 88-111) illustrates the strengths and weaknesses of Wick's historical method, which was strong on details but vague on political and social background.

613
SENN, MATTHIAS. *Die Wickiana. Johann Jakob Wicks Nachrichtensammlung aus dem 16. Jahrhundert. Texte und Bilder zu den Jahren 1560 bis 1571.* Küsnacht-Zürich: Raggi Verlag, 1975, 272 pp., 70 b&w illus., 48 color illus., topical index, bibliog.
A selection of images and their accompanying texts (with New High German transcriptions) illustrating newsworthy events of the period, including numerous documents of the tensions between reformed and non-reformed churches. Many illustrations of the religious wars in France and the Netherlands as well as satires and prodigies relevant to the reform movement.

614
STÄHELI, MARLIES. "Beschreibender Katalog der Einblattdrucke aus der Sammlung Wickiana in der Zentralbibliothek Zuerich." Diplomarbeit. Geneva, Ecôle des Bibliothécaires, 1950, xxxiii, 378 pp., bibliog., indexes.
This is the only complete account of the Wick broadsheet collection. The original organization of the collection is here rearranged into topics, including a section on Reformation and Counter-Reformation subjects.

615
STRAUSS, WALTER L. *The German Single-Leaf Woodcut 1550-1600: A Pictorial Catalogue.* 3 vols. New York: Abaris Books, 1975, 1429 pp., over 1400 illus, bibliog., indexes.
A brief introduction reviews general circumstances of woodcut production

and subject matter preferences in the period. The index includes various citations relevant to Reformation imagery. This corpus includes (without clear discrimination), book and pamphlet illustrations, suites and cycles of illustration, calendars, portraits etc. as well as broadsheets. A wide but not nearly complete compilation of this material.

616

WÄSCHER, HERMANN. *Das deutsche illustrierte Flugblatt. Vol. 1, Von den Anfängen bis zu den Befreiungskriegen.* Dresden: VEB Verlag der Kunst, 1955, 33 pp., 111 illus., bibliog.

Illustrates broadsheets from the graphic collection of the Staatliche Galerie Moritzburg, Halle. The sheets are illustrated with their original texts. For Reformation propaganda, see illustrations 14 *passim.*

V. D. Reformation printers, pamphlets, and chronicles

617

BAINTON, ROLAND H. "Eyn wunderliche Weyssagung, Osiander-Sachs-Luther." *Germanic Review* 21 (1946):161-66, 3 illus. Reprinted in English as "The Joachimite Prophecy: Osiander and Sachs." In R. Bainton, *Studies on the Reformation.* London: Hodder & Stoughton, 1963, pp. 62-66, 2 illus (after p. 142).

A rhymed text by Hans Sachs (taken from Osiander's *Vaticinia Joachimi),* printed in 1527, includes an image of Luther with unexplained attributes: a sickle and rose etc. Bainton identifies its prototype in an Italian manuscript as Baldasare Cossa who became Pope John XXIII and was later deposed. The Pope represents a *homo spiritualis* come to purge the Church.

618

BEHREND, FRITZ. "Die Leidensgeschichte des Herrn als Form im politisch-literarischen Kampf besonders im Reformationszeitalter." *Archiv für Reformationsgeschichte* 14 (1917):49-64.

Concerns the use of Christ's Passion as a prototype for polemical literature, transcribing the text of a 1546 tract on the Elector Johann Friedrich of Saxony. Brief mention of visual uses of the theme, particularly Cranach's illustrations to the *Passional of Christ and Antichrist.*

619

EGLI, FRIDOLIN. "Christoph Froschauer und der Meister H.V." *Zwingliana* 1 (1897-1904):146-50, 6 illus. (preceding p. 129).

Presents the history of Froschauer, Zwingli's publisher in Zurich, and documents his hiring of Heinrich Vogtherr the Elder to illustrate the Stumpf Chronicle and a separately published view of St. Gallen.

620

GRISAR, HARTMANN, and HEEGE, FRANZ. *Luthers Kampfbilder.* 4 parts.
Freiburg im Breisgau: Herder & Co., 1921-23.
Part I: *Passional Christi und Antichristi.* Eröffnung des Bilderkampfes (1521),
xiii, 68 pp., 5 illus.
Part II: Der Bilderkampf in der deutschen Bibel (1522ff.), ix, 45 pp., 9 illus.
Part III: Der Bilderkampf in den Schriften von 1523 bis 1545, viii, 72 pp.,
17 illus.
Part IV: *Die Abbildung des Papsttums* und andere Kampfbilder in Flugblättern.
1538-1545, x, 153 pp., 14 illus.
The basic study of Lutheran polemical imagery, divided into subject
categories, each discussed in relation to relevant historical and literary context.

621

*HAGMANN, ELFRIEDE. "Studien zur Flugblattliteratur des 16. Jahrhunderts mit
besonderer Berücksichtigung Dürers." Ph. D. dissertation, Vienna, 1954,
175 pp.

622

KALKOFF, PAUL. *Die Reformation in der Reichsstadt Nürnberg nach den
Flugschriften ihres Ratschreibers Lazarus Spengler.* Halle/S.: Waisenhaus,
1926, iv, 130 pp., index.
Analyzes several pamphlets, noting the content of their illustrations.
Included are the *Triumphus veritatis* and *Die luterisch Strebkatz.*

623

LEEMANN-van ELCK, PAUL. *Der Buchschmuck der Stumpfschen Chronik.*
Bibliothek des Schweizer Bibliophilen, II, 5. Bern: Paul Haupt, 1935, 70 pp.,
14 illus., index.
Discusses the woodcut decoration of this Protestant chronicle, touching on
some specifically anti-Papal images, mainly by Heinrich Vogtherr the Elder.

624

SCHOTTENLOHER, KARL. *Philipp Ulhart. Ein augsburger Winkeldrucker und
Helfershelfer der 'Schwärmer' und 'Wiedertäufer' (1523-1529).* Historische
Forschungen und Quellen, 4. Munich/Freising: F.P. Datterer, 1921, 160 pp.,
6 illus.
Provides a detailed case study of a printer active in the full spectrum of early
Refromation publishing (Luther, Zwingli, Karlstadt, Denck, and the
Anabaptists), with a bibliography of 191 items from Ulhart's press. Many of
these works were illustrated, this information being noted in the bibliographical
entries, but not discussed as part of the study.

625

SPAMER, ADOLF. *Der Bilderbogen von der geistlichen Hausmagd. Ein Beitrag
zur Geschichte des religiösen Bilderbogens und der Erbauungsliteratur im
populären Verlagswesen Mitteleuropas.* Edited by Mathilde Hain.
Veröffentlichungen des Institutes für Mitteleuropäische Volksforschung an der

Philipps-Universität Marburg-Lahn, 6. Göttingen: Otto Schwartz, 1970, 243 pp., 29 b&w illus., 1 color illus., indexes.

Studies the tradition of popular literature on domestic piety, considering the influence of Protestant thought (see chaps. 4 and 8). Many of these pamphlets and broadsheets were illustrated, though this aspect is not examined.

626
STUHLFAUTH, GEORG. "Mit Hans Sachs an Luthers Totenbahre." *Der Tag. Unterhaltungs Rundschau,* 18. Feb. 1931, p.1, 1 illus.

Discusses a pamphlet by Hans Sachs mourning Luther's death. The title page woodcut, showing Sachs and an allegorical figure flanking Luther's bier, is here attributed to Virgil Solis.

627
VOGLER, GÜNTER. "Das Täuferreich zu Münster im Spiegel der Flugschriften." In *Flugschriften als Massenmedium.* Edited by H.J. Köhler (see no. 516), pp. 309-51, 20 illus.

Examines the contents, and in certain cases the illustrations of pamphlets reporting on the reign of the Anabaptists at Münster in 1535-36. Similarities in emphasis show that these pamphlets were intended to alarm the public by stressing Anabaptist violence and disruption.

628
WEBER, BRUNO. *"Die Welt begeret allezeit Wunder.* Versuch einer Bibliographie der Einblattdrucke von Bernard Jobin in Strassburg." *Gutenberg Jahrbuch,* 1976, pp. 270-90, 3 illus.

Jobin published pamphlets and broadsheets, some in collaboration with Tobias Stimmer and the satirist Johann Fischart. Among these are portraits of reformers and other Protestant documents. The bibliography of Jobin's publications runs to 67 items.

629
WIRTH, JEAN. "Hans Weiditz, illustrateur de la réforme à Strasbourg." In E. Ullmann, *Von der Macht der Bilder* (see no. 386), pp. 299-318.

A well-documented discussion of Weiditz's illustrations (mostly title pages) for radical pamphlets printed in Strasbourg from ca. 1523 to 1530. His designs for the radical editors/publishers Jean Schott and Wolfgang Köpfel and for pamphlets by Otto Brunfels betray a new "iconoclastic art" especially in his rejection of any anthropomorphic concept of God.

630
ZIMMERMANN, HILDEGARD. "Beiträge zu Luthers Kampfbildern." *Mitteilung der Gesellschaft für vervielfältigende Kunst. Beilage der "Graphischen Künste",* no. 4 (1925):61-7, 1 illus.

Offers some emendations relevant to the art historical aspects of Grisar and Heege's catalogue of pamphlets (see no. 620), including the identification of impressions from the original blocks for the *Abbildung des Papsttums* (Wolfenbüttel).

V. E. Propaganda and satire

V. E. 1. General

631
ANDERSSON, CHRISTIANE. "Polemical Prints during the Reformation." In *Censorship: 500 Years of Conflict.* Exhib. cat., New York Public Library. New York: Oxford University Press, 1984, pp. 34-51, 13 illus.

A concise discussion of Reformation polemical imagery and the legal constraints imposed to curb it. Some specific cases are recounted--eg. H. Guldenmund, A. Osiander and H. Sachs' encounter with the Nuremberg Council. Censorship was often exercised to mollify relations between the city and the emperor.

632
BERTHOUD, G., et al. *Aspects de la propagande religieuse.* Travaux d'humanisme et renaissance, 28. Geneva: Librairie E. Droz, 1957, xviii, 429 pp., 42 illus, 6 plates, index.

A collection of 21 studies by various authors mostly concerned with printed propaganda in Europe during the Renaissance-Reformation period. Topics often of tangential relevance to the visual arts. For specific studies of this aspect see nos. 634 and 686.

633
BLUM, ANDRE. *L'Estampe Satirique en France Pendant les Guerres de Religion.* Paris: M. Giard & E. Brière, n.d. [1916], 365 pp., 27 illus., bibliog.

Historical survey of satire in 16th-century France, including the relationship with satirical imagery in Germany and Switzerland. Political and religious caricature, measures for censorship, and social satire discussed.

634
CANTIMORI, D. "Note su alcuni aspetti della propaganda religiosa nell' Europa del Cinquecento." In *Aspects de la propagande religieuse* (see no. 632), pp. 540-51, 4 illus., 1 plate.

Discusses specific instances of religious prognostication, imprese, and trinitarian imagery employed for political and satirical purposes.

635
CHOJECKA, EWA. "Bilderkult und Bildersturm im illustrierten Flugblatt der Reformation." In E. Ullmann, *Von der Macht der Bilder* (see no. 386), pp. 259-63.

Brief discussion of the "Klagrede der armen verfolgten Götzen..." (see no. 192) and of the informational and interpretive role of the broadsheet as an art form.

636
CHRISMAN, MIRIAM USHER. "From Polemic to Propaganda: The Development of Mass Persuasion in the Late Sixteenth Century." *Archiv für Reformationsgeschichte* 73 (1982):175-95.

Traces the rhetoric of persuasion through pamphlets and illustrated broadsheets issued by Protestants and Catholics, stressing the change in approach between polemical statement in the early 1520's and the propaganda from the latter half of the century once the two contending parties had broken completely.

637
COBURG, KUNSTSAMMLUNGEN der VESTE COBURG. *Illustrierte Flugblätter aus den Jahrhunderten der Reformation und der Glaubenskämpfe*. Exhib. cat., 24 July - 31 October 1983. Edited and compiled by Wolfgang Harms and Beate Rattay, et al., xi, 330 pp., 152 entries, 156 illus., bibliog., indexes.

All items are interpreted in documented catalogue entries. Many satires and theological allegories including little-known examples from both the 16th and 17th centuries, all from the Veste Coburg collection. Satires of Catholicism and various Protestant sects included.

638
DUSSA, INGO. "'Edunt Wittenbergae obscoenas figuras...' lutherische Vulgärsprache und Bildpolemik." *Kunstpädagogik*, 1983, 3, pp. 5-9, 10 illus.

The strong metaphors of Luther's language are seen reflected in the many polemical images associated with the Reformation movement.

639
FUCHS, EDUARD. *Die Karikatur der europäischen Völker vom Alterthum bis zum Jahre 1848*. 4th ed., rev. Munich: Albert Langen, 1921, xiii, 479 pp., 576 illus., many in color.

Chapter 4 (pp. 60-77) concerns the Reformation in Germany, and treats both pro- and anti-Protestant caricature.

640
HOFFMANN, KONRAD. "Typologie, Exemplarik und reformatorische Bildsatire." In *Kontinuität und Umbruch. Theologie und Frömmigkeit in Flugschriften und Kleinliteratur an der Wende vom 15. zum 16. Jahrhundert*. Edited by Josef Nolte et al. Spätmittelalter und frühe Neuzeit. Tübinger Beiträge zur Geschichtsforschung, 2. Stuttgart: Klett-Cotta, 1978, pp. 189-210, 25 illus.

Meticulous investigation of the precedents for patterns employed in Reformation polemical and devotional imagery. Demonstrates the continuity of typological formulae from late medieval imagery through the Reformation. Shows how these formulae were adapted and popularized by the incorporation of references to contemporary issues. The broadsheet *Arm gemein Esel* by Hans Sachs and Peter Flötner (1526) is interpreted in relation to the story of Balaam. Several other instances of satire and of *imitatio Christi* are traced to earlier traditions.

641

HENZE, HELENE. *Die Allegorie bei Hans Sachs. Mit besonderer Berück-sichtigung ihrer Beziehungen zur graphischen Kunst.* Hermaea, 11. Halle: Max Niemeyer, 1912, 167 pp., index, 8 illus.

On the relation of Sachs' allegory to contemporary visual art (part 1, chap. 4). On his pictorial sources (part 2, chap. 2). Reformation allegory and satire touched on briefly at various points throughout.

642

HUPP, OTTO. *Scheltbriefe und Schandbilder. Ein Rechtsbehelf aus dem 15. und 16. Jahrhundert.* Munich/Regensburg: Otto Hupp, 1930, 92 pp., 31 illus.

Describes over 40 of these documents dating from 1379-1593. Handwritten, or occasionally printed, and often illustrated, these are personal slanders, signed and directed against specific individuals or groups. The tradition of such documents is significant for interpreting the character of Reformation polemic.

643

HUSSON, JULES F.F. [Champfleury]. *Histoire de la Caricature sous la Réforme et la Ligue.* Paris: E. Dentu, [1880], xiii, 323 pp., 76 illus.

Chapters 4-8 (pp.37-97) discuss and illustrate selected satires and caricatures relating to the Reformation and specific reformers.

644

KUNZLE, DAVID. *The Early Comic Strip. Narrative Strips and Picture Stories in the European Broadsheets from c. 1450 to 1825.* Berkeley/Los Angeles/London: University of California Press, 1973. Vol. 1, 471 pp., 391 b&w illus., 1 color illus., catalogue, bibliog., index.

Chaps. 1-2 treat religious propaganda imagery from the Protestant and Catholic sides during the 16th century. Particular attention is given to interpreting the images in light of their accompanying texts and contemporary political and religious issues. There is a useful list of major broadsheet collections given (p. 431).

645

REUMANN, KURT. "Das antithetische Kampfbild." Ph.D. dissertation, Freie Universität Berlin, 1966, 395 pp., 6 illus., bibliog.

An examination of this formula for propaganda imagery from the late Middle Ages to the present. Sections are devoted to the pope as Antichrist, and the secularization of specific Reformation formulae for propaganda. Lucas Cranach the Elder is the central figure discussed in this context.

646

SAXL, FRITZ. "Illustrated Pamphlets of the Reformation." In *Lectures* (see no. 379), vol. I., pp. 255-66, vol. II., plates 175-181, 18 illus.

Examines various instances of visual satire. Stresses the continuity of popular superstition, showing how Luther perpetuated its imagery by giving it greater precision.

647
SCHALLER, HEINRICH. "Parodie und Satire der Renaissance und Reformation." *Forschungen und Fortschritte* 33 (1959):183-89, 216-19, 10 illus.

An overview of satirical topics in literature and art, including several examples of Reformation polemic: confessional, anti-clerical and papal satire, and mockeries of Catholic theologians. Works by Cranach, Tobias Stimmer among others.

648
SCHARFE, SIEGFRIED. *Religiöse Bildpropaganda der Reformationszeit.* Göttingen: Vandenhoeck & Ruprecht, 1951, vi, 151 pp., 105 illus. (microfilm).

An analytical survey of Lutheran propaganda imagery, with brief attention to the Catholic response. Studies satire and Protestant allegory, including consideration of several rarely discussed images correlated to Luther's writings.

649
SHIKES, RALPH E. *The Indignant Eye. The Artist as Social Critic in Prints and Drawings from the Fifteenth Century to Picasso.* Boston: Beacon Press, 1969, 439 pp., 405 illus., bibliog., index.

An introductory discussion of the artist as critic, giving some attention to attacks on the established church in the 16th century. Alongside the usual major figures included are M. Gerung, N. Hogenberg, and J. Pérrissin.

650
STOPP, FREDERICK J. "Reformation Satire in Germany. Nature, Conditions, and Form." *Oxford German Studies* 3 (1968):53-68.

Analyzes the conceptual framework of Reformation satire and its artistic function. Particular attention given to Cranach's illustrations for Luther's Bible translation, and the *Passional of Christ and Antichrist.*

651
TÜBINGEN, UNIVERSITÄTSBIBLIOTHEK. *Das vervielfältigte Bild. Deutsche Druckgraphik 1480-1550 aus dem Besitz der Eberhard-Karls-Universität Tübingen.* Exhib. cat., 17 Oct. - 19 Nov. 1983 (also in Friedrichshafen, 12 Jan. - 19 Feb. 1984 and Ulm, 11 March - 8 April 1984). Catalogue by Peter Märker. Tübingen: Attempto, 1983.

The exhibition and catalogue organized around several topics including art as propaganda during the Reformation period.

652
ZIMMERMANN, HILDEGARD. "Vom deutschen Holzschnitt der Reformations-zeit." *Archiv für Reformationsgeschichte* 23 (1926):101-12.

General acknowledgement of the importance of illustrated cycles and broadsheets as sources for investigating Reformation polemic. Cites numerous examples available in modern published collections of prints.

V. E. 2. Anti-Catholic satire

V. E. 2. a. Anti-papal satire

653
BAERWINKEL, DR. "Mappe monde nouvelle papistique." *Mitteilungen des Vereins für deutsche Geschichts- und Altertumskunde in Sondersheim* (1926), pp. 25-29, 2 illus.

Describes a large allegorical map (Sondershausen Museum) printed in woodcut (hand-colored) with various satirical episodes and motifs mocking the papacy and activities of the Catholic church. It appears it was published in Zurich, but intended for a French Huguenot public. The map likely dates from 1564-67.

654
CLEMEN, OTTO and LUTHER, J. "Abbildung des Papsttums. 1545." In *Luthers Werke* (see no. 133), *Werke*, vol. 54, pp. 346-73, 11 illus.

Discusses the anti-papal woodcuts that Luther had published in 1538 (the *Papal Arms*) and 1545 (a series of 10). Argues that Luther both authored the accompanying texts and designed the images. Includes a bibliography.

655
CLEMEN, OTTO. "Die Luterisch Strebkatz." *Archiv für Reformationsgeschichte* 2 (1904-5):78-93.

Detailed study of the meaning and context for this Lutheran verse of ca. 1504 satirizing the papacy. Discusses the iconography of the woodcut illustration on the title page (not reproduced) in relation to the printed text.

655a
ESCORCHE-MESSES, FRANGIDELPHE [pseudonym]. *Histoire de la/ mappe-monde papistique,/ auquel et déclairé tout/ ce qui est contenu et pourtraict en la grande Table,/ ou carte de la Mappe-Monde:/ Composée par M. Frangidelphe/ Escorche-Messes./ Imprimée en la ville de Luce Nouvelle,/ Par Brifaud Chasse-diables./ MDLXVI.* Geneva: n.p., 1566, xi, 190 pp., 6 folio woodcuts (assembling into a single map).

A topically organized satire on the papacy (perhaps by Theodore Beza), arranged as a kind of atlas detailing the corruptions of the Church.

656
"DIE GOETHE'SCHEN SAMMLUNGEN." *Zeitschrift für bildende Kunst* 21 (1886):11-14.

Describes a 1524 drawing by Peter Vischer, a rich anti-papal allegory that was in Goethe's collection in 1818 and later.

657
HASE, MARTIN von. "Ein Mönchkalbdruck des Jacob Köbel in Oppenheim mit gefälschtem Impressum." *Gutenberg-Jahrbuch* (1935), pp. 154-58, 1 illus.

Identifies a version of the *Mönchskalb* with the M. Buchführer colophon (a Protestant publisher in Erfurt) as the work of the Catholic publisher J. Köbel of Heidelberg. A brief history of the 16th-century versions of the image is given.

658
KOEGLER, HANS. "Das Mönchskalb vor Papst Hadrian und das Wiener Prognostikon. Zwei wiedergefundene Flugblätter aus der Presse des Pamphilius Gengenbach in Basel." *Zeitschrift für Bücherfreunde* 11, part 2 (1907-08):411-16, 4 illus.
Discusses the prodigy of the Monk-calf in relation to Reformation polemic: an anti-papal satirical tract by Luther and Melanchthon, and a prognostication of 1520 regarding the emperor Charles V.

659
LANGE, KONRAD. *Der Papstesel. Ein Beitrag zur Kultur und Kunstgeschichte des Reformationszeitalters.* Göttingen: Vandenhoeck & Ruprecht, 1891, viii, 118 pp., 4 illus.
A history of monster images in the pre- and Reformation periods given as background to an investigation of the 1498 *Papstesel* print by Wenzel von Olmütz. The image reappears in Luther's and Melanchthon's tract of 1523 ("Deutung der zwo grewlichen figuren", see no. 155) and in Luther's *Abbildung des Papsttums* of 1545 (see no. 131).

660
OSIANDER, ANDREAS the ELDER. *Eyn wunderliche weyssagung von dem babstumb.* [Nuremberg]: Hans Guldenmund, 1527, 34 pp., 30 illus. Reprinted (with illus.) in Osiander, *Gesamtausgabe* (see no. 161), vol. 2, pp. 421-84.
Thirty woodcut illustrations and explanatory texts trace the corruption of the papacy. Also includes a short verse by Hans Sachs.

661
PILTZ, GEORG, ed. *Ein Sack voll Ablass. Bildsatiren der Reformationszeit.* Berlin: Eulenspiegel-Verlag, 1983, 128 pp., 90 illus.
A short text discusses how Luther's reforms led artists to change their pictorial vocabulary in order to reach the "common man." Many examples of this particular satire and other caricatures illustrated.

661a
POUNCEY, PHILIP. "Girolamo da Treviso in the Service of Henry VIII." *Burlington Magazine* 95 (1953):208-11, 4 illus.
Attributes a grisaille panel (the Pope being stoned by the Four Evangelists) from the Royal Collection to Girolamo, rejecting the earlier attribution to a Flemish master.

662
RÖTTINGER, HEINRICH. "Der Bockspielschnitt des Basler Meisters DS." *Gutenberg Jahrbuch*, 1951, pp. 94-100, 1 illus.
Publishes a woodcut illustration not previously connected to its text source:

127

Pamphilius Gengenbach's political verse "Das neue Bockspiel." The print satirizes the Habsburg rulers and the papacy, though it is not explicitly a Reformation document.

663
SCHECKER, HEINRICH B.O. "Die Mappe-Monde Nouvelle Papistique. Ein Kulturdokument der französischen Religionskriege." *Das Jahrbuch der Philosophischen Fakultät zu Leipzig für das Jahr 1923,* part I., pp. 52-53.
Abstract of a dissertation, identifying the woodcut map and interpreting its anti-papal, historical and satirical meaning.

664
STUHLFAUTH, GEORG. "Die beiden Holzschnitte der Flugschrift 'Triumphus veritatis. Sick der warheyt' von Hans Heinrich Freiermut (1524). Ein Beitrag zum Werke des Urs Graf." *Zeitschrift für Bücherfreunde,* n.s. 13 (1921):49-56, 4 illus.
Argues that the woodcuts accompanying this polemical Reformation pamphlet are by Urs Graf, who executed them shortly after his title-page woodcut for "Die Luterisch Strebkatz," also of 1524.

665
TRAEGER, JÖRG. *Münchner Kunsthistorische Abhandlungen.* Edited by W. Braunfels and N. Lieb. Vol. 1. *Der Reitende Papst. Ein Beitrag zur Ikonographie des Papstums.* Munich/Zurich: Schnell & Steiner, 1970, 166 pp., 53 illus., bibliog., indexes.
Briefly discusses the employment of this iconographic type in Protestant propaganda prints (pp. 112-16).

666
WAGNER, ALOIS. "Mathis Gerung. Eine kunstgeschichtliche Studie." *Jahrbuch des historischen Vereins Dillingen* 9 (1896):69-106, 2 illus.
A monographic survey of the artist, characterizing his polemical, anti-papal woodcuts of 1538-53 as if they were a curious deviation in a career dependent primarily on Catholic patrons (pp. 93-95).

667
WENDELER, CAMILLUS. "M. Luthers Bilderpolemik gegen das Pabstum von 1545." *Archiv für Literaturgeschichte* 14 (1886):17-40.
Uses quotations from various letters in an attempt to determine Luther's personal involvement in this series of ten Cranach woodcuts with rhymed texts. Includes a descriptive catalogue of the images.

668
WIRTH, KARL-AUGUST. "Imperator Pedes Papae Deosculatur. Ein Beitrag zur Bildkunde des 16. Jahrhunderts." In *Festschrift für Harald Keller.* Edited by Hans Martin Freiherr von Erffa and Elisabeth Herget. Darmstadt: Eduard Roether, 1963, pp. 175-221, 26 illus.
On visual representations of the kissing of the Pope's foot. Reformers,

especially Luther, were polemically against the practice, and artists propagandized against it too, including Holbein in *The Images of Death*. In a Pencz woodcut the theme is connected with images of Jupiter and peacocks.

669
ZSCHELLETZSCHKY, HERBERT. "Papstthronsturz, Rettungsseil und Riesenfeder. Drei lebenskräftige reformatorische Kampfbildmotive." *Bildende Kunst*, 1983, pp. 218-22.
Examines the rope as a pictorial image in the Reformation where it recurs as a means of saving the people from papal and secular tyranny.

V. E. 2. b. Cranach's *Passional*

670
CRANACH, LUCAS the Elder. *Passional Christi und Antichristi*. Edition and commentary by Hildegard Schnabel. Berlin: Union Verlag, 1972, 58 pp., 27 illus.
Facsimile of the original publication followed by an edition of the accompanying texts and a brief discussion of the work's historical significance.

671
CRANACH, LUCAS the Elder. *Passional Christi und Antichristi. Lucas Cranachs Holzschnitte mit dem Texte von Melanchthon*. Intro. by D.G. Kawerau. Berlin: Grote'sche Verlagsbuchhandlung, 1885, xxxii pp., 28 illus. Reprinted with a revised version of intro. in *Luthers Werke* (see no. 133), *Werke*, Weimar, 1893, vol. 9, pp. 677-715.
Facsimile of the original publication with an historical introduction and a list of previous editions.

672
FLEMING, GERALD. "On the Origin of the Passional Christi and Antichristi and Lucas Cranach the Elder's Contribution to Reformation Polemics in the Iconography of the Passional." *Gutenberg Jahrbuch* (1973), pp. 351-68, 26 illus.
Illustrates Cranach's woodcut cycle with the accompanying texts. Summarizes the contents and briefly discusses the publication's significance for Lutheran propaganda.

673
FLEMING, GERALD. "Der reitende Papst in der Bildpolemik der Reformation." In Feist, *Lucas Cranach* (see no. 887), pp. 149-151.
Discusses the occurance of this motif in Cranach's 1521 illustrations to the *Passional of Christ and Antichrist*.

674
SCHNABEL, HILDEGARD. "Cranachs 'Passional Christi und Antichristi'. Ein Kampfdokument der frühbürgerlichen Revolution." *Bildende Kunst,* 1972, pp. 507-10, 6 illus.
 Cites a letter from Luther to Melanchthon in 1521 complimenting Cranach's cycle of images satirizing the Pope as Antichrist.

675
STUHLFAUTH, GEORG. "Zum Passional Christi und Antichristi." *Archiv für Reformationsgeschichte* 17 (1920):71-73.
 Identifies Julius II and Leo X among the Popes in this cycle of prints. Argues that the changes in the second edition in which Christ is shown bearing the cross were made to improve the satire and not to accomodate a damaged block as suggested by Kawerau (see no. 993).

676
TRAEGER, JÖRG. "Raffael, Luther und die Römische Kirche: Zur Reformation der Bilder." In *Martin Luther: Eine Spiritualität und ihre Folgen. Vortragsreihe der Universität Regensburg zum Lutherjahr 1983.* Edited by Hans Bungert. Schriftenreihe der U. Regensburg, 9. Regensburg: Mittelbayerische Druckerei, 1983, pp. 123-70, 38 illus.
 Seeks to demonstrate a relationship between Raphael's fresco cycle in the *Stanza d'Eliodoro* in the Vatican and Cranach's *Passional of Christ and Antichrist* -- the presentation of the papal self-image in the visual arts and its Lutheran antithesis. The structure and iconography of the frescoes, the role of the theological writings of Aegidius of Viterbo, and the Lutheran reform of imagery are discussed.

677
ZSCHELLETZSCKY, HERBERT. "Eine Bilderkampfschrift der Reformationszeit. Zu Lucas Cranachs d.Ä. 'Passional Christi und Antichristi.'" *Kunsterziehung* 19, 2 (1972):13-17, 7 illus.
 A history of the making and reception of Cranach's 1521 *Passional,* seen as the visual embodiment of Luther's message in *An den christlichen Adel.* Selected scenes are analyzed in detail.

678
ZSCHELLETZSCHKY, HERBERT. "Das Passional Christi und Antichristi." In Weimar, *Lucas Cranach* (see no. 920), pp. 139-47.
 Discussion of the iconography of Cranach's illustrations and their historical significance.

V. E. 2. c. Other

679
BOLTE, JOANNES. "Bilderbogen des 16. und 17. Jahrhunderts." *Zeitschrift des Vereins für Volkskunde* 20 (1910):182-202, 1 illus.
 Describes a previously unknown broadsheet of 1545 portraying the *Hunt for the Pastors* with a verse by Hans Sachs and a woodcut attributed to H.S. Beham (not illustrated in this article). The text and illustration, known separately but not before now in combination, are anti-Catholic. See also Hoffmann, no. 893.

680
BRADY, P.V. "The Ambiguous *Newer Prophet*. A Sixteenth-Century Stock Figure." *Modern Language Review* 62 (1967):672-79.
 Discusses the use of this figure as a satirical device, particularly in late 16th-century broadsheets. Passing references to its employment in Reformation iconography.

681
BURCKHARDT-BIEDERMANN, THEOPHIL. "Über Zeit und Anlaß des Flugblattes: Luther als Hercules Germanicus." *Basler Zeitschrift für Geschichte und Altertumskunde* 4 (1904):38-44.
 Points out that this woodcut aims criticism at both sides: at the excesses of Lutherans as well as the humiliation of the defeated Papists. This Erasmian and humanistic position is confirmed by the text of a contemporary letter (1522) about the print.

682
BURCKHARDT-WERTHEMANN, DANIEL. "Drei wiedergefundene Werke aus Holbeins früherer Baslerzeit." *Basler Zeitschrift für Geschichte und Altertumskunde* 4 (1904):18-37, 5 illus.
 Dates the woodcut *Luther as Hercules Germanicus* ca. 1520, and speculates that the idea for the print may have sprung from a remark by Erasmus which Holbein then recorded in an image.

684
HEGG, PETER. "Die Drucke der 'Göttlichen Mühle' um 1521," *Schweizerisches Gutenbergmuseum* 40 (1954):135-50, 7 illus.
 Discusses the Reformation's satirical employment of this allegorical image, illustrating and describing several early versions. The text of the first Reformation version is connected with Zwingli (on the basis of a letter). Later versions are associated with Luther.

685
KOSLOW, SUSAN. "Frans Hals' Fisherboys: Exemplars of Idleness." *Art Bulletin* 57 (1975):418-32, 31 illus.
 Briefly discusses the different attitudes of Catholics and Protestants towards the fault of idleness, and associates the Protestant attitude with Lucas van Leyden's print of *Three Beggars* and Daniel Hopfer's etching of a *Proverb* (pp.

422-24). Traces the iconography of pose and gesture.

686
MEYLAN, HENRI. "Chasse à l'ours. Gravure satirique dirigée contre les Jésuites de Fribourg (1585)." In *Aspects de la propagande religieuse* (see no. 632), pp. 352-60, 1 illus.

Analyzes an allegorical print portraying the "bear of Bern" fending off the attacks of various animals representing other cantons and Jesuit leaders. Sets the Protestant satire in context of a dispute between Bern and Fribourg.

687
MÜLHAUPT, ERWIN. "Karlstadts 'Fuhrwagen'. Eine frühreformatorische 'Bildzeitung' von 1519." *Luther. Zeitschrift der Luther-Gesellschaft* 50 (1979):60-76, 1 illus.

Analyzes the images and accompanying texts in Cranach's woodcut, identifying positive Augustinian positions in the upper part, set against negative scholastic views below. The texts are related to specific points in Andreas Karlstadt's theology.

688
REINHARDT, HANS. "Einige Bemerkungen zum graphischen Werk Hans Holbeins des Jüngeren." *Zeitschrift für Schweizerische Archäologie und Kunstgeschichte* 34 (1977):229-60, 14 illus.

Part 5 (pp. 242-45) on Holbein and the Reformation in Basel argues that *Luther as Hercules Germanicus* was done after an incomplete Holbein sketch. Discusses other works expressing Protestant tendencies: *Christ the True Light, The Indulgence Seller,* and a title page with the *Separation of the Apostles,* here identified as a piece of Reformation propaganda done for a Lutheran publication planned by the printer Froben in 1520 but only used later (1523 and 1524) in other works.

689
RONDOT, NATALIS. *Graveurs sur bois à Lyon à seizième siècle.* Paris: Georges Rapilly, 1898, 114 pp., 2 illus.

Chap. 3 concerns the satirical tract the *Mappemonde papistique* (see nos. 653 and 663), illustrated with 6 folio plates (1566) possibly by the Lyon artist Pierre Eskrich. The contents of the illustrations and the text are reviewed and associated with Calvinism and Geneva propagandists.

690
STOPP, FREDERICK J. "Henry the Younger of Brunswick-Wolfenbüttel. Wild Man and Werwolf in religious polemics 1538-1544." *Journal of the Warburg and Courtauld Institutes* 33 (1970):200-34, 11 illus.

Henry, a fierce opponent of the Reformation, became known as the "Wilder Mann von Wolfensbüttel," and took the figure of a wild man as his personal device. He was satirized in this form in plays and pamphlets. A connection is drawn with Reformation animal allegory, and particularly Melchior Lorch's engraving the *Pope as Wild Man* (1545).

691

STUHLFAUTH, GEORG. "Drei zeitgeschichtliche Flugblätter des Hans Sachs mit Holzschnitten des Georg Pencz." *Zeitschrift für Bücherfreunde,* n.s. 10, part 2 (1919):233-48, 5 illus.

Satirical Reformation broadsheets described and texts transcribed: *Das sieben hauptig papstier, Inhalt zweierley predig/yede in gemein in einer kurtzen sum begriffen,* and *Der arm gemein esel.* Describes 17th-century versions of the last of these.

692

VETTER, EWALD M. "Sant Peters Schifflin." *Kunst in Hessen und am Mittelrhein* 9 (1969):7-34, 23 illus.

Traces this allegorical image from the Middle Ages to the 18th century. An important Reformation variant of the otherwise orthodox theme appears in an engraving by Matthias Zündt, *The Ship of the Church,* issued in 1570.

693

WOLF, JOHANNES. "Ein bisher unbekannter Spottdruck auf das Augsburger Interim." *Zentralblatt für Bibliothekswesen* 42 (1925):9-19,1 illus.

Discusses an anonymous Protestant broadsheet mocking the Interim with woodcut caricatures of a cardinal, monk, peasant and patrician shown singing a satirical verse set to music. The German broadsheet is set in its historical context and related to other musical satires.

694

ZIJP, ROBERT P. "Polemische Kunst in der Niederländischen Reformation." In E. Ullmann, *Von der Macht der Bilder* (see no. 386), pp. 367-75.

Discusses some anti-Catholic paintings and prints (late 16th, early 17th century) from the Rijksmuseum Het Catharijneconvent in Utrecht.

695

ZSCHELLETZSCHKY, HERBERT. "Vorgefecht des reformatorischen Bildkampfes. Zu Cranachs Holzschnitt 'Der Himmelwagen und der Höllenwagen des Andreas Bodenstein von Karlstadt' von 1522." In Feist, *Lucas Cranach* (see no. 887), pp. 102-6. Reprinted in E. Ullmann, ed., *Kunst und Reformation* (see no. 385), pp. 67-75.

Considers the significance of and contemporary references to this satirical attack on J. Eck and the scholastics. The print (1519) with inscriptions was commissioned by Karlstadt for circulation among his theological acquaintances and others.

V. E. 3. Socio-political commentary and satire

V. E. 3. a. Peasantry & Peasants' War

696
BADSTÜBNER, SIBYLLE, et al. *Deutsche Kunst und Literatur in der früh-bürgerlichen Revolution: Aspekte, Probleme, Positionen.* Berlin: Henschelverlag, 1975, 183 pp., 160 b&w illus., 20 color illus., index.

Illustrated essays on various historical topics, including polemical images, images of the peasantry, and major artists of the period (Cranach, Dürer, Grünewald and Ratgeb). Offers an interpretation of society and culture in relation to the "early bourgeois revolution."

697
BIALOSTOCKI, JAN. " 'Chlopska Melancholia' Albrechta Dürera" [The 'Peasant Melancolia' of Albrecht Dürer]. In J. Bialostocki, *Piec Wieków mysli o sztuce. Studia i rozprawy z dziejów teorii i historii sztuki.* Warsaw: Panstwowe Wydawnictwo Naukowe, 1959, pp. 73-81, 4 illus. In Polish.

An interpretation of Dürer's design for a monument to the Peasants' War. See the author's earlier version of this article in the *Gazette des Beaux-arts* (see no. 698).

698
BIALOSTOCKI, JAN. "La 'Mélancolie paysanne' d'Albrecht Dürer." *Gazette des Beaux-arts,* ser. 6, 50 (1957):195-202, 5 illus.

An analysis of Dürer's design for a monument to the Peasants' War, comparing this woodcut to the *Melancolia* and *Christ in Distress.* The author inclines to an interpretation of the monument as sympathetic to the peasantry.

699
DUDA, FRITZ. "Dürers Gedächtnissäule für den Bauernkrieg. Polemische Gedanken zu einem Artikel von Wilhelm Fraenger in der 'Bildenden Kunst,' H. 9/1970." *Bildende Kunst* , 1972, pp. 38-40.

Argues against Fraenger (see nos. 704 and 705). Interprets the woodcut as a warning to peasants. Dürer's agreement with Luther's condemnation of the peasant revolt is also seen in the inscriptions on the *Four Apostles.*

700
DURUS, ALFRED. "Albrecht Dürer, der Ketzer und die drei gottlosen Maler." *Internationale Literatur* 6 (1936): 136-140, 3 illus. Reprinted as "Albrecht Dürer und der Bauernkrieg." *Bildende Kunst* , 1947, pp. 13-15, 3 illus.

Dürer's sympathy for the peasants and for heretical views is seen in his support for condemned Nuremberg artists. His woodcut *Monument to the Peasants* (1525) is interpreted as supporting the peasant revolt and satirizing the Lutheran nobility. Argues that the *Four Apostles* is not strictly Lutheran but critical of Lutheran clerics as well as princes and officials.

701
DUSSA, INGO. "'Die Welt ist wie ein betrunkener Bauer' (Luther). Bauerndarstellungen zwischen Spätmittelalter und Gegenreformation." *Kunstpädagogik,* 1983, 3, pp. 20-4, 9 illus.

The social rise of the peasant class, already begun in the late 15th century was aided and recorded by Reformation prints.

702
ENTNER, HEINZ, and NEUBAUER, EDITH. *Bundschuh und Regenbogenfahne. Schriftsteller und Künstler im Bauernkrieg.* Berlin: Verlag Tribüne, 1975, 134 pp., 12 b&w illus., 4 color illus.

Briefly integrates the major artistic figures of the period into a broad, social interpretation of cultural expression identifying works of art and popular literature as having helped precipitate a revolution of the masses.

703
FISHMAN, JANE SUSANNAH. *Boerenverdriet. Violence between Peasants and Soldiers in Early Netherlandish Art.* Studies in the Fine Arts, 5. Ann Arbor: UMI Research Press, 1982, x, 152 pp., 41 illus., index., bibliog.

A revision of a dissertation (Univ. of California, Berkeley, 1979). Treats the theme in late 16th- and 17th-century art. P. Bruegel's *Massacre of the Innocents* is given a chapter. The author elaborates on the interpretation of this work as an attack on the Spanish Inquisition in the Netherlands and stresses the association of the Duke of Alba with Herod (chap. 2).

704
FRAENGER, WILHELM. "Dürers Gedächtnis-Säule für den Bauernkrieg." In *Beiträge zur sprachlichen Volksüberlieferung* (Festschrift Adolf Spamer). Berlin: Akademie-Verlag, 1953, 126-40, 3 illus.

See shorter version, no. 705. Also Duda no. 699.

705
FRAENGER, WILHELM. "Dürer's Gedächtnissäule für den Bauernkrieg." *Bildende Kunst ,* 1970, pp. 498-500.

Shorter version of his 1953 article (see no. 704) interpreting this drawing as supporting the peasants and sympathetic to their plight, the opposite of Luther's view.

706
GELLER, ROLF-HERMANN. "Der 'Gemeine Mann' in Flugschrift und Bildzettel. Zur Bildnisdarstellung eines agitatorischen Genres im Zeitabschnitt der frühbürgerlichen Revolution." *Kunstpädagogik,* 1983, 3, pp. 10-13, 12 illus.

The mass production of images in the 16th century made possible a change in the image of the "common man", often in conjunction with polemical Protestant images.

707
HEITZ, GERHARD. *Der Bauer im Klassenkampf. Studien zur Geschichte des deutschen Bauernkrieges und der bäuerlichen Klassenkämpfe im Spätfeudalismus.* Berlin: Akademie-Verlag, 1975, viii, 603 pp., 48 illus., bibliog.

A collection of essays concerning the Peasants' War. Includes a bibliography of works appearing from 1945 to 1972 in socialist countries (pp. 573-600). On questions relating to art and the Reformation see Ullmann (no. 726) and Zschelletzschky (no. 732).

708
HÜTT, WOLFGANG. "Künstler und Bauer in der deutschen frühbürgerlichen Revolution," *Bildende Kunst,* 1975, pp. 106-10, 6 illus.

Associates class struggle and the Reformation in Germany with emergent realism in the portrayal of peasants.

709
KLAMT, JOHANN-CHRISTIAN. "Burgkmairs Bauernturnier und die frühen Bundschuh-Bewegungen -- Ein Deutungsversuch." In E. Ullmann, *Von der Macht der Bilder* (see no. 386), pp. 158-73.

Looks back to Wittenweiler's *Ring* (ca. 1400) in interpreting several 16th-century peasant prints, including the illustrations to Murner's *Von dem großen Lutherischen Narren* (1522).

710
KLINGENBURG, KARL-HEINZ. "Die Wandlung des Bildes vom 'Gemeinen Mann' als Ausdruck der Gesellschaftlichen Rangerhöhung der unteren Volksschichten." in E. Ullmann, ed., *Kunst und Reformation* (see no. 385), pp. 60-66.

Images of the "common man" proliferated during the Reformation period with this figure (sometimes appearing as "Karsthans") representing a revolutionary element in the social unrest of the times, e.g. in prints by Peter Flötner, Nicolaus Hogenberg, and others.

711
KOLDE, THEODOR. "Beiträge zur Reformationsgeschichte. Zum Prozeß des Johann Denck und der 'drei gottlosen Maler' von Nürnberg." *Kirchengeschichtliche Studien. Hermann Reuter zum 70. Geburtstag gewidmet.* Edited by Theodor Brieger et al. Leipzig: J.C. Hinrichs'sche Buchhandlung, 1888, pp. 228-50.

Publishes all the material from the Nuremberg archives relating to the trial of Denck and the three "godless" painters, Sebald and Bartel Beham and Georg Pencz. Includes Denck's confession, the record of the artists' interrogation and the court judgment.

712
KOLDE, THEODOR. "Hans Denck und die gottlosen Maler von Nürnberg." *Beiträge zur bayerischen Kirchengeschichte* 8 (1901/02):1-31, 49-72.

A further investigation of the incidents documented in the author's earlier study (see no. 711). Other difficulties encountered between the Nuremberg Council and artists of Protestant leanings are discussed, particularly the case of Hans Greiffenberger. Part 2 examines the relation of the preacher Denck to H.S. Beham, B. Beham, and G. Pencz, the "three godless painters."

713
LAUBE, ADOLF; STEINMETZ, MAX; AND VOGLER, GÜNTER. *Illustrierte Geschichte der deutsche frühbürgerlichen Revolution.* Berlin: Dietz Verlag, 1974, 416 pp., many illus., bibliog.
A heavily illustrated survey of the Reformation period with particular attention to class conflict.

714
LÜDECKE, HEINZ. "Eine romantische Geschichtsfälschung. Eine Ergänzung zu Wilhelm Fraengers Forschungen über Dürers Bauernkriegssäule." *Deutsches Jahrbuch für Volkskunde* 6 (1960):50-53.
Summarizes Fraenger's interpretation of the peasant monument's (see no. 704), then quotes a lighter interpretation suggested in a novella by August Hagen, *Norica* (1829) in which Dürer produces a similar monument in order to tease Lazarus Spengler.

715
MITTIG, HANS-ERNST. *Dürers Bauernsäule. Ein Monument des Widerspruchs.* Frankfurt am Main: Fischer Verlag, 1984, 80 pp., 33 illus.
Though tacitly a celebration of the nobles' victory in the Peasants' War, the work is also seen as ironic and betraying compassion for the victims. Finally, it expresses detachment and a contradictory attitude to social crisis.

716
MOXEY, KEITH P.F. "Sebald Beham's church anniversary holidays: festive peasants as instruments of repressive humor." *Simiolus* 12 (1981/82):107-30, 14 illus. Reprinted in Ullmann, *Von der Macht der Bilder* (see no. 386), pp. 173-99.
Interprets Beham's large woodcut cycles portraying peasant celebrations of church holidays as supporting Luther's condemnation of these events. Suggests the audience for such prints, made up of artisans, was "venting middle class Lutheran hostility against a portion of society that had proved dangerous to the survival of its newly won faith."

717
NEVEZINA, V.M. *Gosudarstvennyj Muzej Izjascnych Iskusstv. Njurenbergskie gravery 16 veka. Krest'janskaja vojna i process bezboznikov* [Museum of Fine Arts. Nuremberg Graphic Artists of the 16th Century. The Peasants' War and the Trial of the Godless Artists]. Moscow, n.p., 1929, 22 pp., 8 illus.
In Russian. Reviews printed images of peasants by Beham, Dürer and others.

718

RADBRUCH, RENATE MARIA, and RADBRUCH, GUSTAV. *Der deutsche Bauernstand zwischen Mittelalter und Neuzeit.* 2nd ed. Göttingen: Vandenhoeck & Ruprecht, 1961, 109 pp., 71 illus.

A study of representations of peasants in German art. The Reformation period is discussed especially pp. 61-66 and 71-87.

719

SCRIBNER, ROBERT W. "Images of the Peasant." *The Journal of Peasant Studies* 3 (1975):29-48, 9 illus.

Discusses the importance of visual evidence for interpreting attitudes to the peasantry during the Peasants' War of 1525. Contrasts imagery dignifying the peasants in the spirit of Luther's *theologia pauperum* with satirical images. The article consists of commentaries on a series of illustrations from the period in question.

720

UHRIG, KURT. "Der Bauer in der Publizistik der Reformation bis zum Ausgang des Bauernkrieges." *Archiv für Reformationsgeschichte* 33 (1936):70-125, 165-225.

The second part of this study is concerned with visual sources, and treats the Reformation explicitly in relation to Luther's writings (pp. 206-23). H.S. Beham, H. Weiditz and various pamphlet illustrations are discussed.

721

UHRIG, KURT. "Der lutherische Bauer in der Publizistik, insbesondere in der Bilddarstellung in der Reformation." *Luther. Mitteilungen der Luthergesellschaft* 19 (1937):33-42, 4 illus.

The rise of the peasant to a position of prominence in Reformation propaganda is connected with Luther's insistence on egalitarian principles.

722

ULLMANN, ERNST. " Albrecht Dürer und die frühbürgerliche Kunst in Deutschland." In *Albrecht Dürer. Kunst im Aufbruch.* Edited by E. Ullmann (see no. 969), pp. 3-16. Reprinted in E. Ullmann, ed., *Kunst und Reformation* (see no. 385), pp. 87-100.

Reviews Dürer's attitudes to social and political questions of the time expressed in his lament over Luther's death, in the *Monument to the Peasants' War,* other representations of peasants, and various passages in his writings.

723

ULLMANN, ERNST. "Albrecht Dürer und die frühbürgerliche Revolution in Deutschland." In *Albrecht Dürer. Zeit und Werk.* Leipzig: Karl-Marx-Universität, 1971, pp. 55-90, 17 illus.

Reviews Dürer's relationship to the Peasants' Revolt and to the German Reformation.

724

ULLMANN, ERNST. "Bauernkrieg und bildende Kunst." *Wissenschaftliche Zeitschrift,* Gesellschafts-und Sprachwissenschaftliche Reihe, Karl Marx Universität Leipzig, 23 (1974): 467-79.

Argues that the Peasants' Revolt was the critical episode of the "frühbürgerliche Revolution," and that German art up to 1550 reflects the social, economic and political tension of the time, expressing a new, independent and Lutheran spirit.

725

ULLMANN, ERNST. "Bauernkrieg - Bildersturm - bildende Kunst." In E. Ullmann, ed., *Kunst und Reformation* (see no. 385), pp. 76-86.

Sixteenth-century attitudes toward iconoclasm are reviewed (beginning with Karlstadt) and argued to be less anti-art than anti-tradition. Through the medium of prints art played an important role in the developing class struggle.

726

ULLMANN, ERNST. "Die Darstellung des Bauern im Werke von Albrecht Dürer." In G. Heitz, ed., *Der Bauer* (see no. 707), pp. 377-90.

Sees a reflection of general social changes in Dürer's depictions of peasants from 1476-1526, demonstrating his solidarity with the oppressed and his trust that Luther shared these views.

727

ULLMANN, ERNST. "Das Verhältnis Dürers zur frühbürgerlichen Revolution." *Bildende Kunst,* 1971, pp. 268-72, 3 illus.

Reviews Dürer's attitude towards the peasant class and the Reformation. Sees the artist as part of the radical bourgeois opposition who felt solidarity with the people's revolutionary struggle.

728

ZSCHELLETZSCHKY, HERBERT. *Die "Drei gottlosen Maler" von Nürnberg. Sebald Beham, Barthel Beham und Georg Pencz. Historische Grundlagen und ikonologische Probleme ihrer Graphik zu Reformations- und Bauernkriegszeit.* Leipzig: VEB E.A. Seemann Verlag, 1975, 444 pp., 314 illus., bibliog., index.

An extensive examination of the lives and works of these artists, in context of the social disruption in German art and society during the 1520's. The graphic works of these masters are related to the religious and political controversy of the period with special reference to their trial for "godlessness" and their association with the Peasants' Revolt.

729

ZSCHELLETZSCHKY, HERBERT. "Die drei gottlosen Maler von Nürnberg. Zu einigen gesellschaftskritischen Blättern von Künstlern aus Dürers Umkreis." *Bildende Kunst ,* 1971, pp. 240-45, 273, 10 illus.

Summarizes the religious and political views of the three--B. Beham, S. Beham, G. Pencz--based on their trial in 1525. Their partisanship with the peasantry in the Peasants' Revolt is stressed.

730
ZSCHELLETZSCHKY, HERBERT. "Drei Sozialsatiren der 'gottlosen Maler' von Nürnberg." *Deutsches Jahrbuch für Volkskunde* 7 (1961):46-74, 7 illus.
Focuses on three prints (two by H.S. Beham, one by B. Beham), arguing that they reflect sympathy for T. Münzer's ideas and for furtherance of social justice.

731
ZSCHELLETZSCHKY, HERBERT. "Hütet euch, sonst kommt der Bundschuh wieder! Zu einer Flugschrift-Illustration des Erhard Schön." *Kunsterziehung* 5 (1975):5-8, 6 illus.
The title-page woodcut to L. Reinmann's 1523 publication of astrological predictions is interpreted as pro-Reformation and pro-peasant, a warning to the powers that be.

732
ZSCHELLETZSCHKY, HERBERT. " 'Ihr Herz war auf der Seite der Bauern...' Künstlerschicksale und Künstlerschaften zur Bauernkriegszeit." In Heitz, *Der Bauer* (see no. 707), pp. 333-75.
Sees Dürer's *Peasant Monument* as sympathetic to peasants and reviews other artists with similar leanings.

733
ZSCHELLETZSCHKY, HERBERT. "Nur ein harmloses Marktgespräch?" *Kunsterziehung* 18, 10 (1971):14-16.
Are the groups of peasants in Dürer's prints and drawings (late 1490's) just chatting, or are they organizing the Bundschuh?

734
ZSCHELLETZSCHKY, HERBERT. "Sebald Beham ließ sein Volk die großen Hansen sehen." *Bildende Kunst*, 1963, pp. 187-90, 2 illus.
Discusses the Reformation woodcut *The Fall of the Papacy in 1525* (unikum, Preußische Staaatsbibliothek), dating it 1524, and seeing it as the first warning of the approaching Peasants' War.

V. E. 3. b. Other

735
BEARE, MARY. "Observations on some of the illustrated Broadsheets of Hans Sachs." *German Life and Letters* n.s. 16 (1962-63):174-85, 2 illus.
Examines the relation of picture and text in terms of priority for dating and interpretation. In some cases Sachs wrote commentary to existing illustrations; in others the illustrations were done for the text. Concerned principally with Sachs' social satires and secondarily with his relation to the Reformation, but important for details of Sachs' collaborative efforts in broadsheet production.

736
BOLTE, JOANNES. "Bilderbogen des 16. und 17. Jahrhunderts." *Zeitschrift des Vereins für Volkskunde* 17 (1907):425-41, 2 illus.

Concerns animal fables as satire: the hare hunting the hunter, the fox preaching to the geese. Illustrated broadsheets with texts elaborate these topoi, occasionally with Reformation or anti-clerical satire employing verses by Hans Sachs, Johannes Fischart and others.

737
CALMANN, GERTA. "The Picture of Nobody: An Iconographical Study." *Journal of the Warburg and Courtauld Institutes* 23 (1960):60-104, 36 illus.

Includes discussion of the popular personification of *Nobody* (*Niemand*) in Protestant broadsheets. Particular attention given to the work of the Strasbourg satirist Joerg Schan (see pp. 84-86).

738
DAVIS, NATALIE ZEMON. "Holbein's *Pictures of Death* and the Reformation at Lyons." *Studies in the Renaissance* 3 (1956):97-130, 4 illus.

Holbein's 1526 cycle is viewed in relation to the *danse macabre* tradition, in which irony and satire were typical, as was anti-clerical criticism. Holbein's pictures, reflecting similar attitudes, were assimilated into both Catholic and Protestant publications. The text of the former (Lyons, 1538; see no. 218) is scarcely less critical of the clergy and church abuses than the Protestant edition (Lyons, Frellon brothers, 1542), which attempts to camouflage its Reformation views. Only the Protestant edition was condemned by the Catholic Church.

739
FRAENGER, WILHELM. "Der Teppich von Michelfeld." *Deutsches Jahrbuch für Volkskunde* 1 (1955):183-211, 14 illus.

An extensive investigation of the sources and iconography of this allegorical woodcut, stressing its significance as social satire and relating it to the attitudes of radical reformers.

740
FRANZ, GUNTHER. *Huberinus - Rhegius - Holbein. Bibliographische und druckgeschichtliche Untersuchung der verbreitesten Trost- und Erbauungsschriften des 16. Jahrhunderts.* Nieuwkoop: B. de Graaf, 1973, viii, 313 pp., 39 illus., bibliog.

The history and reception of the various editions of Holbein's *Totentanz* (pp. 38-45). The addition in 1542 of two Lutheran *Trostschriften* by the Augsburg Protestants Caspar Huberinus and Urbanus Rhegius highlighted the anti-papal elements. Includes a descriptive bibliography of all early publications of these texts.

741
KUNZLE, DAVID. "World Upside Down: The Iconography of a European Broadsheet Type." In *The Reversible World. Symbolic Inversion in Art and*

Society. Edited by Barbara A. Babcock. Ithaca/London: Cornell University Press, 1978, pp. 39-94, 16 illus.

Analyzes the evolution and variants of this motif, largely in graphic art of the 16th to 18th century. The political background to representations of the Upside Down World is rooted in the Reformation and the Peasants' Revolt (pp. 61ff.). Works by Bosch, Bruegel the Elder and others are discussed.

742
KURTH, BETTY. "Zwei unbekannte Fragmente des Michelfeldter Bildteppichs." *Die graphischen Künste,* n.s. 2(1937):27-31, 5 illus.

The 16th-century woodcut of this title satirizing contemporary morality and religion bears an inscription claiming the print to be a copy of an old tapestry. This claim is verified by the discovery of two portions of a late 15th-century tapestry (English private collection) corresponding precisely to the woodcut in reverse arrangement. Localized to southern Germany.

743
PETERSMANN, FRANK. *Kirchen- und Sozialkritik in den Bildern des Todes von Hans Holbein d. J.* Bielefeld: Ludwig Bechauf Verlag, 1983, vii, 339 pp., 129 illus., bibliog.

Differentiates Holbein's *Pictures of Death* from the medieval Dance of Death tradition by stressing Holbein's attention to critiquing his own time, and the cycle's relation to pamphlet illustrations. Three main themes are identified: criticism of the Catholic church, sympathy for the common man, and for the peasant class.

744
SCHULZE, INGRID. "Zur Widerspiegelung des Klassenkampfes in Werken der deutschen Graphik und Malerei des 16. Jahrhunderts." *Wissenschaftliche Zeitschrift der Martin-Luther-Universität Halle-Wittenberg.* Gesellschafts- und Sprachwissenschaftliche Reihe. 9 (1960):217-40, 26 illus.

Holbein's illustrations of Erasmus's *Praise of Folly,* works from the Cranach atelier, G. Pencz, M. Gerung and others are interpreted as reflections of social disruption. The author follows F. Engels' account of the period, applying it to the visual arts.

745
WIRTH, JEAN. *La jeune fille et la mort: Recherches sur les thèmes macabres dans l'art germanique de la Renaissance.* Publications du Centre de Recherches d'Histoire et de Philologie. V. Hautes études médiévales et modernes, 36. Geneva: Droz, 1979, 194 pp., 156 illus., bibliog., index.

Part III. (pp. 105-68) focuses on artistic conceptions of death and the macabre during the Reformation period, including works by Niklaus Manuel, Urs Graf, Peter Flötner, the Beham brothers and Baldung. Considers the significance of these themes in German art and reviews iconographic changes brought about by Reformation theological notions.

V. E. 4. Anti-Reformation and Intra-Reformation satire

746
BEETS, N. "Een godsdienstige allegorie in Houtsnede." *Oud Holland* 49 (1932): 182-90, 5 illus.

A large woodcut printed in several blocks shows children in triumphal procession bearing captured demons. The author equivocates over whether the print reflects Catholic or Protestant sentiments, and tentatively suggests it may celebrate the fall of the "King of the Anabaptists" at Münster in 1536.

747
CLUTTON, GEORGE. "Two early Representations of Lutheranism in France." *Journal of the Warburg Institute* 1 (1937/8): 287-91, 2 illus.

Examines two woodcuts by Gabriel Solomon in relation to their accompanying texts and other tracts on heresy. Both woodcuts treat Lutheran heresy from a Catholic viewpoint.

747a
COCHLAEUS, JOHANNES. *Sieben Köpffe Martini Luthers.* Leipzig: Valentin Schumann, 1529, 26 pp., 1 illus.

A satirical attack against Luther bearing as its title-page illustration the well-known woodcut grotesque by Hans Brosamer.

748
EHRMANN, JEAN. "Massacre and Persecution Pictures in Sixteenth Century France." *Journal of the Warburg and Courtauld Institutes* 8 (1945):195-99, 10 illus.

Discusses some popular representations of massacres from the later 16th century: 40 woodcuts by Jacques Tortorel and Jean Pérrissin (1569) depicting Reformation strife, and several versions of a classical scene--arguably alluding to Reformation violence--of the Roman Triumvirate by Antoine Caron and others after a lost original.

749
FLEISCHHAUER, WERNER. "Das Zwinglische Bett. Ein Tübinger Holzschnitt im Dienste orthodoxer Polemik." *Hundert Jahre Kohlhammer. 1866-1966.* Stuttgart/Berlin/Cologne/Mainz: Kohlhammer, 1966, pp. 319-23, 1 illus.

Discusses a Lutheran woodcut satirizing Theodore Beza and Calvin's view of predestination.

750
HODNETT, EDWARD. *Marcus Gheeraerts the Elder of Bruges, London and Antwerp.* Utrecht: Haentjens Dekker & Gumbert, 1971, 86 pp., index, 60 illus.

Briefly discusses Gheeraerts' etching *The Image Breakers* (or *Allegory of the Iconoclasts*) as a condemnation of both the Catholic church and Calvinist destructions. Suggests a date of 1566 for the print on grounds of topical appropriateness, thus implying it was done in Flanders rather than London where

the artist worked from 1568-76 (see pp. 26-27).

751
MURNER, THOMAS. *Von dem großen Lutherischen Narren wie in doctor Murner beschworen hat.* Strasbourg: Johann Grüninger, 1522, 112 pp., 58 woodcut illus.
 This satirical tract by the Franciscan T. Murner is the most prominent of his popular attacks on Luther.

752
*SONDHEIM, M. "Die Illustrationen zu Thomas Murners Werken." *Elsaß-Lotharingisches Jahrbuch* 12 (1933):5-81.
 Discusses the illustrations to Murner's polemical, anti-Lutheran text *Von dem Großen Lutherischen Narren* (1522).

753
STOPP, FREDERICK. "Der religiös-polemische Einblattdruck *Ecclesia Militans* (1569) des Johannes Nas und seine Vorgänger." *Deutsche Vierteljahresschrift für Literaturwissenschaft und Geistesgeschichte* 39 (1965):588-638, 16 illus.
 Concerns several illustrated broadsheets from the second half of the century which attack internal dissension among reformers after Luther's death (the *Anatomia Lutheri* or dissection of Luther). The defection of Friedrich Staphylus to Catholicism is satirized in the sheet *Lutherus Triumphans.* Broadsheets attacking the Jesuits and the papacy are also examined as part of the history of Nas' theological polemics.

754
VERWEY, H. de la FONTAINE. "Une Oeuvre de jeunesse de Hendrik Goltzius?" In *Miscellanea I. Q. van Regteren Altena.* Edited by Hessel Miedema et al. Amsterdam: Scheltema & Holkema, 1969, pp. 70-73, 286-88, 15 illus.
 A cycle of engravings attributed to H. Goltzius, *Den doolhof van de dwalende gheesten* (ca. 1574-75), is interpreted as an orthodox attack on the libertine sect the "Family of Love." The inspiration for the series is given to D. V. Coornhert, who became disenchanted with the group and its leader Hendrik Niclaes.

VI. Reformation Religious Iconography

VI.A. General topics

755

BERLINER, RUDOLF. "God is Love," *Gazette des Beaux-Arts,* 6th ser., 42 (1953):7-26, 7 illus.

Artistic and literary formulations of this metaphor are traced through devotional and allegorical imagery from the late Middle Ages to the 17th century. The author identifies a change in the iconography of the Christ figure, which earlier often had a feminine identity, to the Counter-Reformation preference for the adolescent Christ. This change is related to the influence of the Reformation and its anti-Marian cast.

755a

CHRISTIE, SIGRID. *Den lutherske Ikonografi i Norge inntil 1800.* [Lutheran Iconography in Norway up to 1800]. 2 vols. Oslo: Riksantikvaren, 1973. 499 pp., 576 illus., indexes, English summary.

In Norwegian. Vol. 1 examines graphic sources for painting and sculpture, and discusses theological content and particular iconographic programs in Norwegian Protestant art, largely from the 17th and 18th centuries (though much based on earlier prototypes). Vol. 2 analyzes specific subjects: Old and New Testament and religious allegories in that order.

756

CHRISTIE, SIGRID. "Tema og pogram i den gammelluthereske ikonografi" [Theme and Program in Early Lutheran Iconography]. In *Fra Olav til Martin Luther.* Edited by Martin Blindheim. Oslo: Universitets Oldsaksamling, 1975, pp. 207-21, 12 illus., English summary.

In Norwegian. Reviews the development of Lutheran iconographic schemes, mainly from the Cranach school in Germany, and briefly characterizes 16th- and 17th-century Norwegian examples of Reformation imagery.

757

HARASIMOWICZ, JAN. "Typy i programy slaskich oltarzy wieku reformacji" [Types and programs of Silesian altars in the Century of the Reformation]. *Roczniki Sztuki Slaskiej* 12 (1979):7-27, 33 illus. English and German

summary, pp. 25-27.

In Polish. Traces the history of painted and sculpted altarpieces, both Catholic and Protestant, from 1520-1650. A distinctive iconography for Reformation altarpieces in Silesia (centered on a conservative concept of "legal religious opposition") is identified here in Lutheran programs.

758

HARBISON, CRAIG. "Some Artistic Anticipations of Theological Thought." *Art Quarterly,* n.s. 2 (1979):67-89, 7 illus.

Discusses three works (by H. Bosch, Lucas van Leyden, and G. David) as anticipations of Reformation debates over the sacraments. Attempts to show how the "suggestiveness" of certain images may render them active in formulating religious thought and feeling.

759

KRÜCKE, ADOLF. "Der Protestantismus und die bildliche Darstellung Gottes." *Zeitschrift für Kunstwissenschaft* 13 (1959):59-90, 43 illus.

Sees Protestant art of the early Reformation as continuing the late medieval anthropomorphic image of God the Father. Around mid-century Swiss artists began to use the Tetragram instead, a symbol gradually adopted by Lutheran artists (though not always systematically) in order to avoid depiction of the Deity. Continues with an overview through the 19th century.

760

KRUSZELNICKI, ZYGMUNT. "Historyzm i dogmatyzm w sztuce reformacji" [Historicism and Dogmatism in the Art of the Reformation]. *Teka komisji historii sztuki* 6 (1976):5-82, 45 illus. French summary pp. 80-82.

In Polish. Much of Protestant art is a continuation of traditional subjects, simply omitting certain unacceptable elements. But the Reformation also employed new or long-unused subjects (Christ blessing the children); these subjects are discussed in several 16th-century works.

761

LANKHEIT, KLAUS. *Das Triptychon als Pathosformel.* Abhandlungen der Heidelberger Akademie der Wissenschaften, Philosophisch-historische Klasse, 4. Heidelberg: Carl Winter, 1959, 87 pp., 48 illus.

Reviews the demise of the triptych format from the Gothic to modern period. The process of secularization is seen beginning in the Reformation, when the triptych changed in meaning and function, its sections becoming individual works of art (pp. 20-35).

762

MARROW, JAMES. *Passion Iconography in Northern European Art of the Late Middle Ages and Early Renaissance. A Study of the Transformation of Sacred Metaphor into Descriptive Narrative.* Ars Neerlandica, 1. Kortrijk: Van Ghemmert, 1979, xxii, 369 pp., 14 color illus., 144 b&w illus., bibliog., indexes.

An analysis of metaphorical elaborations of Passion imagery in the

pre-Reformation period. The author briefly discusses the Reformation as having largely brought this tradition to a close through a suspicion of allegorical exegesis and a favoring of literal interpretations of scripture (pp. 197-98).

763
MEYER, ALMUT AGNES. *Heilsgewissheit und Endzeiterwartung im deutschen Drama des 16. Jahrhunderts. Untersuchungen über die Beziehungen zwischen geistlichem Spiel, bildender Kunst und den Wandlungen des Zeitgeistes im lutherischem Raum.* Heidelberg: Carl Winter, 1976, 265 pp., 4 illus., bibliog.
The author's Ph.D. dissertation (Heidelberg, 1975). Interpretation of some lesser-known 16th-century German plays, augmented by reference to contemporary Protestant art. Close iconographic connections are found, and it is demonstrated that the visual arts were in most cases the source for dramatic images and formulae rather than vice versa.

764
MICHALSKI, SERGIUSZ. " 'Widzialne slowa' sztuki protestanckiej" [The 'Visible Words' of Protestant art]. In *Slowo i obraz.* Materialy Sympozjum, Komitetu Nauk o Stztuce. Polskiej Akademii Nauk. Nieborów, 29 wrzesnia - 1 pazdziernika 1977. Edited by Agnieszka Morawinska. Warsaw: Panstwowe Wydawnictwo Naukowe, 1982, pp. 171-208, 17 illus.
In Polish. Sixteenth-century Lutheran painting makes lavish use of inscriptions, in altarpieces, portraits, murals and portable easel pictures. The relationship between images and their accompanying inscriptions is analyzed as a means of clarifying the functions of Lutheran painting.

765
PREUSS, HANS. *Das Bild Christi im Wandel der Zeiten.* Leipzig: R. Voigtländer, 1915, 215 pp., 113 illus. 4th rev. ed. Leipzig: Deichertsche Verlag, 1932.
A pictorial history from the catacombs through the 19th century with brief commentary on each image. The Reformation is treated where appropriate.

766
REAU, LOUIS. *Iconographie de l'art chrétien.* 3 vols. (published in 6). Paris: Presses universitaires de France, 1955-59.
Vol. 1 is a general introduction. Vol. 2 concerns iconography of the Bible (Old Testament/New Testament themes). Vol. 3 concerns iconography of saints. The topics of Reformation art and of iconoclasm are discussed in Vol. 1, pp. 444-56.

767
THULIN, OSKAR. *Bilder der Reformation. Aus den Sammlungen der Lutherhalle in Wittenberg.* Berlin: Evangelische Verlagsanstalt, 1953, 84 pp., 72 illus.
Each of the 72 illustrations is accompanied by a short narrative relating the picture to Reformation events.

768
WARBURG, ABY. "Heidnisch-antike Weissagung in Wort und Bild zu Luthers

Zeiten." In *Gesammelte Schriften*. Edited by Gertrud Bing. Vol. 2. Leipzig/Berlin: B.G. Teubner, 1932, pp. 487-558, 32 illus. Reprinted in Aby Warburg, *Ausgewählte Schriften und Würdigung*. Edited by D. Wuttke, Baden-Baden: Valentin Koerner, 1980, pp. 199-305.

An examination of the texts and visual imagery of astrological prophesy in the Reformation period, particularly as pertinent to the writings of Luther and Melanchthon. The adaptation of pagan astrological sources and attitudes to the spiritual and personal needs of the reformers is traced in texts and in the iconography of astrological illustration.

VI. B. Biblical and hagiographical subjects

769

FRANK, VOLKER. "Ein Hauptwerk der Reformationskunst in Sachsen. Georg Lemberger und sein Leipziger Epitaph Schmidburg." *Bildende Kunst,* 1972, pp. 278-80, 4 illus.

Discusses a panel painting of the *Crucifixion* with donor portraits, commissioned in 1522 by Simon Pistor in memory of Heinrich Schmidburg. The location of the cross directly above a painted shrine showing an open Bible is regarded as Protestant in conception. This observation is not elaborated.

770

FÜGLISTER, ROBERT L. *Das lebende Kreuz. Ikonographisch-ikonologische Untersuchung der Herkunft und Entwicklung einer spätmittelalterlichen Bildidee und ihrer Verwurzelung im Wort*. Einsiedeln/Zurich/Cologne: Benziger Verlag, 1964, 225 pp., 19 plates, bibliog.

Pages 157-65 discuss the Reformation iconography of certain elements in the "living cross" representations of the 16th century. New allegorical features inspired by Luther are the personifications of Sin and Death.

771

GMELIN, HANS-GEORG. "Der Abrahamszyklus von Johann Hopffe aus dem Schloß zu Brake." *Niederdeutsche Beiträge zur Kunstgeschichte* 12 (1973):229-48, 20 illus.

Describes an Old Testament cycle of 13 paintings, (now in the Landes-museum, Detmold), done 1590/91 for the palace chapel of a Calvinist donor, Count Simon VI. Based on Netherlandish prototypes, the paintings are clearly Protestant in content.

772

*HARBISON, CRAIG. "The last Judgment in Sixteenth Century Northern Europe: A Study in Art, Revolution and Change." Ph.D. dissertation, Princeton University, 1972, 2 vols. [Vol.I, 336 pp.; vol. 2, 139 illus.].

A fully revised version was published in 1976. See no. 773. *Dissertation Abstracts International* 33, no. 4 (1972):1614A.

773
HARBISON, CRAIG. *The last Judgment in Sixteenth Century Northern Europe: A Study of the Relation between Art and the Reformation.* New York/London: Garland Publishing Inc., 1976, xv, 441 pp., 131 illus., bibliog.

Examines Last Judgment imagery in both Protestant and Catholic contexts, stressing the sustained didactic function of religious art as it develops over the century. Specific consideration given to the issues of free will and pre-destination, secular tendencies, and millenarian ideas. Includes a catalogue of all 16th-century examples of the subject known to the author.

774
HARBISON, CRAIG. "Reformation Iconography: Problems and Attitudes." *Print Review* 5 (1976):78-87, 8 illus.

Intended to complement his longer study on Last Judgment imagery (see no. 773), likewise stressing the importance of Reformation concerns for both Catholic and Protestant art.

775
HINTZENSTERN, HERBERT von. "Die Evangelienbilder der Gothaer Tafelaltars." In *Die Tür des Wortes. Evangelischer Almanach auf das Jahr 1958.* Berlin: Evanglische Verlagsanstalt, 1958, pp. 134-50, 8 illus.

Discusses the large altarpiece of 158 panels (Gotha, Schloß) depicting scenes from the Gospels and Acts, each subject accompanied by a passage from Luther's 1522 Bible. The panel is attributed to Tobias Stimmer and dated ca. 1575.

776
JEZLER, PETER. "Bildwerke im Dienste der dramatischen Ausgestaltung der Osterliturgie -- Befürworter und Gegner." In E. Ullmann, *Von der Macht der Bilder* (see no. 386), pp. 236-49.

Well-documented analysis of Entombment groups used in Easter rituals. The development of this subject is traced from medieval deposition figures through the Baroque period, with particular attention given to Reformation influence on form and iconography.

777
LLOMPART, GABRIEL. "El tema medieval de la Virgen del manto en el siglo de las reformas," *Estudios lulianos* 6 (1962):299-310, 5 illus.

Through documentating the prominence of the *Madonna of Mercy* in devotional art and literature, the author establishes a context for understanding Luther's intense rejection of this type of image in particular as idolatrous. Though mostly concerned with Mediterranean devotional imagery, the discussion of Luther is relevant to northern art as well.

778
LÜDECKE, HEINZ. "Christophorus, Hieronymus und anderes. Bemerkungen zum Thema Kunst und Reformation." *Bildende Kunst,* 1967, pp. 533-37, 9 illus.

The popularity of these subjects in the 15th and 16th centuries is attributed to emerging class consciousness.

779

OERTEL, HERMANN. "Das frühprotestantische Abendmahlsbild in Wittenberg und Dresden." *Kirche und Kunst* 50 (1972):39-42, 3 illus.

Protestant portrayals of the *Last Supper* (mainly by the Cranachs and the sculptor family Walter) are set in the context of Luther's views on the sacrament and on liturgical imagery for the altar.

780

OERTEL, HERMANN. "Das protestantische Abendmahlsbild im Niederdeutschen Raum und seine Vorbilder." *Niederdeutsche Beiträge zur Kunstgeschichte* 13 (1974):223-70, 23 illus.

Discusses 166 German Protestant Last Supper scenes from the 16th to the 18th century (earliest from 1570-80). Most based on Netherlandish, also on Italian or French engravings. Luther's positive attitude toward this subject is seen as significant for its popularity. Includes a bibliography, regional and chronological lists of the works and their models.

781

OERTEL, HERMANN. "Die protestantischen Bilderzyklen im niedersächsischen Raum und ihre Vorbilder." *Niederdeutsche Beiträge zur Kunstgeschichte* 17 (1978):102-32, 31 illus.

Investigates 42 German Protestant Old and New Testament narrative cycles from 1577 to 1768. Demonstrates the use of engravings as models. 16th-century cycles were confessional rather than narrative, but this changed in the 17th century.

782

SCHNEIDER, JENNY. "Daniel und der Bel zu Babylon." *Zeitschrift für Schweizerische Archäologie und Kunstgeschichte* 15 (1954/55):93-98, 7 illus.

Traces this subject from the Apocrypha in 16th- and 17th-century art, relating its employment to Calvinist attacks on image worship. Two designs for glass by Swiss artists in the 1540's (one by Grosshans Thomann), and two engravings after Heemskerck illustrate the early use of the subject.

783

SCHRADE, HUBERT. *Ikonographie der christlichen Kunst. Die Sinngehalte und Gestaltungsformen.* Vol. 1. *Die Auferstehung Christi.* Berlin/Leipzig: Walter de Gruyter & Co., 1932, xii, 388 pp., 205 illus., indexes.

Chapter 7,2 (pp. 294-304) concentrates on the influence of the Reformation, specifically the presence of Death and the Devil in Resurrection scenes in works by Peter Dell the Elder and Wendel Dietterlin the Elder. This is related to Luther's statements about the close connection between the harrowing of hell and the Resurrection. The iconography was quickly adopted by Catholic artists.

784

*STRUMWASSER, GINA. "Heroes, Heroines, and Heroic Tales from the Old Testament: An Iconographic Analysis of the most frequently Represented Old Testaments Subjects in Netherlandish Painting ca. 1430-1570." Ph.D. dissertation. University of California, Los Angeles, 1979, 248 pp.

Traces the shift in Old Testament subjects that are seen as increasingly chosen to stress "earthly and moral" issues in relation to Reformation concerns. *Dissertation Abstracts international* 40 (1979):3597A.

785

*THULIN, OSKAR. "Reformatorische und frühprotestantische Abendmahls-darstellungen." *Kunst und Kirche* 16,2 (1939):30-34, 4 illus.

786

VLAM, GRACE A.H. "The Calling of St. Matthew in Sixteenth-Century Flemish Painting." *Art Bulletin* 59 (1977):561-70, 14 illus.

Interprets the subject in certain cases as a call to faith in the Reformation sense. Matthew, a tax collector and perhaps an indulgence seller, adopts a way of life suggesting Luther's notion of justification by faith. See the subsequent exchange of letters between the author and Leonard Slatkes, *Art Bulletin* 60 (1978):741.

VI. C. Theological and liturgical subjects

787

BEITZ, EGID. "Allegorien der Reformationszeit." *Zeitschrift für christliche Kunst* 39 (1921):165-9, 2 illus.

Discusses a woodcut of the *Sheepfold* (ca. 1520) in terms of its Protestant iconography, and by contrast a curious anti-Protestant painting from the Netherlands. The latter (Cologne, Schnütigen Museum), dating from the late 16th century, represents Christ on a hilltop, approached without success by groups here identified as Lutherans and Jews.

788

BOON, KAREL G. "*Patientia* dans la gravure de la Réforme aux Pays-Bas." *Revue de l'art* 56 (1982):7-24, 22 illus.

Analyzes several allegorical prints which seem to stress this virtue in the face of religious intolerance, and demonstrates the significance of these prints in relation to early Reformation writings. Among the images discussed are designs by B. van Orley, H. Weiditz, Cornelis Anthonisz., M. van Heemskerck and P. Bruegel. Pertinent to the iconography of Anabaptism, Sacramentarianism, and Spiritualism in the Netherlands.

789

GABLER, A. "Taufkufen und Taufkessel im einstigen Bereich des Bistums Augsburg." *Das Münster. Zeitschrift für christliche Kunst und*

Kunstwissenschaft 27 (1974):137-41, 8 illus.
Brief discussion (pp. 137-38) of 16th-century representations of baptisms according to Protestant ritual.

790
GLEISBERG, HERMANN. "Die 'Götliche Müly.'" *Natur und Heimat* 6 (1957):73-74, 1 illus.
Explains the Reformation iconography of a 1521 woodcut showing Erasmus and Luther before the "göttliche Mühle", or sacred mill, grinding the flour of true faith.

791
*GOLDBERG, PAUL. "Die Darstellungen der Erlösung durch Christus und sein Blut und der hl. Eucharistie in der protestantischen Kunst des Reformationszeitalters." Ph.D. dissertation, Marburg, 1924, 222 pp.

792
GRANDJEAN, MARCEL. "Les deux projets de décoration du tympan d'Yverdon et l'iconographie protestante." *Unsere Kunstdenkmäler* 14 (1963):58-60, 2 illus.
In 1570 the newly-Protestant town of Yverdon is documented as having commissioned a statue personifying "True Religion" for the fountain in the main square. This statue antedates the earliest Catholic formulation of the subject known to the author (1593).

793
HELD, JULIUS S. "A Protestant Source for a Rubens Subject." In *Liber Amicorum Karel G. Boon.* Edited by Dieuwke de Hoop Scheffer et al. Amsterdam: Swetz Zeitlinger bv, 1974, pp. 78-95, 18 illus.
Discusses two mid-16th-century paintings, likely of Bruges origin, which constitute a Protestant iconographic variation on the traditional Man of Sorrows theme. These works are related to Calvin's theology and to Cranach's *Allegory of Grace and Salvation.*

794
HINZ, BERTHOLD. "Studien zur Geschichte des Ehepaarbildnisses." *Marburger Jahrbuch für Kunstwissenschaft* 19 (1974):139-218, 74 illus.
Examines the formal and iconographic development of marriage portraits, especially in relation to their evolving socio-economic and political context from the 15th to 17th century. Although the Reformation is not discussed, this study of a major secular genre impinges on issues specifically relevant to discussions of Protestantism and art.

795
LANKHEIT, KLAUS, and LÜCKE, HANS-KARL. "Eucharistie." In *RDK* (see no. 18). Vol. 6, cols. 154-254.
Lutheran and other Reformation illustrations of the eucharist are analyzed and placed in the larger tradition of liturgical imagery. See especially part VIII (cols. 204ff.), and part XII (cols. 236-43), the latter concerned specifically with

Protestantism and the eucharist. The iconography of the eucharist is studied in relation to the theological debate over real and symbolic presence, a central issue in Reformation dispute with the orthodox church.

796

POPELIER, FRANÇOISE. "Images des luttes religieuses dans la peinture des Anciens Pays-Bas." *Bulletin des Musées Royaux des Beaux-Arts de Belgique* 18 (1969):121-39, 18 illus.

Centers on an allegorical painting of *The Good Shepherd* (Brussels, Musées Royaux des Beaux-Arts) by an unknown 16th-century Netherlandish master. The subject became popular in Reformation propaganda prints. But the panel discussed includes a portrait of Philip II shown in a favorable light, leading to the conclusion that this work is allied with the Counter-Reformation and is intended to parody the imagery and theology of the Protestants.

797

SAXL, FRITZ. "Veritas Filia Temporis." In *Philosophy and History. Essays presented to Ernst Cassirer.* Edited by R. Klibansky and H.J. Paton. Oxford: Clarendon Press, 1936, pp. 197-222, 13 illus.

Discusses personifications of truth in the visual arts and their relation to Protestant thought, mainly in England (pp. 202-10).

798

STRASSER, ERNST. "Christus als Lebensbrunnen. Zwei Bildwerke in der St.-Johannis-Kirche zu Lüneburg." *Lüneburger Blätter* 18 (1967):115-18, 2 illus.

Although the image of Christ as the Fountain of Life is rare after the Reformation, Lüneburg possesses two examples -- one painting (ca. 1580), one bas-relief (ca. 1600) -- showing the resurrected Christ atop a fountain with figures crowded around the base, a pictorial allegory of the Lutheran sacrament.

799

STUHLFAUTH, GEORG. *"Das Hauß des Weysen und das haus des unweisen manß. Math. VII.* Ein neu gefundener Eindruck des Hans Sachs vom Jahre 1524." *Zeitschrift für Bücherfreunde,* n.s. 11, part 1 (1919):1-9, 1 illus.

Discusses the attribution of the woodcut (Erhard Schön?) and revises the attribution lists for other Sachs broadsheets. Briefly interprets the allegory of the 1524 sheet which is based on the closing lines of the Sermon on the Mount.

800

VETTER, EWALD M. "Das allegorische Relief Peter Dells d. Ä. im Germanischen Nationalmuseum." In *Festschrift für Heinz Ladendorf.* Edited by Peter Block and Gisela Zick. Cologne & Vienna: Böhlau Verlag, 1970, pp. 76-88, 4 illus.

Deciphers an allegorical composition depicting a ship and various figures, tracing its visual and literary prototypes. The theme of the "Christian life" is, in this case, shown to contain Protestant iconographic elements.

801
VETTER, EWALD M. "Necessarium Adae Peccatum," *Ruperto-Carola, Zeitschrift der Vereinigung der Freunde der Studentenschaft der Universität Heidelberg e.V.* 39 (1966):144-181, 20 illus.

Traces conceptions of the Fall that stressed Adam's active role, primarily in examples from the 16th and 17th centuries. A Spanish variant of the Cranach type of the *Allegory of Grace and Salvation* is discussed, and Luther's contribution to the interpretation of the Fall cited in passing (p. 167).

802
WECKWERTH, ALFRED. "Christus in der Kelter. Ursprung und Wandlung eines Bildmotives." In *Beiträge zur Kunstgeschichte. Eine Festgabe für H.R. Rosemann.* Edited by Ernst Guldan. Munich: Deutscher Kunstverlag, 1960, pp. 95-108, 8 illus.

Analyzes the changing employment of this devotional subject, briefly discussing its later use in Reformation iconography. 16th-century Lutheran and 17th-century Calvinist examples are cited in relation to the Protestant view of the eucharist.

VII. Artists of the Reformation

VII. A. Artists' writings on the Reformation

VII. A. 1. Jörg Breu the Elder

803

BREU, JÖRG der ÄLTERE [GEORG PREU]. *Die Chronik des Augsburger Malers Georg Preu des Älteren. 1512-1537.* Edited by Friedrich Roth. No. 6 of: *Die Chroniken der schwäbischen Städte.* Augsburg. Leipzig: S. Hinzel, 1906. *Die Chroniken der deutschen Städte.* Vol. 29, 110 pp., glossary, indexes. Reprint. Göttingen: Vandenhoeck & Ruprecht, 1966.

An edition of the manuscript chronicle is given with an historical introduction. Breu offers many anecdotal accounts of events reflecting on attitudes toward religious books and images, on the activities of the Anabaptists and other "heretical" groups, and acts of iconoclasm. Breu was a painter and designer of woodcuts active in Augsburg, often for the Fugger family and also Maximilian I.

VII. A. 2. Sébald Büheler

804

DACHEUX, L., ed. *La Petite Chronique de la Cathédrale. La Chronique Strasbourgeoise de Sébald Büheler.* Fragments des anciennes chroniques d'Alsace, 1. Strasbourg: R. Schultz et Cie., 1887, 149 pp.

The Catholic Büheler, himself a painter and admirer of Dürer and Baldung, wrote his chronicle in 1586-88, relating events in Strasbourg beginning in 1540. On iconoclasm: numbers 240-41, 249-50. On Baldung's death: numbers 296-97.

VII. A. 3. Dirk Coornhert

805
*COORNHERT, DIRK VOLCKERTSZOON. *Of Godt in sijn predestineren, verkiesen ende verwerpen, siet op des menschen doen, dan niet. Ghesprake tusschen Ghereformeerde Calvinist ende D. Demostenes.* [n.p.] 1611.

One of several substantial Humanist dialogues, tracts and dramas bearing on the Reformation. Coornhert, a professional engraver as well as a philosopher and theologian, spoke against intolerance among all religious groups.

VII. A. 4. David Denecker

806
ROTH, FRIEDRICH. "Zur Lebensgeschichte des Augsburger Formschneiders David Denecker und seines Freundes, des Dichters Martin Schrot." *Archiv für Reformationsgeschichte* 9 (1912):189-230.

Reviews the histories of these two masters and discusses a polemical Reformation tract which they published together anonymously: *Schmachbuch von der Erschrocklichen Zurstoerung unnd Niderlag deß gantzen Bapstumbs*. Describes the illustrations and reprints, documents relevant to the prosecution of Denecker for violating censorship laws in 1559 and 1564.

VII. A. 5. Albrecht Dürer

807
DÜRER, ALBRECHT. *Tagebuch der Reise in die Niederlande.* In Rupprich's edition of Dürer's writings (see no. 940), I, pp. 146-202. English translation see Conway (see no. 936).

Dürer's diary of his trip (the original lost; extant in two early copies) records his contacts with Netherlandish Protestants and his admiration for Luther (see pp. 160, and 170-72 -- the lament over Luther's supposed death; see also Rupprich's notes on this section pp. 196-99).

808
DÜRER, ALBRECHT. "Widmung an Pirckheimer." In *Underweysung der Messung.* Nuremberg: n.p. 1525. Reprinted with notes in Rupprich's ed. (see no. 940), I, pp. 114-16. Facsimile edition followed by essays in English and German, edited by Alvin Jaeggli, Zurich: Joseph Stocker-Schmid, 1966. English translation with commentary by Walter L. Strauss, *The Painters Manual.* New York: Abaris Books, 1977 (the dedication to Pirckheimer is translated p. 37).

The letter of dedication to Pirckheimer defends the art of painting against its detractors. Dürer insists: "A Christian will no more be led to superstition by a painting or a portrait than a devout man to commit murder because he carries a

weapon by his side." This tract includes the sketch and description of the "monument to commemorate a victory over the rebellious peasants" (fols. J recto & verso; pp. 232-36 in the English translation).

809
DÜRER, ALBRECHT. "Beischüfter auf Bildnissen und Zeichnungen." In Rupprich's edition of Dürer's writings (see no. 940), I, pp. 210-11.
Document 76 transcribes Dürer's inscription on a woodcut by Michael Ostendorfer regarding idolatry (1523). Document 83 transcribes Dürer's inscriptions on the Four Apostles (Munich).

810
GORIS, J.-A. and MARLIER, G. eds. *Albrecht Dürer. Diary of his Journey to the Netherlands. 1520-1521.* English translation. London: Lund Humphries, 1971, 186 pp., 8 color illus., 85 b&w illus.
The introductory essay discusses the religious turmoil of the period and the Protestant leanings of Dürer's numerous contacts in Antwerp. The English translation of the Diary is reproduced from Conway (see no. 936).

VII. A. 6. Filips Galle

811
*GALLE, FILIPS. *Een cort verhael van de gedincweerdichste saken die in de xvij. Provincien vande Nederlanden van daghe tot daghe geschiet zijn sedert den iare ons Heeren M.D. LXVI. totten iare M.D. LXXIX.* Antwerp: Christoffel Plantin, 1579, 60 pp.
A chronicle recounting the early years of the uprising in the Lowlands against the Spanish occupation, accompanied by a map also done by the engraver Galle. The tract was first published in Latin in 1578/9 (surviving only in a later edition published by Sigismund Feyerabend in 1580). The tract was also translated into French. It reveals Galle's strong anti-Spanish stance and his direct engagement in propaganda supporting the House of Orange in the revolt. (For further information, see B.A. Versmaren, no. 285).

VII. A. 7. Hans Greiffenberger

812
GREIFFENBERGER, HANS. *Die Weltt sagt, sy sehe kain besserung von den, die sy Lutherisch nennet...* [Augsburg: MelchiorRamminger], 1523, 7 pp.
A pamphlet by the painter Greiffenberger who mentions the roles of artists and craftsmen in spreading the Reformation.

813
PHILOON, THURMAN E. "Hans Greiffenberger and the Reformation in

Nuernberg." *Mennonite Quarterly Review* 36 (1962):61-75.

A painter and author of Reformation tracts was examined for heresy in 1524 by the city council. He recanted, but in 1526 was convicted for relapse and banished from the city. No works of art attributed to him survive. The article studies the theological position of four of his tracts.

814

RUSSELL, PAUL. "'Your sons and your daughters shall prophesy...' (Joel 2:28). Common People and the Future of the Reformation in the Pamphlet Literature of Southwestern Germany to 1525." *Archiv für Reformationsgeschichte* 74 (1983):122-39.

Surveys 38 pamphlets published by 9 commoners, including 7 by Hans Greiffenberger. All respond to the events of 1523-24: the imprisonment of lay preachers, increased attacks on the Reformation, growing peasant unrest, etc. Luther is seen as part of an older, on-going process.

VII. A. 8. David Joris

815

*JORIS, DAVID, [Joriszoon]. *Te Woder Boeck. Wie een die ick, seyt die Here, sendte sal ontfangt in minen nam, dy ontfangt my; wy my ontfangt, ontfangt dan die my gesonde heeft.* 2 vols. [Deventer ? 1542].

VII. A. 9. Niklaus Manuel Deutsch

816

MANUEL, NIKLAUS. *Niklaus Manuel.* Edited by J. Baechtold (see no. 1086).

The standard edition of Manuel's writings.

VII. A. 9. Bernard Palissy

817

PALISSY, BERNARD. "Bernard Palissy considéré comme évangéliste ou prédicateur de la Réforme et comme écrivain: Son récit de la fondation de l'Eglise réformée de Saintes, d'après l'édition originale et avec les notes manuscrites de l'exemplaire de la B.N. (Z2, 122, E)." *Bulletin de la Société de l'histoire du protestantisme français* 1 (1853):23-34, 83-94.

A brief introduction followed by extracts from Palissy's writings selected to illustrate his particular Protestant religious conviction.

818

PALISSY, BERNARD. *Oeuvres Complètes de Bernard Palissy.* Edited by Paul Antoine Cap. Paris: J.-J. Dubochet et Cie., 1844.

The editor's introduction includes an extensive discussion of the content and significance of Palissy's tract partly concerning theology, the *Recepte véritable,* which is also reprinted in this volume. The tract appears to have been written during Palissy's incarceration which resulted from his involvement in the religious wars in France.

819

PALISSY, BERNARD. "Recepte véritable par laquelle tous les hommes de la France pourront apprendre à multiplier et augmenter leurs thrésors." In *Les oeuvres de Bernard Palissy.* Introductory essay and index by Anatole France. Paris: Charavay Frères Editeurs, 1880, pp. 11-158.

An essay published in 1563, proposing the construction of a palace and garden, the discourse laced throughout with meditations on Christian theology. Specific points about the history of the Protestant church are brought into the discussion alongside reflections on natural science and art.

See also: Filips Galle (Vermaseren, no. 285) and Godevaert van Haecht, no. 274.

VII. B. Artists and Reformation imagery

VII. B. 1. Pieter Aertsen

820

EMMENS, J.A. " 'Eins aber ist nötig' - Zu Inhalt und Bedeutung von Markt- und Küchenstücken des 16. Jahrhunderts." In *Album Amicorum J.G. van Gelder.* Edited by J. Bruyn et al. The Hague: Martinus Nijhoff, 1973, pp. 93-101, 16 illus.

Early "genre" scenes with religious subjects are set in the context of Antwerp's commercial success. Sees many of Aertsen's and Beuckelaer's paintings as moral condemnations of material excess. This issue was important in both Catholic and Protestant discussions of proper religious conduct.

821

MOXEY, KEITH P.F. *Pieter Aertsen, Joachim Beuckelaer, and the rise of secular painting in the context of the Reformation.* New York/London: Garland Publishing, 1977, 284 pp., 72 illus.

Extensive investigation of "secularization" as evidenced by the work of these two masters. Discusses Catholic and Protestant debates over religious imagery in some detail, with special emphasis on the Netherlands and the iconoclastic movement of 1566. Associates the rise of secular subject matter with general suspicions about religious art emerging over the century.

822
MOXEY, KEITH P.F. "Reflections on some unusual Subjects in the Work of Pieter Aertsen." *Jahrbuch der Berliner Museen,* n.s. 18 (1976):57-83, 12 illus.
Traces the development of Aertsen's iconography in the context of Catholic and Protestant theology. Among the works discussed are *The Return from the Procession* (Brussels), *Adoration of the Statue of Nebuchadnezzar* (Rotterdam), and the *Seven Works of Charity* (Warsaw). Concludes that in his later career Aertsen adhered to Catholic prescriptions for proper religious art.

VII. B. 2. Heinrich Aldegrever

823
LUTHER, GISELA. *Heinrich Aldegrever. Ein westfälischer Kupferstecher des 16. Jahrhunderts.* Bildhefte des Westfälischen Landesmuseums für Kunst und Kulturgeschichte, 15. n.p., 1982, 76 pp., 1 color illus., numerous b&w illus., bibliog.
Aldegrever's religious engravings are discussed in relationship to the Reformation and the artist's early support of Luther's cause (pp. 10-16). His secular works are seen as often anti-Catholic (*Dance of Death*), pp. 17-18.

824
SCHWARTZ, HUBERTUS. "Heinrich Aldegrever und die Reformation. Ein Beitrag zur Soester Reformationsgeschichte." *Jahrbuch des Vereins für westfälische Kirchengeschichte* 42 (1949):70-79.
Argues that Aldegrever's work and what is known of his history demonstrate his early acceptance of Protestantism. His displeasure with the interim re-catholicization in Soest (1548-52) is documented.

VII. B. 3. Albrecht Altdorfer

825
HÜTT, WOLFGANG. "Albrecht Altdorfer und die Reformation." *Bildende Kunst,* 1981, pp. 83-86, 8 illus.
Attempts to relate Altdorfer's art to religious policy in Regensburg -- the expulsion of the Jews in 1519 and the late acceptance of Protestantism. Of artisan origin but also a member of council, Altdorfer supposedly reflects a "middle of the road" position on the religious controversy.

VII. B. 4. Hans Asper

826
WÜTHRICH, LUCAS. "Die Zürcher Malerei im 16. Jahrhundert." In *Zürcher*

Kunst nach der Reformation (see no. 492) pp. 9-14, 2 illus.
Discusses painting of the Reformation in Zurich, focusing on Hans Asper who accepted commissions from both Catholics and Protestants.

VII. B. 5. Hans Baldung Grien

827
BAUMGARTEN, FRITZ. "Hans Baldungs Stellung zur Reformation." *Zeitschrift für die Geschichte des Oberrheins,* n.s. 19 (1904): 245-64, 4 illus.
Documentary evidence (all tangential) for Baldung's Protestantism is presented and discussed. Reviews and amends earlier discussion of *Luther as Hercules Germanicus* (Zurich, Stadtbibliothek), arguing (with assistance from J. Springer and especially D. Burckhardt, per letter) that it is by Holbein, not Baldung.

828
BERNHARD, MARIANNE, ed. *Hans Baldung Grien. Handzeichnungen. Druckgraphik.* Munich: Südwest Verlag, 1978, 416 pp., over 300 illus., bibliog.
Considers Baldung's seeming indifference to the Reformation: the fact that he accepted commissions from both camps, and responded to the threat of iconoclasm simply by turning to secular subjects. His sympathy for Protestantism grew gradually and he continued as a commercial success. Undocumented discussion.

829
BOERLIN, PAUL H., et al. *Hans Baldung Grien im Kunstmuseum Basel.* Schriften des Vereins der Freunde des Kunstmuseums Basel, 2. Basel, n.p., 1978, 96 pp., 10 color illus., 57 b&w illus.
Contains essays by four scholars on different aspects of Baldung's work: painting, Paul H. Boerlin; drawing, Tilman Falk; graphic art, Dieter Koepplin; the *Leienbibel,* Richard W. Gassen (see no. 531). Reformation questions are touched on by each in passing.

830
BRADY, THOMAS A. Jr. "Der Gmünder Künstler Hans Baldung Grien (1484/5-1545) in Straßburg. Seine gesellschaftliche Stellung und seine Haltung zur Reformation." *Gmünder Studien* 1 (1976):103-29.
Pages 119-23 review the scholarly opinions on Baldung's Protestantism, agreeing with Baumgarten (see no. 827) that he was a moderate follower of the Reformation.

831
BRADY, THOMAS A. Jr. "The Social Place of a German Renaissance Artist: Hans Baldung Grien (1484/85-1545) at Strasbourg." *Central European History* 8 (1975):295-315.

Argues that the German Reformation did not necessarily result in impoverishment of painters. Documents show Baldung to have been a thriving member of the bourgeoisie who, after the Reformation, turned from church art to private aristocratic sources of patronage.

832
BUSSMANN, GEORG. *Manierismus im Spätwerk Hans Baldung Griens. Die Gemälde der zweiten Straßburger Zeit.* Heidelberg: Carl Winter, 1966, 196 pp., plus 72 illus., index.
 Detailed discussion of all the paintings from this period according to subject matter categories. Focuses on stylistic analysis of mannerism in each work, touching tangentially on questions relating to the Reformation (pp. 116, 139, 150, 171).

833
CURJEL, HANS. *Hans Baldung Grien.* Munich: O.C. Recht Verlag, 1923, 169 pp., plus 176 b&w illus., 3 color illus.
 In a discussion of the Reformation period (pp. 99-109) Baldung is seen as an unconscious pioneer of the new spiritual climate, who then allowed the chiliastic aspects of the pre-Reformation era to dominate -- from the early *memento mori* works to his later obsession with sensuality and the demonic. His interest in the "Erscheinung an sich", the direct, non-analytical representation of visual reality is linked to the Humanist focus on empiricism.

834
ESCHERICH, MELA. *Hans Baldung-Grien Bibliographie. 1509-1915.* Studien zur deutschen Kunstgeschichte, 189. Strasbourg: J.H.Ed. Heitz (Heitz & Mündel), 1916, 135 pp., 2 illus., index.
 Annotated bibliography, chronologically arranged, including the earliest archival records, auction catalogues, etc.

835
FISCHER, OTTO. *Hans Baldung Grien.* Munich: F. Bruckmann, 1939, 76 pp., plus 93 b&w illus., 4 color illus.
 The Reformation's effects on Baldung's art are discussed pp. 10-14, 41-49. His works from 1518-22 are seen as becoming more austere, a result of the questioning nature of Protestantism that led to a weakening of the essential vitality in Baldung's early style.

836
HARTLAUB, G.F. "Der Todestraum des Hans Baldung Grien." *Antaios* 2,1 (1960):13-25, 4 illus.
 Discusses the woodcut of the *Bewitched Groom* (ca. 1545) in light of Rüstow's argument that the Reformation gave prominence to the demonic (see no. 376). Argues rather that this theme had long been important, and that the woodcut represents a dream giving general warning to Christians in a troubled time.

837
HUGELSHOFER, WALTER. "Überlegungen zu Hans Baldung." *Zeitschrift für Schweizerische Archäologie und Kunstgeschichte* 35 (1978):263-75, 10 illus.
Discusses effects of the reformers' rejection of art on Hans Leu and Baldung (pp. 264, 267-68). Changes in Baldung's subject matter (including his many nudes and witches), seem to reflect the upset of the time (pp. 269-70). The question of audience for these new subjects is raised.

838
HULTS, LINDA C. "Baldung and the Reformation." In Washington D.C., National Gallery. *Hans Baldung Grien. Prints and Drawings* (see no. 853), pp. 38-59.
Baldung's early works express an unusual intensity and subjectivity that increase in later works, both secular and religious. Suggests the Reformation freed him from traditional imagery, allowing him to create the late ambivalent works, in which gloomy determinism and sensuality overwhelm Christian content.

839
*HULTS-BOUDREAU, LINDA. "Hans Baldung Grien and Albrecht Dürer: A Problem in Northern Mannerism." Ph.D. dissertation, University of North Carolina, Chapel Hill, 1978.

840
KARLSRUHE, STAATLICHE KUNSTHALLE. *Hans Baldung Grien.* Exhib. cat., 4 July - 27 September 1959. N.p., n.d., 401 pp., ca. 330 illus., bibliog.
The major scholarly contribution to Baldung (exhibitition organized and catalogue written by Carl Koch), including full documentation on his works, copies, and followers. Reformation issues are mentioned *passim*.

841
KOCH, CARL. "Über drei Bildnisse Baldungs als künstlerische Dokumente vor Beginn seines Spätstils." *Zeitschrift für Kunstwissenschaft* 5 (1951):57-70, 8 illus.
In a brief discussion (pp. 69-70) of the sensuality and worldly beauty of Baldung's Madonna's from 1525-35, the author points out the similarities with images of classical goddesses and questions the response to such pictures. Cites a Strasbourg document of 1541 recounting outrage at paintings of the Virgin "schandtlich und entblößt gemalet".

842
KOCH, CARL. *Die Zeichnungen Hans Baldung Griens.* Berlin: Deutscher Verein für Kunstwissenschaft, 1941, 215 pp., plus 283 illus., bibliog.
Briefly discusses Baldung's willing acceptance of Reformation attitudes, seeing the battle against outdated forms reflected in the artist's own progress toward artistic liberation. His success is especially apparent in figure studies and portraits (pp. 10-12).

843
LANCKORONSKA, MARIA GRÄFIN. "Scherz, Satire, Ironie und tiefere Bedeutung in Baldungs Bacchus-Bilder." *Gutenberg Jahrbuch* 35 (1960):334-43.

Argues that Baldung's representations of Bacchus (mainly 1515-1517) demonstrate the artist's outrage over conditions in the Catholic church. Sees the scenes of drunkenness as powerful pre- and early Reformation denunciations of the corrupt clergy.

844
MENDE, MATTHIAS. *Hans Baldung Grien. Das graphische Werk. Vollständiger Bildkatalog der Einzelholzschnitte, Buchillustrationen und Kupferstiche.* Unterschneidheim: Verlag Dr. Alfons Uhl, 1978, 72 pp., text plus 696 illus., bibliog., index.

Reformation questions are touched on in the introduction, in the bibliographical essay, and in the informative, well-documented commentaries accompanying the plates.

845
NEUBAUER, EDITH. "Zum Problem 'Künstler und Gesellschaft.' Dargestellt am Beispiel von Hans Baldung Grien." In *Lucas Cranach.* Edited by P. Feist et al (see no. 887), pp. 162-165.

Characterizes Baldung's stature as a citizen of Strasbourg and stresses his support of the Reformation.

846
OLBRICH, HARALD. "Hans Baldung Grien in der Krise seiner Zeit." In *Lucas Cranach.* Edited by P. Feist et al (see no. 887), pp. 157-161.

Baldung's works, increasingly personal from the 1520's on, were made for a humanistically educated, Protestant circle. Suggests that the allegorical compositions of 1530/31 were metaphors of the perception of reality shared by the new intellectual elite.

847
OLDENBOURG, M[ARIA] CONSUELO. *Die Buchholzschnitte des Hans Baldung Grien. Ein bibliographisches Verzeichnis ihrer Verwendungen.* Studien zur deutschen Kunstgeschichte, 335. Baden-Baden/Strasbourg: Heitz, 1962, 159 pp., 203 illus.

Expands the information in the Karlsruhe Baldung catalogue (see no. 840). Appendix includes short discussions of Baldung's patrons, several of whom were Protestants.

848
OSTEN, GERT von der. *Hans Baldung Grien. Gemälde und Dokumente.* Berlin: Deutscher Verlag für Kunstwissenschaft, 1983, 345pp., 208 plates., bibliog., index.

A substantial, detailed study of Baldung's life and work including a large appendix of contemporary documents. The Reformation is mentioned in passing

(see index) but its relationship to Baldung's art is not explored.

849
OSTEN, GERT von der. "Zur Ikonographie des Hans Baldung Grien." In *Festschrift für Herbst von Einem.* Edited by Gert von der Osten and Georg Kauffmann. Berlin: Gebr. Mann, 1965, pp. 179-87, 5 illus., (plates 36-37).
Section II on eucharistic allegories argues that Baldung's reserve in religious matters was not a sign of indifference. Throughout his career he was concerned with subjects like the *Pietà with Angels* and the *Last Supper,* themes of special significance for Protestants. Also sees Reformation allusions in Baldung's treatment of the *Madonna and Child* theme.

850
PARISET, FRANÇOIS-GEORGES. "L'art et l'humanisme en Alsace." *Revue d'Alsace* 86 (1939):3-48.
In questioning the extent to which Baldung was a Humanist, finds religious feelings decisive. A new emotionality in his works after 1512 is seen as the result of a pre-Reformation religious crisis, with later works reflecting the Reformation atmosphere of Strasbourg (pp. 15-31).

851
PARISET, FRANÇOIS-GEORGES. "Grünewald et Baldung." *Cahiers alsaciens d'archéologie, d'art et d'histoire* 19 (1975-76):147-66, 11 illus.
A discussion of the changing emotional character of Baldung's art specifically in relation to the adoption of the Reformation in Strasbourg.

852
PARISET, FRANÇOIS-GEORGES. "La peinture et la sculpture à Strasbourg au siècle de la Réforme." In *Strasbourg au coeur religieux du XVIe siècle.* Hommage à Lucien Febvre. Actes du Colloque international de Strasbourg (25-29 mai 1975). Edited by Georges Livet and Francis Rapp. Strasbourg: Librairie Istra, 1977, pp. 559-75.
Surveys sculpture, graphic art and painting in Reformation Strasbourg. Briefly mentions various artists, then focuses on Baldung, a "Humanist attached to the values of paganism."

853
WASHINGTON, D.C., NATIONAL GALLERY OF ART. *Hans Baldung Grien. Prints and Drawings.* Exhib. cat. Jan. 25 - April 5, 1981; New Haven, Yale University Art Gallery, April 23 - June 14, 1981. Exhib. organized and cat. edited by James H. Marrow and Alan Shestack. N.p., 1981, xiv, 281 pp., 224 illus.
The question of the Reformation and Baldung's art is touched on in introductory essays (see Hults 838; and pp. 17-18) and in several of the commentaries accompanying the 89 catalogue entries.

854
WIRTH, JEAN. "Ste. Anne est une sorcière." *Bibliothèque d'Humanisme et*

Renaissance 40 (1978):449-80, 1 illus.

Investigates the history of the cult of St. Anne in the 16th century in order to interpret her enigmatic gesture in Baldung's woodcut of the *Virgin with St. Anne*. Worship of St. Anne was especially condemned by Protestants (p. 457). Shows that she was often conceived of as a sorceress, and that Baldung meant to depict her in that guise as well. That his meaning was more humorous than profound was appropriate in Alsace where neither the cult of St. Anne nor witchcraft were taken very seriously.

VII. B. 6. Hans Sebald Beham and Barthel Beham

855

ROSENBERG, [CARL] ADOLF. *Sebald und Barthel Beham. Zwei Maler der deutschen Renaissance*. Leipzig: Verlag E.A. Seemann, 1875, iv, 143 pp., 25 illus.

The lives and works of the two artists are related, with Reformation connections touched on pages 6-10 and *passim*.

856

SEIBT, G.K. WILHELM. *Hans Sebald Beham, Maler und Kupferstecher, und seine Zeit*. Frankfurt: Heinrich Keller, 1882, 45 pp.

An early attempt to place Beham within the restless religious atmosphere of Reformation Nuremberg. Records the details of the "three godless painters" and their sentencing, and connections with Karlstadt's and Müntzer's teachings.

857

WALDMANN, EMIL. *Die Nürnberger Kleinmeister*. Meister der Graphik, 5. Leipzig: Klinkhardt Verlag [1910], viii, 116 pp., 236 illus.

The early, basic monograph on the Beham brothers and Georg Pencz, setting their work in context of the period. Their trial for heresy is treated briefly.

VII. B. 7. Hans Bocksberger the Elder and family

858

GOERING, M. "Die Malerfamilie Bocksberger." *Münchner Jahrbuch für bildende Künste*, n.s. 7 (1930):185-280, 62 illus.

A detailed survey of the oeuvres of the Bocksberger family of artists: Hans (or Johann) the Elder, Melchior, and Hans the Younger (illustrations for Lutheran Bibles). The appendixes include a catalogue of works, and texts of archival documents relating to the artists. Detailed notes with bibliographical references.

VII. B. 8. Cornelis Bos

859
CUVELIER, J. "Le Graveur Corneille van den Bossche (XVIe siècle)." *Bulletin de l'Institut historique belge de Rome* 20 (1939):1-49, 8 illus.
Documents the career of the Antwerp printmaker and dealer, better known as Cornelis Bos, who was indicted for heresy along with several other artists in 1544. Bos' possessions were confiscated and sold, and he was banished from the city.

VII. B. 9. Jörg Breu the Elder and the Younger

860
KRÄMER, GODE. "Jörg Breu d.Ä. als Maler und Protestant." In Augsburg, *Welt im Umbruch* (see no. 407). pp. 115-33, 13 illus.
Traces Breu's growing adherence to Protestantism through his *Chronicle* (see no. 803), with particular attention to his response to iconoclasm. After his alliance with the Reformation is established, the artist's works are studied for reflections of specific Protestant iconography, in particular two versions of the *Mocking of Christ* in Augsburg (Städtische Kunstsammlung, ca. 1522), and Innsbruck (Tiroler Landesmuseum Ferdinandeum, ca. 1524).

861
RÖTTINGER, HEINRICH. "Breu-Studien." *Jahrbuch der Kunsthistorischen Sammlungen des allerhöchsten Kaiserhauses,Wien* 28 (1909):31-91, 35 illus.
Briefly discusses the relation of Jörg Breu the Younger's woodcut subjects and their parallel in Reformation drama (pp. 84ff.).

VII. B. 10. Pieter Brueghel the Elder

862
AUNER, MICHAEL. "Pieter Bruegel. Umrisse eines Lebensbildes." *Jahrbuch der Kunsthistorischen Sammlungen in Wien*, n.s. 52 (1956): 51-122, 10 illus.
Argues that Bruegel was directly associated with Anabaptists in the Netherlands. Interprets the *Bearing of the Cross* (1564) and *St. John the Baptist Preaching* (1566) as reflecting the artist's personal acceptance of Anabaptist theology. Speculates that one B. Batthyány, likely a Protestant, was the patron for the *St. John the Baptist Preaching* and is represented among the crowd in this painting (see especially pp. 74, 84, 103-18).

863
BANGS, JEREMY D. "Pieter Bruegel and History." *Art Bulletin* 60 (1978):704-5.
Redates *Dulle Griet* to 1564, arguing that it refers to a heresy trial and execution in that year of two Protestant ministers who were betrayed by a

bonnet-seller known as "Lange Griet" or "Lange Margriet."

864
DEBLAERE S.J., ALBERT. "Bruegel and the Religious Problems of his Time." *Apollo* 105, n.s. 179 (March 1977): 176-80, 6 illus.
Describes the political and religious disputes of the time, but dismisses (without documentation) all scholarship attempting to show a relation between Bruegel's art and contemporary religious and political events.

865
FERBER, STANLEY. "Peter Bruegel and the Duke of Alba." *Renaissance News* 19 (1966):205-19, 6 illus.
Argues that the leader of troops in Bruegel's *Massacre of the Innocents* is the Duke of Alba, head of the Spanish expedition to suppress the revolt of the Netherlands. Regards this and other of Bruegel's works as reflecting an Erasmian critique of religious intolerance.

866
GENAILLE, R. "Le 'Dénombrement de Bethléem' et la persistance des goûts anversois chez Bruegel l'Ancien." *Jaarboek van het Koninklijk Museum voor Schone Kunsten, Antwerpen,* 1981, pp. 61-95, 15 illus.
This essay discusses the possible allusions to contemporary political and religious strife in Bruegel's work, and is sceptical of such claims. See especially the discussion of the *Massacre of the Innocents* (Brussels, Musée royaux des Beaux-Arts, pp. 85ff.).

867
GROSSMANN, FRITZ. "Bruegel's 'Woman taken in Adultery' and other Grisailles." *Burlington Magazine* 94 (1952):218-29, 8 illus.
Relates the painting of 1565 to the religious attitudes of Bruegel's close acquaintance, the Humanist A. Ortelius. The work is interpreted as a call for Christian charity amid contemporary conflicts between Catholics and Protestants in the Netherlands.

868
KLAMT, JOHANN-CHRISTIAN. "Anmerkungen zu Pieter Bruegels Babel-Darstellungen." In *Pieter Bruegel und seine Welt..* Edited by Otto von Simson and Matthias Winner. Berlin: Gebr. Mann Verlag, 1979, pp. 43-49, 11 illus.
The absence of Nimrod in the Rotterdam version of the *Tower of Babel* is explained by identifying a papal procession on a ramp at the center of the painting. The tower is thus interpreted as a critique of the Catholic Church, associating the Pope with Babylon.

869
KUNZLE, DAVID. "Bruegel's Proverb Painting and the World Upside Down." *Art Bulletin* 59 (1977):197-202, 3 illus.
Distinguishes Bruegel's *Flemish Proverbs* (1559) from later broadsheets of

the Upside Down World. Whereas broadsheets often reflect revolutionary aspirations of the lower classes, Bruegel's work tends to a conservative view critical of the peasantry in the wake of the Peasants' Revolt of 1525. See also the later exchange between the author and J. Bruyn, *Art Bulletin* 60 (1978):741-43.

870
MANSBACH, S.A. "Pieter Bruegel's Towers of Babel." *Zeitschrift für Kunst-geschichte* 45 (1982):43-56, 11 illus.

Discusses Bruegel's two representations of the *Tower of Babel* (Vienna and Rotterdam) as reflections of the artist's wish for a liberal, enlightend resolution to the political and religious conflicts of the time. Protestant sympathies are attributed to Bruegel.

871
STRAUSS, HEINRICH. "Pieter Bruegel in seiner Zeit. Meisterwerke des Malers als politische Allegorien." *Archiv für Kulturgeschichte* 61 (1979):340-52.

Primarily a summary of previous interpretations, arguing that various of Bruegel's works are "allegorical" references to the political and religious turmoil of his time. Several paintings discussed briefly from this point of view.

872
STRIDBECK, CARL G. "Bruegels Fidesdarstellung. Ein Document seiner religiösen Gesinnung." *Kunsthistorisk Tidskrift* 23 (1954):1-11, 1 illus.

Interprets Bruegel's allegorical drawing of 1559 in relation to the writings of D.V. Coornhert. Argues the iconography reflects the tolerant Catholicism of Coornhert rather than a Protestant viewpoint.

873
STRIDBECK, CARL G. *Bruegelstudien.* Stockholm Studies in the History of Art, 2. Stockholm: Almqvist & Wiksell 1956, 379 pp., 109 illus., indexes.

Discusses the relationship of Bruegel's drawing *Fides* (pp. 132-43) and the painting *Combat between Carnival and Lent* (pp. 192-206) in relation to Protestantism. Reiteration of the author's previous articles on these same subjects.

874
STRIDBECK, CARL G. "'Combat between Carnival and Lent' by Pieter Bruegel the Elder. An Allegorical Picture of the Sixteenth Century." *Journal of the Warburg and Courtauld Institutes* 19 (1956):96-109, 3 illus.

Bruegel's painting seen as a condemnation of human folly exemplified in the exaggerations of both the Catholic practice of Lent and the Protestant celebration of Carnival. This equal condemnation is related to the views of D.V. Coornhert and A. Ortelius.

875
SULLIVAN, MARGARET A. "Madness and Folly: Pieter Bruegel the Elder's *Dulle Griet.*" *Art Bulletin* 59 (1977):55-66, 13 illus.

Regards this painting as a satire directed against both the established Church

and rebels fomenting civil war in the Netherlands. As a condemnation of both sides of a religious and civic controversy, the painting reflects Bruegel's detached view.

876
TERLINDEN, CH. "Pierre Bruegel le Vieux et l'histoire." *Revue belge d'archéologie et d'histoire de l'art* 12 (1942):229-57.
 Well-documented review of the evidence for Bruegel's relation to the libertine sect known as the *Scola caritatis*, arguments attributing his departure for Brussels to his "heretical" associations, and other hypotheses about Bruegel's critical response to Spanish oppression. Concludes that attempts to relate Bruegel's life and work to particular historical events are finally not convincing.

877
ZUPNICK, IRVING L. "Bruegel and the Revolt of the Netherlands." *Art Journal* 23 (1964):283-89, 12 illus.
 Interprets Bruegel's drawings of the *Virtues, Christ in Limbo, Fall of the Magician,* and the painting *Dulle Griet,* as references to the Spanish repression of the Netherlands between 1559-1564.

VII. B. 11. Antoine Caron

878
ADHEMAR, JEAN. "Antoine Caron's Massacre Paintings." *Journal of the Warburg and Courtauld Institutes* 12 (1949):199-200.
 Relates Caron's paintings of the *Massacres of the Triumvirate* to a report by Theodore Beza recounting the arrival at court in 1561 of three paintings on this subject. Beza's account employs the paintings as a prophesy of violence against French Protestants.

879
EHRMANN, JEAN. *Antoine Caron. Peintre à la Cour des Valois.* Geneva: Droz/Lille: Giard, 1955, 59 pp., 32 illus., bibliog.
 Includes discussion of Caron's massacre pictures as representing contemporary battle between the reformed and Catholic churches (pp. 16-21, 29-30).

VII. B. 12. a. Lucas Cranach the Elder

880
ANDERSSON, CHRISTIANE D. "Religiöse Bilder Cranachs im Dienste der Reformation." In *Humanismus und Reformation als kulturelle Kräfte in der deutschen Geschichte* . Edited by Lewis W. Spitz. Berlin: W. de Gruyter, 1981, 43-79, 170-173, 17 illus.

Demonstrates the relation between Cranach's woodcut of the *Holy Kinship* (ca. 1510) and the cult of St. Anne at Wittenberg. Discusses changing interpretation of this image during the Reformation when it was reissued with verses by Melanchthon. Describes related instances of reinterpretation in Cranach's work, particularly *Christ and the Adultress* and *Christ blessing the Children.*

881
BASEL, KUNSTMUSEUM. *Lukas Cranach. Gemälde, Zeichnungen, Druck-graphik.* Exhib. Cat., June 15 - Sept. 8, 1974. By Dieter Koepplin und Tilman Falk. 2 vols. Basel: Birkhäuser Verlag, 1974-76, 844 pp., 361 b&w illus., 26 color illus., bibliog., index.
Detailed discussion of works exhibited with essays by various authors on specific items. See especially entries on Cranach's illustrations for Luther's Bible (I, pp. 331-32), Reformation themes (II, pp. 498ff.).

882
BEHREND, HORST. *Lucas Cranach. Maler der Reformationszeit.* Berlin: Christlicher Zeitschriftenverlag, [1967], 63 pp., 33 illus.
Narrates the story of friendship between Cranach and Luther, touching on the Reformation image question. The illustrations serve as background and are not discussed.

883
DIMITROV, DIMITAR G. "Lukas Kranah -- hudoznik na humanisma: Reformacijata" [Lucas Cranach -- Painter of Humanism and of the Reformation]. *Izkusstvo* 22,3 (1972):27-34, 9 illus.
In Bulgarian. Brief assessment of Cranach's career.

884
DIXON, LAURINDA S. "The *Crucifixion* by Lucas Cranach the Elder: A Study in Lutheran Reform Iconography." *Perceptions, Indianapolis Museum of Art* 1 (1981):34-42, 18 illus.
Places the painting of 1532 (Indianapolis Museum of Art) in the context of Luther's career, and seeks to identify several of the figures as portraits of contemporaries. The converted centurion is identified as John the Steadfast.

885
DRECKA, WANDA. "'Allégorie de la rédemption' de Lucas Cranach, le Vieux." *Bulletin du Musée National de Varsovie* 4 (1963):1-13, 8 illus.
Discusses a version of this widespread Reformation theme (Warsaw, National Museum). Relates the iconography of this painting (ca. 1526-29) to other versions of the allegory and to theological writings.

886
EHRESMANN, DONALD L. "The Brazen Serpent. A Reformation Motif in the Works of Lucas Cranach the Elder and his Workshop." *Marsyas* 13 (1966):32-47, 8 illus.

The motif is discussed as a Lutheran symbol of justification by faith. The evolution of the symbol is traced in the visual arts and in Luther's writings. Cranach's use of it in versions and adaptations of the *Allegory of Law and Grace* is discussed in detail.

887

FEIST, PETER, et al., eds. *Lucas Cranach. Künstler und Gesellschaft. Referate des Colloquiums zum 500. Geburtstag Lucas Cranachs d. Ä. Staatliche Lutherhalle, Wittenberg, 1.-3. Oktober 1972.* Berlin: Eigenverlag der Staatlichen Lutherhalle, 1973, 224 pp., 125 illus.

Publishes 35 papers on Cranach and related topics delivered at the colloquium (see nos. 556, 673, 695, 845, 846, 891, 912, 919 and 1238). Includes an essay by Feist ("Künstler und Gesellschaft," pp. 123-28, reprinted in E. Ullmann, ed., *Kunst und Reformation,* pp. 30-40, see no. 385) concerning theoretical problems in the relation of religion and society.

888

FRIEDLÄNDER, MAX J., and ROSENBERG, JAKOB. *Die Gemälde von Lucas Cranach.* Basel/Boston/Stuttgart: Birkhäuser Verlag, 1979, 205 pp., 466 b&w illus., 33 color illus., bibliog., indexes. English translation. *The Paintings of Lucas Cranach.* Rev. ed. Ithaca, N.Y.: Cornell University Press, 1978.

An updating of the first edition (Berlin: Deutscher Verein für Kunstwissenschaft, 1932). Additional illustrations, catalogue entries, and bibliography.

889

GLASER, CURT. *Lukas Cranach.* Leipzig: Insel Verlag, 1921, 239 pp., 117 illus.

Includes a brief, general discussion of Cranach's relation to the Reformation (pp. 148-62).

890

GROTE, LUDWIG. *Lucas Cranach der Maler der Reformation.* Dresden: Heinrich Naumann, 1883, 111 pp.

An early biography of the artist which treats Cranach's activities in relation to the reformers. Addressed to a general audience.

891

HIEPE, RICHARD. "Lucas Cranach in der ökonomisch-politischen Konstellation der frühbürgerlichen Revolution." In Feist, *Lucas Cranach,* (see no. 887), pp. 77-80.

Discusses the implications of Marxist criticism for an understanding of Cranach's work. Traces the development of his style from the early period of "free" expression through his adaptation to the commercial potential of the Wittenberg market.

892

HINTZENSTERN, HERBERT von. *Lucas Cranach d. Ä. Altarbilder aus der Reformationszeit.* 2nd ed. Berlin: Evangelische Verlagsanstalt, 1975, 124 pp.,

51 b&w illus., 1 color illus.
Survey of selected paintings by Cranach from 1503-53. General introduction followed by historical and iconographic discussion for each of 26 works.

893
HOFFMANN, KONRAD. "Cranachs Zeichnungen 'Frauen überfallen Geistliche'." *Zeitschrift des deutschen Vereins für Kunstwissenschaft* 26 (1972):3-14, 10 illus.
Analyzes the complexities of these drawings of ca. 1540 (Berlin, Kupferstichkabinett), identifies their precedents, and relates them to a contemporary dispute between Luther and Simon Lemnius over clerical celibacy. Interprets the works as a satire against hypocritical Catholic clerics and simultaneously against the follies of unruly housewives.

894
JAHN, JOHANNES. *Lucas Cranach d. Ä. 1472-1553. Das gesamte graphische Werk*. Munich: Rogner & Bernhard, 1972, 799 pp., over 600 illus.
Corpus of illustrations of Cranach's drawings and prints with a brief introduction, selected passages from documents and earlier literature. For documents see pp. 587ff.

895
JAHN, JOHANNES. "Der Weg des Künstlers." In *Lucas Cranach*. Edited by H. Lüdecke (see no. 901), pp. 17-81, 94 illus.
Includes a brief discussion of Cranach's relation to the Reformation and his commitments to Catholic as well as Protestant patrons (pp. 56-64).

896
KIBISH, CHRISTINE O. "Lucas Cranach's *Christ Blessing the Children:* A Problem of Lutheran Iconography." *Art Bulletin* 37 (1955):196-2 03, 3 illus.
Explains the sudden interest in this subject as reflecting Luther's dispute with the Anabaptists over infant baptism. The Gospel passages on which Cranach's paintings are based were important for Luther's justification of this practice. See also H. Preuss, "Zum Luthertum" (see no. 906), uncited by Kibish.

897
KNAAKE, K. "Ueber Cranach's Presse." *Centralblatt für Bibliothekswesen* 7 (1890):196-207.
No publications survive with imprints carrying Cranach's name. But there are many references to Cranach and Christian Döring having published Luther's writings. The textual evidence is marshaled, and a substantial number of publications identified (lacking in imprints, but grouped on typographical grounds). These works are identified as the results of Cranach's collaboration between ca. 1522-25.

898
KUMMER, BERNHARD. "Reformatorische Motive in der Kunst Cranachs, seines

Sohnes und seiner Schule." Ph.D. dissertation, Friedrich Schiller Universität, Jena, 1958, ix, 166 pp., 72 illus., bibliog.

A substantial examination of Reformation iconography in Cranach's polemical and theological imagery concentrating on its relation to Luther's writings and particularly Luther's conception of allegory. Main topics are anti-papal imagery, portraiture, and the evangelical, dogmatic compositions.

899
LILIENFEIN, HEINRICH. *Lukas Cranach und seine Zeit*. Bielefeld and Leipzig: Velhagen & Klasing, 1942, 114 pp., 145 b&w illus. 32 color illus.

Monographic survey. On Cranach's activity and the Reformation, pages 46-59. In the person of Luther "sollten die geängstigte deutsche Seele, das verwundete deutsche Gewissen den Erwecker und Führer finden" (p. 5).

900
LINDAU, M.B. *Lucas Cranach. Ein Lebensbild aus dem Zeitalter der Reformation*. Leipzig: Veit & Comp., 1883, x, 402 pp., 1 illus.

Cranach's activity in service of the Reformation is studied in part 2 (pp. 116-265). Monograph with additional biographical details and documentation expanding the basic work by Joseph Heller (*Lucas Cranachs Leben und Werke*. Bamberg, 1821) and Schuchardt (see no. 911).

901
LÜDECKE, HEINZ, ed. *Lucas Cranach der Ältere. Der Künstler und seine Zeit*. Berlin: Henschelverlag, 1953, 215 pp., 150 b&w illus., 4 color illus., bibliog.

A collection of essays and documents assembled in conjunction with the exhibitions at Weimar and Wittenberg in 1953. For relevant contents, see nos. 895 and 903.

902
LÜDECKE, HEINZ, ed. *Lucas Cranach der Ältere im Spiegel seiner Zeit*. Berlin: Rütten & Loening, 1953, 143 pp., bibliog., 27 b&w illus., 1 color illus.

Publishes texts of documents and other contemporary references to Cranach and his work. Notable are Luther's remarks, the account of the Wittenberg University uprising, and a polemic expressing the virtues of a Lutheran altarpiece in an attack against Calvinist iconoclasm.

903
LÜDECKE, HEINZ. "Lucas Cranach in seiner Zeit." In *Lucas Cranach*. Edited by H. Lüdecke (see no. 901), pp. 99-127, 68 illus.

Discussion of the socio-economic class conflict as a context for the artist's work. Sees Cranach as a spokesman for revolutionary attitudes in the Reformation.

904
McCLINTON, KATHARINE MORRISON. "The Lutheran Reformation Paintings of Lucas Cranach, the Elder." *Response in Worship, Music, the Arts* 4 (1962):2-6, 5 illus.

Brief description of how Cranach "Germanized" religious painting and thereby realized the religious program of Luther. Very general, undocumented essay.

905
MEIER, KARL E. "Fortleben der religiös-dogmatischen Kompositionen Cranachs in der Kunst des Protestantismus." *Repertorium für Kunstwissenschaft* 32 (1909):415-35, 1 illus.
 Cranach's allegorical representations of *Law and Grace* are classified into 3 basic types. The heritage of these particular Protestant formulations is traced in various media through the 16th and 17th centuries.

906
PREUSS, HANS. "Zum Luthertum in Cranachs Kunst." *Neue kirchliche Zeitschrift* 32 (1921):109-21.
 Notes the many examples of *Christ Blessing the Children* by Cranach and his workshop. Relates the subject directly to Luther's dispute with the Anabaptists (1527-28) on the matter of infant baptism, and Luther's remarks on childhood generally. The significance, popularity, and emotional tone of these works is thus accounted for.

907
ROSENBERG, JAKOB. *Die Zeichungen Lucas Cranachs d. Ä.* Berlin: Deutscher Verein für Kunstwissenschaft, 1960, 42 pp., 117 illus.
 Essential catalogue of the drawings.

908
SCHADE, WERNER. *Die Malerfamilie Cranach.* Dresden: VEB Verlag, 1974, 476 pp., 328 b&w illus., 81 color illus., bibliog., index. *English translation by Helen Sebba. *Cranach. A Family of Master Painters.* New York, 1980.
 Monographic study of Cranach the Elder and his sons. Briefly discusses Cranach and Reformation iconography (pp. 71-74). The appendix includes a list of primary documents on the family organized by year from 1492-1607 (pp. 401-53).

909
SCHEIDIG, WALTHER. "Urkunden zu Cranachs Leben und Schaffen." In *Lucas Cranach.* Edited by H. Lüdecke (see no. 901), pp. 156-77.
 Includes transcriptions and annotations of relevant documents: over the conflict between members of the workshop and students at Wittenberg University; Luther's correspondence to and about Cranach; commissions for art works; and workshop expenses.

910
SCHENK zu SCHWEINSBERG, EBERHARD Freiherr. "Die früheste Fassung des Gemäldes der Ehebrecherin vor Christus von Lucas Cranach d.Ä." *Kunst in Hessen und am Mittelrhein* 6 (1966):33-41, 8 illus.
 Redates this newly cleaned painting (Fulda, Schloßmuseum) to ca. 1506-8

on stylistic grounds and discusses its relation to other versions of the subject. Also argues that the Latin inscription from the Gospel must date the work prior to Luther's translation of the New Testament.

911
SCHUCHARDT, CHRISTIAN. *Lucas Cranach des Aelteren. Leben und Werke.* 3 vols. Leipzig: F.A. Brockhaus, 1851-71, indexes.
 Classic study of the master, including publication of early commentary on the artist's work and primary documents regarding his life and work.

912
SCHULZE, INGRID. "Lucas Cranach und die Universität Wittenberg." In *Lucas Cranach.* Edited by P. Feist (see no. 887), pp.71-76.
 Discussion of Cranach's anti-papal and anti-ecclesiastical subjects in relation to Andreas Karlstadt, and the influence of Luther and Melanchthon on his religious works.

913
SZEKELY, GYÖRGY. "Wandlungen in Deutschland im Leben Cranachs." *Acta Historiae Artium Academiae Scientiarum Hungaricae* 19 (1973):231-49.
 Brief discussion of Cranach's activities in relation to the Reformation (pp. 238-41), and his social pretensions (pp. 243-46).

914
TALBOT, CHARLES W. Jr. "An Interpretation of Two Paintings by Cranach in the Artist's Late Style." *National Gallery of Art. Report and Studies in the History of Art.* Washington D.C., 1967, pp. 67-88, 14 illus.
 Analyzes a *Crucifixion* (Washington D.C., National Gallery of Art) from 1536, identifying its Protestant features in contrast to Cranach's early work. The conventional identification of the equestrian figure as Longinus is disputed on theological and iconographic grounds. Studies comparable changes of style and meaning in Cranach's *Nymph of the Spring,* surviving in several versions.

915
THULIN, OSKAR. *Cranach-Altäre der Reformation.* Berlin: Evangelische Verlagsanstalt, 1955, 167 pp., 192 illus.
 The basic survey of Cranach's major Protestant commissions; principally an iconographic study of 5 altarpieces and an epitaph monument. Concentrates on identifying the reformers portrayed in these works, elucidating the theological implications of the iconographic programs, and tracing related imagery.

916
THULIN, OSKAR. "Um Cranachs Künstlertum und Persönlichkeit." *Luther. Mitteilungen der Luthergesellschaft* 26 (1955):87-96, 8 illus.
 Musings about Cranach's Humanist and Protestant connections.

917
TROSCHKE, ASMUS von. "Studien zu Cranachischer Kunst im Herzogthum

Preussen." Doctoral dissertation. Königsberg, 1938. Printed Borna-Leipzig: Robert Noske, 1938, 48 pp., 9 illus.

Discusses a number of paintings in Prussian collections, several with Reformation content.

918
UHLITZSCH, JOACHIM. "Lucas Cranach - Der Maler der deutschen Reformation." *Bildende Kunst,* 1953, pp. 3-9, 2 color illus., 7 b&w illus. (Note: in table of contents listed incorrectly as "...der dtn. Renaissance").

Singles out Cranach's "realistic" works as praiseworthy contributions to the popular Reformation, while identifying certain works as "unsuccessful", these having been done for feudal patrons.

919
ULLMANN, ERNST. "Lucas Cranach der Ältere. Bürger und Hofmaler." In *Lucas Cranach.* Edited by P. Feist (see no. 887), pp. 59-65. Reprinted in E. Ullmann, ed., *Kunst und Reformation* (see no. 385), pp. 41-52.

Brief discussion of Cranach's style and patrons in the context of Reformation society.

920
WEIMAR, SCHLOSSMUSEUM. *Lucas Cranach. 1472-1553. Ein grosser Maler in bewegter Zeit.* Exhib. cat., 22 June - 15 October, 1972, 192 pp., 87 b&w illus., 1 color illus.

Includes essays briefly discussing Cranach in an historical context. See also no. 678.

921
WESTPHAL, VOLKER. "Zum Gemälde des Lucas Cranach d. Ä. 'Christus segnet die Kinder'." *Weltkunst* 41 (1971):226, 1 illus.

Publishes a previously unknown version of *Christ Blessing the Children* (Westdeutsche Kunstmesse, Cologne), attributed here to L. Cranach the Elder. This version is most closely related to those in Hamburg and Naumburg but appears to be earlier in date (before 1538).

VII. B. 12. b. Lucas Cranach the Younger

922
JURSCH, HANNA. "Der Cranach-Altar in der Stadtkirche zu Weimar." *Wissenschaftliche Zeitschrift der Friedrich-Schiller-Universität, Jena.* Gesellschafts- und Sprachwissenschaftliche Reihe, 3 (1954):69-80, 12 illus.

This Reformation altar of 1555 by Cranach the Younger centers on a crucifixion, allegorized according to the established Lutheran iconography of grace and salvation. This and the accompanying scenes are surveyed, and the historical circumstances at the time of the commission discussed.

923
JURSCH, HANNA. "Die Kunstdenkmäler." In *Die Stadtkirche zu St. Peter und Paul in Weimar*. Edited by Eva Schmidt. Berlin: Union Verlag, 1955, pp. 65-106, ca. 50 illus.

Surveys the monuments in the Weimar Stadtkirche, nearly all from the Reformation period. The Cranach *Crucifixion* altar (1555), the *Luther Triptych* showing 3 portraits of the reformer (1572), and various epitaphs and bronze panels are included. The curious triptych has a rhymed life of Luther inscribed on it, the text reprinted here (pp. 144-46).

924
JUSTI, LUDWIG. *Das grosse dreiteilige Gemälde aus der Herderkirche zu Weimar*. Berlin: Staatliche Museen, 1951, 24 pp.

Places into historical context the allegorical *Crucifixion* altarpiece of 1555 (Weimar, Stadtkirche) representing the Reformation concept of grace and salvation. The painting was executed in Cranach's workshop.

925
SCHADE, WERNER. "Die Epitaphbilder Lucas Cranachs d.J." In *Ze studiów nad sztuka XVI. wieku na Slasku i w krajach sasiednich*. Warsaw: Muzeum Slaskie we Wroclawin, 1968, pp. 63-76, 4 illus.

Discusses four major epitaph altars: *Epitaph for Friedrich the Wise* (Weimar Stadtkirche), *Raising of Lazarus* (destroyed), and two *Crucifixion* altars. The significance of epitaph monuments for the formal readoption of religious images in churches is stressed, in particular the changing relation between imagery and scripture as perceived by the reformers.

926
STROH, OTTO. "Der Wittenberger Altar. Theologischer Gemeindevortrag ueber das kirchliche Erbe der Reformation anlaesslich des 400. Todestages Dr. Martin Luthers." *Concordia Theological Monthly* 17 (1946):280-96.

Surveys the altar in the context of Luther's teaching on preaching, the eucharist, baptism, and confession. Seeks to elucidate the true "ecclesiastical heritage" of the Reformation. Cites primary sources only.

927
THULIN, OSKAR. "Die Reformatoren im Weinberg des Herrn. Ein Gemälde Lucas Cranachs d. J." *Luther-Jahrbuch* 25 (1958):141-45, 7 illus.

The *Vineyard of the Apostles* of 1569 in the Wittenberg Stadtkirche is interpreted for its theological content. It was donated as an epitaph for the biblical scholar and Protestant Paul Eber. The poem inscribed on the frame is transcribed and related to the Lutheran iconography of the work.

VII. B. 13. François Dubois

928

EHRMANN, JEAN. "Tableaux de massacres au XVIe siécle." *Bulletin de la Société de l'histoire du Protestantisme Français* 118 (1972):445-55, 2 illus.

Discusses two 16th-century paintings in the Lausanne museum showing massacres: the *Triumvir* (artist unknown), and *St. Bartholomew's Day* (François Dubois). Finds these and the many other massacre scenes of the time revealing a pattern of change in French art that leads to mannerism.

VII. B. 14. Albrecht Dürer

VII. B. 14. a. General

929

ANZELEWSKY, FEDJA. *Albrecht Dürer. Das malerische Werk*. Berlin: Deutscher Verlag für Kunstwissenschaft, 1971, 303 pp., 315 b&w illus., 8 color illus., index.

The most recent and thorough catalogue of Dürer's paintings. This is an essential reference work which touches on Dürer's relation to reformers in passing. For the history of the *Four Apostles,* pp. 274-79.

930

BAINTON, ROLAND H. "Dürer and Luther as the Man of Sorrows." *Art Bulletin* 29 (1947):269-72, 5 illus. Reprinted as "The Man of Sorrows in Dürer and Luther," in R. Bainton, *Studies on the Reformation*. Boston: Beacon Press, 1963, London: Hoddard and Stoughton, 1964, pp. 51-61.

Discussion of Dürer's portrayals of himself in the guise of Christ (1500 and 1522) is followed by a history of the visual and literary depictions of figures in imitation of Christ. Reviews Protestant and Catholic examples, with reference to a narrative of Luther's trial and a woodcut (1545) of Luther preaching, in which the Elector Johann Friedrich of Saxony is shown bearing a cross.

931

BALLSCHMITER, THEA; KLINGMANN, RENATE; and HAASE, BARBARA. "Zum Problem des Humanismus und Realismus in der Kunst Albrecht Dürers." *Wissenschaftliche Zeitschrift der Ernst-Moritz-Arndt-Universität Greifswald.* Gesellschafts- und Sprachwissenschaftliche Reihe 20 (1971):201-208, 4 illus.

Dürer's works, especially the *Riders of the Apocalypse* and the *Four Apostles,* are interpreted as reflections of the changing relationship between the individual and society. The Humanist realism and anti-papal convictions in his art are seen as transmitting the new consciousness of the Reformation era to the people.

932
BRAUNFELS, WOLFGANG. "Die reformatorische Bewegung im Spiegel von Dürers Spätwerk." In *Albrecht Dürer: Kunst einer Zeitwende*. Edited by H. Schade, (see no. 961), pp. 123-43, 2 illus.
The literary evidence for the development of Dürer's response to the Reformation serves as a basis for examining personal and devotional aspects of his late work. Drawings for a *Passion* cycle (1521) and the *Four Apostles* of 1526 (Munich, Alte Pinakothek) are treated among other works.

933
BÜHLER, WILHELM. "Dürers Melancholie und die Reformation," *Mitteilungen der Gesellschaft für vielfältigende Kunst* 49 (1926):10-11.
Regards the architectural elements and other measuring instruments in this print as signifying the end of Gothic church construction, and thus a foreshadowing of the Reformation. The implied significance of Gothic building is related to Albrecht von Scharfenberg's Grail Tempel in the [*Jüngerer*]*Titurel*, a text the author supposes Dürer must have known.

934
CHADRABA, RUDOLF. *Dürers Apokalypse. Eine ikonologische Deutung*. Prague: Verlag der Tschechoslowakischen Akademie der Wissenschaften, 1964, 213 pp., 126 illus., bibliog., index.
Dürer's *Apocalypse* is seen as a harbinger of the Reformation, prophesying the social changes and catastrophes which were shortly to follow.

935
CHADRABA, RUDOLF. "Politische Sinngehalte in Dürers Apokalypse." *Wissenschaftliche Zeitschrift der Humboldt-Universität zu Berlin*. Gesellschaft- und Sprachwissenschaftliche Reihe 12 (1963):79-106, 19 illus.
Argues that this woodcut cycle reflects the struggle of the German bourgeoisie against feudalism and the Roman papacy, specifically prefiguring "utopian" aspirations of Luther (which he later betrayed in accepting the territorial hegemony of the princes).

936
CONWAY, WILLIAM MARTIN. *Literary Remains of Albrecht Dürer*. London: C.J. Clay and Sons, 1889, xi, 288 pp., 14 illus., index. Reprinted as *The Writings of Albrecht Dürer*. Translated and edited by William Martin Conway, introduction by Alfred Werner. London: Peter Owen, 1958, xviii, 288 pp., 23 illus., index.
Translations of significant passages from Dürer's writings (from his publications and manuscripts), prefaced by historical introductions. On Dürer's intellectual and religious development, pp. 142-61, including a list of Luther's writings in Dürer's possession and a lengthy passage from the *Netherlandish Diary* appealing to Erasmus on Luther's behalf.

937
DOBBERT, EDUARD. "Albrecht Dürer und die Reformation." In Dobbert: *Reden*

und Aufsätze kunstgeschichtlichen Inhalts. Edited by Alfred G. Meyer and Oskar Wulff. Berlin: Wilhelm Ernst und Sohn, 1900, pp. 21-50.

Sees Dürer as a precursor and adherent of the Reformation. His religious convictions and basic sympathy with Luther's and Zwingli's ideas are identified in his works.

938
DORNIK-EGER, HANNA. *Albrecht Dürer und die Graphik der Reformationszeit.* Schriften der Bibliothek des Österreichischen Museums für angewandte Kunst, 2. Vienna: Österreichisches Museum für angewandte Kunst, 1969, 68 pp., 68 plates.

Published to accompany a museum exhibition, the introduction offers a concise treatment of Dürer's relation to the Reformation and of scholarly treatment of this subject. Sees critique of the Church in some early works (*Angels' Mass,* Rennes, Musée des Beaux-Arts). Distinguishes Dürer's and Cranach's approaches to Reformation art, and includes a descriptive catalogue of 85 works.

939
DORNIK-EGER, HANNA. "Albrecht Dürers Stellung zu Humanismus und Reformation." *Mitteilungen der Gesellschaft für vergleichende Kunstforschung in Wien* 25 (1972/73):1-6, 1 illus.

Identifies criticism of the established church in several early works, especially in the so-called *Angels' Mass* (Rennes, Musée des Beaux-Arts), which she interprets as an allegory directed against church abuses, specifically the sale of indulgences.

940
DÜRER, ALBRECHT. *Dürer. Schriftlicher Nachlass.* Edited by Hans Rupprich. 3 vols. Berlin: Deutscher Verein für Kunstwissenschaft, 1956-69.

Each volume contains an introductory essay, detailed annotations and notes, indexes and numerous illustrations. The essential, authoritative edition of Dürer's written works. Vol. 1 contains autobiographical writings, letters, and personal documents.

941
DÜRER, ALBRECHT. *Dürers Schriftlicher Nachlass.* Edited by K. Lange and F. Fuhse. Halle: Max Niemeyer, 1893, xxiv, 420 pp., index, 2 illus.

An early edition of Dürer's writings, now made obsolete by Rupprich's edition.

942
DVORAK, MAX. "Dürers Apokalypse." In *Kunstgeschichte als Geistesgeschichte. Studien zur abendländischen Kunstentwicklung.* Munich: R. Piper, 1928, pp. 191-202, 1 illus.

The woodcut cycle is seen as a sermon ("Predigt") reflecting pre-Reformation unrest, its anti-Roman elements a precursor to Luther's own dealing with the period's most important spiritual problems.

943
GROTE, LUDWIG. "Vom Handwerker zum Künstler. Das gesellschaftliche Ansehen Albrecht Dürers." In *Festschrift für Hans Liermann zum 70. Geburtstag. Erlanger Forschungen.* Reihe A: Geisteswissenschaften, 16 (1964):26-47.

Discusses briefly Dürer's relation to the group of Nurembergers associated with the Augustinian Johann von Staupitz, and the theological matters current within this circle. Dürer's relations with Melanchthon and other reformers considered in passing.

944
*HAACK, FRIEDRICH. "Die bildende Kunst und die Reformation." In *Die Reformation in Nürnberg.* Vereinigung evangelischer Akademiker in Nürnberg, 1925, pp. 65-73.

Sees connections between Dürer's art and Reformation emphasis on individuality.

945
HARBISON, CRAIG. "Dürer and the Reformation: The Problem of the Re-dating of the *St. Philip* Engraving." *Art Bulletin* 58 (1976):368-73, 3 illus.

Attributes the delay in completing the *St. Philip* engraving (1523-26) to Dürer's internal struggle over the value and function of religious imagery. Dürer's response to the Reformation debate on images is examined through his writings, his works contemporary with the *St. Philip* (the *Last Supper* woodcut and the *Four Apostles*), and Luther's writings.

946
HORN, CURT. "Dürer und die Reformation." *Kunst und Kirche* 5, no. 1 (1928/9):13-25, 5 illus.

Reexamines the question of Dürer's religious conviction, largely through an interpretation of his imagery (religious subjects and portraits). Dürer's late work is taken to reflect an increasing respect for Lutheranism, but finally a moderate position denying the radical elements on both sides.

947
HÜTT, WOLFGANG. "Verhältnis und Beitrag Albrecht Dürers zur Kunst der Reformationszeit." *Bildende Kunst,* 1971, pp. 235-39, 7 illus.

Identifies Humanist and Reformation elements in several works by Dürer.

948
KRODEL, GOTTFRIED. "Nürnberger Humanisten am Anfang des Abendmahls-streites. Eine Untersuchung zum Verhältnis Pirkheimers und Dürers zu Erasmus von Rotterdam besonders in den Jahren 1524-26." *Zeitschrift für bayerische Kirchengeschichte* 25 (1956):40-50.

Argues that in spite of differences (e.g. interpretation of the Last Supper) both Pirckheimer and Dürer came to share Erasmus' views about extremes in the Reformation movement. The *Four Apostels* panels are seen as a powerful statement against fanaticism (pp. 45-50).

949
KUSPIT, DONALD BURTON. "Dürer and the Lutheran Image." *Art in America*
63,1 (1975):56-61, 8 b&w illus., 5 color illus.
Examines the development of Dürer's late portraits, arguing that variations in
format and expression are related to the sitters' religious convictions. Those
among the leaders of the Reformation (Melanchthon, Holzschuher, Muffel etc.)
are said to reflect the experience of religious conversion.

950
*KUSPIT, DONALD BURTON. "Dürer and the Northern Critics, 1502-1572."
Ph.D. dissertation, University of Michigan, 1971, 383 pp.
In part concerned with the relation of Dürer's art to Protestantism.
Melanchthon's view of Dürer's art as the perfect rhetoric for religion, in
particular as a vehicle for Protestant introspection. See *Dissertation Abstracts
International* 32, no. 3 (1971):1414A.

951
KUSPIT, DONALD B. "Melanchthon and Dürer: the search for the simple style."
The Journal of Medieval and Renaissance Studies 3 (1973):177-202, 2 illus.
Analyzes Melanchthon's literary references to Dürer, in particular an
illustration of a principle of rhetoric where Dürer's "simple style" is praised.
This observation is related to classical rhetoric, and finally to Melanchthon's
concept of a Protestant style for which he saw Dürer's work ideally suited. This
notion of style is then shown to be essentially subjective and revelatory.

952
LEINZ-v. DESSAUER, ANTOINE. *Savonarola und Albrecht Dürer. Savonarola,
der Ritter in Dürers Meisterstich.* Munich: Schnell & Steiner, 1961, 59 pp., 36
illus.
A shorter version appeared in *Das Münster* 14 (1961). Connects the figure
of the knight in *Knight, Death and the Devil* with Savonarola. Argues that
Dürer's response to news of Luther's death and his appeal to Erasmus as "Ritter
Christi" imply familiarity with Savonarola's thought. Appendix (pp. 41-58)
includes relevant texts by Savonarola.

953
LÜDECKE, HEINZ, and HEILAND, SUSANNE. *Dürer und die Nachwelt.
Urkunden, Briefe, Dichtungen und wissenschaftliche Betrachtungen aus vier
Jahrhunderten.* Berlin: Rütten und Loening, 1955, 451 pp., 41 illus., bibliog.,
index.
A collection of early references to Dürer beginning in 1505. Pages 17-68
contain observations by various German Humanists and reformers culled from
essays, letters, books etc. (all translated or rendered into modern German).

954

MAURER, WILHELM. "Humanismus und Reformation im Nürnberg Pirckheimers und Dürers." *Jahrbuch für fränkische Landesforschung* 31 (1971):19-34.

Analyzes the effects of Humanism and of the Evangelical movement on Pirckheimer and Dürer. Drawn more to Luther than to Erasmus, and not deeply influenced by Humanism, Dürer remained true to the Lutheran approach while recognizing problems in the official progress of the Reformation.

955

MENDE, MATTHIAS. *Dürer-Bibliographie.* Wiesbaden: Otto Harrassowitz, 1971, xliv, 707 pp., indexes, 24 illus.

Comprehensive bibliography of primary and secondary sources ordered by topics. See especially part X on spiritual and political currents. 10,271 entries, annotated.

956

NUREMBERG, GERMANISCHES NATIONALMUSEUM. *Albrecht Dürer. 1471-1971.* Exhib. cat., 21 May - 1 August, 1971. Munich: Prestel-Verlag, 1971, 414 pp., 732 cat. entries, 16 color illus., 173 b&w illus., index of names.

A section is devoted to Dürer and the Reformation (pp. 199-213), prefaced with an essay by Bernward Deneke. The entries describe a variety of documents relating Dürer to reformers, visual and written sources pertaining to the image controversy, and pertinent works of art.

957

OECHSLIN, WERNER. "Albrecht Dürer tra storia dell'arte e ideologia (in occasione del cinquecentesimo anniversione dell'artista)." *Paragone. Arte* 22, no. 261 (1971):56-69, 1 illus.

Sharp and amusing criticism of German chauvinism as seen through various Dürer centennials and publications. Pages 63ff. review the history of scholarly (and not very scholarly) argument on Dürer's relationship to and significance for German Protestantism.

958

PANOFSKY, ERWIN. *Albrecht Dürer.* 2 vols. 3rd ed. Princeton: Princeton University Press, 1948, indexes, bibliog., 8 figs., 325 illus.

A full monographic study of the artist with a catalogue of works in all media. Dürer's relation to the Reformation movement, his specific response to Luther's teachings, and the influence of Protestant thought on his work are considered. See esp. chap. 7.

959

RASMUSSEN, JÖRG. "Zu Dürers unvollendetem Kupferstich 'Die große Kreuzigung.'" *Anzeiger des Germanischen Nationalmuseums,* 1981, pp. 56-79, 13 illus.

Identifies the iconographic idiosyncracies of this print and relates them to Dürer's Lutheran inclinations. The print is termed a "confessio Lutherana," and

its unfinished state attributed to a growing disillusionment on the artist's part over certain aspects of the Reformation.

960
SAXL, FRITZ. "Dürer and the Reformation." *Lectures* (see no. 379) vol. I, 267-76, vol. II., plates 182-94. Reprinted in F. Saxl, *A Heritage of Images* (see no. 379), pp. 105-17, 28 illus. (nos. 145-72).
Traces Italian and Humanist elements in Dürer's work and their integration with Lutheran ideas. Criticism of the papacy is seen already in the *Apocalypse* series, and Dürer's concern with Reformation issues is shown through reference to his writings, the *Mount of Olives* drawings (1521) and the *Four Apostles*.

961
SCHADE, HERBERT, ed. *Albrecht Dürer. Kunst einer Zeitwende*. Regensburg: Verlag Pustet, 1971, 143 pp., 12 illus.
Collection of 6 lectures delivered in 1970 by various scholars as part of the 500th year celebration of Dürer's birth. The editor's introduction (pp. 9-16) briefly reviews the importance of Dürer's career in the context of religious conflict in the early Reformation. See also Braunfels, no. 932.

962
SILVER, LARRY. "Christ-Bearer: Dürer, Luther, and St. Christopher." In *Essays in Northern European Art presented to Egbert Haverkamp-Begemann on his sixtieth birthday*. Doornspijk: Davaco, 1983, pp. 239-44, 4 illus.
Argues that Dürer's unusual fascination with the image of St. Christopher in 1521 (2 prints and a sheet of drawings) reflects his conversion to Lutheranism. Citations from Luther's writings referring to the saint are related to the images.

963
SINGER, HANS WOLFGANG. *Versuch einer Dürer-Bibliographie*. Studien zur deutschen Kunstgeschichte, 41. Strasbourg: J.H.Ed. Heitz, 1903; 2nd expanded edition 1928, xi, 198 pp., index.
Divided into 3 main sections: A, original works (chronologically and then topically arranged); B, large biographical/monographic studies (alphabetically by author); C, shorter studies (sub-divided under various topics i.e. C4=Dürer's religion). Many entries are briefly annotated.

964
SKRINE, PETER. "Dürer and the Temper of his Age." In *Essays on Dürer*. Edited by C.R. Dodwell. Manchester Studies in the History of Art, 2. Manchester & Toronto: Manchester and Toronto University Presses, 1973, pp. 24-42, 1 illus.
An assessment of Dürer's career in light of his relation to Humanist and Reformation patterns of thought and patronage.

965
STEJSKAL, KAREL. "Novy Vyklad Dürerovy Apokalypsy" [A new Interpretation of Dürer's Apocalypse]. *Uméni* n.s.14 (1966):1-64, 29 illus. German summary

pp. 60-64.

In Czech. Supports interpretations by M. Dvorak and R. Chadraba (see nos. 934, 935 and 942), specifically Chadraba's arguments about the *Apocalypse* as harbinger of the Reformation. Discusses the conflicting relationship of art to church in the Reformation period.

966

THODE, HENRY. "Albrecht Dürer. Deutsche Kunst und deutsche Reformation." In *Der Protestantismus am Ende des XIX. Jahrhunderts in Wort und Bild.* Edited by C. Werckshagen. Berlin: Wartburg, 1901, pp. 117-40, 38 illus.

Dürer is seen as a profound exponent of Protestantism whose early work presages Luther's later teaching.

967

THODE, HENRY. "Albrecht Dürer. Deutsche Kunst und deutsche Reformation." *Deutsch-evangelisches Jahrbuch* 1 (1909):148-73.

Subjectively interprets Dürer's religious art throughout his career as a reflection of Lutheran sensibility.

968

TIMKEN-ZINKANN, R.F. *Ein Mensch namens Dürer. Des Künstlers Leben, Ideen, Umwelt.* Berlin: Gebr. Mann, 1972, 225 pp., 88 illus.

Various aspects of Dürer's religious views and his art are discussed. One section (pp. 189-97) analyzes the validity of theories identifying anti-papal and social revolutionary propaganda in Dürer's works. Finds that Dürer was loyal to the Reformation (pp. 57, 131-35) but questions arguments for the presence of pre-Reformation elements (Chadraba, Lanckoronska) and for political interpretation of the *Peasant Monument.*

969

ULLMANN, ERNST et al, eds.. *Albrecht Dürer. Kunst im Aufbruch.* Vorträge der kunstwissenschaftlichen Tagung mit internationaler Beteiligung zu 500. Geburtstag von Albrecht Dürer. Karl-Marx-Univeristät Leipzig, 31. Mai bis 3. Juni 1971. Leipzig: Karl-Marx-Universität, 1972, xv, 392 pp., 107 b&w illus., 3 color illus.

A collection of articles by various scholars on Dürer and his time. See Ullmann (no. 722) and Wollgast (no. 1024).

970

WAETZOLDT, WILHELM. *Dürer und seine Zeit.* Vienna: Phaidon, 1935, 592 pp., 8 color illus., 351 b&w illus., index.

Includes a very well-balanced and comprehensive discussion of Dürer's relation to developments in the religious art of his time and the importance for him of Luther's teachings.

971

WEIGEL, RUDOLF. "Dr. Martin Luther, abgebildet von Albrecht Dürer." *Deutsches Kunstblatt* 1,38 (1850):297.

The first to see Luther's features in the St. John figure in Dürer's unfinished *Large Crucifixion* engraving.

972

WEIST. "Ein Glaubensbekenntnis in Bildern. 3 Kupferstiche Albrecht Dürers." *Die Wartburg* 4 (1905):442-44.

Identifies anti-papal tendencies in pre-Reformation prints, suggesting this anticipates the artist's Protestant leanings.

973

WIEDERANDERS, GERLINDE. *Albrecht Dürers theologische Anschauungen.* Berlin: Evangelische Verlagsanstalt, 1975, 131 pp., 20 illus., bibliog.

Poses the question of how much Dürer's work reflects his theological position. Reviews several themes: images of Christ, the Virgin, the Prodigal Son, etc. Pages 71-118 focus on Dürer and the Reformation. Concludes that mysticism and Humanism remained important influences, contributing to his firm commitment to the Reformation.

974

WITTBER, ALFRED. *Ritter trotz Tod und Teufel. Protestantisches zu Albrecht Dürers Kupferstich.* Berlin: Evangelische Verlagsanstalt, 1959, 24 pp., 1 illus. (cover).

An undocumented essay arguing a Reformation spirit in Dürer's image of the Christian knight.

975

ZSCHELLETZSCHKY, HERBERT. "Dürers Apokalypse-Folge -- ein Revolutionslied in religiösen Bildern." *Kunsterziehung* 18,5 (1971):7-13, 7 illus.

Sees hidden religious and social criticism in Dürer's *Apocalypse* cycle.

VII. B. 14. b. Dürer's belief

976

BAUCH, GUSTAV. "Zu Christoph Scheurls Briefbuch." *Neue Mitteilungen aus dem Gebiet historisch-antiquarischer Forschungen,* Halle, 19 (1898):400-456.

Publishes abstracts of two letters by Scheurl concerning Dürer, Luther, and Cranach. These documents are critical evidence for Dürer's interest in Luther's theology (p. 454).

977

BAUCH, GUSTAV. "Zu Luthers Briefwechsel." *Zeitschrift für Kirchengeschichte* 18 (1898):391-412.

Publishes two previously unprinted letters from Christoph Scheurl from 1519 which provide evidence of Dürer's concern for theological questions and his relation to Luther (p. 397).

978
CLEMEN, OTTO. "Melanchthon und Dürer. *Beiträge zur bayerischen Kirchen-geschichte* 26 (1920):29-38.
Dürer's interest in the theological questions of his time and his affinity with Melanchthon's views are illustrated by quotations from two letters by Christoph Scheurl and from Melanchthon's writings.

979
DANKO, JOSEPH. "Albrecht Dürers Glaubensbekenntnis. Eine theologisch-kunstgeschichtliche Studie." *Theologische Quartalschrift* 70 (1888):244-286.
Concisely summarizes the opinions taken in the debate over Dürer's religious position, reviewing the evidence and analyzing the arguments. Offers a careful, unpolemical Catholic view.

980
DREXLER, E. "Albrecht Dürers Stellung zur Reformation." *Archiv für christliche Kunst* 16 (1898):104-7, 111-15; 17 (1898):13-17, 24-27.
Reasonable, documented and detailed discussion of Dürer's Protestant leanings based on quotations from his writings and some analysis of his works.

981
EDER, KARL. "Dürer als religiöser Maler. *Christliche Kunstblätter* 69, 4-6 (1928):33-37, 5 illus.
Dürer withdrew his sympathy from the Lutheran movement because of the "iconoclasm, atheism, fanaticism and communism" it inspired in Nuremberg.

982
*FRIZZONI, GUSTAVO. "Delle Relazioni di Alberto Duro colla riforma religiosa di Lutero." *Arte e storia* 3 (1884):42-43.

983
FRUHSTORFER, KARL. "War Albrecht Dürer Protestant?" *Christliche Kunst-blätter* 69,10-12 (1928):124.
Dürer was never really against the Catholic Church but against "Freigeisterei."

984
*FUSSGÄNGER, THEODOR. "Albrecht Dürer und sein Verhältnis zur Reformation." *Evangelische Kirchenzeitung für Österreich* 13 (1896):257-59, 277-78, 293-95.

985
*GERKE, FRIEDRICH. *Der Christus Dürers und Luthers. Glaube und Volk in der Entscheidung.* (1936). Reprinted in F. Gerke, *Reformatio* (see no. 428).
Stresses parallels in Dürer's and Luther's particular views on the relation between Christ and human suffering.

986
GRIMM, HERMANN. "Der Abgeordnete Reichensperger und die Deutsche Kunst." *Preußische Jahrbücher* 37 (1876):92-96, 642-50.
A critical response to Reichensperger's views (see no. 1009) on Dürer's faith. Reasonable arguments presented for Dürer's commitment to Luther.

987
GÜNTHER, RUDOLF. "Dürer und Luther." *Monatsschrift für Gottesdienst und kirchliche Kunst* 33 (1928):192-96.
General musings on the significance of Dürer and Luther as exemplifications of the "German spirit."

988
KALKOFF, PAUL. "Dürers Verhältnis zu Luther und seiner Lehre." *Luther. Mitteilungen der Luthergesellschaft* 5 (1923):33-42.
General overview of Dürer's attitude towards Protestantism from 1520 to 1526.

989
KALKOFF, PAUL. "Zur Lebensgeschichte Albrecht Dürers. Dürer im Mittelpunkt der lutherischen Bewegung in den Niederlanden und sein Verhältnis zu Erasmus von Rotterdam." *Repertorium für Kunstwissenschaft* 27 (1904):346-62.
Follows an earlier article of 1897 (see no. 990), offering a closer look at the reformer circles Dürer associated with in Antwerp. Argues that Dürer was Erasmian as well as Lutheran.

990
KALKOFF, PAUL. "Zur Lebensgeschichte Albrecht Dürer's. Dürer's Flucht vor der niederländischen Inquisition und Anderes." *Repertorium für Kunstwissenschaft* 20 (1897):443-63.
Detailed history of Dürer's sojourn in the Netherlands (1520-21) and his contact there with Protestant circles.

991
KAPPUS, THEODOR. "Albrecht Dürer und die Reformation." *Die Wartburg* 4 (1905):439-442, 1 illus.
Praises Dürer as a fiercely German and Protestant artist.

992
KAUFMANN, LEOPOLD. *Albrecht Dürer.* Görres-Gesellschaft, no. 1, 1881. Cologne: J.P. Bachem, 1881, viii, 112 pp.
Chapter XI on Dürer and the Reformation admits Dürer's early admiration for Luther but argues that he, along with Pirckheimer, later retracted, ending his life as a faithful son of the Catholic church.

993
KAWERAU, GUSTAV. "Dürers Stellung zur Reformation." *Die christliche Welt* 1 (1887):411-14.

A polemical rehearsal of arguments for supposing Dürer was a Protestant.

994
KINKEL, GOTTFRIED. "Eine populäre Biographie Dürers, nebst einigen neuen Notizen des Referenten über Dürers religiöse Ansicht und über dessen Kupferstich 'Nemesis'." *Zeitschrift für bildende Kunst* 16 (1881):332-36.
A review of L. Kaufmann's study of Dürer (see no. 992), with additional comments on Dürer's religious convictions. Points out that it was still possible before 1530 to be a Catholic and an admirer of Luther. That Dürer was critical of the cult of the Virgin is demonstrated by a previously unpublished comment in Dürer's hand on M. Ostendorfer's woodcut showing the *Church of the Schöne Maria in Regensburg.*

995
KLEIN, TIM. "Albrecht Dürer und die Reformation." *Zeitwende* 4 (1928):377-79.
A plea for reasonableness in discussions of Dürer's religious views. Points out that Dürer belonged to neither the "Protestant" nor "Catholic" church, since neither existed as such during his lifetime. He, like Luther, was still in the "old church", though his sympathy lay clearly with the reforming movement.

996
KLEMM, H. "Wie Albrecht Dürer unserem Doktor Martin Luther Handlangerdienste tat." *Der alte Glaube* 5 (1904):609-13.
Argues that Dürer helped prepare the German people for Luther's message, particularly with *Melencolia I.*

997
KOLDE, THEODOR. "Albrecht Dürer und die Reformation." *Konservative Monatsschrift* 44 (1887):355-67, 449-55.
Places Zucker's interpretation of Dürer as a loyal supporter of Luther (see no. 1026) within the broader context of the Reformation years in Nuremberg.

998
LANGE, KONRAD. "War Dürer ein Papist?" *Die Grenzboten* 55, 1 (1896):266-280.
Polemical denunciation of Georg Anton Weber's attempts to interpret Dürer as a Catholic (see no. 1021). Reiterates various arguments for the artist's Protestant convictions.

999
LUTZ, HEINRICH. "Albrecht Dürer in der Geschichte der Reformation." *Historische Zeitschrift* 206 (1968):22-44.
Reviews Dürer's attitude toward Protestantism through careful reading of available historical documents. Discusses the complexity of Dürer's beliefs as they developed in the later stages of his career.

1000
LUTZ, HEINRICH. "Albrecht Dürer und die Reformation. Offene Fragen." In

Miscellanea Bibliothecae Hertzianae. Zu Ehren von Leo Bruhns, Franz Graf Wolff Metternich, Ludwig Schudt. Römische Forschungen der Bibliotheca Hertziana, 16. Munich: Verlag Anton Schroll & Co., 1961, pp. 175-83.

Examines documents indicating Dürer's connections with Luther, Zwingli, Melanchthon, Karlstadt, and Denck. Dürer's silence over the trial of Denck and "die drei gottlosen Maler," and Pirckheimer's disaffection with the Reformation after 1525 question the degree of Dürer's allegiance to the new order. Concludes that Dürer's early enthusiasm for Luther changed to an attitude reflecting scepticism and disappointment.

1001
*MATHEWS, WENDELL GLEN. "Albrecht Dürer as a Reformation Figure." Ph.D. dissertation, University of Iowa, 1968, 206 pp.

Examines various interpretations of Dürer's religious beliefs and their relevance to his art, centering on 19th-century scholarship. Finally argues that Dürer's involvement with the Reformation can best be seen in his concept of the "Word of God" as evidenced in the artist's religious thought from 1520 on. See *Dissertation Abstracts* 29 (1968):669.

1002
MIEDEMA, REIN. *Albrecht Dürer en de reformatie.* Huis ter Heide: De Tijdstroom, 1926, 152 pp., 32 illus.

Dürer's career is surveyed in a topical essay suggesting analogies with Reformation attitudes. This is not a documented study of his religious position or the iconography of his art.

1003
O'DONNELL, H. G. *Die religiöse Kunstrichtung Albrecht Dürers. Eine Prüfung der Ansichten des Herrn von Rettberg, Verfasser von Nürnbergs Kunstleben.* Stuttgart/Vienna: A. Pichler's Witwe & Sohn, 1854, 14 pp.

Forcefully opposes R. von Rettberg's view (see no. 447) that Dürer was a Protestant. Dürer's life and works are reviewed, and his sympathy for the "sogenannte Reformation" denied.

1004
O'SHEA, JOHN J. "The Question of Albert Duerer's religion." *The American Catholic Quarterly Review* 37 (1912):110-23.

Intensely partisan attack on the notion of the Reformation, and an attempt to rescue Dürer from any association with it.

1005
PFEIFFER, GERHARD. "Albrecht Dürer und Lazarus Spengler." In *Festschrift für Max Spindler zum 75. Geburtstag.* Edited by Dieter Albrecht et al. Munich: C.H. Beck'sche Verlagsbuchhandlung, 1969, pp. 379-400.

Discusses the evolving responses of Spengler and Pirckheimer to the Reformation, and in this context the evidence for Dürer's attitude to Lutheran teaching. The author concludes that Spengler and Dürer were first attracted to Protestant positions for Humanist reasons, but finally divided over the

institutionalization of the faith in Nuremberg.

1006
PFLEIDERER, RUDOLF. "Albrecht Dürer gehört uns! Eine Untersuchung und Feststellung betreffend sein Verhältnis zur evangelischen Sache. Zum Reformationsjubeljahr 1917." *Christliches Kunstblatt für Kirche, Schule und Haus* 59 (1917):309-17, 1 illus.
Dürer is interpreted as a committed Protestant.

1007
PREUSS, HANS. "Lutherisches in Dürers Kunst." In *Geschichtliche Studien. Albert Hauck zum 70. Geburtstage.* Leipzig: Hinrichs, 1916, pp. 331-38.
Attempts to analyze Dürer's piety in relation to Luther by surveying particular themes and finding certain similarities, for example their common notion of a "manly" Christ.

1008
RAUSCHER, J. "Dürer und die Reformation" *Christliches Kunstblatt für Kirche, Schule und Haus* 55 (1913):41-51.
Reviews the question of Dürer's religious allegiance through his and others' writings and by surveying the artistic testimony, finding a deep commitment to Luther's views.

1009
REICHENSPERGER, A. *Ueber deutsche Kunst.* Cologne: J.P. Bachern, 1876, 27 pp.
A defensive attack on Hermann Grimm (see no. 986). Reiterates his own view that Dürer denied Protestantism. Quotes in full Pirckheimer's letter regarding Dürer's beliefs.

1010
REMBERT, KARL. "Dürer, Albrecht; seine Stellung zu den kirchlichen Reformparteien." In *Mennonitisches Lexikon.* Edited by C. Hege et al. Vol. 1. Frankfurt, Heinrich Schneider, 1913, pp. 486-93.
Analyzes Dürer's religious views by surveying his major works (finding early criticism of the Church) and his connections with Protestants and Humanists of the time.

1011
RUPPRICH, HANS. *Dürers Stellung zu den agnoëtischen und kunstfeindlichen Strömungen seiner Zeit.* Bayerische Akademie der Wissenschaften. Philosophisch-historische Klasse, Sitzungsberichte, 1. Munich: Verlag der Bayerischen Akademie der Wissenschaften, 1959, 31 pp.
A detailed examination of Dürer's recorded views on art, stressing in particular his responses to the anti-image tendencies among radical movements of the Reformation. Dürer's defence of religious art on classical, scriptural, and Humanist grounds became pointed in a dedication to the *Unterweisung der Messung* (see no. 808), where his remarks are assumed to be aimed especially at

the Anabaptists. Dürer's other comments on the Reformation and art are analyzed as well, including the inscriptions on the *Four Apostles* and a previously unknown dedication letter, intended for the *Treatise on Human Proportion* (pp. 23-26).

1012

SCHRADE, HUBERT. "Die religiösen Grundlagen von Dürers Schriften zur Kunst." *Zeitschrift für deutsche Bildung* 10 (1934):22-29.

Quotations asserting the ethical-religious foundation of art are culled from Dürer's writings and discussed briefly. Dürer's thought is related to Johannes Tauler, and only tangentially to Luther and the Reformation.

1013

SEEBAß, GOTTFRIED. "Dürer und die Reformation." *Luther. Zeitschrift der Luther-Gesellschaft* 42 (1971):49-66.

Shorter version of his Festschrift article (see no. 1014) with quotations here rendered in modern German.

1014

SEEBAß, GOTTFRIED. "Dürers Stellung in der reformatorischen Bewegung." In *Albrecht Dürers Umwelt. Festschrift zum 500. Geburtstag Albrecht Dürers am 21. Mai 1971.* Nuremberg: Selbstverlag des Vereins für Geschichte der Stadt Nürnberg, 1971, pp. 101-31.

A critical review of scholarship, followed by an evaluation of direct and indirect evidence for determining Dürer's change of religious conviction. The author concentrates on the stages leading up to Dürer's declaration for Luther in the 1521 *Diaries,* relating the testimony of his writings to his intellectual circle and the progress of the Reformation in Nuremberg.

1015

STIASSNY, ROBERT. "Dürer und die Reformation." *Die Gegenwart. Wochenschrift für Literatur, Kunst und öffentliches Leben* 32 (1887):249-50, 265-67.

Reviews evidence for Dürer's adherence to Luther, and concludes the artist remained loyal to the reformer's views, though points out that the churches were not yet separate during Dürer's lifetime.

1016

[STRAETER, A.] "Albrecht Dürer's Briefe, Tagebücher und Reime." *Historisch-politische Blätter für das katholische Deutschland* 75 (1875):284-95.

Uses selected passages from Dürer's writings to argue that he remained fundamentally Catholic.

1017

STROBEL, GEORG THEODOR. "Melanchthon von Albrecht Dürer." In Strobel, *Miscellaneen Literarischen Inhalts.* Vol. 6. Nuremberg, n.p., 1782, pp. 207-14.

Publishes passages from letters by Melanchthon and Pirckheimer referring to Dürer and Luther.

1018
STUHLFAUTH, GEORG. "Albrecht Dürer in neuester konfessioneller Beleuchtung." *Deutsch-evangelische Blätter. Zeitschrift für den gesamten Bereich des deutschen Protestantismus* 32 (1907):835-59.
Discusses the question of Dürer's religious convictions, dealing critically with Georg Anton Weber's arguments (see nos. 1021 and 1022) for the artist's Catholicism, and concluding Dürer was a Protestant.

1019
THAUSING, MORIZ. *Dürer. Geschichte seines Lebens und seiner Kunst.* 2 vols. 2nd edition, Leipzig: E.A. Seemann, 1884.
A chapter on the Reformation (pp.218-89) covers Dürer's religious views as expressed in his writings and his works of art as well as reviewing the biographical factors that argue for his Lutheran leanings, such as his friendship with Pirckheimer and his association with self-declared Protestant artists.

1020
THAUSING, MORIZ. "Dürer und die Reformation." In Thausing, *Wiener Kunstbriefe*. Leipzig: E.A. Seemann, 1884, pp. 99-117. First in *Neue Freie Presse* (Vienna) 25 Oct. 1881.
Argues for Dürer's loyalty to the Lutheran cause.

1021
WEBER, [GEORG] ANTON. *Albrecht Dürer. Sein Leben, Wirken und Glauben kurz dargestellt.* Regensburg/New York/Cincinnati: Friedrich Pustet, 1894, iv, 115 pp., 11 illus., index.
A chapter given to Dürer's religious convictions (pp. 53-108) strongly defends the artist's unbroken allegiance to Catholicism.

1022
WEBER, GEORG ANTON. "Zur Streitfrage über Dürer's religiöses Bekenntniß." *Der Katholik. Zeitschrift für katholische Wissenschaft und kirchliches Leben* 79 (1899):322-33, 410-27.
Reviews scholarly opinions on the question of Dürer's religious convictions, adding a few more details to his arguments (see no. 1021) that the artist remained Catholic.

1023
WEBER, PAUL. *Beiträge zu Dürers Weltanschauung. Eine Studie über die 3 Stiche Ritter und Teufel, Melancholie und Hieronymus im Gehäus.* Studien zur deutschen Kunstgeschichte, 23. Strasbourg: J.H.Ed. Heitz, 1900, 110 pp., 11 illus., index.
Sees Dürer's engravings as expressive of an inner conflict that itself reflected the melancholic mood of the "German nation" at the time of the Reformation crisis.

1024

WOLLGAST, SIEGFRIED. "Albrecht Dürer - Sein Verhältnis zum 'linken Flügel' der Reformation." In *Albrecht Dürer. Kunst im Aufbruch.* Edited by E. Ullmann (see no. 969), pp. 199-205.

The inscription on the *Four Apostles* reveals Dürer's scepticism about church institutions. Argues that his familiarity with mysticism and his disappointment over the events of 1525 led him to sympathize with the radical elements of the Reformation. Dürer's association with the Behams, Sebastian Franck and possibly L. Hätzer are seen as further evidence of this.

1025

ZUCKER, MARKUS. *Albrecht Dürer.* Schriften des Vereins für Reformations-geschichte, 17 (1899-1900). Halle a.S.: Max Niemeyer, 1900, v, 184 pp., 66 illus., index.

Chapter 16 on Dürer's attitude to the Reformation demonstrates the artist's loyalty to Lutheran ideas. The author surveys the biographical evidence for Dürer's religious convictions (his writings, personal acquaintances etc.).

1026

ZUCKER, MARKUS. *Dürers Stellung zur Reformation.* Erlangen: Verlag von Andreas Deichert, 1886, vi, 80 pp.

In order to support the interpretation of Dürer as a Lutheran, especially as presented by Thausing (see no. 1019), Zucker presents here all the relevant written sources in chronological order and with commentary.

1027

ZUCKER, MARKUS. "Dürers Stellung zur Reformation." In *Beiträge zur bayerischen Kirchengeschichte* 1 (1895):275-80.

Zucker here defends his earlier study (see no. 1026) against opponents who deny that the extant documents are valid proof of Dürer's commitment to Luther. He argues especially against G.A. Weber's thesis (see no. 1021) that the inscriptions on the *Four Apostles* cannot be used as evidence.

VII. B. 14. c. Dürer's *Four Apostles*

1028

CHRISTENSEN, CARL C. "Dürer's 'Four Apostles' and the Dedication as a Form of Renaissance Art Patronage." *Renaissance Quarterly* 20 (1967):325-34.

Material incorporated into the author's book (see no. 419, excursus, pp. 181ff.).

1029

EINEM, HERBERT von. "Dürers 'Vier Apostel.'" *Anzeiger des Germanischen National-Museums* (1969):89-103, 7 illus.

Interprets the panels and their inscriptions in relation to Dürer's Lutheran

sympathies, stressing the significance of this work as a statement of Dürer's artistic ideals and the threat posed to them by radical elements of the Reformation.

1030
HEIDRICH, ERNST. *Dürer und die Reformation.* Leipzig: Klinkhardt & Biermann, 1909, 82 pp., 1 illus.
 One of the first extended investigations of the question, concentrating primarily on the *Four Apostles,* with an excursus treating contextual evidence for Dürer's Lutheran sympathies. The author argues that the inscriptions on the paintings warn against radical elements of the Reformation rather than the Roman Church.

1031
KAUFFMANN, HANS. *Albrecht Dürer "Die Vier Apostel."* Utrecht: Vrienden Kunsthistorisch Instituut Utrecht, 1973, 33 pp. 7 illus.
 The text of a lecture, placing the work in the context of Dürer's career and the period. Detailed attention is given to the Nuremberg Rathaus where Dürer finally intended the paintings to go. The panels are related to the decorative scheme and iconography of the building.

1032
KÜHNER, KARL. "Neue Geschichtspunkte zur Würdigung von Dürers 'Vier Apostel'-Bild," *Protestantische Monatshefte* 15 (1911):233-38.
 Interprets the panels' inscriptions as directed specifically against religious extremists, Anabaptists, and the revolutionary peasants.

1033
LANKHEIT, KLAUS. "Dürers 'Vier Apostel'." *Zeitschrift für Theologie und Kirche* 49 (1952):238-54, 4 illus.
 Agrees with Panofsky that the inscriptions caution against radical elements in the Reformation, and accepts the panels were originally intended as wings for a cult image. But the wings alone (inscriptions now supplanting a center panel) break from tradition, giving prominence to the Word in accord with Luther's view of the importance of preaching. The *Four Apostles* opens the way to the Lutheran *Kanzelaltar,* a painted sermon.

1034
MARTIN, KURT. *Albrecht Dürer. Die Vier Apostel.* Werkmonographien zur bildenden Kunst in Reclams Universal-Bibliothek, 87. Stuttgart: Philipp Reclam, 1963, 32 pp., 19 illus., bibliog.
 A summary of the panels' history and the history of their interpretation told through an interweaving of commentary and quotations from Dürer's works and from scholarly publications. Reports technical examinations which contradict Panofsky's reconstruction of the evolution of the figures (see no. 1037). In fact, it appears that the four-figure composition with inscriptions was conceived from the outset.

1035
MERZ, HEINRICH. "Luther, Dürer und die 'vier Apostel'." *Christliches Kunstblatt für Kirche, Schule und Haus* 29, 2 (1887):17-26.

Discusses the *Four Apostles* as evidence that Dürer remained a loyal friend of Luther and firm Protestant until his death.

1036
NEUMANN, CARL. "Die vier Apostel von Albrecht Dürer in ihrer ursprünglichen Gestalt." *Zeitschrift für deutsche Bildung* 6 (1930):450-59, 6 illus.

Stresses the importance of the inscriptions in Dürer's conception of these figures. Considers the significance of the passages chosen and of the relationship between text and image here and in other works by Dürer.

1037
PANOFSKY, ERWIN. "Zwei Dürerprobleme." *Münchner Jahrbuch der bildenden Kunst,* n.s. 8 (1931):1-48, 29 illus.

Argues the original plan for the *Four Apostles* was rethought by Dürer in 1525 when the Nuremberg Council officially accepted the Reformation. An earlier figure of Philip was transformed into St. Paul and set in opposition to St. Peter. The program of the Apostles and Evangelists representing the four temperaments was established. The panels were presented by Dürer as a warning to the town council about the need for good leadership (pp. 38-48).

1038
PREUSS, HANS. "Dürers religiöse Sendung." *Korrespondenzblatt für die evangelisch-lutherischen Geistlichen in Bayern* 53 (1928):80-82.

The *Four Apostles* is regarded as a clear expression of Dürer's allegiance to Lutheran views.

1039
SCHUBRING, PAUL. "Dürer und die Reformation." *Christliches Kunstblatt für Kirche, Schule und Haus* 52 (1910):370-74.

Supports Heidrich's interpretation of the *Four Apostles* (see no. 1030) as demonstrating a personal commitment to Luther and a criticism of the excesses of Anabaptists and zealots. Artistic weaknesses in the panels are seen as reflections of Dürer's individual anxieties.

1040
STRIEDER, PETER. "Albrecht Dürers 'Vier Apostel' im Nürnberger Rathaus." In *Festschrift Klaus Lankheit.* Edited by Wolfgang Hartmann. Cologne: M. DuMont Schauberg, 1973, pp. 151-57, 8 illus. (nos. 46-53).

Interprets the panels as a personal memorial and as an admonishment to the Nuremberg city council that they must rule their reformed city according to God's law as well as man's. The original negotiations over the gift of the panels are recorded in a copy of 1627, published here, including Dürer's wish that the panels never be removed from Nuremberg.

1041
ULLMANN, ERNST. "Albrecht Dürer und das Menschenbild der frühbürgerlichen Revolution in der bildenden Kunst." In *450 Jahre Reformation.* Edited by Leo Stern and Max Steinmetz. Berlin: Deutscher Verlag der Wissenschaften, 1967, pp. 248-61, plates 71-80.

Sees a new, individualized image of man growing out of Reformation art, with Dürer's *Four Apostles,* portraits, etc. illustrating a new social consciousness.

1042
VOGT, ADOLF MAX. "Albrecht Dürer -- Die Vier Apostel." In *Festschrift Kurt Badt zum siebzigsten Geburtstage.* Edited by Martin Gosebruch. Berlin: Walter de Gruyter & Co., 1961, pp. 121-34.

Set in context of Reformation unrest and its pertinence for Dürer, the painting is analyzed mainly in terms of its formal structure as a transmitter of religious meaning.

1043
ZASKE, NIKOLAUS. "Albrecht Dürers Vier Apostel -- wissenschaftliche Interpretation und schöpferische Anneigung." *Wissenschaftliche Zeitschrift der Ernst-Moritz-Arndt-Universität, Greifswald.* Gesellschafts- und Sprachwissenschaftliche Reihe 20 (1971):165-70, 1 illus.

Considers these panels in relation to their possible original intentions (wings of a Crucifixion, donor panels?). The theoretical implications of the residue of such original intentions in the final works donated to the city council are explored.

VII. B. 15. Jean Duvet

1044
EISLER, COLIN. *The Master of the Unicorn. The Life and Work of Jean Duvet.* New York: Abaris Books, 1979, xiv, 370 pp., 158 illus., bibliog., index.

Detailed monograph on this French painter and engraver including a catalogue of his works. Duvet's career is tied to contemporary religious conflict. His Calvinist position is discussed in relation to his work (3 chaps. devoted to the *Apocalypse* series of 1555/61 showing anti-Roman sentiments, and further allusions to political turmoil in France).

VII. B. 16. Conrad Faber

1045
HINZ, BERTHOLD. "Innerlichkeit und ihre äusserlichen Bedingungen: das humanistische Bildnis des Justinian und der Anna von Holzhausen." *Städel Jahrbuch,* n.s. 5 (1975):97-110, 7 illus.

Places this portrait by Conrad Faber (Frankfurt, Städelsches Kunstinstitut) in the context of Reformation notions of marriage. The Lutheran and Anabaptist positions are considered in particular. Holzhausen's part in suppressing the Anabaptists in Münster (the siege of the city is portrayed in the painting) is related to the portrait as a statement of social and political position.

VII. B. 17. Peter Flötner

1046
BANGE, E.F. *Peter Flötner*. Meister der Graphik, 14. Leipzig: Klinkhardt & Biermann, 1926, vii, 43 pp., 52 illus.
Surveys Flötner's woodcuts, including numerous anti-papal satires, with a descriptive catalogue in chronological order and a concordance relating his numbering to previous catalogues raisonnés.

VII. B. 18. Jean Goujon

1047
DEONNA, W[ALDEMAR]. "Un relief de Jean Goujon à Genève?" *Gazette des Beaux-Arts* 71,2 (1929):357-71, 5 illus.
Concerns a bas-relief (1561) decorating the Collège de Calvin in Geneva. Two allegorical figures of Science and War are seen to reflect the spirit of the city in times of religious struggle, acknowledging that science cannot flourish without the aid of arms. Concludes this piece was done by a disciple of Goujon's after a design by the master. The notes contain useful bibliography on the Collège de Calvin (the new buildings were inaugurated in 1559) and on Goujon.

1048
SANDONNINI, TOMMASEO and MONTAIGLON, ANATOLE DE. "Jean Goujon, la vérité sur sa religion et sur sa morte." *Bulletin historique et littéraire de la Société du protestantisme francais* 35(1886):376-80.
Legend had previously held that the artist Goujon, as a Protestant, died a martyr in the Bartholomew's Day Massacre. A document republished here shows that in fact he died in Bologna as a refugee from religious persecution, four years before the massacre.

VII. B. 19. Matthias Grünewald

1049
HAGEN, OSKAR. *Matthias Grünewald*. Munich: R. Piper & Co., 1919, 227 pp., 111 illus.
Considers the drawing of three grotesque heads as a demonic Trinity, a

blasphemous satire on Catholic doctrine (pp. 196-202; 223-24). Not directly concerned with the question of Grünewald's relation to the Reformation.

1050
HOFFMANN, HANS. *Das Bekenntnis des Meisters Mathis. Eine Deutung der Erasmus-Mauritius-Tafel des Matthias Grünewald.* Munich: Evangelischer Presseverband für Bayern, 1961, 52 pp., 6 b&w plates, 1 color plate.
Interprets the figure of St. Erasmus as Albrecht of Brandenburg, and St. Mauritius as Luther. The painting itself is thus taken as Grünewald's testimony to Luther.

1051
HÜTT, WOLFGANG. *Mathis Gothardt-Neithardt, genannt 'Grünewald'. Leben und Werk im Spiegel der Forschung.* Leipzig: VEB E.A. Seemann Verlag, 1968, 196 pp., 147 illus.
Emphasizes general social and economic trends as background for Grünewald's art. Argues for his close association with Protestant attitudes and for a strong sympathy with the peasantry, despite his activity as a court artist. This view is supported by reference to Grünewald's death inventory, his acquaintances, his art and secondary literature (esp. pp. 5-28; 150-54).

1052
KAYSER, STEPHEN S. "Grünewald's Christianity." *Review of Religion* 5 (1940):3-35, 4 illus.
Centers on the pre-Reformation Isenheim Altarpiece and explicates its message as a statement of revelation urging a renewal of faith. Parallels are drawn with the preachings of Geiler von Kaisersberg, in contrast to the Lutheran iconography for the relation of Old and New Testaments (as in Cranach's theological allegories).

1053
KEHL, ANTON. *"Grünewald"-Forschungen.* Neustadt a.d. Aisch: Kommissionsverlag Ph. C.W. Schmidt, 1964, 247 pp., 49 illus., bibliog.
A collection of documents important for Grünewald scholarship. Chap. 9 (pp. 109-14) deals with the artist's religious position, concluding on the basis of a 1528 inventory (document no. 22, pp. 151-60) that he may have followed Luther's teachings.

1054
MARKERT, EMIL. "Trias Romana. Zur Deutung einer Grünewaldzeichnung." *Wallraf-Richartz-Jahrbuch* 12/13 (1943):198-214, 7 illus.
Disputes interpretation of the ca. 1520 drawing of three heads (Berlin) as a satire on the Trinity. Explicates the image in relation to writings by Ulrich von Hutten as a satire on papal Rome, personifying her three vicious "citizens": pleasures of the flesh, greed, and pride.

1055
NEMILOV, A. "Matis Nithart-Grjuneval'd i iskusstvo epohi Krest'janskoj vojny v

Germanii" [Matthias Nithart-Grünewald and the art at the time of the Peasants' War in Germany]. *Iskusstvo* 38,4 (1975):57-64, 8 b&w illus., 2 color illus. In Polish. Considers Grünewald's relation to the Reformation as seen through his art.

1056

RÜGAMER, WILHELM. "Der Isenheimer Altar Matthias Grünewalds im Lichte der Liturgie und der kirchlichen Reformbewegung." *Theologische Quartalschrift* 120 (1939):145-63; 371-82; 442-60. 121 (1940):86-102; 217-44.
 Detailed iconographic analysis of the panels in terms of traditional Christian symbols drawn especially from the liturgy. The author seeks to identify appeals for church reforms within the more traditional aspects of the work.

1057

SCHMID, HEINRICH ALFRED. *Die Gemaelde und Zeichnungen von Matthias Grünewald.* 2 vols. Strasbourg: Verlag von W. Heinrich, 1911, vol. 1: 69 plates; vol. 2: viii, 395 pp., 87 illus., bibliog., index.
 Grünewald's first major biographer discusses the artist's possible Reformation leanings pp. 45-48. He suggests potentially anti-trinitarian sentiments in the drawing of three grotesque heads in a nimbus, and questions the likelihood of Anabaptist sympathies, concluding there is no real evidence.

1058

VOßBERG, HERBERT. "Grünewald und die Wittenberger Reformation." *Herbergen der Christenheit. Jahrbuch für deutsche Kirchengeschichte 1965.* Beiträge zur Kirchengeschichte Deutschlands, 5. Berlin: Evangelische Verlagsanstalt, 1965, pp. 9-33.
 Approaches the question of Grünewald's relationship to the Protestant Reformation by correlating the artist's activities (based partly on new archival material) with Reformation events, documenting his contacts with Lutheran circles, etc. Concludes Grünewald was sympathetic to the reform movement.

1059

VOßBERG, HERBERT. "Grünewalds Sohn bei Luther." *Lutherische Kirche* 5(1974):107-10.
 Recounts the contents of a 17th-century family chronicle which reports a meeting between Grünewald's adopted son and Luther in Wittenberg in 1538. The discussion supposed to have taken place gives evidence of Luther's awareness of Grünewald.

1060

ZÜLCH, W.K. *Der historische Grünewald: Mathis Gothardt-Neithardt.* Munich: F. Bruckmann Verlag, 1938, 449 pp., 214 illus., index.
 Basic study of Grünewald's career in relation to the history of his time, with frequent reference to Luther and the Reformation.

VII. B. 20. Maarten van Heemskerck

1061

BANGS, JEREMY D. "Maerten van Heemskerck's *Bel and the Dragon* and Iconoclasm." *Renaissance Quarterly* 30 (1977):8-11, 3 illus.

The biblical subject provides a strong parallel for iconoclasm, and Heemskerck's representation is taken to reflect Protestant sympathies. The Old Testament priests (promoting idolatry in the story) are shown as tonsured monks, a critical allusion to contemporary Catholic practice.

1062

CAST, DAVID. "Marten van Heemskerck's *Momus criticizing the works of the gods* : a problem of Erasmian iconography." *Simiolus* 7 (1974):22-34, 4 illus.

Relates the painting of 1561 to the mid-century revival of Erasmus' teachings. The writings of Hadrianus Junius and D.V. Coornhert (adduced as possible patrons for the work) place Heemskerck's allegory in the context of religious scepticism fostered among liberal Haarlem Humanists of the time.

1063

GROSSHANS, RAINALD. *Maerten van Heemskerck*. Berlin: Horst Boettcher Verlag, 1980, 298 pp., 8 color illus., 247 b&w illus., bibliog., index.

Basic catalogue of the artist's work. Introductory essay briefly characterizes Heemskerck's work as reflecting a "liberal" Catholic view, holding to a narrow path between the two religious fronts of his time (see pp. 50-5).

1064

HOETINK, H.R. "Heemskerck en het zestiende eeuwse spiritualisme." *Bulletin Museum Boymans-van Beuningen* 12 (1961):12-25, 11 illus.

Briefly relates Heemskerck's drawings of the *Story of Job* to Spiritualist ideas current in the writings of Coornhert. Catalogues these and other drawings in the Boymans collection.

1065

SAUNDERS, ELEANOR ANN. "A commentary on iconolasm in several print series by Maarten van Heemskerck." *Simiolus* 10 (1978/79):59-83, 21 illus.

Studies cycles of unusual Old Testament subjects after designs by Heemskerck. The evidence of their captions and contemporary apologists interpreting the relevant biblical texts (citing Philips Marnix van St. Aldegonde and others) shows that Heemskerck's work intentionally supported Catholic criticism of Protestant image-breaking in the Netherlands. Heemskerck's attitudes are also linked to those of D.V. Coornhert, A. Ortelius, C. Plantin, and Filips Galle.

1066

*SAUNDERS, ELEANOR ANN. "Old Testament Subjects in the Prints of Maarten van Heemskerck 'Als een claere Spiegele der Tegenwooridige Tijden.'" Ph.D. dissertation: Yale University, 1978.

VII. B. 21. Lucas d'Heere

1067

CUST, LIONEL. "Notice of the Life and Works of Lucas d'Heere, Poet and Painter of Ghent, with reference to an Anonymous Portrait of a Lady in the Possession of the Duke of St. Albans." *Archaeologia* 54 (1894):59-80, 2 illus.

Gives a detailed account of the artist's career through the religious troubles in the Netherlands, with an overview of his artistic and literary production. Assembles the basic documentary evidence for reconstructing his biography.

1068

RUDELSHEIM, MARTEN. "Lucas d'Heere." *Oud Holland* 21 (1903):85-110, 1 illus., appendix.

A detailed tracing of the career of the painter and poet, who was active in the Netherlands during the second half of the 16th century. The author concentrates on whether Lucas' verse betrays Protestant or Catholic sentiments, particularly in reference to the sacraments. This question is set in context of contemporary political and religious struggles.

1069

WATERSCHOOT, W. "Leven en betekenis van Lucas d'Heere." *Koninklijke Academie voor Nederlandse Taal- en Letterkunde,* 1974, pp. 16-126.

Detailed, well-documented monographic study of the Flemish poet and painter, mainly concerned with his writings and political activity. The relation of his career to the political and religious vicissitudes of the time discussed *passim.*

1070

YATES, FRANCES A. *The Valois Tapestries.* Studies of the Warburg Institute, 23. London: Warburg Institute, 1959, xx, 157 pp., 47 plates, index.

Part I, chaps. IV-V, discusses the activities of Lucas d'Heere as an artist and tapestry designer, the effect of his religious convictions on his career considered *passim.*

VII. B. 22. Jan van Hemessen

1071

WALLEN, BURR. *Jan van Hemessen. An Antwerp Painter between Reform and Counter-Reform.* Studies in Renaissance Art History, 2. Ann Arbor: UMI Research Press, 1983, xvii, 387 pp., 151 illus., catalogue of works, bibliog., index.

A revision of the author's dissertation (N.Y. University, 1976). Hemessen's genre subjects with their strong didactic pitch are seen, along with certain of his religious works from the latter part of his career, as reflecting the ascetic preachings of Ignatius Loyola. Secular painting may thus reflect the Catholic response to Protestantism (chap. 10). The spread of the Anabaptist,

Sacramentarian and Loist heresies in Antwerp, and other artists' involvement are also summarized (chap. 7).

VII. B. 23. Hans Holbein the Younger

1072
GROSSMANN, FRITZ. "A Religious Allegory by Hans Holbein the Younger." *Burlington Magazine* 103 (1961):491-94, 1 illus.

Identifies the *Allegory of the Old and New Testaments* (now in Edinburgh, National Gallery of Scotland), formerly ascribed to Michael Ostendorfer, as a work by Holbein from ca. 1524-25. Discusses this Protestant allegory and its relation to other versions of the subject.

1073
HERVEY, MARY. *Holbein's "Ambassadors." The Picture and the Men.* London: George Bell and Sons, 1900, xii, 258 pp., 25 illus.

The presence of a Lutheran hymnbook in this painting and the two particular hymns displayed represent the hopes of one of the sitters, George de Selve, for a reconciliation between Catholic and Protestant churches (pp. 219-23).

1074
HIS, EDUARD. "Holbeins Verhältniss zur Basler Reformation." *Repertorium für Kunstwissenschaft* 2 (1879):156-59.

A Basel document of 1530 records a statement given by Holbein explaining his failure to follow the recently adopted regulations of the Reformation church concerning weekly attendance and communion.

1075
HOFFMANN, KONRAD. "Hans Holbein d.J.: Die 'Gesandten'." In *Festschrift für Georg Scheja*. Edited by Albrecht Leuteritz et al. Sigmaringen: Jan Thorbecke, 1975, pp. 133-50, 5 illus.

The anamorphic skull seems to float on a separate plane, emphasizing the impossibility of resolving it and the portrait still-life simultaneously. This device is related to 1 Corinthians 13: 12-13 and the idea of "deus absconditus"; the hidden nature of God was judged an argument for religious tolerance by several Renaissance Humanists. The hymnal and lute further emphasize the call for spiritual and political reconciliation.

1075a
KOEGLER, HANS. "Kleine Beiträge zum Schnittwerk Hans Holbeins d.J. - Der Meister C.S." *Monatsheft für Kunstwissenschaft* 4 (1911):389-408, 4 illus.

Relates Holbein's woodcut *Christ the True Light* to Guillaume Farel's Protestant disputation (Basel, 1524), suggesting that the title "Evangelical Light" would better reflect the print's Protestant meaning.

1076

LEROY, ALFRED. *Hans Holbein et son temps.* Paris: Albin Michel, 1943, 253 pp., 41 illus.

Chapter 4 (pp. 72-92) discusses the effects of the Reformation in Basel between 1521 and 1527 and Holbein's decision to leave the city.

1077

SAXL, FRITZ. "Holbein and the Reformation." In *Lectures* (see no. 379). Vol. I, pp. 277-85, vol. II, plates 195-99. Reprinted in F. Saxl, *A Heritage of Images* (see no. 379), pp. 119-29, 16 illus. (no. 173-88).

Holbein, though a follower of Luther from 1529 on, was much closer to Erasmian Humanism in his reformist ideals.

1078

SCHMID, HEINRICH ALFRED. *Hans Holbein der Jüngere. Sein Aufstieg zur Meisterschaft und sein englischer Stil.* 3 vols. Basel: Holbein-Verlag, 1945 & 1948; vol. of plates (1945): 47 pp., 204 illus.; text vol. I: pp. 1-271, illus. 1-85, text vol. II: pp. 272-470, illus. 86-140, bibliog., list of illus., index.

Survey of Holbein's career including an overview of the Reformation in Basel and its effect on Holbein (pp. 134-43) and of his illustrations for the Lutheran Bible (pp. 247-55).

VII. B. 24. Daniel Hopfer

1079

WEGNER, WOLFGANG. "Beiträge zum graphischen Werk Daniel Hopfers." *Zeitschrift für Kunstgeschichte* 20 (1957):239-59, 16 illus.

Examines a group of etchings noteworthy for their connection to Reformation texts. The *Glaubensbekenntnis, Vater Unser,* and four prints illustrating passages from the New Testament are tied to Lutheran and Zwinglian catechisms and popular theological pamphlets. By this means Hopfer's prints are related to the early Reformation in Augsburg during the first half of the 1520's.

VII. B. 25. Joos van Liere

1080

HAVERKAMP-BEGEMANN, EGBERT. "Joos van Liere." In *Pieter Bruegel und seine Welt.* Edited by Otto von Simson and Matthias Winner. Berlin: Gebr. Mann, 1979, pp. 17-28, plates 5-15.

This article mainly concerns problems of attribution, but enhances previously published documentation on the artist's career. Joos migrated first to Frankenthal and later to villages around Antwerp to continue practicing his Protestant faith. Finally he gave up painting entirely for preaching, and in 1581 wrote a letter calling for destruction of Catholic religious art (see esp. pp. 21-22).

VII. B. 26. David Joris

1081
KOEGLER, HANS. "Einiges über David Joris als Künstler." *Öffentliche Kunstsammlung Basel. Jahresberichte,* n.s. 25-27 (1928-30):156-201, plates 12-20, 12 illus.

Surveys Joris' career as a radical reformer and artist, cataloguing a number of drawings and woodcuts. Joris worked initially in the Netherlands, was banned for religious agitation, and ultimately fled to Basel in 1544 where he died in 1556. He published a book (see no. 815) of his theological writings with his own illustrations (*Wunderbuch,* 1544), though relations between his religious activities and his art are not discussed in any detail.

VII. B. 27. Georg Lemberger

1082
GROTE, LUDWIG. *Georg Lemberger: Aus Leipzigs Vergangenheit,* 2. Leipzig: H. Haessel, 1933, 72 pp., 31 illus., bibliog.

A printing of the author's 1923 dissertation (Halle). Lemberger's works, especially Bible illustrations, are analyzed and described.

VII. B. 28. Lucas van Leyden

1083
BUSCH, WERNER. "Lucas van Leydens 'Große Hagar' und die augustinische Typologieauffassung der Vorreformation." *Zeitschrift für Kunstgeschichte* 45 (1982): 97-129, 19 illus.

Associates the symbolism of Lucas' print (of ca. 1507) with Augustinian and Pauline notions of biblical typology. The motif of the flourishing and barren tree is related to the later Lutheran allegories of salvation and grace (see especially pp. 109-20).

1084
SILVER, LAWRENCE A. "The *Sin of Moses:* Comments on the Early Reformation in a Late Painting by Lucas van Leyden." *Art Bulletin* 55 (1973):401-9, 5 illus.

Argues that Lucas' painting of *Moses Striking the Rock* (Boston, Museum of Fine Art) is addressed to the issue of keeping faith in the sacraments and reflects debate among Catholics and reformers at the time. Interprets the iconography as falling short of the extreme position taken by Sacramentarians, and more in line with Erasmus who condemned the Jews for adhering to the letter rather than the spirit of the Law. (See also exchange of letters, *Art Bulletin* 56 (1974):309-11; and 57 (1975):148-49).

VII. B. 29. Niklaus Manuel Deutsch

1085
ABBE, DEREK van. "Niklaus Manuel von Bern and his Interest in the Reformation." *Journal of Modern History* 24 (1952):287-300.
Concentrates on Manuel's dramatic works. Suggests that his Protestant tendencies are apparent in his art, especially the *Dance of Death,* and that he gave up art not out of a rejection of images but a conviction about the importance of service.

1086
BAECHTOLD, JAKOB, ed. *Niklaus Manuel.* Bibliothek älterer Schrifwerke der deutschen Schweiz, 2. Frauenfeld: J. Huber, 1878, ccxxiii, 471 pp.
Includes introductory essays on Manuel's life and works and editions of his writings. The essay on art, by F. Salomon Vögelin (pp. lix-cxx) interprets various works as church satires reflecting a Reformation spirit. The *Klagred der armen Götzen* (pp.237-54) is accepted as by Manuel (see no. 192).

1087
BEERLI, CONRAD ANDRE. *Le peintre poète Nicolas Manuel et l'évolution sociale de son temps.* Travaux d'Humanisme et Renaissance, 4. Geneva: Librairie Droz, 1953, x, 382 pp., 1 color plate, 27 b&w plates, 36 illus. in text, bibliog., index.
Surveys Manuel's art in the changing social, political, artistic and philosophical climate of early 16th-century Bern. Reviews specific effects of the Reformation on Manuel and other northern artists (pp. 216-21), then turns to the Swiss reform and Manuel's "revolutionary" works which with few exceptions (stained-glass window designs, etc.) are literary. Iconoclastic unrest and Manuel's response are discussed in chapters 11 and 12.

1088
BERN, KUNSTMUSEUM. *Niklaus Manuel Deutsch. Maler, Dichter, Staatsmann.* Exhib. cat., 22 September - 2 December 1979. Bern: Kunstmuseum, 1979, xii, 554 pp., 8 color plates, 192 b&w plates, 70 illus. in text, bibliog.
Thorough, well-documented overview of Manuel's activity as an artist and later as a reformer. Contemporary documents and works by related artists included. Eight essays on various aspects of his career include two touching on Reformation issues (see nos. 1090 and 1091).

1089
GRÜNEISEN, C. *Niclaus Manuel. Leben und Werke eines Malers und Dichters, Kriegers, Staatsmannes und Reformators im sechzehnten Jahrhundert.* Stuttgart & Tübingen: J.G. Cotta'sche Buchhandlung, 1837, xv, 466 pp., 1 illus.
The classic study. Does not deal with art and the Reformation directly.

1090
HUGGLER, MAX. "Niklaus Manuel und die Reformatoren." In Bern, Kunstmuseum. *Niklaus Manuel Deutsch* (see no. 1088), pp. 100-13.

Summarized in *450 Jahre Berner Reformation* (see no. 1101), pp. 380-82.
Analyzes Manuel's poetic works in relation to Luther and Zwingli. Sees
influence of Dürer and Cranach in paintings and drawings, though little visual
record of Manuel's conversion to Protestantism.

1091
IM HOF, ULRICH. "Niklaus Manuel als Politiker und Förderer der Reformation,
1523-1530." In Bern, Kunstmuseum. *Niklaus Manuel Deutsch* (see no. 1088),
pp. 92-99.
Surveys Manuel's rise as a politician and his attitude toward the
Reformation.

1092
IM HOF, ULRICH. "Niklaus Manuel und die reformatorische Götzenzerstörung,"
Zeitschrift für Schweizerische Archäologie und Kunstgeschichte 37
(1980):297-300, 5 illus.
Relates a design for painted glass by Niklaus Manuel representing *King
Josiah overseeing the Destruction of Idols* (1527) to the adoption of the
Reformation ban against religious images in Bern during 1527-28. The
iconography is connected with contemporary religious politics in the city.

1093
MANDACH, C. von. "Die Antoniustafel von Niklaus Manuel." *Anzeiger für
Schweizerische Altertumskunde* 37 (1935):1-28, 20 illus.
Discusses how this panel (one wing of an altarpiece, now Bern,
Kunstmuseum) with two scenes from a *Life of St. Anthony* may have been
rescued from the iconoclasm in Bern, pp. 10-12.

1094
MANDACH, C. von. "Die Antonius-Tafeln von Niklaus Manuel im Berner
Kunstmuseum," *Zeitschrift für schweizerische Archaeologie und Kunst-
geschichte* 4 (1942):225-29, 6 illus.
Reports the acquisition by the Bern Kunstmuseum of a second wing of the
St. Anthony altarpiece. Argues that Manuel's Reformation spirit is evident in the
serious, factual nature of representation which eschews the magical and the
humorous.

1095
RETTIG, G.F. "Ueber ein Wandgemälde von Niklaus Manuel und seiner Krankheit
der Messe. Ein Beitrag zur Reformationsgeschichte der Schweiz." In *Programm
der Berner Kantonsschule* 1862. Bern, 1862, pp. 3-36.
Pages 8-16 discuss a wall painting of the *Foolishness of the aged Solomon*
(1518; known only through a copy). Grüneisen's arguments (see no. 1089)
connecting it to Manuel's poor relationship with his grandfather are rejected.
Rather the emphasis should be placed on the critique of idolatry in general and the
decay of the Christian church.

1096

STUMM, LUCIE. *Niklaus Manuel Deutsch von Bern als bildender Künstler*. Bern: Stämpfli, 1925, ix, 108 pp., 72 b&w illus., 1 color illus., chronological list of works, bibliog.

Brief discussion of the few late works reflecting Manuel's Reformation views.

1097

TAVEL, HANS CHRISTOPH von. "Kunstwerke Niklaus Manuels als Wegbereiter der Reformation." In E. Ullmann, *Von der Macht der Bilder* (see no. 386), pp. 223-31.

Manuel's adherence to Reformation ideas grew out of his criticism of the moral waywardness he observed in his fellow citizens. This attitude can be seen already in his early works, particularly in criticism of Swiss confederate behavior.

1098

TAVEL, HANS CHRISTOPH von. "Niklaus Manuel als Maler und Zeichner." In *450 Jahre Berner Reformation* (see no. 1101), pp. 313-49, 29 illus.

Manuel's drawings and paintings show from the beginning an interest in death and in fate (war and love). A new sober piety is expressed in his last works (i.e. the *St. Anthony* altarpiece) of the 1520's before he finally ceased working in the visual arts.

1099

TAVEL, HANS CHRISTOPH von. *Niklaus Manuel. Zur Kunst eines Eidgenossen der Dürerzeit*. Bern: K.J. Wyss Erben, 1979, 112 pp., 27 b&w illus., 8 color illus.

In a section on Manuel's developing Protestantism and his rejection of visual art (pp. 79-98) the author identifies criticism of the Church in Manuel's work already before 1515, concluding that he found the visual arts insufficient for religious teaching.

1100

VETTER, FERDINAND. "Die Basler Reformation und Niklaus Manuel." *Schweizerische Theologische Zeitschrift* 24 (1907):17-32, 241-61.

Reviews Manuel's involvement in the Basel reforms of 1528-29, including his report of the local iconoclasm (pp. 251-56).

1101

450 JAHRE BERNER REFORMATION. *450 Jahre Berner Reformation. Beiträge zur Geschichte der Berner Reformation und zu Niklaus Manuel*. Bern: Historischer Verein des Kantons Bern, 1980, 700 pp., 5 color plates, 37 b&w plates, other illus. in text, charts, bibliog.

A variety of essays on the Reformation in Bern and on Manuel (see nos. 1090 and 1098) followed by an extensive bibliography (639 entries) organized according to topics and covering 1956-1979.

VII. B. 30. Barent van Orley

1102
BEETS, N. "Een godsdienstige allegorie door Barent van Orley." *Oud Holland* 49 (1932): 129-37, 2 illus.

The artist was among a group brought before the Inquisition in 1527 and charged with heresy. A large allegorical drawing with inscriptions (Rijksmuseum, Amsterdam) representing the corruption of the priesthood and papacy is here attributed to van Orley and associated with his trial.

VII. B. 31. Michael Ostendorfer

1104
WYNEN, ARNULF. "Michael Ostendorfer (um 1492-1559): Ein Regensburger Maler der Reformationszeit." Ph.D. dissertation, University of Freiburg, 1961, 431 pp., bibliog.

A monographic study of the artist with a catalogue of works and transcriptions of primary documents. The influence of the Reformation is discussed in general terms (pp. 193ff, 201-2). The *Reformations-Altar* (Regensburg, Königliche Bibliothek) of 1553-55 is analyzed stylistically and iconographically (pp. 64-81).

VII.B.32. Bernard Palissy

1105
DUPUY, ERNEST. *Bernard Palissy, l'homme - l'artiste - le savant - l'écrivain.* 1894. 2nd ed. Paris, 1902. Facsimile reprint. Geneva: Slatkine Reprints, 1970, 342 pp., indexes.

A biography of the artist which devotes a section to his relation to the Reformation (Part I, chap. 3). Palissy was an early and ardent follower of Calvin.

VII. B. 33. Georg Pencz

1106
*GMELIN, HANS GEORG. "Georg Pencz als Maler." Ph.D. dissertation, Albert-Ludwig-Universität, Freiburg im Breisgau, 1961.

See the author's article, no. 1107.

1107
GMELIN, HANS GEORG. "Georg Pencz als Maler." *Münchner Jahrbuch der bildenden Kunst,* ser. 3, 17 (1966):49-126, 66 illus., bibliog.

A condensation of the author's 1961 dissertation. Relates what is known of Pencz's biography, including details of his trial and his artistic career. His works are discussed at length. Includes a catalogue (pp. 73-115) and relevant passages from archive material (pp. 115-22).

VII. B. 34. Pieter Pourbus

1108

BRUGES, MEMLINGMUSEUM (Sint Janshospitaal). *Pieter Pourbus. Meester-schilder 1524-1584.* Exhib. cat., 29 June - 30 September 1984. By Paul Huvenne. 335 pp., 43 color illus., 97 b&w illus., bibliog.

A lavishly produced, monographic survey of the Bruges portraitist and altarpiece painter. Pourbus established himself as the major painter of orthodox religious works in the city. His fortunes throughout the years of Calvinist ascendency and suppression are recounted in the text (pp. 53-70).

VII. B. 35. Barthélemy Prieur

1109

LAMY, [Madame] and BRIERE, GASTON. "L'inventaire de B. Prieur, sculpteur du roi." *Bulletin historique et littéraire de la Société de l'histoire du Protestantisme français* 96(1949):41-68.

An account of the inventory of possessions left by this Protestant artist (died 1611) including numerous exegetical texts, Calvin's commentaries on the Bible, and works defending the Reformation.

VII. B. 36. Jörg Ratgeb

1110

BUSHART, BRUNO. "Jörg Ratgeb." *Zeitschrift für Württembergische Landesgeschichte* 33 (1974):272-78, [Stuttgart: 1976].

A critical response to Fraenger's book (see no. 1111), disputing the evidence given for Ratgeb's political involvement, his commitment to the peasants, and his connection with the "Stabularii" sect.

1111

FRAENGER, WILHELM. *Jörg Ratgeb. Ein Maler und Märtyrer aus dem Bauernkrieg.* Dresden: Verlag der Kunst, 1972, 288 pp., 150 b&w illus., 24 color illus., index of names.

Published 8 years after Fraenger's death with only the first two chapters fully prepared by Fraenger himself. Sectarian tendencies are identified in Ratgeb's early works, with special attention to the motif of the wandering

Apostles and its possible anticipation of Anabaptist theological tendencies (pp. 61-75).

1112
FRAENGER, WILHELM. "Jörg Ratgeb, ein Maler und Märtyrer des Bauern-krieges." *Castrum Peregrini* 29 (1956):5-25, 2 illus.
Mainly concerns the *Herrenberg Altarpiece* of 1519 (Stuttgart, Staatsgalerie), Ratgeb's major surviving work. This is discussed in relation to later Anabaptist texts and iconography, and seen as an anticipation of the painter's execution for his activities in the Peasants' Revolt of 1525.

1113
ZÜLCH, WALTER KARL. "Jerg Ratgeb, Maler." *Wallraf-Richartz-Jahrbuch* 12/13 (1943):165-97, 26 illus.
A critical examination of the hypothesis that Ratgeb's art betrays his alledged participation in the revolutionary peasant movement and the Peasants' War of 1525 (for which he was executed in 1526). See esp. pp. 165-74. His historical documentation and artistic development are studied and interpreted.

VII. B. 37. Ligier Richier

1114
*DENIS, PAUL. *Ligier Richier, l'artiste et son oeuvre.* Paris & Nancy: Berger-Levrault, 1911, xxv, 426 pp., 95 illus., cat., bibliog.
A sculptor from Lorraine who converted to Protestantism and moved to Geneva because of his religion. He seems to have abandoned the artistic profession along with his former faith. See especially pp. 371ff.

VII. B. 38. Tilmann Riemenschneider

1115
WITTE, HERMANN. "Tilmann Riemenschneiders religiöse Haltung. Ein Versuch." *Archiv für Kulturgeschichte* 29 (1939):276-303.
Riemenschneider's pre-Reformation works are seen to reveal the unrest of the times. Though he remained within the Catholic church, his works show him somewhere mid-way to Protestantism.

VII. B. 39. Bernard Salomon

1116
RONDOT, NATALIS. *Bernard Salomon. Peintre et tailleur d'histoires à Lyon, au XVIe siècle.* Lyons: Mougin-Rusand, 1897, 92 pp., index.

Discusses the proposal made by others that Salomon was a secret adherent of the Reformation, and notes the sharp upsurge of Protestantism in Lyons during the 1520's. The author is reluctant to see evidence of Reformation ideas in Salomon's biblical illustrations or elsewhere.

VII. B. 40. Virgil Solis

1117
O'DELL-FRANKE, ILSE. *Kupferstiche und Radierungen aus der Werkstatt des Virgil Solis.* Wiesbaden: Franz Steiner, 1977, xii, 241 pp., 1295 illus., bibliog., indexes.
 Detailed study of the productions of the Solis family workshop (including Lutheran Bible illustrations by Virgil Solis). Discusses assistants, techniques, thematic categories of the prints, and influences, followed by a complete descriptive catalogue.

VII. B. 41. Tobias Stimmer

1118
BASEL, KUNSTMUSEUM. *Tobias Stimmer: 1539-1584.* Exhib. cat. 23 Sept. - 9 Dec. 1984, 519 pp., 16 color illus. and 288 b&w illus., 388 entries, bibliog., index.
 Covers the complete works of this German artist (died 1584), who completed important commissions of Protestant artistic projects: the astronomical clock in Strasbourg Cathedral, and broadsheets as well as a cycle of woodcuts for a picture Bible published by Bernard Jobin and the Protestant author Johann Fischart. See especially the essays and catalogue entries by Paul Tanner on these projects.

1119
BENDEL, MAX. *Tobias Stimmer. Leben und Werke.* Zurich/Berlin: Atlantis-Verlag, 1940, 280 pp., 140 b&w illus., 11 color illus bibliog.
 Account of the artist's life and work including a chronological list of all known paintings and drawings. The question of the Reformation touched on in passing.

VII. B. 42. Geofroy Tory

1120
GÖRANSSON, ANNA MARIA. "Livsträdet och Geofroy Tory" [The Tree of Life and Geofroy Tory.] *Symbolister, Tidskrift för Konstvetenskap* 30 (1957):57-85, 17 illus.

In Swedish. Discusses a print by the French printer and woodcutter Tory derived from the Cranach Allegory of Grace and Salvation and its heritage. The iconography of contrasting virtue and vice is further examined in other works of the period, with special attention to Reformation use of the tree of life as a symbol.

VII. B. 43. Heinrich Vogtherr the Elder

1121
FUNKE, JUTTA. "Beiträge zum graphischen Werk Heinrich Vogtherrs d.Ä." Ph.D. dissertation, Freie Universität Berlin, 1967, 154 pp., bibliog.
Cites but does not discuss the artist's Reformation songs and tracts. The preface to Vogtherr's *Kunstbüchlein* laments the contemporary decline of art. Funke relates this to iconoclasm and cites other such references from the period.

1122
GEISBERG, MAX. "Heinrich Satrapitanus und Heinrich Vogtherr." *Buch und Schrift* 1 (1927):96-100.
Identifies the artist of the so-called *Stammbaum des Glaubens* of 1524 (woodcut) as Vogtherr the Elder. Under the pseudonym Satrapitanus, Vogtherr also published Reformation pamphlets and songs.

1123
JENNY, MARKUS. "Ein bisher unbekanntes Selbstporträt des Reformations-schriftstellers und Künstlers Heinrich Vogtherr d.Ä." *Zwingliana* 11 (1963):617-18, 2 illus.
Attributes the illustrations in the *Stumpf Chronicle* to Vogtherr the Elder (1490-1556), a Protestant and man of many professions who worked for Froschauer on the *Chronicle* and included a self-portrait among the woodcut illustrations.

1124
RÖTTINGER, HEINRICH. "Die beiden Vogtherr." *Jahrbuch für Kunst-wissenschaft* 1927, pp. 164-84, 12 illus.
Surveys the graphic works of both father and son, especially the former's Protestant Bible illustrations where, as in his written works, he criticizes the Catholic clergy.

1125
SCRIBA, OTTO. "Heinrich Vogtherr, der Maler, ein vielseitiger Künstler der Reformationszeit," *Archiv für hessische Geschichte und Altertumskunde,* n.s. 13 (1922):125-62. Also printed in *Beiträge zur hessischen Kirchengeschichte* 7 (1921):302-39.
Wall paintings in the parish church at Wimpfen are ascribed to Heinrich Vogtherr the Elder, who began publishing Protestant works as early as 1523 and whose evangelical faith is identified in other of his artistic and literary creations.

VII. B. 44. Martin de Vos

1126

ZWEITE, ARMIN. "Die Gemälde der Celler Schloßkapelle." In Celle, Bomann-Museum. *Reformation im Fürstentum Lüneburg. 450 Jahr Augsburger Bekenntnis.* Exhib. cat., 2 June - 15 July 1980, pp. 28-48, 3 b&w illus., 2 color illus.

A short version of two chapters from the author's book on Martin de Vos (see no. 1127). Describes the well-preserved Protestant decorative program in some detail. It is not polemically anti-Catholic, but emphasizes New Testament scenes. Many of the paintings are attributed to Vos.

1127

ZWEITE, ARMIN. *Marten de Vos als Maler. Ein Beitrag zur Geschichte der Antwerpener Malerei in der zweiten Hälfte des 16. Jahrhunderts.* Berlin: Gebr. Mann, 1980, 399 pp., 245 illus., catalogue, bibliog., index.

Comprehensive monograph on an artist with known Protestant associations. Chapter 4 examines a cycle of panel paintings from the dining hall of a Calvinist merchant in Antwerp, Gilles Hooftman. The program originally included five subjects from the life of St. Paul. These were executed in 1568 and evidence a definite Protestant slant, in particular an appeal for religious tolerance and a comment on idolatry.

1128

ZWEITE, ARMIN. "Studien zu Marten de Vos. Ein Beitrag zur Geschichte der Antwerpen Malerei in der zweiten Hälfte des 16. Jahrhunderts." Ph.D. dissertation, Georg-August-Universität, Göttingen, 1974. 3 vols., 196 illus., bibliog. Revised and published. See no. 1127.

VIII. Architecture, Architectural Decoration and Furnishing

VIII.A. Architecture - general

1129
DRUMMOND, ANDREW LANDALE. *The Church Architecture of Protestantism. An Historical and Constructive Study.* Edinburgh: T. & T. Clark, 1934, xviii, 342 pp., 34 plates, bibliog., indexes.
Sixteenth-century Protestant architecture is discussed briefly pp. 19-26.

1130
HAMBERG, PER GUSTAF. *Tempelbygge för Protestanter. Arkitekturhistoriska Studier i äldre reformert och Evangelisk-Luthersk Miljö* [Temple buildings for Protestants. Architectural-historical Studies in the older Reformed and Evangelical Lutheran Milieu]. Stockholm: Svenska Kyrkans Diakonistyrelses Bokförlag, 1955, 254 pp., 103 illus., bibliog., index.
In Swedish. A survey of Protestant church architecture in western Europe from the 16th to the 18th century, organized primarily by region. There are chapters on French Huguenot, Dutch, and Scandinavian architecture. An English translation is planned.

1131
DER KIRCHENBAU. *Der Kirchenbau des Protestantismus von der Reformation bis zur Gegenwart.* Edited by the Vereinigung Berliner Architekten. Berlin: Ernst Toeche, 1893, 559 pp., 1041 illus., indexes.
Brief consideration of 16th-century monuments (pp. 31-40), primarily in Germany.

1132
KUNST, HANS-JOACHIM. "Reformation and Hall-Church." In *Martin Luther - 450th Anniversary of the Reformation.* Bad Godesberg: Inter Nationes, 1967, pp. 135-45 (notes pp. 160-62), 2 illus.
Questions the notion that the Protestant hall-church was a form of protest, specifically more community-spirited than the basilica form. Reformation church buildings are shown to be modified versions of traditional structural modes.

217

1133

*MATTHAES, JENNY RUTH. "Untersuchungen zum Symbolbegriff und zur Symbolik der evangelisch-lutherischen Kirche." Ph.D. dissertation, Technische Hochschule Dresden, 1951, 106 pp., numerous illus.

1134

SENN, OTT H. *Evangelischer Kirchenbau im ökumenischen Kontext: Identität und Variabilität - Tradition und Freiheit.* Schriftenreihe des Instituts für Geschichte und Theorie der Architektur an der Eidgenössischen Technischen Hochschule Zürich, 26. Basel/Boston/Stuttgart: Birkhäuser Verlag, 1983, 120 pp., numerous illus.

Develops a theory of Protestant architecture, supported by drawings and plans, from the 16th century to the present. Analyzes 16th-century local and sectarian adaptations of existing architecture and new buildings.

1135

WESSEL, KLAUS. "Symbolik des protestantischen Kirchengebäudes." Appendix to Kurt Goldammer, *Kultsymbolik des Protestantismus.* Stuttgart: Anton Hiersemann, 1960, pp. 83-98.

Reviews Zwingli's, Calvin's, and especially Luther's views on the significance and correct use of the various parts of church buildings, finding much less symbolism than had been characteristic in medieval times.

1136

WHITE, JAMES F. *Protestant Worship and Church Architecture: Theological and Historical Considerations.* New York: Oxford University Press, 1964, xi, 224 pp., 60 illus., bibliog., index.

Chapter 4, "Reformation Experiments", discusses how Protestant church architecture transformed inherited structures to fit its needs and ideals. Surveys developments on the continent and in England from the 16th through the 18th century.

VIII. A. 1. Germany

1137

*DÖTT, ILSE-KÄTHE. "Protestantische Querkirchen in Deutschland und der Schweiz." Ph.D. dissertation, Münster, 1955, 151 pp.

1138

HEUTGER, NICOLAUS C[arl]. *Historische Weserstudien.* Hildesheim: Lax, 1972, x, 163 pp., 24 illus.

The section on evangelical church art in Lower Saxony (pp. 33-56) discusses the architecture and interior decoration of several building types: palace chapels, city churches and village churches, chancerys and grave monuments.

1139

HITCHCOCK, HENRY-RUSSELL. *German Renaissance Architecture.* Princeton: Princeton University Press, 1981, 379 pp., 531 illus., index.

A detailed and well-illustrated survey of the topic arranged according to types of structures (religious, civic, etc.). See in particular chap. 6 on the revival of church building in the late 16th century.

1140

KADATZ, HANS-JOACHIM. *Deutsche Renaissancebaukunst von der früh-bürgerlichen Revolution bis zum Ausgang des Dreißigjährigen Krieges.* Berlin: VEB Verlag für Bauwesen, 1983, 430 pp., many illus., bibliog.

Richly illustrated survey touching on changes brought by the political and spiritual circumstances of the time.

1141

KRAUSE, HANS-JOACHIM. *Die Schlosskapellen der Renaissance in Sachsen.* Das christliche Denkmal, 80. Berlin: Union Verlag, 1970, 32 pp., 20 illus.

Discusses the architecture and original decoration of five Protestant palace chapels that were built in Saxony in the 16th century (3 of them now destroyed): Torgau, Grimmenstein (Gotha), Dresden, Freudenstein (Freiberg), and Augustusburg.

1142

LEMPER, ERNST-HEINZ. *Die Thomaskirche zu Leipzig. Die Kirche Johann Sebastian Bachs als Denkmal deutscher Baukunst.* Leipzig: Koehler & Amelang, 1954, 239 pp., 84 illus., bibliog.

Chap. 5 is devoted to the 16th- and 17th-century history of the church and the changes brought by the Reformation.

1143

LUTHERGEDENKSTÄTTEN: Tradition und Denkmalpflege. Berlin: VEB Verlag für Bauwesen, 1983, lxiv pp., numerous illus.

Contains articles by various scholars, mainly on the restoration of 16th-century German architecture related to Luther's life.

1144

*OHLE, WALTER. "Die protestantischen Schloßkapellen der Renaissance in Deutschland." Ph.D. dissertation, Leipzig, 1936.

1145

RITTER, ANNELIES. "Über die Gotteshäuser der Stadt Göttingen in der Reformationszeit." *Göttinger Jahrbuch,* 1954, pp. 18-24.

Documents the destruction or transformation of specific churches and chapels in the city following the acceptance of the Reformation. This study proceeds to clarify the remarks made in the General Consistory session of 1591 regarding religious houses that had been converted.

1146

*SCHLIEPE, WALTER. "Über Zusammenhänge in der Entwicklungsgeschichte protestantischer Emporenkirchen bis zu George Bähr. Ein Beitrag zur Entwicklungsgeschichte des Emporenraumes in Sachsen." Ph.D. dissertation, Dresden, 1957.

1147

WEX, REINHOLD. "Oben und unten, oder Martin Luthers Predigtkunst angesichts der Torgauer Schloßkapelle." *Kritische Berichte* 11 (1983):4-24, 3 illus., bibliog.

Focuses on Luther's sermon of 5 Oct. 1544 at the consecration of the new Protestant chapel built by Johann Friedrich I, then Kurfürst von Sachsen. Analyzes Luther's description of a proper Protestant church and discusses the palace chapel in some detail.

1148

*WEX, REINHOLD. "Ordnung und Unfriede - Raumprobleme des protestantischen Kirchenbaus im 17. und 18. Jahrhundert in Deutschland." Ph.D. dissertation, Marburg, 1981.

Contains a chapter on Luther's sermons and Protestant architecture (see the author's article based on this chapter, no. 1147).

VIII. A. 2. Other

1149

GERMANN, GEORG. *Der protestantische Kirchenbau in der Schweiz: Von der Reformation bis zur Romantik.* Zurich: Orell Füssli, 1963, 212 pp., 117 illus., bibliog., indexes.

Discusses the questions raised for church architecture by the Reformation (rebuild or modify) and analyzes some early churches. Nineteen new Protestant churches were built before 1600.

1150

MATTHES, ERNST. "Evangelische Kirchenbauten in Steiermark und ihre Zerstörung." *Der Säemann* 7, 9 (1927):5-7.

Numerous Protestant churches and chapels erected in central Austria during the 16th century were systematically destroyed between 1599 and 1600 during the reign of Ferdinand II (1590-1637). Each building is listed here with a brief description of its history and destruction.

1151

*SCHNORRENBERG, JOHN MARTIN. "Early Anglican Architecture, 1558-1662: Its Theological Implications and its Relation to the Continental Background." Ph.D. diss., Princeton University, 1964, 321 pp.

Reviews the styles of Calvinist, Roman Catholic, and Lutheran architecture. Examines the development of Anglican architecture and contrasts Protestant

architecture of the North with the styles of more radical groups on the continent. The Gothic style is seen as an essential Anglican trait reflecting the conservatism of this reform movement. See *Dissertation Abstracts* 25, no. 11 (1965):6519-20.

1152
WIESENHÜTTER, ALFRED. *Der Evangelische Kirchbau Schlesiens von der Reformation bis zur Gegenwart*. Breslau, 1926. 2nd ed., revised by Gerhard Hultsch. Düsseldorf: Verlag der Schlesischen Evangelischen Zentralstelle, 1954, 50 pp., 189 illus., index of churches.
The first section (pp. 12-19) discusses Protestant churches from the Reformation period.

1153
WIESENHÜTTER, ALFRED. *Protestantischer Kirchenbau des deutschen Ostens in Geschichte und Gegenwart*. Kunstdenkmäler des Protestantismus. Leipzig: E.A. Seemann, 1936, 224 pp., 189 illus., index, bibliog.
The Reformation period and church architecture are discussed in the introduction by Oskar Thulin and in the text pp. 13-39.

VIII. B. Church furnishings and monuments

VIII. B. 1. general

1154
BAXANDALL, MICHAEL. *The Limewood Sculptors of Renaissance Germany*. New Haven/London: Yale University Press, 1980, xx, 420 pp., 4 color illus., 247 b&w illus., bibliog., index.
Considers contemporary evidence for the perceptions and functions of religious sculpture in relation to Reformation criticism and destruction of art. The effects of the Reformation on the sculptor's profession are also examined, in particular the cessation of commissions for large winged retables and the emergence of new types of sculpture and subject matter (see esp. chap. 3).

1155
BELLMANN, FRITZ; HARKSEN, MARIE-LUISE; and WERNER, ROLAND. *Die Denkmale der Lutherstadt Wittenberg*. Weimar: Hermann Böhlaus Nachfolger, 1979, 301 pp., 207 plates, numerous illus. in the text, bibliog., indexes.
A detailed descriptive inventory of Wittenberg's artistic and historical monuments, which are largely from the 16th century. Many diagrams of buildings are included, as well as lists of church altars, descriptions of pre-iconoclasm church interiors, etc.

1156
HAEBLER, HANS CARL von. *Das Bild in der evangelischen Kirche*. Berlin:

Evangelische Verlagsanstalt, 1957, 260 pp., 112 illus., index.

Part 1, chapter 1 gives an overview of the tradition of images in the reformed church with emphasis on Lucas Cranach. Chapter 2 discusses decorative schemes in Protestant churches, specifically tombs, epitaph-altars, pulpits, baptismal fonts, etc.

1157

KRAUSE, HANS-JOACHIM. "Zur Ikonographie der protestantischen Schloß-kapellen des 16. Jahrhunderts." In E. Ullmann, *Von der Macht der Bilder* (see no. 386), pp. 395-412.

Well-documented, detailed study of the original furnishings and iconography of 16th-century Protestant palace chapels in Germany (Torgau, Dresden, Augustusburg, Schwerin, Schmalkalden) based on archival findings. Suggests Luther himself may have been involved in the decorative program in Torgau.

1158

LUTZE, EBERHARD. "Plastik des 16. Jahrhunderts als Reformationskunst." *Kunst und Kirche* 17 (1940):5-7, 3 illus.

Reviews influence of the Reformation on sculpture, especially in the Nuremberg area.

1159

*SCHMIDT, EVA, ed. *Die Stadtkirche zu St. Peter und Paul - Herderkirche - zu Weimar.* Festschrift zu ihrer Wiedereinweihung am 14. Juni 1953. Jena, 1953.

An earlier, shorter version of the 1955 publication (see no. 1160). Includes an essay by K. Wiesner, "Die Predigt des Cranach-Altars", pp. 39-48.

1160

SCHMIDT, EVA, ed. *Die Stadtkirche zu St. Peter und Paul in Weimar.* Berlin: Union Verlag, 1955, 161 pp., 67 illus., bibliog.

Includes essays by various scholars on the history of the church and its contents, and a catalogue of 63 objects. A section on artistic monuments (pp. 65-106) by Hanna Jursch discusses a triptych dated 1555 by Cranach the Younger showing the Crucifixion attended by Luther and Cranach the Elder, with numerous other Old and New Testament scenes in the background. A 1572 triptych depicting Luther three times, as a monk, as Junker Jörg and as a scholar is also discussed, as are numerous epitaph monuments from the 16th century.

1161

SCHWEMMER, WILHELM. "Das Mäzenatentum der Nürnberger Patrizierfamilie Tucher vom 14.-18. Jahrhundert." *Mitteilungen des Vereins für Geschichte der Stadt Nürnberg* 51 (1962):18-59.

Includes a history of the Veit Stoss *Annunciation,* one of Tucher's donations. In spite of Nuremberg's abolition of the cult of the Virgin, this piece was allowed to hang (though generally covered from view).

1162

SPECKER, HANS EUGEN, and WORTMANN, REINHARD, eds. *600 Jahre*

Ulmer Münster: Festschrift. Forschungen zur Geschichte der Stadt Ulm, 19. Ulm/Stuttgart: Kommissionsverlag W. Kohlhammer, 1977, 600 pp., 184 b&w plates, 5 color plates, plus unnumbered illus. in the texts.

A collection of articles on various aspects of the cathedral and its history. On the Reformation see Hoffmann, K. (no. 259) and H. Tüchle (no. 255).

1163

STRASSER, ERNST. "Das Wesen der lutherischen Kirchenkunst." In *Das Erbe Martin Luthers und die gegenwärtige theologische Forschung. Ludwig Ihmels zum 70. Geburtstag 29. 6. 1928 dargebracht.* Edited by Robert Jelke. Leipzig: Dörffling & Franke, 1928, pp., 428-48.

General essay on Lutheran church art, briefly touching on the Reformation period.

1164

*SVAHNSTRÖM, G. "Reformationstiden kyrkoinventarier (Gotland) [Church-inventories of the Reformation Age]. *Götlandskt Arkiv* 33 (1961):60-70. In Swedish.

1165

*UNGERER, ALFRED. *L'Horloge Astronomique de la Cathédrale de Strasbourg.* With collaboration of M.M.A. Danjon & G. Rougier. Paris: Société astronomique de France. [1922]. 60 pp., illus., bibliog.

The iconographic scheme employed in this large astronomical clock was designed by Protestant advisers and includes an image of the *Last Judgment* by Tobias Stimmer conforming to Protestant theology.

1166

WIESMANN, HANS, and HOFFMANN, HANS. *Das Großmünster in Zürich.* Mitteilungen der Antiquarischen Gesellschaft in Zürich, 32. Zürich: Antiquarische Gesellschaft, 1937-42, vi, 283 pp., 80 plates, 30 illus., index.

A detailed history of the Zurich Großmunster with a carefully reconstructed description of the altarpieces and other interior decoration present before the iconoclasm of 1524 (pp. 196-217), and a shorter account of the changes wrought by the Reformation (pp. 235-41).

VIII. B. 2. Chancels, pulpits and choir screens

1167

JANSEN, WILHELM. "Beobachtungen zu der Kanzelfüllung vom Jahre 1582 aus der Kirche in Ostönnen." *Soester Zeitschrift des Vereins für die Geschichte von Soest und der Börde* 76(1962):31-36, illus. p. 27.

Argues that a sculpted panel made for the pulpit in Ostönnen's reformed church did not represent the Trinity (there was never a dove) but the crucified Christ as central declaration of the new faith.

1168

KÖCKE, ULRIKE. "Lettner und Choremporen in den nordwestdeutschen Küstengebieten, ergänzt durch einen Katalog der westdeutschen Lettner ab 1400." Ph.D. dissertation, Ludwig-Maximilians-Universität Munich, 1972.

Discusses the development of choir screens and galleries in the post-Reformation era, the changes in their function and form, and surveys specific examples especially in Frisia.

1169

MAI, HARTMUT. *Der evangelische Kanzelaltar: Geschichte und Bedeutung.* Halle (Saale): Max Niemeyer, 1969, 316 pp., 291 illus., bibliog.

Reworked and shortened version of his 1964 dissertation, excluding the section on the religious-sociological aspects of the altar (intended to be published as part of another study). Few examples of altars and churches before 1650. Extensive bibliography.

1170

MAI, HARTMUT. "Die Kanzel in der Hauptkirche zu Kamenz. Ein Denkmal Oberlausitzer Reformationsgeschichte." *Sächsische Heimatblätter* 18 (1972):14-20, 8 illus.

A new pulpit adorned with biblical scenes and allegories was erected for the church in 1562. The iconography of the pulpit program is traced to the *Biblia pauperum.* Connections with Lutheran writings are pointed out.

1171

MAI, HARTMUT. "Der Kanzelaltar -- wertvolles reformatorisches Erbe?" *Deutsches Pfarrerblatt* 66 (1966):459-62.

Although the *Kanzelaltar* developed out of traditional forms, it is evaluated as an important Protestant contribution and expression of the new church. The iconography of the altar is discussed.

1172

POKORA, JAKUB. "Slowo i obraz w programie ideowym protestanckich Kazalnic slaskich XVI i 1 pol XVII w." [Word and image in the ideological program of Protestant pulpits in Silesia, 16th and first half of the 17th century.] In *Slowo i obraz.* Materialy Sympozjum Komitetu Nauk o Stztuce. Polskiej Akademii Nauk. Edited by Agnieszka Morawinska. Warsaw: Panstwowe Wydawnictwo Naukowe, 1982, pp. 151-70.

In Polish. Discusses and illustrates the decoration of pulpits in a group of Silesian churches. This decoration reflects the importance of preaching the word of God in Lutheran liturgy. There are two types of decoration: independent inscriptions from the Bible, and Biblical inscriptions as illustrations. The illustrations sometimes merely "ornament" the text, at other times expand upon it. The inscriptions are usually in German, occasionally in Latin, Hebrew, very occasionally in Greek or Aramaic. The Old and New Testaments appear equally often.

1173

POSCHARSKY, PETER. *Die Kanzel: Erscheinungsform im Protestantismus bis zum Ende des Barocks.* Gütersloh: Gerd Mohn, 1963, 315 pp., 84 illus., indexes.

Surveys the history of pulpits from the Middle Ages through the Baroque, with major emphasis on Lutheran and Reformed pulpits of the 16th and 17th centuries (pp. 56-213). The decorative programs are shown to be aimed at support of the sermons, a complementary expression of the preacher's message.

VIII. B. 3. Epitaphs

1174

BIALOSTOCKI, JAN. "Kompozycja emblematyczna epitafiow slaskich XVI wieku" [Emblematic compositions in Silesian epitaphs of the 16th century]. In *Ze studiow nad sztuka XVI wieku na slasku i w krajach sasiednich.* Warsaw: Muszeum Slaskie we Wroclawin, 1968, pp. 77-93, 21 illus.

In Polish. Studies the adoption of emblematic symbolism and compositional arrangements in painted and carved epitaph monuments of the 16th and 17th centuries. Examples are largely Eastern European.

1175

BRESLAU, SILESIAN MUSEUM. *Malarstwo Slaskie. 1520-1620.* [Silesian Painting. 1520-1620]. Exhib. cat., December 1966 - March 1967. Introduction by Bozena Steinborn. Breslau: Zakt. Graf. "Ruch," 1966, 69 pp., 54 illus.

In Polish. Includes numerous Protestant epitaphs and one painting from 1530 showing Luther preaching before a background landscape with an allegory of Grace and Salvation.

1176

CHRISTENSEN, CARL C. "The Significance of the Epitaph Monument in Early Lutheran Ecclesiastical Art (ca. 1540-1600): Some Social and Iconographical Considerations." In *The Social History of the Reformation.* Edited by Lawrence P. Buck and Jonathan W. Zophy. Columbus: Ohio State University Press, 1972, pp. 297-314.

Discusses epitaph monuments placed in Protestant churches during the 16th century. Examines the Protestant aspect of the subjects portrayed: stress on salvation, theological allegories, and personifications. Portraits, coats-of-arms, and inscriptions further add a secular dimension to religious epitaphs and are seen to reflect specific Protestant values.

1177

HENTSCHEL, WALTER. *Dresdner Bildhauer des 16. und 17. Jahrhunderts.* Weimar: Böhlau, 1966, 170 pp., 9 text illus. and 120 plates.

Discusses 16th-century Protestant epitaphs.

1178
JOHNSEN, WILHELM. "Zur Geschichte der Reformation in Dithmarschen nach dem Zeugnis einiger Kunstdenkmäler jener Zeit." In *Aus Schleswig-Holsteins Geschichte und Gegenwart: Festschrift Volquart Pauls.* Edited by Fritz Hähnsen et al. Neumünster: Wachholtz, 1950, pp. 46-61, 2 illus.
Two stone epitaphs from the first half of the 16th century are identified as monuments to pastors of the Protestant church.

1179
KUHN, CHARLES L. "The *Mairhauser Epitaph* : An Example of Late Sixteenth-Century Lutheran Iconography." *Art Bulletin* 58 (1976):542-46, 5 illus.
The subject of Christ and Nicodemus on this epitaph monument is related to Lutheran belief in justification by faith. Further reference is made to the Trinity and Christ Blessing the Children, the latter in relation to Luther's controversy with the Anabaptists over infant baptism.

1180
*STEINBÖCK, WILHELM. "Protestantische Epitaphien des 16. Jahrhunderts im Stadtmuseum Wels." *Jahrbuch des Musealvereins Wels* 18 (1972):87-110.

1181
STEINBORN, BOZENA. "Malowane epitafia mieszczanski na Slasku w latach 1520-1620." [Painted burgher epitaphs in Silesia 1520-1620]. *Roczniki Sztuki Slaskiej* 4 (1967):1-138, 54 plates, table of contents (p. 138), summaries in German (pp. 126-30) and French (pp. 130-33).
In Polish. Of 16th-century paintings conserved in Silesia, some 80 per cent are Protestant epitaph images. Typical subjects are analyzed, and stylistic influences traced.

1182
VACKOVA, JARMILA. "Epitafni obrazy v predbelohorskych Cechach." [Epitaph paintings in Bohemia before the 30-Years' War]. *Umeni* 17 (1969):131-56, 17 illus.
In Czech. Includes a catalogue of 98 epitaph paintings (alphabetically according to location). The essay discusses the epitaph form as an expression of Lutheran ideology.

1183
VACKOVA, JARMILA. "Three Late Sixteenth-Century Netherlandish Epitaphs at Brno." *Jaarboek van het Koninklijk Museum voor Schone Kunsten te Antwerpen,* 1978, pp. 51-61, 8 illus.
Analyzes the iconography of three Protestant epitaph paintings commissioned by wealthy citizens in Brno. All were painted by unidentified Netherlandish artists.

1184
VACKOVA-SIPOVA, JARMILA. "Pozdne renesancni malovane epitafy v Brne"

[Post-Renaissance painted epitaphs in Brno]. *Umeni,* n.s. 8 (1960):587-600, 10 illus.

In Czech. Concerns several late 16th-century paintings, mainly epitaphs, and their Protestant iconography.

1185
WERNICKE, E. "Grabdenkmäler aus dem Jahrhundert der Reformation in evangelischen Kirchen Deutschlands." *Christliches Kunstblatt für Kirche, Schule und Haus* 24 (1882):49-55, 73-79.

Recognizes specifically evangelical traits in German grave monuments of the 16th century: emphasis on the family, a new attitude towards death, an absence of intercessor figures.

VIII. B. 4. Glass

1186
DIDIER-LAMBORAY, ANNE-MARIE. "Deux vitraux de l'histoire de Daniel d'après Martin van Heemskerck à l'église Saint-Antoine de Liège." *Bulletin, Institut royal du patrimoine artistique* 11 (1969):134-141, 4 illus.

Publishes a stained glass medallion depicting a story from the apocryphal Book of Daniel: The priests of Baal and their families secretly entering the temple. The composition is based on an engraving after Heemskerck, and is interpreted as a Protestant attack on the Catholic cult of image worship.

1187
RAHN, J.R. "Konfessionell-Polemisches auf Glasgemälden." *Zwingliana* 1 (1897-1904):355-61, 3 illus.

Discusses four 16th-century glass paintings representing violent Protestant denunciations of the Pope and clerics.

1188
RIJKSEN, A.A.J. *Gespiegeld in kerkeglas. Hollands leed en vreugd in de Glasschilderingen van de St. Janskerk te Gouda.* Lochem: Uitgevers-maatschappij "De Tijdstroom", 1947, xvi, 337 pp., 3 color illus., 104 b&w illus., bibliog.

A history of glass painters and paintings in Holland during the 16th century, focusing on the windows of St. Jan's church in Gouda. The paintings are shown to reflect much of the historical circumstances, expressing a new, positive spirit in mid-century and later commenting on Habsburg repression with sometimes quite specific allusions to contemporary events. The effects of iconoclasm and changes in patronage are discussed. Though there is no index, the table of contents is very detailed.

1189
SCHUBART, ROBERT H. "Bemerkungen zur Ikonographie von Valentin Buschs Glasmalerei im Querhaus Süd (Stirnwand) der Kathedrale von Metz." *Zeitschrift*

für die Geschichte der Saargegend 25 (1977):67-85, 4 illus.

Examines the iconography of a set of stained glass windows put up from 1519-27, precisely the years during which the church in Metz was struggling against the Reformation movement. The windows are seen to reflect an assertion of orthodoxy directed against Luther's teachings.

VIII. B. 5. Altarpieces

1190

CHRISTIE, SIGRID. "Seljord Kirke. IV. Altertavlens ikonografi" [Seljord Church. IV. Altarpiece iconography]. *Foreningen til Norske Fortidsminnesmerkers Bevaring Arbok* 126 (1971):61-68, 5 illus. (Illus. of the altarpiece itself occur earlier, pp. 49-59).

In Norwegian. This small Romanesque church in Norway contains an altarpiece from 1588, early post-Reformation, showing Moses and Aaron with the tables of the Law. The text includes the ban on images and clearly represents a Protestant view.

1191

GERLAND, OTTO. "Die Antithesis Christi et Papae in der Schlosskirche zu Schmalkalden." *Zeitschrift des Vereins für hessische Geschichte,* n.s. 16 (1891):189-201.

Describes the forty 16th-century panels (all lost but listed in the Marburg archives) that once decorated the chapel of the Wilhelmsburg palace in Schmalkalden. Reviews the theme of Christ and the Pope as antitheses in Reformation art, particularly Cranach's *The Passional of Christ and Antichrist,* which is seen as model for these lost works painted by Georg Kronhard.

1192

HÄCKER, OTTO. "Evangelische Altarkunst der Renaissance und Barockzeit in Schwaben." *Das Schwäbische Museum* 9 (1933):5-16, 9 illus.

Though primarily covering 17th-century churches, pages 5-9 review the Protestant attitudes toward altarpieces in northern and southern Germany in the 16th century.

1193

HINTZENSTERN, HERBERT von. *Die Bilderpredigt des Gothaer Tafelaltars.* Berlin: Evangelische Verlagsanstalt, 1965, 134 pp., 84 illus.

Explicates the program of a hinged polyptych (2nd quarter 16th century) in the Gotha Schloßmuseum. The altarpiece depicts Old and New Testament scenes with accompanying texts. Various scenes are related to Luther's writings; the inscriptions were taken from an early printing of Luther's Bible translation.

1194

*KIESER, HARRY. "Das grosse Gothaer Altarwerk. Ein grosses Werk deutscher

Reformationszeit." Doctoral dissertation, Albertus-Universität Königsberg, 1939.

The first and basic art historical study of the Gotha altarpiece, attributing it to Matthias Gerung.

1195

SVENSSON, POUL, ed. *Lojttavlen. Et sonderderjysk alterskab.* ["Lojt Altarpiece. A southern Jutland winged altar"]. Froslev: De unges Kunstkreds, 1983, 173 pp., numerous illus. (some color), bibliog., summaries in English and German.

In Danish. A series of essays concerning the adornment of the parish church in Lojt (Lojtingers), Denmark. Otto Norn, "Lojttavlen i rum og lys," ["The Lojt Altarpiece in the light of Liturgical History"] gives the history of this altarpiece, placed in the church in 1520, shortly before the Reformation, and not removed.

1196

THULIN, OSKAR. "Altar und Kanzel der Torgauer Schloßkirche." *Luther. Mitteilungen der Luthergesellschaft* 28 (1957):86-90, 7 illus.

Discusses the 16th-century altar with alabaster and marble reliefs in the palace church at Torgau (destroyed in WW II.).

1197

*THULIN, OSKAR. "Luthers Auffassung vom Altar und die Praxis im frühen protestantischen Kirchenbau." *Kunst und Kirche* 15,2 (1938):14-17.

VIII. B. 6. Ceiling and wall paintings

1198

ANTON, ELISABETH. "Studien zur Wand- und Deckenmalerei des 16. und 17. Jahrhunderts in protestantischen Kirchen Norddeutschlands." Ph.D. dissertation, Munich, 1974. Privately printed. Augsburg: Blasaditsch, 1977, xiv, 268 pp., 25 illus.

Reviews early Protestant attitudes toward images in northern Germany, then surveys a selected group of eleven churches with wall paintings, followed by a section on various iconographic categories present (New Testament, Last Judgment, etc.).

1199

BADSTÜBNER, ERNST. "Protestantische Bildprogramme. Ein Beitrag zu einer Ikonographie des Protestantismus." In E. Ullmann, *Von der Macht der Bilder* (see no. 386), pp. 329-40.

Discusses Cranach's *Allegory of Law and Grace* as a basis for later Protestant pictorial cycles, and Luther's allegorization of church architecture and decoration.

1200

CLAUSSEN, HILDE. "Wandmalereien aus lutherischer Zeit in der Pfarrkirche zu

Sonneborn." *Westfalen. Hefte für Geschichte, Kunst und Volkskunde* 41 (1963):354-81, 27 illus.

Discusses the iconography and graphic prototypes for the 16th-century Protestant wall paintings in the church. A Passion cycle, various Old Testament scenes, illustrations of the Decalogue and catechism as well as other didactic subjects appear. The decoration is dated to the 1560's on historical grounds.

1201
GULDAN, ERNST. "Ein protestantischer Bildzyklus in der Steiermark." *Österreichische Zeitschrift für Kunst und Denkmalpflege* 11 (1957):8-12, 4 illus.

Reconstructs a late 16th-century fresco cycle rediscovered at an inn in Tipschern. The Old Testament illustrations from the *Life of Joseph* are interpreted as typologically referring to the reformers, this reading supported by reference to contemporary Protestant dramas.

1202
GULDAN, ERNST, and RIEDINGER, UTTO. "Die protestantischen Deckenmalereien der Burgkapelle auf Strechau." *Wiener Jahrbuch für Kunstgeschichte* 18 (1960):28-86, 55 illus.

Detailed study of an elaborate decorative program of 1579 before the re-Catholicization of the area in 1600. The typological and allegorical scheme is interpreted, and its visual and textual sources traced. The theological program is attributed to David Chytraeus of Rostock.

1203
HOPPE, THEODOR; WAGNER, FRANZ; and WALLISER, FRANZ. "Zur Restaurierung der Fresken im Rittersaal des Schlosses Goldegg." *Österreichische Zeitschrift für Kunst und Denkmalpflege* 15 (1961):152-64, 13 illus.

The frescoes of 1536 (restoration work in progress at the time of article) include religious subjects within a profane program. The religious elements are shown to reflect the donor's Protestant faith, and the cycle seen as a significant early mixture of profane and evangelical views.

1204
HORN, ADAM. "Die wiedergewonnenen Bocksberger-Fresken in der Schloßkapelle zu Neuburg a.d. Donau." *Kirche und Kunst* 31 (1952):2-6, 6 illus.

Describes and discusses this Protestant fresco cycle.

1205
KAEß, FRIEDRICH, and STIERHOF, HORST. *Die Schloßkapelle in Neuburg an der Donau.* Kunst in Bayern und Schwaben, 1. Weißenhorn: Anton H. Konrad, 1977, 94 pp., 20 b&w illus., 30 color illus.

The text (pp. 7-20) usefully summarizes Riedinger's findings (see no. 1209) and relates them to the accompanying photos.

1206
LEMPER, ERNST-HEINZ. *Die Stadtkirche St. Marien zu Pirna.* Das christliche Denkmal, 25. Berlin: Union Verlag, 1957, 31 pp., 17 illus.

Major portions of the choir vault were completed during the 1540's, just following the introduction of the Reformation in Saxony. An elaborate Lutheran program of ceiling paintings was done, including Old and New Testament, classical and allegorical subjects. Contemporary wall paintings (obscured by renovations in 1788 and 1802) included a satire against Tetzel's sale of indulgences, sacramental subjects, and an illustrated Lutheran catechism. The programs are attributed to Antonius Lauterbach (died 1569), friend of Luther and the pastor who introduced the Reformation at Pirna (pp. 14-22).

1207

LINDGREN, MERETH. "Evangelische Ikonographie in schwedischen Kirchenmalereien, 1530-1630." In E. Ullmann, *Von der Macht der Bilder* (see no. 386), pp. 122-128.

Reviews the results of studying 76 extant works from the 16th century in Sweden, mostly wall and ceiling paintings in churches. The iconography is discussed according to subjects (Old and New Testament, allegories etc.). Sources for these subjects are mainly prints.

1208

OERTEL, HERMANN. "Die St. Stephanikirche zu Helmstedt (als Beispiel protestantischer Bildausstattung)." *Braunschweigerisches Jahrbuch* 55 (1974):113-26, 3 illus.

Though the program for this church was carried out in the 17th century, the author surveys significant precedents for religious decorative schemes in Protestant churches of the previous century.

1209

RIEDINGER, RUDOLF. "Der typologische Gehalt der Fresken in der Schloss-kapelle zu Neuburg an der Donau." *Zeitschrift für bayerische Landesgeschichte* 38 (1975):900-44, 1 illus.

The fresco cycle in Ottheinrich's palace chapel in Neuburg (1543; not uncovered until 1951) was executed by Hans Bockberger according to the conception of Osiander. Reviews Ottheinrich's life and Osiander's writings. Makes sense of the painting cycle by finding its unified typological content reflecting a Lutheran picture-sermon by Osiander (derived largely from medieval iconography).

1210

STEINBÖCK, WILHELM. "Fresken des 16. Jahrhunderts in der Bürger-spitalskirche von Bad Aussee." *Jahrbuch des Kunsthistorischen Institutes der Universität Graz* 6 (1971):39-57, 26 b&w illus., 4 color illus.

History of the frescoes executed 1554-58. The program is shown to betray Protestant beliefs while utilizing traditional modes of representation.

1211

STEINGRÄBER, ERICH. "Die freigelegten Deckenmalereien in Neuburg an der Donau." *Deutsche Kunst und Denkmalpflege* 10 (1952):127-32, 4 illus.

Offers a detailed description of the Bocksberger frescoes and their

significance as very early examples of monumental painting in a Protestant structure. The specifically "evangelical" aspects of the program are elucidated and related to Luther's views.

1212
STIERHOF, HORST. "Einige Bemerkungen zur Schloßkapelle Ottheinrichs in Neuburg und ihren Fresken." *Neuburger Kollektaneenblatt* 122 (1969):38-46.
 An introductory discussion of the palace chapel and its decoration (completed 1543) as an expression of Protestant religious practice.

1213
STIERHOF, HORST. "Wand- und Deckenmalereien des Neuburger Schlosses im 16. Jahrhundert." *Neuburger Kollektaneenblatt* 125 (1972):5-72, 9 illus, table of contents, bibliog.
 Publication of the author's Ph.D. dissertation (Munich, 1972). The Protestant paintings by Bocksberger in the Neuburg palace chapel are discussed (pp. 20-34). The author believes Osiander may have designed the iconographic program. Jörg Breu d.J. and Hans Schroer also participated in the palace decoration.

1214
WIBIRAL, NORBERT. "Wandmalereien der Reformationszeit im Chor der Pfarrkirche von Frankenmarkt." *Österreichische Zeitschrift für Kunst und Denkmalpflege* 16 (1962):128-40, 9 illus.
 Description of wall paintings uncovered in 1959/60 depicting the Ten Commandments, Glorification of the Virgin and the Last Judgment. Suggests the latter two subjects betray a Catholic bias, indicating the paintings were done during the period of religious unrest in the area (1525-55) for a Catholic patron wishing to make an anti-Luther statement.

IX. Decorative and Minor Arts

1215

BARNARD, FRANCIS PIERREPONT. *Satirical and Controversial Medals of the Reformation: The Biceps or Double-Headed Series.* Oxford: Clarendon Press, 1927, 45 pp., 6 plates.

A brief introduction explaining the nature and purpose of satirical medals of this particular type (issued both by Catholic and Reformation polemicists). Following is a catalogue of 186 examples arranged by type and described.

1216

BRAEKMAN, E.M. *Les Médailles des Gueux et leurs résurgences modernes.* Brussels: n.p., 1972, 63 pp., 12 plates, bibliog.

A brief introduction and catalogue of medals struck for the "gueux," the revolutionary Protestant party in the Netherlands. The figurative and emblematic imagery of these medals is classified and interpreted.

1217

DORNIK-EGGER, HANNA. "Reformatorische Ikonographie auf deutschen Büchern der Renaissance." *Alte und Moderne Kunst* 12, no. 95 (1967):22-27, 14 illus.

Discusses the Reformation iconography of several leather bookbindings impressed with biblical and allegorical subjects and portraits. These derive mainly from designs originating in the circles of Dürer and Cranach, and appear on bindings of Reformation texts and unrelated texts as well.

1218

GEIGER, HANS-ULRICH. "Zürcher Münz- und Medaillenkunst im 16. Jahrhundert." In *Zürcher Kunst nach der Reformation* (see no. 492), pp. 27-32, 2 illus.

Reviews the growing craft of metalwork in 16th-century Zurich (Jakob Stampfer, Lorenz Rosenbaum), flourishing because of Protestant acceptance of secular art forms and the abundance of available precious metals melted down from ecclesiastical treasures.

1219
GERHARDT, JOACHIM. "Der Croy-Teppich in Greifswald." *Luther. Mitteilungen der Luthergesellschaft* 29 (1958):91-93, 1 illus.
Brief discussion of the tapestry and its historical connections with the Reformation in Pomerania.

1220
GRÄBKE, HANS ARNOLD, ed. *Der Reformationsteppich der Universität Greifswald.* Der Kunstbrief, 30. Berlin: Gebr. Mann, 1947, 32 pp., 18 illus.
Description and history of the elaborate 1554 portrait tapestry that depicts the princely families of Saxony and Pomerania and a number of reformers attending a sermon by Luther. The iconography is interpreted, stressing its emphasis on the written and spoken word in Protestant thought. The tapestry is based on a design from the Cranach workshop.

1221
GROHNE, ERNST. "Die bremischen Truhen mit reformatorischen Darstellungen und der Ursprung ihrer Motive." *Schriften der Bremer Wissenschaftlichen Gesellschaft, Reihe D: Abhandlungen und Vorträge* 10 (1936):3-88, 38 illus.
Studies 16th- and 17th-century wooden chests with relief carvings of Reformation subjects. The iconography is traced to Cranach's *Allegory of Grace and Salvation* portrayals and a wide range of other visual sources.

1222
HABICH, GEORG. "Studien zur deutschen Renaissancemedaille, III: Friedrich Hagenauer." *Jahrbuch der königlich preussischen Kunstsammlungen* 28 (1907):181-98, 230-72, 132 illus.
Concerns a designer and caster of medals (mainly portraits) active in Augsburg and Strasbourg in the 1520's-40's. See pp. 269-72 for Hagenauer's complaint over the decline in commissions for works of art during this period.

1223
HANNOVER, KESTNER-MUSEUM. *Münzen und Medaillen zur Reformation. 16. bis 20. Jahrhundert.* Exhib. cat., 19 May - 25 July 1983. By Margildis Schlüter, xix, 176 pp., many illus.
An illustrated catalogue of medals and coins from the Kestner Museum's collection.

1224
KRUEGER, INGEBORG. "Papst und Teufel. Ein neuerworbener Siegburger Trichterhalskrug." *Das Rheinische Landesmuseum Bonn,* 1975, pp. 54-56, 3 illus.
Describes a 16th-century pitcher bearing profile heads of the pope and the devil (the design based on a satirical medal).

1225
KRUEGER, INGEBORG. "Reformationszeitliche Bildpolemik auf rheinischem Steinzeug." *Bonner Jahrbücher* 179 (1979):259-95, 30 illus.

Investigates the Reformation iconography of the relief images on two 16th-century ceramic jugs, one a double-headed pope/devil, the other an anti-Interim image (the Augsburg Interim of 1548-52). Includes a review of all anti-Interim images known to the author, and a brief discussion of *Christ's Sheepfold* images.

1226

LESSING, JULIUS. "Der Croy-Teppich im Besitz der königlichen Universität Greifswald." *Jahrbuch der Königlich Preussischen Kunstsammlungen* 13 (1892):146-60, 4 illus.

Published separately, Berlin, 1902. A detailed discussion of the tapestry, its background and the history of its Protestant donors. The inscriptions, read in relation to the images and figures, are interpreted as specifically Protestant.

1227

RABENAU, KONRAD von. "Reformation und Humanismus im Spiegel der Wittenberger Bucheinbände des 16. Jahrhunderts." In E. Ullmann, *Von der Macht der Bilder* (see no. 386), pp. 319-28.

Investigates the interweaving of Reformation and Humanist motifs on book covers from Wittenberg starting around 1535.

1228

RÖTTGEN, HERWARTH. "Georg Lemberger, Hans Brosamer und die Motive einer Reformationsmedaille." *Anzeiger des Germanischen Nationalmuseums* (Nuremberg: Germanisches Nationalmuseum, 1963), pp. 110-15, 8 illus.

Discusses the iconography and visual sources of two medals of 1556 and 1565. The popularity of medals during the Reformation period is connected to the new emphasis on a literary and theological or didactic use of images.

1229

SCHMIDT, RODERICH. "Der Croy-Teppich der Universität Greifswald, ein Denkmal der Reformation in Pommern." In *Johann Bugenhagen* (see no. 65), pp. 89-107, 1 illus.

The tapestry is seen as a pictorial record of local Reformation events. The history of the donors and reformers portrayed (especially Bugenhagen) is related to these events.

1230

SCHNELL, HUGO. *Martin Luther und die Reformation auf Münzen und Medaillen.* Munich: Klinkhardt & Biermann, 1983, 381 pp., 1059 b&w illus., 8 color illus., bibliog., index.

A thorough survey and catalogue of the coins and medals related to Luther and the Reformation from the 16th century and from subsequent jubilaums.

1231

SCHULTZE, VICTOR. *Geschichts- und Kunstdenkmäler der Universität Greifswald.* Greifswald: Julius Abel, 1906, 67 pp., 21 illus.

Pages 39-54 give the history and a description of the Croy tapestry,

connecting its style to the Cranach school and stressing the evangelical tone of its inscriptions.

1232
STEPPE, JAN-KAREL. " 'De overgang van het mensdom van het Oude Verbond naar het Nieuwe'. Een Brussels wandtapijt uit de 16e eeuw ontstaan onder invloed van de Lutherse ikonografie en prentkunst." *De Gulden Passer* 53 (1975):326-59, 9 illus.

A Flemish tapestry representing the *Passing of Humanity from the Old Law to the New* (Palencia, Cathedral) of ca. 1530-40 is shown to derive from Lutheran images, particularly the *Allegory of Grace and Salvation* initiated by Cranach. The iconography is discussed in relation to visual precedents and the writings of St. Paul.

1233
STRAUSS, KONRAD. *Die Kachelkunst des 15. und 16. Jahrhunderts in Deutschland, Österreich und der Schweiz.* Vol. 1. Strasbourg: Ed. Heitz, 1966, 160 pp., 1 color illus., 82 b&w illus., bibliog.

Protestant motifs on a 16th-century tile oven (destroyed W.W. II) from Grafenegg Castle and some related tiles (pp. 90-103, pls. 38-45).

1234
THOMPSON, J.D.A. "The Beggars' Badges and the Dutch Revolt." *Numismatic Chronicle,* 7th ser., 12 (1972):289-94, 12 illus.

Discusses several illustrated and inscribed badges issued by the so-called "beggars," supporters of Henry of Brederode who protested Spanish political and religious policy in the Netherlands in the 1560's-70's.

1235
THÜMMEL, HANS GEORG. "Der Greifswalder Croy-Teppich und das Bekenntnisbild des 16. Jahrhunderts." *Theologische Versuche* (Berlin) 11(1979):187-214, 17 illus.

An iconographic study of the tapestry as a Protestant "confessional picture." Traces the development of this type of image from the early 16th to the 17th century.

1236
TUULSE, ARMIN. "Gustav Vasas Reformationstavlor" [Gustav Vasas' Reformation Pictures.] *Fornvännen* 52 (1957):54-73, 15 illus. German summary pp. 72-73.

In Swedish. A lost cycle of painted wall-hangings from Vasas' Gripsholm Palace (known through 18th-century copies) are interpreted as a Reformation allegory of the faithless wife (*Ecclesia*) and Vasas as the worthy husband who punishes her (he broke with the Catholic church in 1521). The artist was from the Cranach school.

1237
WISCHERMANN, HEINFRIED. "Ein pommersches *Schandgemälde* auf Papst

Paul III von 1546 - ein Beitrag zur Bildpolemik der Reformationszeit." *Jahrbuch der Berliner Museen,* n.s. 21 (1979):119-35, 13 illus.

Concerns a sculpted model for a medal dated 1546 with a portrait of the Danzig patrician Hans Klur (Berlin, Staatliches Museum), probably executed by Hans Schenk. The verso portrays a satire of the Pope conceived as a parody of the *Laocoon* group. The iconography is deciphered in relation to Lutheran anti-papal imagery and polemic.

1238

ZASKE, NIKOLAUS. "Der Greifswalder Croy-Teppich." In *Lucas Cranach.* Edited by P. Feist (see no. 887), pp. 107-110.

Discusses the history and significance of this mid-16th-century tapestry depicting Luther preaching before a crucifix to an audience of the Saxon/Pomeranian household. The tapestry derives from designs from the Cranach workshop.

1239

ZIMMERMANN, HEINRICH. "Der Kartonnier des Croy-Teppichs." *Jahrbuch der Berliner Museen* 1 (1959):155-60, 3 illus.

Examination of the commission and execution of the tapestry, its relation to Cranach and his Reformation iconography.

X. Iconography of the Reformers

X. A. General

1240

ARNOLD, PAUL. *Medaillenbildnisse der Reformationszeit.* Berlin: Evangelische Verlagsanstalt, 1967, 119 pp., 49 illus.

A brief introduction, a part devoted to Luther (pp. 20-28), followed by reproductions of medals representing personalities of the Reformation period. Examples from 1519-56 by various designers, each medal briefly described.

1241

BEZA, THEODORE. *Icones, id est verae imagines virorum doctrina simul et pietate illustrium.* Geneva: Jean de Laon, 1580, ca. 350 pp., 82 illus. Facsimile reproductions of the portraits in *Beza's "Icones." Contemporary Portraits of Reformers of Religion and Letters.* Introduction and biographies by C.G. McCerie. London: The Religious Tract Society, 1906, xvi, 249 pp., 51 illus. Facsimile reprint: *Icones. 1580.* Continental Emblem Books, 2. Edited by John Horden. Menston, England: Scholar Press, 1971. Note by R.M. Cummings.

Contains biographical sketches and woodcut portraits of illustrious men, mainly reformers, arranged in geographical groups. 38 *icones,* many frames left blank. 44 pages of emblems with accompanying verses on Christian virtue.

1242

BLANKE, FRITZ. "Iconographie der Reformationszeit--Fragen um ein Cranachbild." *Theologische Zeitschrift.* Theologische Fakultät der Universität Basel 7 (1951): 467-71, 3 illus.

Identifies among the reformers in a painting by Cranach (Museum of Art, Toledo, Ohio), Andreas Osiander and Georg Spalatin. They appear with Luther and Melanchthon surrounding Johann Friedrich of Saxony. Inscriptions on the back of the painting list the newly identified portraits incorrectly.

1243

BOESCH, PAUL. "Adam und Eva auf einer Chorherrenscheibe von Carl von Egeri." *Zeitschrift für schweizerische Archaeologie und Kunstgeschichte* 11 (1950):22-27, 1 illus.

Identifies a glass painting (New York, Honegger coll.) as the work of Carl

von Egeri, dating it 1550-52. The names and coats-of-arms of the donors appear at the bottom; they are six well-known Zurich theologians, including Bullinger and Zwingli.

1244

BOESCH, PAUL. "Der Zürcher Apelles. Neues zu den Reformatorenbildnissen von Hans Asper." *Zwingliana* 9 (1949):16-50, 2 illus.

Concerns a commission of 1550 by Christopher Hale for a set of portraits of Swiss reformers. The correspondence includes details of the commission and remarks on the question of idolatry and portraiture. The author seeks to identify the portraits of Zwingli, Conrad Pellikan, Theodore Bibliander, Bullinger, Gewalther, and Oecolampadius.

1245

DEGERING, HERMANN. *Zehn Bilder und Porträts von der Hand Lucas Cranach des Jüngeren.* Berlin: Reichsdruckerei, 1928, 8 pp., 10 color facsimile plates.

A facsimile edition of the so-called *"Stammbuch"* or *Geneology* of Lucas Cranach the Younger, consisting of 10 paintings on parchment originally intended for inclusion in a special parchment printing of the 1541 Lutheran Bible.

1246

GEISBERG, MAX. "Einige Bilder aus der Wiedertäuferzeit." *Westfalen. Mitteilungen des Vereins für Geschichte und Altertumskunde* 7 (1915):88-91, 5 illus. (following p. 96).

Describes and identifies five previously unknown or rare woodcuts, mainly portraits of Anabaptists by Breu, Aldegrever and an unidentified master.

1247

GEISBERG, MAX. *Die münsterischen Wiedertäufer und Aldegrever. Eine ikonographische und numismatische Studie.* Studien zur deutschen Kunstgeschichte, 76. Strasbourg: J.H. Ed. Heitz, 1907, 78 pp., 23 illus. Reprint. Baden-Baden: V. Koerner, 1977.

Studies the iconography of the Anabaptist leaders through the portraits, medals and coins produced primarily during their reign in Münster from 1534-35. Principally concerns the major figures Jan van Leiden and Bernhard Knipperdolling. The nature of Aldegrever's relations with the Anabaptists is scrutinized.

1248

HABICH, GEORG. "Eine Sammlung von Augsburger Reformatorenbildnissen des 16. Jh. Ein Beitrag zur Kenntnis der Augsburger Wachsbildnerei." In *Augsburger Kunst der Spätgotik und Renaissance.* Beiträge zur Geschichte der deutschen Kunst, 2. Edited by Ernst Buchner and Karl Feuchtmayr. Augsburg: Dr. Benno Filser, 1928, pp. 449-57, 7 illus.

Discusses a set of drawings made from wax models for portrait medals originally in the collection of the Merck family in Augsburg. The portraits of leading reformers were made in the second half of the 16th century.

1249

HAMBURG, KUNSTHALLE. *Köpfe der Lutherzeit.* Exhib. cat., 4 March - 24 April 1983. Edited by Werner Hoffmann. Munich: Prestel Verlag, 1983, 318 pp., 85 b&w illus., 15 color illus., bibliog.
Review: see Parshall no. 518.
Richly illustrated catalogue covering the wide range of portraiture from German-speaking areas during the period of Luther's life. Some satirical images are included along with many serious portraits of Humanists, reformers, and anonymous figures of the time. The topic of art and the Reformation is discussed in the relevant entries and in Hoffmann's introductory essay (pp. 9-17).

1250

HIRTH, GEORG, ed. *Bilder aus der Lutherzeit. Eine Sammlung von Porträts aus der Zeit der Reformation in getreuen Facsimile-Nachbildungen.* Munich/Leipzig: G. Hirth, 1883, xi, 37 pp., 63 illus.
A collection of images from the Reformation period, mostly engraved portraits, with a short introduction.

1251

MECHEL, CHRISTIAN von. *Lucas Cranachs Stammbuch enthaltend die von Ihm selbst in Miniatur gemalte Abbildung des den Segen erteilenden Heilandes und die Bildnisse der vorzüglichsten Fürsten und Gelehrten aus der Reformations-Geschichte.* Berlin: Georg Decker, 1814, 13 pp., 13 illus.
Early publication of the so-called *"Stammbuch"* emphasizing its importance as a Reformation document. For a critique of Mechel's thesis see Degering (no. 1245).

1252

MUNICH [no location given]. *Aus der Frühzeit der evangelischen Kirche.* Aus-stellung zum Deutschen Evangelischen Kirchentag. Exhib. cat., 1959. Forword by L. Grote, catalogue by H. Röttgen. Nuremberg, n.p., 1959, 28 pp., 28 illus.
Illustrates portraits of reformers and patrons, documents, graphic art, paintings and artifacts from the early history of the Reformation. The objects exhibited on loan from the Germanisches Nationalmuseum, Nuremberg.

1253

NORDHOFF, J.B. "Meister Eisenhuth." *Bonner Jahrbücher* 96 (1895):304-31.
Argues that Aldegrever's portraits of the Anabaptist leaders establish his sympathy with this sect. A document from the Antwerp magistrate in 1536 complains of the many printers and painters executing such portraits. Johan Dusentschuer, a goldsmith and Anabaptist leader in Soest, is suggested as an intermediary for Aldegrever's connection to the Münster sect.

1254

PFEIFFER, GERHARD. "Albrecht Dürer's 'Four Apostles': A Memorial Picture from the Reformation Era." In *The Social History of the Reformation.* Edited by Lawrence P. Buck and Jonathan W. Zophy. Columbus: Ohio State University Press, 1972, pp. 271-96, 5 illus.

The Apostles are identified as portraits of four leading Reformation Humanists associated with the foundation of the Gelehrtenschule in Nuremberg: P. Melanchthon as John, J. Camerarius as Paul, H. Paumgartner as Mark, and M. Roting as Peter. The panels should be understood as a dedication to the city council of Nuremberg, and an admonishment to the council to follow good judgment. This article is a substantial revision of an earlier publication, see no. 1256.

1255
PFEIFFER, GERHARD. "Judas Iskarioth auf Lucas Cranachs Altar der Schlosskirche zu Dessau." In *Festschrift Karl Oettinger*. Edited by Hans Sedlmayr and Wilhelm Messerer. Erlangen: Universitätsbund Erlangen-Nürnberg e.V., 1967, pp. 389-400, 3 illus.
Discusses an altarpiece (ca. 1565) portraying various reformers in attendance at the Last Supper. Argues that the figure of Judas is a portrait of Friedrich Staphylus, a one-time adherent of Lutheranism who then betrayed the faith.

1256
PFEIFFER, GERHARD. "Die Vorbilder zu Albrecht Dürer's 'Vier Aposteln': Melanchthon und sein Nürnberger Freundeskreis." *Wissenschaftliche Beilage zum Jahresbericht des Melanchthon-Gymnasiums*. Nuremberg, 1959/60, 30 pp., 6 illus.
The author's initial publication attempting to identify Dürer's *Four Apostles* as portraits of contemporary Nuremberg reformers. Later revised and expanded (see no. 1254).

1257
SANDER, HJALMAR. "Zur Identifizierung zweier Bildnisse von Lucas Cranach d. Ä." *Zeitschrift für Kunstwissenschaft* 4 (1950):35-48, 6 illus.
Identifies the subjects of two portraits, each depicting a man associated with the Lutheran reform: *Johann Schöner* (Hannover, Kestner Museum) of 1528, and *Georg Spalatin as a Young Man* (formerly Berlin, Lipperheide coll.) of 1509.

1258
SARAN, BERNHARD. "Eobanus Hesse, Melanchthon und Dürer. Unbefangene Fragen zu den 'Vier Aposteln'." *Oberbayerisches Archiv* 105 (1980):183-210, 9 illus.
Examines in detail the implications of Mark and John as portraits of Hesse and Melanchthon. Recent laboratory evidence reveals different stages in the development of the composition, Mark appearing as the last addition. The paintings and their inscriptions are discussed in relation to the writings of these two Humanists, altogether reflecting a change in Dürer's attitude to the Reformation.

1259
SCHUSTER, PETER-KLAUS. "Individuelle Ewigkeit: Hoffnungen und Ansprüche im Bildnis der Lutherzeit." In *Biographisches und*

Autobiographisches in der Renaissance. Arbeitsgespräch in der Herzog August Bibliothek Wolfenbüttel vom 1. bis 3. November 1982. Edited by August Buck. Wolfenbütteler Abhandlungen zur Renaissanceforschung, 4. Wiesbaden: Otto Harrassowitz, 1982, pp. 121-73, 30 illus.

An analysis of portraiture and self-portraiture predicated on the standard of Dürer's accomplishments and specially directed to prints. The iconography of portraiture and its presentation of role or status are discussed, the spiritual dimension of these aspects seen to dominate the representational concept of the period. Erasmus, Luther, Melanchthon, and U. von Hutten are among the subjects. Cf. Schuster's essay in Hamburg, Kunsthalle, *Köpfe der Lutherzeit* (see no. 1249).

1260

STRASBOURG, L'ANCIENNE DOUANE. *Humanisme et Réforme à Strasbourg.* Exposition organisée par les Archives, la Bibliothèque et les Musées de la ville. Exhib. cat. 5 May - 10 June 1973, 65 pp., 45 b&w illus., 6 color illus.

Includes numerous works of art related to the Reformation (book illustrations, portraits of reformers).

1261

STUHLFAUTH, GEORG. "Unerkannte Bildnisse des Kurfürsten Friedrich des Weisen von Sachsen, des Königs Franz I. von Frankreich, und des Kaisers Karl V. im Passional Christi und Antichristi von Lucas Cranach d. Ä." *Theologische Blätter* 13 (1934):352-53.

Identifies specific portraits in Cranach's woodcut cycle.

1262

TROSCHKE, ASMUS von. "Miniaturbildnisse von Cranach d. J. in Lutherbibeln." *Zeitschrift des Deutschen Vereins für Kunstwissenschaft* 6 (1939):15-28, 12 illus.

Discusses the embellishment of luxury editions of Lutheran Bibles with illuminated portraits of patrons and reformers, and in one case a theological allegory.

1263

WOLFENBÜTTEL, HERZOG AUGUST BIBLIOTHEK. *Reformatoren in Niedersachsen: Luthers Anhänger im 16. Jahrhundert.* Exhib. cat., April 1983. Wolfenbütteler Schriften zum Lutherjahr 1983 in Niedersachsen, vol. 1, 38 pp., 35 illus.

An exhibition of reproductions and original books, manuscripts and portraits of Luther's followers in the region during the 16th century. Reformers' careers briefly recounted.

1264

ZIMMERMANN, HILDEGARD. "Die Bilderausstattung der sogen. Reformatoren-Bibel der Landesbibliothek zu Dresden." *Luther-Jahrbuch* 11 (1929):134-48, 1 illus.

A group of portraits of Reformation leaders was bound together with a Bible

and other manuscripts. These various woodcuts are identified and described. Most are from the Cranach circle.

X. B. Individual Reformers

X. B. 1. Gregor Brück

1265
BORNKAMM, HEINRICH. "Zu Cranachs Reformatorenbild." *Theologische Zeitschrift* 8 (1952):72-74.
Comment on F. Blanke's article (see no. 1242) contesting Blanke's identification of one of the figures in this painting (Toledo, Ohio, Museum of Art). The figure identified by Blanke as Andreas Osiander is here argued to be Gregor Brück, chancellor to Johann Friedrich of Saxony. See also nos. 1267 and 1268.

1266
FABIAN, EKKEHART. "Cranach-Bildnisse des Reformationskanzlers Dr. Gregor Brück." *Theologische Zeitschrift* 20 (1964):266-80.
The last word on portraits of Brück! To the Toledo portrait (see nos. 1265, 1267 and 1268), the author adds portraits of 1533 and 1557. All three stem from the Cranach workshop. They are not discussed except for identifying the sitter.

1267
*FABIAN, EKKEHART. *Der Reformations-Kanzler Dr. Gregor Brück als der grosse "Unbekannte" auf dem wiederentdeckten "Wittenberger Reformatoren-bild" von Lukas Cranach d. Ä.* Frankfurt, n.p., 1951, 18 pp.
Proposes an identification for one of the figures in Cranach's painting in the Toledo Museum of Art. See Fabian's subsequent note and dispute with Bornkamm (nos. 1265 and 1268).

1268
FABIAN, EKKEHART. "Zum 'Wittenberger Reformatorenbild' Cranachs." *Theologische Zeitschrift*. Theologische Fakultät der Universität Basel 8 (1952):232-36.
The author lays prior claim to the identification of Gregor Brück in the group portrait in the Toledo Museum of Art (see Bornkamm, no. 1265), and proceeds to identify yet another figure in this remarkable assembly as Johann Bugenhagen.

X. B. 2. Johann Bugenhagen

1269
THULIN, OSKAR. "Das Bugenhagenbildnis im Zeitalter der Reformation." In W.

Rautenberg, ed., *J. Bugenhagen* (see no. 65) pp. 71-88, 13 illus.
Describes and illustrates a number of 16th-century portraits of Bugenhagen by Cranach and his circle.

X. B. 3. Jean Calvin

1270
DOUMERGUE, EMILE. *Iconographie Calvinienne*. Lausanne: Georges Bridel, 1909, vii, 279 pp., 102 illus., descriptive catalogue of the portraits and of medallions.
Survey of portraits of Calvin (part 1) and of Reformation caricatures in Germany and France (part 2) up to the 18th century. Caricatures specifically involving Calvin are separately treated.

1271
WEERDA, JAN. *Holbein und Calvin. Ein Bildfund*. Neukirchen: Verlag der Buchhandlung des Erziehungsvereins, 1955, 39 pp., 1 color illus., 7 b&w illus.
Discussion of a portrait in the Schloß Aschbach collection inscribed "Calvin peint par Holbein." Concludes it is of Calvin and possibly by Holbein.

X. B. 4. Joachim Camerarius

1272
HOFMANN, MICHEL. "Joachim Camerarius in der Maske des Apostels Paulus." *Fränkische Blätter für Geschichtsforschung und Heimatpflege* 13 (1961):33-34, 2 illus.
Accepts Pfeiffer's identification (see no. 1256) of St. Paul in Dürer's *Four Apostles* as a portrait of Camerarius -- a Bamberg native son thus honoring his city.

X. B. 5. Desiderius Erasmus

1273
DIEPOLDER, HANS. *Bildnisse des Erasmus von Rotterdam von Hans Holbein d. J.* Der Kunstbrief, 57. Berlin: Gebr. Mann, 1949, 32 pp., 20 illus.
Discusses portraits of Erasmus by Holbein, Massys and Dürer including paintings, drawings and prints.

1274
GANZ, PAUL. "Les portraits d'Erasme de Rotterdam." *Revue de l'Art Ancien et Moderne* 67 (1935):3-24, 16 illus.
A detailed discussion of all the known portraits of Erasmus.

1275
GERLO, ALOIS. *Erasme et ses portraitistes. Metsijs - Dürer - Holbein.*
Nieuwkoop: B. de Graaf, 1969, 72 pp., bibliog., index.
A thorough discussion of the major portraits and Erasmus' contact with the
artists. Good bibliography.

1276
HAARHAUS, JULIUS R. "Die Bildnisse des Erasmus von Rotterdam." *Zeitschrift
für bildende Kunst,* n.s. 10 (1898/99):44-56, 12 illus.
Discusses several portraits of, or putatively of, Erasmus.

1277
HECKSCHER, WILLIAM S. "Reflections on Seeing Holbein's Portrait of Erasmus
at Longford Castle." In *Essays in the History of Art Presented to Rudolf
Wittkower.* Edited by Douglas Fraser et al. London: Phaidon Press, 1967, pp.
128-48, 17 illus.
Detailed iconographic study of the portrait in relation to Erasmus' intellectual
history, including his dispute with Luther (*Liberum arbitrium*), his uncertain
relations with the papacy, and his personal difficulties with his own work.

1278
KOEGLER, HANS. "Zum graphischen Werk der Brüder Holbein. Hans Holbeins
d.J. Holzschnitt-Bildnisse von Erasmus und Luther." *Jahresbericht der
öffentlichen Kunstsammlung Basel* 17 (1920):35-47, 9 illus.
Sees woodcut portrait medallions of Luther and Erasmus as companion
pieces. Reviews the history of several related portraits.

1279
REINHARDT, HANS. "Erasmus und Holbein." *Basler Zeitschrift für Geschichte
und Altertumskunde* 81 (1981):41-70, 11 illus.
Discusses Erasmus' relationship to his portraitists, especially Holbein. This
is followed by a consideration of the Reformation's impact on artists and their
profession.

1280
ROTTERDAM, BOYMANS-VAN BEUNINGEN MUSEUM. *Erasmus en zijn tijd.*
2 vols. Exhib. cat., 3 Oct. - 23 Nov. 1969. Text (unpaginated), 571 entries,
index, bibliog., over 200 b&w illus., 8 color illus.
An exhibition including works of art, artifacts, books and documents
pertinent to Erasmus and his cultural and historical setting. Organized
chronologically by stages and locations of Erasmus' career.

1281
TIETZE-CONRAT, E. *Erasmus von Rotterdam im Bilde.* Vienna: Ed. Hölzel,
1921, 22 pp., 10 illus.
A general introduction to portraits of Erasmus.

1282

TREU, ERWIN. *Die Bildnisse des Erasmus von Rotterdam.* Basel: Gute Schriften, 1959, 55 pp., 20 illus., bibliog.

Recounts Erasmus' life and discusses the numerous portraits. Considers his relationship to the Reformation and his appearance on a Protestant altarpiece by L. Cranach the Younger (Michael Meienburg Epitaph, Nordhausen; destroyed in W.W. II).

X. B. 6. Johann Hess

1283

FÖRSTER, RICHARD. "Die Bildnisse von Johann Hess und Cranachs 'Gesetz und Gnade'." *Schlesiens Vorzeit in Bild und Schrift. Jahrbuch des schlesischen Museums für Kunstgewerbe und Altertümer,* n.s., 5 (1909):117-43, 10 illus.; appendix, pp. 205-6.

Discusses a portrait of Hess from 1546 (Breslau, Schlesisches Museum) and later copies of it. An epitaph panel (Breslau, Maria Magdalenenkirche) with verses by Melanchthon is dated 1548-49 and related to Cranach's allegories of the Old and New Testaments. An overview of types is given (19 versions are discussed, the last two in the appendix).

X. B. 7. Martin Luther

1284

*BOTT, GERHARD; EBELING, GERHARD; and MOELLER, BERND, eds. *Martin Luther. Sein Leben in Bildern und Texten.* Frankfurt: Suhrkamp, 1983, 380 pp., 300 illus., index.

1285

DIECK, ALFRED. "Cranachs Gemälde des toten Luther in Hannover und das Problem der Luther Totenbilder." *Niederdeutsche Beiträge zur Kunstgeschichte* 2 (1962):191-218, 9 illus.

Examines the origins and proliferation of portraits of Luther in death, and their heritage in portrayals of him as living. Hypothesizes a lost drawing by Cranach at the root of this visual recension.

1286

FALKE, OTTO von. "Martin Luther, Bildwirkerei von Seger Bombeck." *Pantheon* 3, part 1 (1929):148-150, 1 illus.

Describes a tapestry portrait of ca. 1550 (on the art market, Berlin), done by an artist associated with the Cranach workshop.

1287

FICKER, JOHANNES. "Älteste Bildnisse Luthers." *Zeitschrift des Vereins für*

Kirchengeschichte der Provinz Sachsen 17 (1920):1-50, 19 illus.
An overview of Luther portraits executed during his lifetime.

1288
FICKER, JOHANNES. "Die Bildnisse Luthers aus der Zeit seines Lebens."
Lutherjahrbuch 16 (1934):103-61, 20 illus.
Arranges the portraits according to type (as monk, doctor, knight etc.), in all
media. The catalogue identifies 40 portraits of Luther's family and 447 portraits
of Luther himself, including death portraits and commemorative portraits. A
basic reference source for Luther iconography.

1289
FICKER, JOHANNES. "Die Erstgestalt von Cranachs erstem Lutherbildnis." In
*Studien und Kritiken zur Teologie. Eine Festgabe Ferdinand Kattenbusch zum 3.
10. 1931.* Gotha: Leopold Klotz, 1931, pp. 285-91, 2 illus.
Publishes the previously unknown state of Cranach's 1521 engraved Luther
portrait (unique impression, Weimar, Staatliche Kunstsammlung), before the
profile head in the upper left had been burnished out. Argues the profile is a
self-portrait of Cranach and was meant as a sign of the deep friendship between
the two men.

1290
FICKER, JOHANNES. "Neue alte Bilder Luthers." *Luther. Mitteilungen der
Luther-Gesellschaft* 6 (1924):54-76, 9 illus.
Identifies and discusses a number of recently discovered Luther portraits in
various media (woodcuts, drawings, medals), including a medal showing Luther
combating the Pope "al antica" in the nude!

1291
GRUNTHAL, HENRY. "Unknown Portrait Medal of Martin Luther." *Numismatist*
56 no. 4 (1943):266-67, 1 illus.
Identifies a Renaissance medal with a portrait of Luther on one side and
Christ on the other.

1292
HAGELSTANGE, ALFRED. "Die Wandlungen eines Lutherbildnisses in der
Buchillustration des XVI. Jahrhunderts." *Zeitschrift für Bücherfreunde* 11
(1907):97-107, 6 illus.
Traces copies and adaptations of a Luther portrait showing the reformer as a
tonsured monk placed in an architectural niche. The type derives from Cranach.
The final example illustrated includes the dove of the Holy Spirit.

1293
HAHNE, H. "Luthers Totenmaske." *Luther. Vierteljahresschrift der Luther-
gesellschaft* 13 (1931):74-79, 8 illus.
Analysis of the head and hands of a wax Luther figure in the Marktkirche,
Halle, concluding it is an actual body cast from the 16th century, reworked in the
17th, and may well be Luther's death mask.

1294
JORDAN, JULIUS. "Luthers Bild." *Luther. Mitteilungen der Luthergesellschaft*, Part I, 1 (1919):64-69; Part II, 4 (1922):25-27, 2 illus.
Speculates on Luther's actual appearance, arguing it is best represented in Cranach's 1521 engraving and in his 1522 woodcut of Luther as Junker Jörg.

1295
JUNCKER, CHRISTIAN. *Das guldene und silberne Ehren-Gedächtniß des theuren Gottes-Lehrers D. Martini Lutheri. In welchem dessen Leben/Tod/Familie und Reliquien... beschrieben und aus mehr als 200 Medaillen oder Schau-Müntzen und Bildnissen mit Anmerkungen erkläret werden, durch Ch. Juncker.* Frankfurt & Leipzig: J.A. Endter, 1706, lviii, 562 pp., numerous illus., index.
A collection of over 200 medals and portraits illustrating various aspects of Luther's life, each described and discussed.

1296
KNOLLE, THEODOR. "Der Prototyp des Lutherbildes mit dem Schwan." In *Forschungen zur Kirchengeschichte und zur christlichen Kunst.* Festschrift Johannes Ficker. Edited by Walter Elliger. Leipzig: Dieterich'sche Verlagsbuchhandlung, 1931, pp. 222-42, 1 illus. (plate 31).
The full-length portrait of Luther by Jacob Jacobsen (dated 1603) is discussed in terms of its tradition, including earlier portraits of this type, the meaning of the swan as a symbol, etc.

1297
LILJE, HANNS. *Martin Luther. Eine Bildmonographie.* Hamburg: Furche, 1964, 240 pp., 160 illus.
Luther's biography is narrated with illustrations from contemporary works of art.

1298
LILJE, HANNS. *Martin Luther in Selbstzeugnissen und Bilddokumenten.* n.p., Rowohlt, 1965, 155 pp., 68 illus., bibliog., index.
General introduction to the Reformation era and Luther's role in it. The numerous illustrations are not discussed in the text.

1299
LUTHER IM PORTRAIT. DRUCKGRAPHIK 1550-1900. Cat. of a travelling exhibition, 1983-84. Bad Homburg, Bad Oeynhausen, Paderborn, Gütersloh, Bielefeld, Osnabrück. Stadt Bad Oeynhausen: Jonas Verlag in Kommission, 1983, 100 pp., 114 illus.
Portraits from various regions catalogued, and preceded by an introductory essay.

1300
MARTIN LUTHER. DOKUMENTE SEINES LEBENS UND WIRKENS. No editor. Weimar: Hermann Böhlaus Nachfolger, 1983, 438 pp., many illus.,

some color, bibliog., index.

A chronologically arranged survey of events in Luther's life illustrated through documents, printed propaganda, books and paintings (245 items).

1301

MENZHAUSEN, JOACHIM. "Die entwicklungsgeschichtliche Stellung des Wittenberger Luther-Standbildes." *Jahrbuch: Staatliche Kunstsammlungen Dresden,* 1961-62, pp. 115-27, 6 illus.

An overview of monumental statues of Luther, locating them in a tradition of such public imagery. Treats works from the 16th to the 19th century, stressing the importance of Cranach for heroic conceptions of the reformer.

1302

OSTEN, GERT von der. "Lukas Furtenagel in Halle." *Wallraf-Richartz Jahrbuch* 34 (1972):105-18, 8 illus.

Reconsiders the documentary evidence for Furtenagel having made a death portrait and death mask of Luther (see Stuhlfauth, 1927, no. 1307 and Dieck, no. 1285), confirming his authorship of the drawing in Berlin, Kupferstichkabinett. Other attributions to Furtenagel are discussed, and the artist's relation to Cranach and Lutheran patronage examined.

1303

PREUSS, HANS. *Lutherbildnisse. Ausgewählt und Erläutert.* Leipzig: R. Voigtländer, n.d., 64 pp., 42 illus.

A brief, general essay on Luther portraits, illustrated by examples from the 16th to the 20th century. Five of the illustrations are cited as having not been previously published.

1304

ROGGE, JOACHIM. *Martin Luther. Eine Bildbiographie.* Gütersloh: Gerd Mohn, 1982, 391 pp., 530 b&w illus., 12 color illus.

A brief introduction and album of topographical photos, works of art from all periods, documents etc. pertaining to Luther, organized according to the stages of his career.

1305

SCHOTTENLOHER, KARL. "Denkwürdige Reformationsdrucke mit dem Bilde Luthers." *Zeitschrift für Bücherfreunde,* n.s. 4, part 2 (1912/13):221-31, 11 illus.

Discusses the origins and dating of several images of Luther, both portraits and allegorical representations, published between 1521-25. Relevant to the early iconography of the reformer.

1306

SCHRECKENBACH, PAUL, and NEUBERT, FRANZ. *Martin Luther: Ein Bild seines Lebens und Wirkens.* Leipzig: J.J. Weber, 1916, vi, 184 pp., 379 b&w illus., 5 color illus.

Brief, general text and a corpus of iconographical and topographical

illustrations, including a number of portraits and other works rarely, if ever, reproduced.

1307
STUHLFAUTH, GEORG. *Die Bildnisse D. Martin Luthers im Tode.* Weimar: Hermann Bohlaus, 1927, 56 pp., 27 illus.
 This is the basic study of the Luther death portraits in all media from the 16th century. The recension from the drawing (Berlin, Kupferstichkabinett) and variants are traced. The contributions of Cranach, Lucas Furtenagel, Jost Amman, and Hans Guldenmund among others are discussed.

1308
STUHLFAUTH, GEORG. "D. Martin Luther in der Bildniszeichnung des Toten von Lucas Furtenagel." *Kunst und Kirche* 17 (1940):17, 1 illus. (p. 1).
 Describes the drawing (Berlin, Kupferstichkabinett) and its provenance.

1309
THULIN, OSKAR. "Luther in den Darstellungen der Künste." *Luther-Jahrbuch* 32 (1965):9-27.
 Briefly surveys the representation of Luther in the visual arts, literature and music from the 16th century with some cursory remarks on the later tradition.

1310
THULIN, OSKAR. "Luther in the arts." In *The Encyclopedia of the Lutheran Church* (see no. 16) 2, pp. 1433-42, 4 illus.
 Discusses 16th-century portraits of Luther, their function as "spiritual weapons", and his appearance on numerous Cranach altarpieces (pp. 1433-38).

1311
THULIN, OSKAR. "Das Lutherbild der Gegenwart." *Luther-Jahrbuch* 23 (1941):123-148, 67 illus.
 Traces the image of Luther in the visual arts into this century, identifying the "classic" prototypes for subsequent iconography in the portraits and the death mask from Luther's own time.

1312
THULIN, OSKAR. *Martin Luther: Sein Leben in Bildern und Zeitdokumenten.* Munich & Berlin: Deutscher Kunstverlag, 1958, 111 pp., 1 color plate, 70 b&w plates, additional illus. in text.
 Luther's life presented through chronologically arranged quotations from contemporary documents and illustrated with various works of art.

1313
THULIN, OSKAR. "Original-Luther-Bild oder Werkstatt-Arbeit?" *Luther. Mitteilungen der Luthergesellschaft* 29 (1958):40-42, 4 illus.
 Discusses several methods of reproduction used in the 16th century, especially in the production of portraits of Luther and other reformers.

1314
VOGEL, JULIUS. "Luther als Junker Georg." *Zeitschrift für bildende Kunst* 53, n.s., 29 (1918):57-64, 6 b&w illus., 1 color illus.
 Reviews the paintings and engravings representing Luther as Junker Jörg, finding the panel of 1521 (Leipzig, Museum) the prototype for all later versions.

1315
WARNKE, MARTIN. *Cranachs Luther: Entwurfe für ein Image.* Frankfurt am Main: Fischer Taschenbbuch Verlag, 1984, 79 pp., 43 illus.
 Analyzes portraits of Luther done throughout his career, considering typological, iconographical and subjective aspects in the presentation of the Reformer's public image in comparison to those of his contemporaries.

1316
ZIMMERMANN, HILDEGARD. "Bildnis-Holzschnitte und Texte zu Luthers Gedächtnis." *Zeitschrift für Buchkunde* 2 (1925):99-109, 2 illus.
 Discusses the recension of Luther portraits in woodcut, with special reference to two broadsheets with commemorative texts issued shortly after Luther's death (ca. 1550). The broadsheets employ woodcut illustrations deriving from the Cranach workshop, and were published by the Wittenberg printer Georg Rhau.

1317
ZIMMERMANN, HILDEGRAD. "Holzschnitte und Plattenstempel mit dem Bilde Luthers und ihre Beziehungen zur Werkstatt Cranachs." *Jahrbuch der Einbandkunst* 1 (1927):112-21, 10 illus.
 Discusses portraits of Luther stamped on 16th-century book bindings and their graphic prototypes.

X. B. 8. Philip Melanchthon

1318
HARKSEN, SIBYLLE. "Bildnisse Philipp Melanchthons." In *Philipp Melanchthon. Humanist, Reformer, Praeceptor Germaniae.* Philipp Melanchthon 1497-1560, 1. Berlin: Akademie-Verlag, 1963, pp. 270-87, 11 illus., bibliog.
 Discusses the various 16th-century portraits of Melanchthon by Dürer, Holbein, Cranach, and others.

1319
NUREMBERG, STADTBIBLIOTHEK. *Melanchthon und Nürnberg: Ausstellung aus Anlaß der 400. Wiederkehr seines Todestages.* Exhib. cat., 29 April 1960 -, 22 pp., 4 illus., 171 entries.
 Brief identification of each item exhibited, including portraits, medals and documents pertinent to Melanchthon's career in Nuremberg.

1320

THULIN, OSKAR. "Melanchthons Bildnis und Werk in zeitgenössischer Kunst." In *Philipp Melanchthon. Forschungsbeiträge zur vierhundertsten Wiederkehr seines Todestages dargeboten in Wittenberg 1960.* Edited by Walter Elliger. Göttingen: Vandenhoeck & Ruprecht, 1961, pp. 180-93, 3 illus., 33 plates.

An overview of contemporary portraits of Melanchthon with some remarks on iconography: prints, drawings, paintings, and medals by various artists including Cranach the Elder, Dürer, J. Binck, Holbein the Younger and others.

1321

ZIMMERMANN, WERNER. "Melanchthon im Bildnis." In: *Philipp Melanchthon 1497-1560. Gedenkschrift zum 400. Todestag des Reformators, 19. April 1560/1960.* Edited by Georg Urban. Bretten: Melanchthonverein, 1960, pp. 127-58, 27 illus.

Illustrates portraits of Melanchthon, many from the 16th century.

X. B. 9. Johannes Oecolampadius

1322

FICKER, JOHANNES. "Das Bildnis Ökolampads." *Zwingliana* 4 (1921-28):4-20, 1 illus.

An iconographic investigation of several 16th-century portraits of Oekolampadius to determine which of them is most accurate.

X. B. 10. Huldreich Zwingli

1323

BOESCH, PAUL. "Die Bildnisse von Huldrich Zwingli." *Toggenburgerblätter für Heimatkunde* 13 (1950):1-16, 7 illus.

Discusses several 16th-century portraits of Zwingli and finds that all go back to two early works: a medal by J. Stampfer and a painting by H. Asper (Winterthur, Kunstmuseum).

1324

HOFFMANN, HANS. "Ein mutmaßliches Bildnis Huldrych Zwinglis." *Zwingliana* 8, Heft 9 (1948):497-501, 1 illus.

Discusses a Dürer portrait of a man, dated 1516, in the Galerie Czernin in Vienna (now in the National Gallery, Washington, D.C.), and concludes it is probably of Zwingli (Anzelewsky, see no. 929, suggests it may be of J. Dorsch, but not of Zwingli). This is a short version of an article in the appendix to Farner's study of Zwingli (see no. 168).

Index of Authors, Editors and Compilers

Abbé, Derek van, 1085
Adhemar, Jean, 878
Albrecht, Dieter, 1005
Allen, P.S., 202, 204
Alt, Heinrich, 20
Andersson, Christiane, 425, 631, 880
Anonymous, 656
Antal, Frederick, 341
Anton, Elisabeth, 1198
Anzelewsky, Fedja, 929, 1324
Arens, Franz, 342
Arnold, Paul, 1240
Aschenbrenner, Th., 187
Auner, Michael, 862
Autenboer, E. van, 267-68
Axters, Stephanus, 464

Baader, J., 409
Babcock, Barbara A., 741
Backhouse, M., 289
Badstübner, Ernst, 1199
Badstübner, Sibylle, 696
Baechtold, Jakob, 816, 1086
Baerwinkel, Dr., 653
Bäumer, Remigius, 201
Bainton, Roland H., 617, 930
Baker, Derek, 3
Ballschmiter, Thea, 931
Bange, E.F., 1046
Bangs, Jeremy D., 117, 465, 863, 1061
Barack, K.A., 243
Barge, Hermann, 103-105, 113, 244
Barnard, Francis Pierrepont, 1215
Battisti, Eugenio, 343
Battles, Ford Lewis, 77
Bauch, Gustav, 976-77

Baum, G., 227
Baumgart, Fritz, 526
Baumgarten, Fritz, 827, 830
Baxandall, Michael, 1154
Beare, Mary, 735
Becker, Jochen, 290, 320
Becker, Rudolf Zacharias, 588
Beenakker, A.J.M., 291
Beerli, Conrad André, 1087
Beets, N., 746, 1102
Behrend, Fritz, 618
Behrend, Horst, 882
Beitz, Egid, 787
Bellmann, Fritz, 1155
Bende, J., 498
Bendel, Max, 1119
Bender, Harold S., 95
Benesch, Otto, 344
Benoît, D., 26
Benoit, Jean-Daniel, 79
Benzing, Joseph [Josef], 118, 551
Bergmann, Rosemarie, 119
Bergner, T., 373
Berliner, Rudolf, 349, 755
Bern, 450 Jahre, 1101
Bernhard, Marianne, 828
Berthoud, G., 632
Beuzart, P., 21
Beza, Theodore, 71, 227, 1241
Bialostocki, Jan, 347, 499, 697-98, 1174
Binder, Ludwig, 101
Bing, Gertrud, 768
Blanke, Fritz, 1242, 1265
Blaschke, Karlheinz, 412-13
Blenk, C., 292
Blin, Jean Baptiste Nicolas, 231

Blindheim, Martin, 501, 756
Block, Peter, 800
Blum, André, 633
Bobrovszky, Ida, 500
Bodensieck, Julius, 16
Boerlin, Paul H., 829
Boesch, Paul, 1243-44, 1323
Bolte, Joannes, 679, 736
Boon, Karel G., 788
Bornert, René, 395
Bornkamm, Heinrich, 1265, 1267
Bossert, Gustav, 120
Bott, Gerhard, 1284
Bourguet, P., 396
Bourrilly, V.-L., 228
Brady, P.V., 680
Brady, Thomas A. Jr., 397, 830-31
Braekman, E.M., 1216
Brand, P.J., 293
Branden, F. Jos. van den, 466
Brandt, Geeraert the Elder, 269-70
Braun, Konrad, 193
Braunfels, Wolfgang, 17, 442, 665, 932
Bredekamp, Horst, 219, 256, 346
Breen, Joh. C., 271
Brendler, Gerhard, 460
Breu, Jörg the Elder, 803
Brieger, Theodor, 711
Brière, Gaston, 1109
Brom, Gerard, 467
Bromley, J.S., 295
Bruck, Robert, 415
Brückner, Wolfgang, 22, 510-11
Brunotte, Heinz, 15
Brunus, Conradus *see* Braun, Konrad
Brutel de la Rivere, G.J., 157
Bruyn, J., 820
Bruyn Kops, C. J. de, 294
Bryer, Anthony, 221
Bubenheimer, Ulrich, 106-7
Bucer, Martin, 24, 59-64,
Buchholz, Friedrich, 342, 348-49
Buchner, Ernst, 1248
Buck, August, 1259
Buck, Lawrence P., 1176, 1254
Büheler, Sebald, 804
Bühler, Wilhelm, 933

Büsser, Fritz, 69
Bugge, Ragne, 191, 501
Bullinger, Heinrich, 24, 46, 66-71, 74-75,
Bungert, Hans, 676
Burckhardt, D., 827
Burckhardt-Biedermann, Theophil, 681
Burckhardt-Werthemann, Daniel, 682
Burke, P., 323
Busch, Werner, 1083
Bushart, Bruno, 1110
Bussmann, Georg, 832

Calmann, Gerta, 737
Calvin, Jean, 46, 76-80,
Campen, J.W.C. van, 276
Campenhausen, Hans Freiherr von, 19, 23, 121, 167
Cantimori, D., 634
Cap, Paul Antoine, 818
Caro, Jakob, 152-53
Carrière, Victor, 232
Cast, David, 1062
Chadraba, Rudolf, 934-35, 965, 968
Chastel, André, 220
Chojecka, Ewa, 512, 635
Chrisman, Miriam Usher, 398, 636
Christensen, Carl C., 7, 122, 233, 257, 416-419, 1028, 1176
Christie, A.M., 433
Christie, Sigrid, 755a, 756, 1190
Claus, Helmut, 551
Claussen, Hilde, 1200
Clemen, O., 152-53, 589, 654-55, 978
Clutton, George, 747
Cochläus, Joannes, 194, 747a
Cochrane, Arthur C., 24
Cohausz, Alfred, 245
Conway, William Martin, 936
Coornhert, Dirk Volckertszoon, 805
Cordey, Jean, 402
Coulton, George Gordon, 350
Coupe, William A., 590
Coussemaker, Charles Edmond H. de, 296
Coutts, Alfred, 93
Craeybeckx, J., 323

Cramer, S., 25
Cranach, Lucas the Elder, 670-71
Crespin, Jean, 26
Crew, Phyllis Mack, 295
Crouch, Joseph, 351
Cunitz, Ed., 227
Curjel, Hans, 833
Cust, Lionel, 503, 1067
Cuvelier, J., 859

Dacheux, L., 804
Dankó, Joseph, 979
Dannenfeld, K.H., 172
Davidson, Jane P., 476
Davies, Horton, 504
Davis, Natalie Zemon, 234, 236, 738
Deblaere S. J., Albert, 864
Decker-Hauff, Hansmartin, 243
Degering, Hermann, 1245, 1251
Dehio, Georg, 422-424
Delius, Walter, 27
Denck, Hans, 94
Denecker, David, 806
Deneke, Bernward, 956
Denis, Paul, 1114
Deonna, W[aldemar], 484-85, 1047
Des Marez, G., 272
Detmer, H., 249
Devoghelaere, Hub, 468
Deyon, Solange, 235
Didier-Lamboray, Anne-Marie, 1186
Dieck, Alfred, 1285, 1302
Diepolder, Hans, 1273
Dierickx, M., 296-97
Dietenberger, Johannes, 195
Dimitrov, Dimitar G., 883
Dis, Leendert M. van, 56
Distel, Theodor, 246
Dixon, Laurinda S., 884
Dobbert, Eduard, 937
Dobneck, Johann, *see* Cochläus,
 Joannes
Dodwell, C.R., 964
Dodgson, Campbell, 527
Dött, Ilse-Käthe, 1137
Donk, Martin *see* Duncanus, Martinus
Dornik-Eger, Hanna, 938-39, 1217
Dorpius, Heinrich, 247

Dorsten, J[an] A[drianus] van, 505
Doumergue, Emile, 81, 1270
Drecka, Wanda, 885
Drexler, E., 980
Driessche, Roger van, 298
Drugulin, Wilhelm, E., 591
Drummond, Andrew Landale, 1129
Dubose, Lucius Beddinger, 82
Duda, Fritz, 699
Düfel, Hans, 123-24
Dürer, Albrecht, 807-09, 940-41, 1011
Dürr, Emil, 335, 493
Duke, A.C., 273, 299
Duncanus, Martinus, 196
Dupuy, Ernest, 1105
Durus, Alfred, 700
Dussa, Ingo, 638, 701
Duverger, J., 469
Duyse, H. van, 282
Dvorak, Max, 470, 942, 965

Ebeling, Gerhard, 1284
Eck, Johannes, 197-98
Ecker, Gisela, 513
Eckert, Willehad Paul, 163, 352
Eder, Karl, 981
Edsman, Carl-Martin, 506
Edwards, Mark U., Jr., 125
Eeghen, I.H. van, 300
Egli, Emil, 184, 329, 494
Egli, Fridolin, 619
Ehresmann, Donald L., 886
Ehrmann, Jean, 748, 879, 928
Einem, Herbert von, 1029
Eire, Carlos M.N., 353, 416
Eisler, Colin, 1044
Elliger, Walter, 1296
Emmens, J.A., 820
Emser, Hieronymus, 200
Engelhardt, Adolf, 426
Entner, Heinz, 702
Erasmus, Desiderius, 202-204,
Escherich, Mela, 834
Escorche-Messes, Frangidelphe, 655a
Estebe, Janine, 236

Fabian, Ekkehart, 1266-68
Falk, Tilman, 829, 881

Falke, Otto von, 1286
Farner, Oskar, 168, 528, 1324
Fechter, D.A., 326
Fehr, Hans, 592
Feist, Peter, 887
Fellmann, Walter, 94
Ferber, Stanley, 865
Feuchtmayr, Karl, 1248
Feuchtmüller, Rupert, 392
Feyrabend, Sigmund, 209
Ficker, Johannes, 529-30, 1287-90, 1322
Mrs. Finn, *see* Elizabeth Ann McCaul
Finsler, Georg, 169, 177, 184, 339
Fischart, Johann, 210
Fischer, Friedrich, 327
Fischer, Otto, 835
Fishman, Jane Susannah, 703
Fleischhauer, Werner, 749
Fleming, Gerald, 672-73
Fleming, John, 379
Förster, Richard, 1283
Fraenger, W., 592, 704-05, 714, 739, 1110-12
Fraenkel, Pierre, 198
France, Anatole, 819
Frank, Volker, 769
Franz, Gunther, 740
Fraser, Douglas, 1277
Freedberg, David, 28, 212, 221, 301-2
Freys, E., 105
Friedlaender, Gottlieb, 71
Friedländer, Max J., 888
Friesen, Abraham, 354
Fris, Victor, 303-4
Frizzoni, Gustavo, 982
Fromment, Anthoine, 328
Fruhstorfer, Karl, 983
Fuchs, Eduard, 639
Füglister, Robert, L., 770
Funke, Jutta, 1121
Fussgänger, Theodor, 984
Fyot, Eugène, 237

Gabler, A., 789
Gäbler, Ulrich, 170
Galle, Filips, 811
Ganz, Paul Leonhard, 486, 1274

Garside, Charles, Jr., 96, 171-72, 416
Gassen, Richard W., 531-32, 829
Geffcken, Johannes, 533
Geiger, Hans-Ulrich, 1218
Geisberg, Max, 192, 248, 427, 514, 534, 594-597, 1122, 1246-47
Gelder, Herman Arend Enno van, 305, 355, 471-473
Geller, Rolf-Hermann, 706
Genaille, R., 866
Gerhardt, Joachim, 1219
Gerke, Friederich, 428, 985
Gerland, Otto, 1191
Gerlo, Aloïs, 1275
Germann, Georg, 1149
Gertz, Ulrich, 356
Eyn gesprech auff das kurtzt zwuschen eynem Christen und Juden, 54
Giese, Rachel, 205
Glaser, Curt, 889
Glaser, Hubert, 442
Gleisberg, Hermann, 790
Gmelin, Hans-Georg, 771, 1106-7
Göransson, Anna Maria, 1120
Goering, M., 858
Goeters, J.F. Gerhard, 97
Goldammer, Kurt, 1135
Goldberg, Paul, 791
Goris, J.-A., 810
Gosebruch, Martin, 1042
Gräbke, Hans Arnold, 1220
Grandjean, Marcel, 792
Grau, Marta, 83
Greiffenberger, Hans, 812, 814
Grimeston, Edward, 279
Grimm, Hermann, 986, 1009
Grisar, Hartmann, 620, 630
Grohne, Ernst, 1221
Grosshans, Rainald, 1063
Grossmann, Fritz, 867, 1072
Grote, Ludwig, 598, 890, 943, 1082, 1252
Grüneisen, Carl, 29, 1089, 1095
Grüneisen, Ernst, 535-36
Grunthal, Henry, 1291
Günther, Rudolf, 987
Guldan, Ernst, 802, 1201-2
Gundersheimer, Werner L., 218

Gutmann, Joseph, 233, 310

Haack, Friedrich, 944
Haarhaus, Julius R., 1276
Haase, Barbara, 931
Habich, Georg, 1222, 1248
Haebler, Hans Carl von, 1156
Haecht, Godevaert van, 274
Häcker, Otto, 1192
Hähnsen, Fritz, 1178
Haendcke, Berthold, 357-58
Hätzer, Ludwig, 96, 98
Hagelstange, Alfred, 1292
Hagen, Oskar, 1049
Hagmann, Elfriede, 621
Hahne, H., 1293
Hain, Mathilde, 625
Hamberg, Per Gustaf, 1130
Hammer, Wilhelm, 154
Hampe, Theodor, 429
Harasimowicz, Jan, 757
Harbison, Craig, 375, 416, 758,
 772-774, 945
Harksen, Marie-Luise, 1155
Harksen, Sibylle, 1318
Harms, Wolfgang, 597, 599, 637
Hartlaub, G. F., 836
Hartmann, Olov, 126
Hartmann, Wolfgang, 1040
Hasak, Maximilian, 229
Hase, Martin von, 551, 657
Hasse, Hellmut, 108
Haverkamp-Begemann, Egbert, 1080
Heckscher, William S., 1277
Heege, Franz, 620, 630
Heege, Grisar, 630
Hege, C., 1010
Hegg, Peter, 684
Heidrich, Ernst, 1030, 1039
Heiland, Susanne, 953
Heimpel, Hermann, 258
Heinen, W., 31
Heinrich, Dieter, 462
Heitz, Gerhard, 707
Held, Julius S., 793
Heller, Joseph, 900
Hentschel, Walter, 1177
Henze, Helene, 641

Herget, Elisabeth, 668
Herkenrath, Erland, 72
Herrin, Judith, 221
Hertz, Karl and Barbara, 360
Hervey, Mary, 1073
Hetzer see Hätzer
Heutger, Nicolaus C[arl], 1138
Heyden, Cornelius van der, 100
Heydenreich, Ludwig H., 538
Heyer, Walter, 50
Hiepe, Richard, 891
Hillerbrand, Hans Joachim, 8
Hintzenstern, Herbert von, 775, 892,
 1193
Hinz, Berthold, 794, 1045
Hirth, Georg, 1250
His, Eduard, 1074
Hitchcock, Henry-Russell, 1139
Hoberg, Martin, 539-40
Hobi, Urs, 340
Hodnett, Edward, 750
Hoetink, H.R., 1064
Hoffmann, Hans, 168, 1050, 1166,
 1324
Hoffmann, Konrad, 30, 259, 640,
 679, 893, 1075
Hoffmann, Werner, 1249
Hofmann, Hans-Ulrich, 541
Hofmann, Michel, 1272
Hofmann, Werner, 359
Hohenemser, Paul, 593
Holl, Karl, 360
Holländer, Eugen, 600
Holt, Elizabeth G., 190
Hoop Scheffer, Dieuwke de, 793
Hoppe, Theodor, 1203
Horden, John, 1241
Horn, Adam, 1204
Horn, Curt, 946
Hottinger, J.J., 67
Howe, Günter, 167
Hoyer, Siegfried, 512
Huijbers, H.F.M., 277
Honour, Hugh, 379
Huber, Rudolf, 598
Hübener, P., 430
Hübmaier, Balthasar, 102

Hütt, Wolfgang, 431-32, 542, 708, 825, 947, 1051
Hugelshofer, Walter, 487, 837
Huggler, Max, 543, 1090
Hults, Linda C., 838
Hults-Boudreau, Linda, 839
Hultsch, Gerhard, 1152
Humbel, Frida, 173
Hupp, Otto, 642
Husson, Jules F.F., 643
Huvenne, Paul, 1108

Ihlenfeld, Kurt, 127
Im Hof, Ulrich, 1091-92
Imhoff, Christoph von, 163
Irmscher, Johannes, 455
Iserloh, Erwin, 31, 199

Jaeggli, Alvin, 808
Jahn, Johannes, 544, 894-95
Jansen, Wilhelm, 1167
Janssen, Johannes, 433
Jedin, Hubert, 188-89
Jelke, Robert, 1163
Jenny, Markus, 545, 1123
Jezler, Peter, 776
Johnsen, Wilhelm, 1178
Jones, William Paul, 361
Jong, Otto Jan de, 306
Jordan, Julius, 1294
Joris, David, 815
Jürgens, Walther, 546
Juncker, Christian, 1295
Jung, A[ndre], 238
Junghans, Helmar, 142, 434-35
Jursch, Hanna, 922-23, 1160
Justi, Ludwig, 924

Kadatz, Hans-Joachim, 1140
Kaeß, Friedrich, 1205
Kalkoff, Paul, 436, 622, 988-90
Kantzenbach, Friedrich W., 578
Kappus, Theodor, 991
Karlstadt, Andreas Bodenstein von, 109-10
Kauffmann, Georg, 849
Kauffmann, Hans, 1031
Kaufmann, Joseph, 307

Kaufmann, Leopold, 992, 994
Kawerau, D.G., 671
Kawerau, Gustav, 993
Kayser, Stephen S., 1052
Kehl, Anton, 1053
Kernkamp, G.W., 608
Kerssenbroch, Hermann von, 249-50
Kessler, Johannes, 329
Kibish, Christine O., 896
Kidd, Rev. B.J., 362
Kieser, Harry, 1194
Kilian, Abbot, 332
Kingdon, Robert M., 239
Kinkel, Gottfried, 994
Kirchenbau, Der, 1131
Kirschbaum, Engelbert, 17
Kitzinger, Ernst, 32
Klagrede der armen verfolgten Götzen, 192
Klamt, Johann-Christian, 709, 868
Klaus, Bernhard, 559
Kleijntjens, J.C.J., 275-277
Klein, Tim, 995
Kleist, Heinrich von, 226
Klemm, H., 996
Kleyntjens, Jos. *see* Kleijntjens, J.C.J.
Klibansky, R., 797
Klijn, M. de, 474
Klingenburg, Karl-Heinz, 710
Klingmann, Renate, 931
Kloss, Hildegard, 515
Knaake, K., 897
Knappert, Laurentius, 308
Knipping, John B., 475
Knolle, Theodor, 134, 1296
Koch, Carl, 840-42
Koch, Ernst, 73
Köcke, Ulrike, 1168
Köhler, Hans Joachim, 516, 627
Köhler, Walther, 174
Koegler, Hans, 658, 1075a, 1081, 1278
Koenigsberger, H.G., 42
Koepplin, Dieter, 829, 881
Kohls, Ernst-Wilhelm, 547-549
Kolde, Theodor, 711-12, 997
Kolff, D.H.A., 278, 299
Kooiman, Willem Jan, 175

Koslow, Susan, 685
Kossman, E.H., 148
Kottmeier, David, 33
Krämer, Gode, 860
Krause, Hans-Joachim, 1141, 1157
Krebs, Manfred, 399
Krenn, Peter, 390
Kreßel, H., 128
Kretzenbacher, Leopold, 222
Kreußler, Heinrich Gottlieb, 437
Krodel, Gottfried, 948
Krücke, Adolf, 759
Krueger, Ingeborg, 1224-25
Kruszelnicki, Zygmunt, 760
Kuczynski, Arnold, 601
Kühner, Karl, 1032
Kuhn, Charles L., 1179
Kummer, Bernhard, 898
Kunst, Hans-Joachim, 1132
Kunzle, David, 644, 741, 869
Kurth, Betty, 742
Kuspit, Donald Burton, 949-51
Kuttner, Erich, 309
Kuyper, A., 84

Lamy, [Madame], 1109
Lanckoronska, Maria Gräfin, 550, 843, 968
Lange, Konrad, 659, 998
Langer, Otto, 251
Lankheit, Klaus, 761, 795, 1033
Larsen, Erik, 476
Lasch, Gustav, 85
Laube, Adolf, 602, 713
Le Petit, Jean François, 279
Leemann-van Elck, Paul, 517, 623
Lehfeldt, Paul, 129
Lehmann, Hans, 176
Lehmann, Helmut T., 135
Leinz-v. Dessauer, Antoine, 952
Lemper, Ernst-Heinz, 1142, 1206
Leroy, Alfred, 1076
Lessing, Julius, 1226
Lestocquoy, [Jean], 400
Leuteritz, Albrecht, 1075
Libman, M.J., *see* Liebmann, Michael J.
Lichtblau, John H., 360

Lieb, N., 665
Liebmann, Michael J., 364-65
Lieske, Reinhard, 438
Lietzmann, Hans, 110
Lilienfein, Heinrich, 899
Lilje, Hanns, 366, 1297-98
Lindau, M.B., 900
Lindgren, Mereth, 1207
Livet, Georges, 852
Llompart, Gabriel, 777
Loewen, Harry, 111
Loewenich, Walther von, 42, 130
Lottin, Alain, 235
Lücke, Hans-Karl, 795
Lüdecke, Heinz, 714, 778, 901-03, 953
Luther, Gisela, 823
Luther, Johannes, 551, 654
Luther, Martin, 46, 131-38, 155, 552-53
Luthergedenkstätten, 1143
Lutz, Heinrich, 999-1000
Lutze, Eberhard, 1158

Maedebach, Heino, 420
Märker, Peter, 651
Mai, Hartmut, 1169-71
Mâle, Emile, 367
Maltby, William S., 310
Mandach, C. von, 1093-94
Mander, Karel van, 382, 477
Manlius, Johann, 147
Mansbach, S.A., 870
Manuel Deutsch, Niklaus, 192, 816
Markert, Emil, 1054
Marlier, Georges, 206, 810
Marnix, Philips van St. Aldegonde, 148-151
Marrow, James, 762, 853
Marsch, Angelika, 439
Martin, Hans, Freiherr von Erffa, 668
Martin, Kurt, 1034
Martin, Peter, 554
Mathews, Wendell Glen, 1001
Matthaes, Jenny Ruth, 1133
Matthes, Ernst, 1150
Maurer, Wilhelm, 954
McCaul, Elizabeth Ann, 326

McCerie, C.G., 1241
McClinton, Katharine Morrison, 904
McNeil, John T., 77
Mechel, Christian von, 1251
Meier, Karl E., 905
Melanchthon, Phillip, 152, 155-56
Mellink, A.F., 148
Mende, Matthias, 549, 844, 955
Menzhausen, Joachim, 1301
Merklein, Wolfgang, 112
Merschmann, Friedrich, 247
Merz, Heinrich, 1035
Messerer, Wilhelm, 1255
Meuche, Hermann, 603
Meyer, Almut Agnes, 763
Meyer, Alfred G., 937
Meyer, Karl, 555
Meylan, Henri, 686
Michalski, Sergiusz , 33a, 34, 764
Micron, Marten, 57
Miedema, Hessel, 754
Miedema, Rein, 1002
Mittig, Hans-Ernst, 715
Moded, Hermann, 158
Moeller, Bernd, 1284
Mösch, Johann, 330-31
Molanus, Joannes, 213
Montaiglon, Anatole de, 1048
Morawinska, Agnieszka, 764, 1172
Moreau, Edouard de, 478
Motley, John L., 311
Moxey, Keith P.F., 35, 716, 821-22
Mülhaupt, Erwin, 687
Müller, Gerhard, 161
Müller, Karl, 104, 113
Müller, Nikolaus, 440
Müller, Theodor, 332
Müller, Ulrich, 513
Müntz, Eugène, 368, 405
Muller, Frederik, 604
Muller-Dumas, Janine, 488
Murner, Thomas, 751
Mynors, R.A.B., 202

Näf, Werner, 333
Nauwelaerts, M.A., 207
Nemilov, A., 1055
Nesselstrauß, Cäcilia G., 556

Netter, Maria, 557-58
Neubauer, Edith, 702, 845
Neubert, Franz, 1306
Neumann, Carl, 1036
Neumeister, Ingeburg, 603
Nevezina, V.M., 717
Newdorffer, Georg, 214
Niemeyer, Gerlinde, 260
Nierop, Henk F.K. van, 312
Niesel, Wilhelm, 86
Nigg, Walter, 223
Nijhoff, Wouter, 605
Nolte, Josef, 640
Nordhoff, J.B., 1253

Obelkevich, James, 449
Ochs, Peter, 489
O'Dell-Franke, Ilse, 1117
O'Donnell, H.G., 1003
Oechslin, Werner, 957
Oecolampadius, Johannes, 159-60, 334
Oelschläger, Ulrich, 211
Oertel, Hermann, 560, 779-781, 1208
Ohle, Walter, 1144
Olbrich, Harald, 87, 846
Oldenbourg, M[aria] Consuelo, 561, 847
O'Shea, John J., 1004
Osiander, Andreas, 161, 660
Osten, Gert von der, 369-70, 848-49, 1302
Ozment, Steven, 7, 371

Paleotti, Gabriele, 189, 215
Palissy, Bernard, 817-19
Pannier, Jacques, 402
Panofsky, Erwin, 208, 372, 376, 958, 1034, 1037
Pariset, François-Georges, 850-52
Parker, Goeffrey, 295, 313
Parshall, Peter W., 36, 443a, 518, 1249
Parsons, Talcott, 476
Paton, H.J., 797
Pelikan, Jaroslav J., 135
Petersmann, Frank, 743

Pfeiffer, Gerhard, 445, 1005, 1254-56, 1272
Pfleiderer, Rudolf, 1006
Phillips, John, 266
Philoon, Thurman E., 813
Pianzola, Maurice, 373
Pijper, F., 25
Piltz, Georg, 661
Pipkin, H. Wayne, 177
Pirckheimer, Willibald, 163
Platter, Felix, 326
Platter, Thomas, 326
Pokora, Jakub, 1172
Pollmann, Jop., 88
Popelier, Françoise, 796
Poscharsky, Peter, 1173
Pouncey, Philip, 661a
Preus, James S., 114
Preuss, Hans, 42, 139, 145, 374, 765, 896, 906, 1007, 1038, 1303
Prims, Floris, 314
Prodi, Paolo, 189, 216
Puc-Bijelic, Breda, 562

Quinn, Robert MacLean, 446

Rabenau, Konrad von, 1227
Rabinel, A., 396
Radbruch, Gustav, 718
Radbruch, Renate Maria, 718
Rahn, J.R., 1187
Rapp, Francis, 852
Rasmussen, Jörg, 261, 959
Rattay, Beate, 637
Rauscher, J., 1008
Rautenberg, Werner, 65
Réau, Louis, 50, 240, 766
Recueil des choses advenues en Anvers, 55
Regnault, J.-M., 241
Reichensperger, A., 986, 1009
Reicke, Bo, 37
Reingrabner, Gustav, 391
Reinhardt, Hans, 563, 688, 1279
Rembert, Karl, 1010
Rettberg, R. von, 447, 1003
Rettig, G.F., 1095
Reuchlin, 71

Reumann, Kurt, 645
Revilliod, Gustave, 328
Richeome, Louys, 217
Riedinger, Rudolf, 1205, 1209
Riedinger, Utto, 1202
Riegl, Alois, 479
Rijksen, A.A.J., 1188
Rijn, G. van, 607, 608
Ritter, Annelies, 1145
Roepke, Claus-Jürgen, 448
Röttgen, Herwarth, 1228, 1252
Röttinger, Heinrich, 519, 609, 662, 861, 1124
Roey, J. van, 480
Rogge, Christian, 140
Rogge, Joachim, 1304
Romane-Musculus, Paul, 377, 396
Rondot, Natalis, 689, 1116
Rookmaker, H.R., 12
Roosbroeck, Rob. van, 274, 315
Rosenberg, [Carl] Adolf, 855
Rosenberg, Jakob, 888, 907
Roth, Eric, 74
Roth, Friedrich, 803, 806
Roth, Paul, 335-36, 493
Rothkrug, Lionel, 449-50
Rott, Hans, 262, 378, 399, 451-52
Roy, Maurice, 403
Rudelsheim, Marten, 1068
Rüegg, Walter, 178
Rügamer, Wilhelm, 1056
Rüsch, E.G., 172
Rüstow, Alexander, 372, 376, 836
Rupprich, Hans, 1011
Russell, Paul, 814
Ryckaert, M., 316

Sachs, Hans, 617
Sainctes, Claude De, 230
Sander, Hjalmar, 1257
Sandonnini, Tommaseo, 1048
Saran, Bernhard, 1258
Sauer, J., 453
Saunders, Eleanor Ann, 1065-66
Sauzet, Robert, 242
Saxer, Ernst, 89
Saxl, Fritz, 379, 646, 797, 960, 1077
Schade, Herbert, 961

Schade, Oskar, 610
Schade, Werner, 908, 925
Schaller, Heinrich, 647
Scharfe, Martin, 263
Scharfe, Siegfried, 648
Schecker, Heinrich B.O., 663
Scheerder, J., 317-319
Scheible, Josef, 611
Scheidig, Walther, 909
Schenk zu Schweinsberg, Eberhard
 Freiherr, 910
Scheurl, Christoph, 977
Schildhauer, Johannes, 252
Schiller, Friedrich, 226
Schlemmer, A., 396
Schlichter, Rudolf, 380
Schliepe, Walter, 1146
Schlüter, Margildis, 1223
Schmid, Heinrich Alfred, 1057, 1078
Schmidt, Eva, 923, 1159-60
Schmidt, Hugo, 594
Schmidt, Otto, 18
Schmidt, Philipp, 564-566
Schmidt, Roderich, 1229
Schnabel, Hildegard, 521, 670, 1674
Schneider, Jenny, 782
Schnelbögl, Fritz, 454
Schnell, Hugo, 1230
Schnorrenberg, John Martin, 1151
Schoch, Rudolf, 329
Scholliers, E., 323
Een schoon Tafelspel van een
 Prochiaen, 56
Schottenloher, Karl, 13, 520, 624,
 1305
Schrade, Hubert, 783, 1012
Schramm, [Johannes] Albert, 567
Schreckenbach, Paul, 1306
Schrot, Martin, 806
Schubart, Herta, 568
Schubart, Robert H., 1189
Schubring, Paul, 1039
Schuchardt, Christian, 900, 911
Schultze, Victor, 253, 1231
Schulze, Ingrid, 455, 744, 912
Schuster, Peter-Klaus, 359, 1259
Schwartz, Hubertus, 824
Schwarz, Karl, 569

Schwemmer, Wilhelm, 1161
Scriba, Otto, 1125
Scribner, Robert W., 416, 522-23,
 719
Sebba, Helen, 908
Sedlmayr, Hans, 1255
Seebaß, Gottfried, 162, 1013-14
Séguy, Jean, 38
Sehling, Emil, 456
Seibt, G.K. Wilhelm, 856
Seidlitz, W. von, 570
Seiffert, Hans W., 602
Semjen, Andras, 324
Senn, Matthias, 39, 612-13
Senn, Ott H., 1134
Shestack, Alan, 853
Shikes, Ralph E., 649
Sickingen, Franz von, 211
Sider, Ronald J., 115-16
Silver, Larry, 962, 1084
Simson, Otto von, 868, 1080
Singer, Hans Wolfgang, 963
Skrine, Peter, 964
Slive, Seymour, 481
Smit, J., 280
Smith, Jeffrey Chipps, 408
Smolderen, L., 290, 320
Smolinsky, Heribert, 201
Sörries, Reiner, 40
Somweber, Erich, 337
Sondheim, M., 752
Soutendam, J., 281
Spamer, Adolf, 625
Specht, Reinhold, 254
Specker, Hans E., 457, 1162
Spelman, Leslie P., 90, 141, 381
Spitz, Lewis W., 880
Spörri, Hermann, 179
Sprenger, Paul, 91
Springer, J., 827
Staedtke, Joachim, 75
Stäheli, Marlies, 614
Staehelin, Ernst, 159a, 160
Staehelin, Rudolph, 180
Starke, Elfriede, 142, 553
Stechow, Wolfgang, 382
Steck, R., 495

Steinböck, Wilhelm, 392-93, 1180, 1210
Steinborn, Bozena, 1175, 1181
Steingräber, Erich, 1211
Steinmetz, Max, 41, 460, 713, 1041
Stejskal, Karel, 965
Stengel, Walter, 571-72
Stephan, Bernd, 458
Steppe, Jan-Karel, 1232
Stern, Alfred, 497
Stern, Leo, 1041
Stiassny, Robert, 1015
Stierhof, Horst, 1205, 1212-13
Stimmer, Tobias, 210
Stirm, Margarete, 42-43
Stolz von Gebweiler, Johann, 338
Stopp, Frederick J., 650, 690, 753
Strachan, James, 573
[Straeter, A.], 1016
Strasser, Ernst, 798, 1163
Strauss, Heinrich, 871
Strauss, Konrad, 1233
Strauss, Walter L., 597, 615, 808
Streuber, Wilh. Theod., 338
Strickler, Joh., 496
Stridbeck, Carl G., 872-74
Strieder, Peter, 1040
Strobel, Georg Theodor, 1017
Stroh, Otto, 926
Strumwasser, Gina, 784
Stuhlfauth, Georg, 44, 383, 626, 664, 675, 691, 799, 1018, 1261, 1302, 1307-8
Stumm, Lucie, 1096
Stumpf, Johann, 45
Stupperich, Robert, 63, 172
Sullivan, Margaret A., 875
Svahnström, G., 1164
Svensson, Poul, 1195
Swoboda, Karl, 470
Szekely, György, 913

Talbot, Charles W. Jr., 425, 914
Tanner, Paul, 1118
Tappolet, Walter, 46
Tavel, Hans Christoph von, 490, 1097-99
Terlinden, Ch., 876

Thausing, Moriz, 1019-20, 1026
Theodorescu, Razvan, 508
Thiel, Heinrich, 574
Thimme, Wilhelm, 156
Thode, Henry, 966-67
Thompson, D.F.S., 202
Thompson, J.D.A., 1234
Thümmel, Hans Georg, 1235
Thulin, Oskar, 47, 143, 384, 459, 575, 767, 785, 915-16, 927, 1153, 1196-97, 1269, 1309-13, 1320
Tietze-Conrat, E., 1281
Timken-Zinkann, R.F., 968
Timm, W., 576
Tobler, G., 495
Toorenenbergen, J.J. van, 149
Traeger, Jörg, 665, 676
Treu, Erwin, 1282
Troschke, Asmus von, 917, 1262
Tüchle, Hermann, 255
Tuulse, Armin, 1236
Uhlitzsch, Joachim, 918
Uhrig, Kurt, 720-21
U[llens], F.G., 321
Ullmann, Ernst, 48, 264, 385-86, 460, 722-727, 919, 969, 1041
Ungerer, Alfred, 1165
Urban, Paul, 393
Utenhoven, Jan, 57

Vacková, Jarmila, 1182-83
Vacková-Sipová, Jarmila, 1184
Vaernewijck, Marc van, 282-83
Vahanian, Gabriel, 387
Den Val der Roomscher Kercken, 57
Vanden Propheet Baruch, 58
Vanderhaeghen, Ferd., 283
Vauzèle, Jean de, 218
Vedder, Henry C., 102
Végh, Julius v., 224
Veluanus, Johannes Anastasius, 164
Verheyden, A.L.E., 284, 318, 322
Verlinden, C., 323
Vermander, P., 241
Vermaseren, B.A., 285
Verwey, Herman de la Fontaine, 482, 754
Vetter, Ewald M., 692, 800-1

Vetter, Ferdinand, 1100
Vey, Horst, 370
Virck, Hans, 404
Viret, Pierre, 165
Vischer, Wilhelm, 497
Vlam, Grace A.H., 786
Vloten, J. van, 286
Vögeli, H.H., 67
Vögelin, F. Salomon, 1086
Vogel, Heinrich, 43
Vogel, Julius, 1314
Vogler, Günter, 627, 713
Vogt, Adolf Max, 1042
Volz, Hans, 577-78
Voßberg, Herbert, 1058-59

Wäscher, Hermann, 616
Waetzoldt, Wilhelm, 970
Wagner, Alois, 666
Wagner, Franz, 1203
Waldmann, Emil, 857
Wall, Constant van de, 477
Wallen, Burr, 1071
Walliser, Franz, 1203
Walter, Gottfried, 144
Walther, Christoff, 579
Wandersleb, Martin, 49
Warburg, Aby, 768
Warnke, Martin, 225-26, 265, 1315
Waterschoot, W., 1069
Weber, Bruno, 525, 628
Weber, Georg Anton, 998, 1018,
 1021-22, 1027
Weber, Max, 476
Weber, Otto, 15
Weber, Paul, 1023
Weckwerth, Alfred, 802
Weerda, Jan, 50, 1271
Wegg, Jervis, 483
Wegner, Wolfgang, 1079
Weig, Gebhard, 457
Weigel, Rudolf, 971
Weis, Frederick Lewis, 99
Weiss, N., 405
Weist, 972
Wells, Guy, 295
Wencelius, Léon, 51, 92
Wendeler, Camillus, 667

Wendland, Henning, 578, 580
Werckshagen, C., 966
Werner, Alfred, 936
Werner, Johannes, 461
Werner, Roland, 1155
Wernicke, E., 1185
Wessel, Klaus, 1135
West, Robert, 388
Westphal, Volker, 921
Wex, Reinhold, 1147-48
White, James F., 1136
Wibiral, Norbert, 1214
Wiederanders, Gerlinde, 973
Wiesenhütter, Alfred, 1152-53
Wiesmann, Hans, 1166
Wiesner, K., 1159
Wilde, Johannes, 470
Wildenstein, Georges, 406
Williams, George H., 52, 389
Wils, I.M.P.A., 287-88
Winckelmann, Otto, 404
Winkler, Gerhard B., 462
Winner, Matthias, 868, 1080
Wirth, Jean, 145-46, 629, 745, 854
Wirth, Karl-August, 668
Wischermann, Heinfried, 1237
Wittber, Alfred, 974
Witte, Hermann, 1115
Wittmann, Tibor, 324
Woisetschläger-Mayer, Inge, 394
Wolf, Johannes, 693
Wollgast, Siegfried, 1024
Woltjer, J.J., 325
Woltman, Alfred, 463
Woodfield, Richard, 53
Wortmann, Reinhard, 1162
Wüthrich, Lucas, 826
Wulff, Oskar, 937
Wuttke, D., 768
Wynen, Arnulf, 1104
Wyss, Bernhard, 339

Yates, Frances A., 1070

Zaske, Nikolaus, 1043, 1238
Zick, Gisela, 800
Ziegler, Clemens, 166
Zijp, Robert P., 694

Zimmer, Graf von, 243
Zimmermann, Heinrich, 1239
Zimmermann, Hildegard, 582-585,
 630, 652, 1264, 1316-17
Zimmermann, Werner, 1321
Zink, Fritz, 598
Zophy, Jonathan W., 1176, 1254
Zschelletzschky, Herbert, 669,
 677-78, 695, 728-734, 975
Zucker, Markus, 997, 1025-27
Zülch, Walter Karl, 586-87, 1060,
 1113
Zürcher, Richard, 491
Zupnick, Irving L., 877
Zweite, Armin, 1126-28
Zwingli, Huldreich, 46, 174, 176,
 182-186

Index of Exhibitions by Location

Augsburg, Zeughaus and Rathaus, 407
Austin, Archer M. Huntington Art
Gallery, 408

Basel, Kunstmuseum, 881, 1118
Basel, Universitätsbibliothek, 509
Berlin, Museum für Deutsche
Geschichte, 410
Berlin, Schloß Charlottenburg, 411
Berlin, Staatliche Museen, 345
Bern, Kunstmuseum, 1088
Braunschweig, Städtisches Museum,
414
Breslau, Silesian Museum, 1175
Bruges, Memlingmuseum, 1108

Coburg, Kunstsammlungen der Veste
Coburg, 420, 637
Cologne, Oberstolzenhaus, 421

Detroit, Institute of Arts, 425

Geneva, Musée historique de la
Réformation, 488

Hamburg, Kunsthalle, 359, 1249
Hannover, Kestner-Museum, 1223
Heidelberg, Universitätsbibliothek,
537
Helsinki, Tuomiokirkon Krypta, 507

Karlsruhe, Staatliche Kunsthalle, 840

Münster, Stadtmuseum, 441
Munich, [location not listed], 1252
Munich, Residenz, 442

Nuremberg, Germanisches
Nationalmuseum, 443, 443a, 444,
559, 598, 956, 1252
Nuremberg, Stadtbibliothek, 1319
Nuremberg, Stadtgeschichtliche
Museen, 606

Paris, Archives Nationales, 401
Paris, Bibliothèque Nationale, 402
Princeton, Art Museum, 375

Rotterdam, Boymans-van Beuningen
Museum, 1280

Strasbourg, L'Ancienne Douane, 1260

Tübingen, Universitätsbibliothek, 651

Ulm, Stadtarchiv, 457
Utrecht, Catharijne-Convent, 524

Washington, D.C., National Gallery of
Art, 853
Weimar, Schlossmuseum, 920
Wolfenbüttel, Herzog August
Bibliothek, 581, 1263

Zurich, Helmhaus, 492

Index of Subjects

Aaron, 1190
Abraham and Hagar, 1083
Aegidius of Viterbo, 676
Aertsen, Pieter, 820-22
Alba, Duke of, 290, 318, 320, 703, 865
Albrecht of Brandenburg, 1050
Aldegonde, Philips Marnix van St., *see* Marnix
Aldegrever, Heinrich, 823-24, 1246, 1253
Alkmaar, iconoclasm in, 294
Allegory of Grace and Salvation, 145, 801, 1083, 1120, 1072, 1175
 see also Cranach, Lucas the Elder
Alsace, 238, 399, 561, 850, 854
altars, 128, 249, 255, 1196-97
 see also altarpieces, *Kanzelaltäre*
altarpieces, 61, 128, 137, 143, 255, 259, 331, 337, 393, 453, 757, 761, 764, 775, 892, 902, 915, 922, 926, 1033, 1052, 1056, 1093-94, 1098, 1104, 1108, 1112, 1154, 1159-60, 1166, 1190-97, 1255, 1282
Altdorfer, Albrecht, 825
Altdorfer, Erhard, 546
Amman, Jost, 209, 1307
Amsterdam, iconoclasm in, 271, 312
Anabaptism, 8, 52, 70, 93-4, 97, 99, 102, 241, 247-250, 265, 322, 399, 427, 441, 462, 627, 746, 788, 803, 862, 896, 906, 1011, 1032, 1039, 1045, 1057, 1071, 1111-12, 1179, 1246, 1247, 1253
Anglican Church, 266, 1151
animal fables, 736

Anne, St., 854, 880
Anthonisz., Cornelis, 788
Anthony, St., 1093, 1094, 1098
anti-Catholic satire, *see* satire
antinomianism, 145
anti-papal satire, *see* satire
Antichrist, 523, 645, 670-78
anti-Reformation satire, *see* satire
Antwerp, 466, 480, 483, 750, 810, 820, 859, 989, 1071, 1080, 1127, 1253
--iconoclasm in, 274, 279, 290, 302, 314-15, 320-21
Apocalypse, 527, 538, 541, 544, 554, 1044
 see also , September Testament
--Athos cycle, 538
Apocrypha, 782, 1186
Apostles, 927, 1111
astrology, 768
architecture, 92, 129, 144, 266, 343, 349-351, 374, 413, 415, 453, 485, 499, 504, 1129-53
architectural decoration and furnishing, 1129-1214
Armentières, 241
arm gemein esel, see Sachs
ars moriendi, 428
Artois, 400
Asper, Hans, 176, 487, 492, 826, 1244, 1323
Asperen, iconoclasm in, 273
Augsburg, 407, 740, 789, 803, 806, 1079, 1222, 1248
 see also Confessions
--Augsburg Interim, 693, 1225
--iconoclasm in, 261

271

Augustine, St., 77, 1083
Augustusburg, 1141, 1157
Austria, 390-4, 1150, 1214
 See also individual cities and
 regions

Bad Aussee, 1210
Baden, 453
Balaam, 640
Baldung Grien, Hans, 376, 530, 531,
 547-9, 561, 745, 804, 827-54
Bamberg, 1272
baptism, 789, 896, 926, 1179
Basel, 404, 489, 493, 497, 509, 682,
 688, 1074, 1076, 1078, 1081,
 1100
--iconoclasm in, 233, 327, 334-336,
 338, 416
Baumgartner, *see* Paumgartner
Batthyány, B., 862
Bavaria, 442, 448
Beggars' Party, *see* gueux
Beham, Bartel, 745, 855-57, 1024
 see also Drei gottlose Maler
Beham, Hans Sebald, 553, 679, 716,
 720, 734, 745, 855-57, 1024
 see also Drei gottlose Maler
Bel and the Dragon, *see* Daniel
Bern, 495, 686, 1087, 1092, 1101
--iconoclasm in, 327
Beuckelaer, Joachim, 820, 821
Beza, Theodore, 655a, 749, 878
Bible illustration, 142, 209, 349, 414,
 526-87 *passim* , 829, 858, 881,
 1078, 1082, 1117-18, 1124, 1245,
 1262
Biblia pauperum, 564, 1170
Bibliander, Theodore, 1244
Binck, Jacob, 1320
Bocksberger, Hans der Ältere, 858,
 1209, 1211, 1213
Bocksberger, Hans der Jüngere, 858
Bocksberger, Melchior, 858
Bohemia, 230, 540, 1182
Bologna, 1048
Bombeck, Seger, 1286
Bontemps, Pierre, 403

book illustration, 411, 425, 490, 491,
 508, 1260
bookbindings, 1217, 1227, 1317
Bos, Cornelis, 859
Bosch, Hieronymus, 741, 758
Bosgeuzen, iconoclasm in, 289
Brake Schloß, 771
Braun, Konrad, 193
Braunschweig, 414
--iconoclasm in, 49
Brazen Serpent, 886
Breda, iconoclasm in, 291
Breu, Jörg the Elder, 803, 860
Breu, Jörg the Younger 861, 1213
Brielle, iconoclasm in, 288
Brno, 1183, 1184
broadsheets, 44, 142, 173, 290, 398,
 427, 434, 443, 520-522, 525, 576,
 581, 588-616, 735-36, 741, 753,
 799, 869, 1316
Brosamer, Hans, 519, 747a, 1228
Brück, Gregor, 1265-8
Bruegel, Pieter the Elder, 36, 482,
 484, 703, 741, 788, 862-76
Bruges, 750, 793, 1108
Brunfels, Otto, 629
Brunus, Conradus, *see* Braun, Konrad
Brussels, 297, 469, 1232
Buchführer, M., 657
Bucer, Martin, 59-64, 451, 530, 547
Büheler, Sébald, 804
Bugenhagen, Johann, 65, 414, 1229,
 1268-69
Bullinger, Heinrich, 39, 50, 66-75,
 101, 194, 528, 1243-44
Bundschuh, 702, 709, 733
Burgkmair, Hans, 709
Busch, Valentin, 1189

calendars, 615
Calvin, Jean, 23, 27, 34, 42-43, 46,
 50-51, 76-92, 157, 353, 402, 476,
 569, 749-50, 793, 1135, 1270-1
Camerarius, Joachim, 1254, 1272
Campen, Gerard J. van, 482
Campen, Willem J. van, 482
Capito, Wolfgang, 159a, 334

caricatures, 611, 633, 639, 643, 661, 693, 1270
carnival, 873-74
Caron, Antoine, 748, 878-79
Carthusians, 497
catechisms, 528, 533-536, 547, 1079, 1200, 1206
Catholic Reconciliation, 331
Catholic reform, see Counter Reformation
Cecilia, St., 226
Celle, 1126
censorship, 301, 429, 513, 631, 633, 806
Chalon-sur-Saône, iconoclasm in, 237
chancels, see altars
Charles V, Emperor, 197, 259, 658, 1261
choir screens, 1168
Christ, images of, 191, 197, 428, 572, 698, 755, 765, 787, 798, 802, 862, 867, 877, 910, 930, 973, 985, 1007, 1075a, 1225
 see also, Allegory of Grace and Salvation
--Christ blessing the children, 760, 880, 896, 906, 921, 1179
--Christ's entombment, 776
--Christ's Passion, 618, 688, 762, 769-86 passim , 793, 849, 860, 884, 914, 922-5, 932, 959, 971, 1167, 1200
--living cross, 770
Christopher, St., 778, 962
church furnishings and monuments, 156, 393-4, 421, 438, 499, 1118, 1126,1129-1214
Chytraeus, David, 1202
Coburg, 420, 425
Cochläus, Johannes, 44, 747a
coins, 437
Coligny, Admiral, 401
Compar, Valentin, 178-79, 183
Confessions, 24
--Augsburg Confession, 150, 156, 407, 439, 459
--Confessio Augustana, see Augsburg Confession

--Second Helvetic, 66, 73
--Tetrapolitan Confession, 24, 59
Conincxloo, Gillis van, 474
Coninxloo, Jan van, 469
Constantinople, 34
Coornhert, Dirk Volkertszoon, 277, 482, 754, 805, 872, 874, 1062, 1064-65
Cossa, Baldasare, 617
Counter Reformation, 215-16, 336, 343, 367, 406, 475, 614, 701, 755, 796, 1071, 197-218
Cousin, Jehan the Elder and Younger, 403
Coverdale Bible, 563
Cranach, Lucas the Elder, 19, 124, 127, 142, 145, 243, 342, 349, 376, 415, 437, 440, 455, 519-565 passim, 580, 583-4, 620, 645, 647, 667, 670-78, 696, 779, 880-921, 938, 976, 1052, 1090, 1156, 1159-60, 1199-1320 passim
 see also Karlstadt, Himmelwagen
--Allegory of Grace and Salvation , 793, 801, 885-86, 905, 1120, 1199, 1221, 1232, 1283
--Allegory of Law and Grace , see Allegory of Grace and Salvation
--Passional of Christ and Antichrist, 618, 620, 650, 670-78, 1191, 1261
Cranach, Lucas the Younger, 898, 908, 922-27, 1160, 1245, 1262, 1282
Cranach school, 756, 1236
Cranach workshop, 356, 909, 1220, 1231, 1238-39, 1264, 1266, 1286, 1316-17
Cranmer, Thomas, 563
Croy Tapestry, 1219-20, 1226, 1229, 1231, 1235, 1238-39
Custodis, Hieronymus, 503

Daniel, 782, 1186
Daniel, Book of, 159
Danzig, 1237
David, Gerard, 758
Debrecen, 500

Delft, iconoclasm in, 280-1
Dell, Peter the Elder, 783, 800
Den Briel, *see* Brielle
Denck, Hans, 93-94
 see also Drei gottlose Maler
Denck, Johann, *see* Denck, Hans
Denecker, David, 806
Denmark, 1195
Dessau, 1255
Dieffolt, Heinrich, 337
Dietenberger, Johannes, 195
Dietrich, Veit, 152
Dietterlin, Wendel the Elder, 783
Disputation, Second Zurich, *see* Zurich
Döring, Christian, 897
Dominicans, 214, 338
Donk, Martin, *see* Duncanus,
 Martinus
Dorsch, J., 1324
drama, 234, 467, 471-72, 763, 861,
 1085
 see also Rederijkers
Drei gottlose Maler, 162, 409, 700,
 711-12, 717, 728-730, 856,
 1000
 see also Beham, Pencz and Denck
Dresden, 779, 1141, 1157
Dubois, François, 928
Dürer, Albrecht, 124, 142, 153, 163,
 168, 264, 342, 347, 349, 364,
 374, 408, 428, 448, 460, 463,
 538, 544, 549, 583, 700, 717,
 722-23, 726-27, 733, 804, 807-10,
 839, 929-1043, 1090, 1217,
 1273, 1275, 1318, 1320, 1324
--*Apocalypse*, 931, 934-35, 942, 960,
 965, 975
--Dürer's belief, 976-1027
--*Four Apostles*, 162, 376, 699-700,
 809, 929, 931-32, 945,
 948, 960, 1011, 1024, 1027-43,
 1254, 1256, 1258, 1272
--*Monument to the Peasants' War*,
 697-700, 704-5, 714-15,
 722, 732, 808, 968,
Duncanus, Martinus, 196
Dusentschuer, Johan, 1253
Duvet, Jean, 484, 1044

Early Bourgeois Revolution, 431-32,
 674, 696-734 *passim*, 891, 1041
Eastern Orthodox Church, 34
Eber, Paul, 927
Ecclesia, 1236
Eck, Johannes, 197-99, 695
effigies, 22
Egeri, Carl von, 1243
Elst, Nicolaas van der, 469
Elstracke, Renold, 503
Emden, 50
Emser, Hieronymus, 103, 198, 200-01
Engebrechtsz., Cornelis, 117
Engels, Friedrich, 744
England, 3, 266, 351, 382, 503-5,
 563, 797, 1136, 1151
 see also London
epitaphs, 393, 414, 769, 915, 923,
 925, 927, 1156, 1160, 1174-85,
 1282-83
Erasmus of Rotterdam, 172, 202-08,
 471-72, 682, 744, 790, 936, 948,
 952, 954, 989, 1062, 1084, 1259,
 1273-82
Erasmus, St., 1050
Erfurt, 657
Eskrich, Pierre, 689
eucharist, 779, 791, 795, 802, 849,
 926, 1074

Faber, Konrad, 427, 1045
Family of Love, 482, 505, 754, 876
Farel, Guillaume, 1075a
Ferdinand II, Emperor, 1150
Feyerabend, Sigismund, *see*
 Feyrabend
Feyerabend, Sigmund, 209, 574, 811
Fides , 872-73.
Finland, 507
Fiore, Joachim da, 617
Fischart, Johann, 210, 398, 543, 628,
 736, 1118
Flanders, 157, 367
Flötner, Peter, 640, 710, 745, 1046
Flugblätter, *see* broadsheets
Flugschriften, *see* pamphlets
France, 188, 353, 367-68, 381-82,

395-406, 612-13, 633, 663, 747-48, 818-19, 928, 1044, 1130, 1165, 1189
--iconoclasm in, 227-42
Francis I, King of France, 228, 1261
Franck, Sebastian, 1024
Frankenmarkt, 1214
Frankenthal, 1080
Franz, Abbot, 332
Franz von Sickingen, 211
Freiberg, 1141
Freiermut, Hans Heirich, 664
Frellon brothers, publishers in Lyon, 738
Freudenstein, see Freiberg
Freytag, Gustav, collection, 593
Fribourg, 686
Friedrich the Wise of Saxony, 415, 436, 458, 584, 925, 1261
Friedrich III, Elector of Palatine, 262
Friesland, 325, 1168
Frisia, see Friesland
Froben, Johann, 688
Froschauer, Christoph, 517, 619, 1123
Frühbürgerliche Revolution , see Early Bourgeois Revolution
Fugger family of Augsburg, 803
Furtenagel, Lukas, 1302, 1307-08

Galle, Filips, 285, 811, 1065
Geneva, 485, 689, 1114
--Collège de Calvin, 1047
--Company of Pastors, 239
--iconoclasm in, 239, 328
Gengenbach, Pamphilius, 658, 662
Germany, 407-63, 1137-48 and passim
see also individual cities and regions
--iconoclasm in, 224, 243-65
Gerung, Matthias, 455, 527, 649, 666, 744, 1194
Gheeraerts, Marcus, 503, 505, 750
Ghent, 1067
--iconoclasm in, 282, 283, 298, 303, 304

glass decoration, 176, 257, 782, 1087, 1092, 1186-9, 1243
God the Father, images of, 29, 92, 629, 759
Goethe, Johann Wolfgang von, 656
Götliche Müly , see Göttliche Mühle
Göttingen, 1145
Göttliche Mühle, 684, 790
Goldegg, Schloß, 1203
Goltzius, Hendrik, 482, 754
Gotha, 775, 1141, 1193-94
Gottlose Maler, see Drei gottlose Maler
Gouda, 1188
Goujon, Jean, 403, 484, 1047-48
grace, see Allegory of Grace and Salvation
Graf, Urs, 664, 745
Grafenegg Castle, 1233
Grebel, Conrad, 41, 95
Gregory, St., 561
Greiffenberger, Hans, 162, 264, 712, 812-14
Greifswald, see Croy Tapestry
Grien, Hans Baldung, see Baldung
Grimani Breviary, 550
Gripsholm Palace, 1236
Grünewald, 376, 571-72, 576, 586-87, 696, 851, 1049-60
Gueux, 1216, 1234
guilds, 278, 325, 397, 418
Guldenmund, Hans, 631, 1307

Haarlem, 1062
--iconoclasm in, 277
Haecht, Godevaert van, 274
Haetzer, Ludwig, see Hätzer
Hätzer, Ludwig, 96-99, 174, 1024
Hagen, August, 714
Hagenauer, Friedrich, 1222
Hale, Christopher, 1244
Halle, 576, 1302
Hals, Frans, 685
Handschuchsheim, Dieter von, 211
Habsburgs, 662, 1188
hedge preaching, see preachers
Heemskerck, Maarten van, 782, 788, 1061-66, 1186

Heenvliet, iconoclasm in, 287
Heere, Lucas d', 503, 505, 1067-70
Heidelberg, 451, 657
--iconoclasm in, 262
Heidelberg, Bernhard von, 229
Helmstedt, 1208
Hemessen, Jan van, 1071
Henry of Brederode, 1234
Henry VIII, King of England, 661a
Henry the Younger of Wolfenbüttel, 690
Hercules Germanicus, 681-82, 688, 827
Herford, 245
Hess, Johann, 1283
Hesse, Eobanus, 1258
Hetzer, Ludwig, *see* Hätzer
Hirschvogel, Augustin, 569
Hoefnagel, Joris, 503, 505
Hogenberg, Nicolaus, 649, 710
Holbein, Hans the Younger, 36, 218, 376, 526, 536, 538, 545, 555, 557-58, 563, 681-82, 688, 738, 743-44, 827, 1072-78, 1271, 1273, 1275, 1277-79, 1318, 1320
--*Pictures of Death*, 218, 668, 738, 740, 743
Holzhausen, Anna von, 1045
Holzhausen, Justinian von, 427, 1045
Holzschuher, Hieronymus, 949
Honterus, Johannes, 74, 101
Hooftman, Gilles, 1127
Hopfer, Daniel, 685, 1079
Hopffe, Johann, 771
Hortulus Animae, 570, 584
Huberinus, Caspar, 740
Hübmaier, Balthasar, 102, 462
Huguenots 217, 231, 240, 398, 402, 653, 1130
Hulst, iconoclasm in, 293
Humanism, 344, 355, 467, 482, 850, 852, 867, 931, 939, 947, 953-54, 960, 973, 1005, 1010, 1062, 1077, 1227, 1260
Hungary, 498, 500
Hussites, 219-20, 230, 256, 455
--*Jena Codex*, 256
Hutten, Ulrich von, 1054, 1259

hymnals, *see* songbooks

iconoclasm, 44, 49, 76, 95, 97, 104, 129-30, 134, 148, 151, 158, 161, 163, 168, 172, 174, 180, 192, 197, 199, 201, 206, 211, 217, 219-340, 343, 346, 353, 356, 359, 362, 367, 371, 389, 397, 399, 405, 408, 416, 433, 453, 477, 483, 487, 489, 531, 725, 750, 766, 803-04, 821, 828, 860, 902, 981, 1061, 1065, 1087, 1093, 1100, 1121
--Byzantine iconoclasm, 32, 44, 221
idolatry, *see* image controversy
image controversy, 20-218, 262, 337, 353, 359, 362, 367, 389, 434, 444, 448, 462, 501, 504, 528, 584, 782, 808-09, 882, 956, 1011, 1061, 1092, 1095, 1127, 1186, 1244
images, cult of, *see* image controversy
imitatio Christi, 640
imprese, 634
incarnation, 197
indulgences, 30, 436, 661, 688, 786, 939, 1206
Ireland, 3
Italy, 367, 423

Jacobsen, Jacob, 1296
Janssen, Cornelis, 503
Jena Codex , *see* Hussites
Jerome, St., 206, 778
Jesuits, 71, 398, 686, 753
Jews, 54, 222, 787, 825, 1084
Job, 1064
Jobin, Bernard, 398, 628, 1118
Joel, 574
Johann der Beständige, *see* John the Steadfast
Johann Friedrich, Elector of Saxony, 618, 930,1147, 1242, 1265
John the Evangelist, St., 326, 971
 see also Dürer, *Four Apostles*
John the Baptist, St., 862
John the Steadfast, Elector of Saxony, 884

John XXIII (anti-pope), 617
Jong, J. de, 273
Jonghe, A. de, 286
Joris, David, 815, 1081
Joseph, Old Testament, 1201
Josiah, Old Testament, 1092
Judas, 1255
Jud, Leo, 39
Julius II, Pope, 675
Junius, Hadrianus, 1062

Kaisersberg, Geiler von, 1052
Kanzelaltäre, 1033, 1167-73 *passim*
Karlstadt, Andreas Bodenstein von,
 23, 34, 41-42, 97, 103-116, 134,
 136, 138,198, 201, 264, 437, 440,
 725, 856, 912, 1000
--*Fuhrwagen, see Himmelwagen*
--*Himmelwagen und der Höllenwagen*,
 103, 106, 687, 695
--*Von Abtuung der Bilder*, 30, 96,
 103, 105, 108, 110, 200
Karsthans, 61, 710
Kilian, Abbot, 332
Klagrede der armen verfolgten Götzen,
 30, 192, 635, 1086
Kleinbasel, iconoclasm in, 335
Kleist, Heinrich von, 226
Klur, Hans, 1237
Knipperdolling, Bernhard, 1247
Köbel, Jacob, 657
Köpfel, Wolfgang, 629
Kronhard, Georg, 1191

Ladenspelder, Johan, 482
landscape, 474, 491
Laocoon, 1237
Last Judgment, 772-73, 1165, 1198,
 1214
Lauterbach, Antonius, 1206
Leeuwarden, 325
--iconoclasm in, 325
Leiden, 117, 465
--iconoclasm in, 278, 308
Leiden, Jan van, 1247
Leipzig, 529, 601, 1142
Lemberger, Georg, 769, 1082, 1228
Lemnius, Simon, 893

Lent, 134, 873-74
Leo X, Pope, 675
Leu, Hans, 837
Leyden, Lucas van, *see* Lucas van
 Leyden
Liège, 1186
Liere, Joos van, 1080
Liesborn, iconoclasm in, 260
limbo, 146, 877
living cross, *see* Christ, images of
Loists, 1071
Lojt, 1195
Lojtingers, *see* Lojt
London, 503, 750
--Dutch Reformed Church, 503
Lorch, Melchior, 690
Lorraine, 1114
Lowlands, *see* Netherlands
Loyola, Ignatius, 1071
Lucas van Leyden, 36, 685, 758,
 1083-84
Lucius, Jakob, 519
Lüneburg, 798
Lufft, Hans, 544, 579
Luterisch Strebkatz, 622, 655, 664
Luther, Martin, 9, 19, 23, 27, 34, 37,
 42-51 *passim*, 58, 103-4, 111,
 113, 117-46, 155, 167, 206, 349,
 353, 359, 366, 376, 382, 391,
 408-37 *passim*, 443a, 458, 507,
 518, 523, 526-87 *passim*, 617,
 620, 630, 638, 646-61 *passim*,
 667, 674, 677, 681, 684, 699,
 701, 705, 716, 719-722, 726,
 747a, 751, 755a, 768, 770, 775-86
 passim, 790, 801, 807, 814, 823,
 882, 884, 886, 893, 896-99, 902,
 906, 909, 912, 923, 926, 930,
 936-37, 954, 958, 960, 962,
 976-1027 *passim*, 1035, 1050,
 1053, 1059-60, 1090, 1135, 1143,
 1147-48, 1157, 1160, 1206, 1230,
 1242, 1259, 1277, 1284-1317
Lyons, 689, 738, 1116

Mainz, 576
Malines, *see* Mecheln
Malachi, 574

Mannerism, 839, 928
Manuel Deutsch, Niklaus, 192, 745,
 816, 1085-1101
Mappe monde nouvelle papistique,
 653, 655a, 663, 689
Marburg, 404
Margaret of Parma, 286
mariolatry, 27, 46, 123-24, 147, 367,
 450, 462, 570, 755, 777, 841,
 973, 994
Mark Brandenburg, 411
Mark, St., *see* Dürer, *Four Apostles*
Marnix van St. Aldegonde, Philips,
 148-51, 1065
marriage, 794
martyrs, 26, 1048, 1112
mass, 182
Massys, *see* Metsys
Master C.S., 1075a
Master Eisenhuth, 1253
Master H.V., *see* Vogtherr the Elder
Master of Alkmaar, 294
Master of Liesborn, 260
Master M.S., 519
Matthew, St., 786
Mauritius, St., 1050
Maximilian I, Emperor, 803
Mecheln, iconoclasm in, 267
medals, 176, 345, 459, 1215-40
 passim, 1247-48, 1290-91, 1295,
 1319-20, 1323
Meienburg, Michael, 1282
Melanchthon, Philip, 145, 152-156,
 534, 536, 563, 658-59, 674, 768,
 880, 912, 943, 949-51, 978, 1000,
 1017, 1242, 1254, 1256, 1259,
 1283, 1318-21
Merck family of Augsburg, collection,
 1248
Merseburg, iconoclasm in, 246
Metsijs, *see* Metsys
Metsys, Quinten, 1273, 1275
Metz, 1189
Micah, *see* Micha
Micha, 94, 574
Michelfeldt Tapestry, 455, 739, 742
Middelburg, 286

minor arts, 1215-39
Moded, Hermannus, 157
Modern Devotion, 464
Mönchskalb, 155, 657, 658
Monk-calf, see Mönchskalb
Molanus, Johannes, 212-13
Momus, 1062
monasteries, 163, 252, 281, 332, 335,
 426
Moses, 1084, 1190
Münster, 427, 441, 627, 746, 1045,
 1247, 1253
--iconoclasm in, 247-50, 265
Münster, Thomas, 41, 256, 264, 856
Müntzer, Thomas, *see* Münster,
 Thomas
Münzer, Thomas, *see* Münster,
 Thomas
Muffel, Jakob, 949
Murau, 394
Murner, Thomas, 514, 709, 751-52
music, 1, 41, 84, 139, 156, 171-72,
 351, 381, 693, 1309

Nas, Johannes, 753
Nebuchadnezzar, 822
Nemo, 36, 737
Netherlands, 25, 28, 35, 56-58, 148,
 157-58, 164, 226, 235, 241,
 369-370, 382, 464-83, 505, 524,
 604-5, 607-8, 612-13, 694, 784,
 786, 1031, 1216
 see also Spain, Spanish oppression
--iconoclasm in, 224, 267-325
Neuburg an der Donau, 1204-5, 1209,
 1211-13
--iconoclasm in, 262
Neuenburg, iconoclasm in, 327
New Testament, 582, 755a, 766,
 769-86 *passim*, 910, 1075, 1079,
 1126, 1172, 1193, 1198, 1206-7
 see also Apocalypse & September
 Testament
Newdorffer, Georg, 214
Nicholas of Lyra, 557-58
Niclaes, Hendrik, 754
Nicodemism, 353
Nicodemus, 1179

Niemand, see Nemo
Nijmegen, iconoclasm in, 277
Nîmes, iconoclasm in, 242
Nobody, see Nemo
nominalism, 31
Norway, 501, 755a, 756, 1190
Nuremberg, 93, 162, 408-9, 417-18,
 426, 429-30, 444-45, 447, 454,
 622, 631, 700, 711-12, 717,
 728-730, 813, 856, 943, 948,
 954, 981, 1005, 1014, 1028-43,
 1158, 1161, 1254, 1256, 1319
 see also Dürer, Four Apostles
--iconoclasm in, 257

Oecolampadius, Johannes, 159-60,
 1244, 1322
Old Testament, 36, 60, 79, 98, 224,
 755a, 766, 769-86 passim, 868,
 870, 1061, 1064-66, 1083-84,
 1092, 1095, 1172, 1190, 1193,
 1200-01, 1206-07
 see also individual names, Bible
 Illustration, Ten Commandments
Olmütz, Wenzel von, 659
Oostwinkel, iconoclasm in, 316
Orlamünden, 104
Orley, Bernard van, 469, 788, 1102
Orley, Valentin van, 469
Ortelius, Abraham, 867, 874, 1065
Osiander, Andreas, 162, 617, 631,
 660, 1209, 1213, 1242, 1265
Ostendorfer, Michael, 809, 994, 1072,
 1104
Ostönnen, 1167
Ottheinrich, Elector of Palatine, 262,
 451-2, 1209, 1212

Paderborn, iconoclasm in, 245
Paleotti, Gabriele, 215-16, 406
Palissy, Bernard, 817-19, 1105
pamphlets, 19, 30, 443a, 444, 516,
 521, 581, 588-616, 720, 805-06,
 812-14, 1079, 1122
 see also Reformation theologians
 & iconoclasm, 54-339 passim
Pannemaker, Pieter de, 469
Papstesel, 155, 659

Paris, 188, 406
--iconoclasm in, 228
Patientia (Virtue), 788
patronage, 255, 258, 262, 406, 415,
 417, 422, 451-2, 458, 465, 499,
 527, 666, 828, 831, 847, 862,
 895, 919, 964, 1028, 1161, 1188,
 1222, 1226, 1239
Paul the Apostle, Saint, 1127, 1232
 see also Dürer, Four Apostles
Paumgartner, Hieronymus, 1254
peasantry, 264, 696-734, 814, 1032,
 1051, 1110
Peasants' War, 373, 461, 602-3,
 696-734, 741, 869, 1055,
 1111-13
Pellikan, Conrad, 1244
Pencz, Georg, 668, 691, 744, 857,
 1106-7
 see also Drei gottlose Maler
Perényi, Peter, 569
Pérrissin, Jean, 649, 748
Peter, St., 692
 see also Dürer, Four Apostles
Petrejus, Joh. 251
Pfalz, iconoclasm in, 262
Philip, St., 945, 1037
Philip II, King of Spain, 290, 483,
 796
pilgrimage shrines, 450
pilgrimages 100, 300, 462
Pirckheimer, Willibald, 163, 808, 948,
 954, 992, 1000, 1005, 1009,
 1017, 1019,
Pirna, 1206
Pistor, Simon, 769
Plantin, Christopher, 1065
Platter, Felix, 326
Platter, Thomas, 326
Plock, Hans, 571-72, 576, 586-87
Pomerania, 1219-20, 1229, 1237
portraits, 22, 36, 61, 176, 279, 340,
 374, 376, 401-02, 414, 427, 479,
 491, 563, 581, 588, 595, 615,
 764, 794, 898, 915, 923, 946,
 949, 971, 1041, 1045, 1067,
 1073, 1075, 1108, 1123, 1176,
 1220, 1259

-- of reformers, 19, 58, 86, 127, 168, 176, 352, 628, 1240-1324
Pourbus, Pieter, 1108
prayerbooks, 550, 553-70, 584-5
--*Prayerbook of Maximilian,* 550
preachers, 220, 242, 295, 307, 814, 1080
see also sermons
--hedge preaching, 280, 292
predestination, 749, 773
Prieur, B., 1109
prodigies, 155, 525, 600, 634, 657-659
see also Wick
prognostications, *see* prodigies
propaganda, 44, 145, 398, 402, 408, 631-768, 811
prophets, 94, 574
Prussia, 917
Psalters, 529
Pseudo-Beham, 427
pulpits, 1167-73
Puritanism, 350-51

Ranten, 394
Raphael Sanzio, 676
Ratgeb, Jörg, 696, 1110-13
Reael, Laurens Jacobsz., 271
rederijkers, 35, 56, 471-72
Regensburg, 462, 825, 994, 1104
Reinmann, L., 731
relics, 91, 436, 584
Rembrandt van Rijn, 81, 350
Reymerswaele, Marinus C. van, 206
Rhau, Georg, 584, 1316
Rhegius, Urbanus, 740
Richeome, Louys, 217
Richier, Ligier, 484, 1114
Riemenschneider, Tilmann, 1115
Rihel, Wendelin, 531-32, 532, 548-49
Rippensz., Peter, 300
Rosenbaum, Lorenz, 1218
Rostock, 1202
Roting, Michael, 1254
Rubens, Peter Paul, 793
Rumania, *see* Transylvania
Russia, 34
Ryff, Fridolin, 327, 497

Sachs, Hans, 44, 606, 609, 631, 640-41, 660, 679, 735-36, 799
--*Arm gemein Esel,* 588, 640, 691
--*Seven-headed Papal-animal,* 44
Sacramentarianism, 788, 1071, 1084
sacraments, 137, 506, 758, 779, 798,1068, 1084, 1179, 1206
see also individual sacraments
Saint Bartholomew's Day Massacre, 612, 928, 1048
Saint Gall, 619
--iconoclasm in, 327, 329, 332-33
saints 17, 20, 33, 55, 100, 140, 192, 197, 206, 255, 454, 766, 769-86 *passim,* 880, 962, 971, 1028-43, 1050
see also individual saints' names, Dürer's *Four Apostles,* and martyrs
--cult of saints, 100, 151, 172, 190, 206, 367, 450, 854
Salomon, Bernhard, 568, 1116
Saracens, 222
sarcophagi, 508
satire, 22, 155, 192, 511, 514, 515, 591, 631-768, 843, 875
--anti-Catholic satire, 256, 300, 653-695, 823, 893, 912, 1049, 1057, 1102, 1215
--anti-papal satire, 131, 328, 398, 523, 527, 645, 647, 653-669, 734, 740, 806, 868, 898, 912, 968, 972, 1046, 1054, 1187, 1224-25, 1237
--anti-Reformation satire, 746-54, 787, 796
Satrapitanus, Heinrich, *see* Vogtherr, Heinrich the Elder
Savonarola, 952
Saxony, 254, 412, 1138, 1141, 1146, 1206, 1220
Sayn-Witgenstein, Count Ludwig von, 71
Scandinavia, 1130
Schäufelein, Hans L., 570
Schan, Jörg, 737
Schandbilder, 642
Scharfenberg, Albrecht von, 933
Scheltbriefe, 642

Schenk, Hans, 1237
Scheurl, Christoph, 976-78
Schiller, Johann Christoph Friedrich von, 226
Schmalkalden, 1157, 1191
Schmidburg, Heinrich, 769
Schön, Erhard, 192, 731, 799
Schöner, Johann, 1257
Schott, Johann, 561, 629
Schroer, Hans, 1213
Schrot, Martin, 806
Schwerin, 1157
sculpture, 92, 183, 249, 251, 265, 290, 320, 337, 349, 403, 453, 757, 779, 792, 798, 852, 1047, 1109, 1114-15, 1154, 1158, 1167, 1174, 1177, 1196, 1221, 1301
Séez, Diocese of, iconoclasm in, 231
Seljord, 1190
Selve, George de, 1073
September Testament, 538, 541-42, 552, 554, 556, 565, 582-83
sermons, 30, 108, 134, 136, 146, 160, 469, 942, 1147-48, 1173
 see also preachers
shrines, 449
Siebenbürgen, see Transylvania
Silesia, 757, 1152, 1172, 1174, 1181
Simon VI, Count, 771
Simulacres & historiees faces de la mort, see Holbein, Pictures of Death
Skielderup, Jens, 501
Slovenia, 562
Soest, 824, 1253
Solis, Virgil, 574, 1117
Solomon, Old Testament, 1095
Solomon, Gabriel, 747
Solothurn, iconoclasm in, 330, 331
songbooks, 530, 539-40, 545, 1073
Sonneborn, 1200
Spain, 367
--Spanish oppression of the Netherlands, 284-85, 321, 483, 703, 811, 865, 876-7, 1102, 1234
Spalatin, Georg, 1242, 1257
Spengler, Lazarus, 622, 714, 1005
spiritualism, 97, 788, 1064

stained glass, see glass decoration
stabularii, Reformation sect, 1110
Stampfer, Jakob, 1218, 1323
Staphylus, Friedrich, 753, 1255
Staupitz, Johann von, 943
Steiermark, 390, 393, 1150, 1201
Stevens, Richard, 503
Stimmer, Tobias, 210, 398, 543, 628, 647, 775, 1118-19, 1165
Stoss, Veit, 428, 1161
Stralsund, 252
Strasbourg, 60, 62, 395, 397, 399, 404, 530-31, 548-49, 628-29, 737, 831-32, 850-52, 1118, 1222, 1260
--iconoclasm in, 229, 233, 238, 399, 416, 804
Strechau, 1202
Stumpf Chronicle, 619, 1123
Sundgau, 561
Swabia, 1192
--iconoclasm in, 263
Sweden, 506, 1164, 1207, 1236
Switzerland, 29, 45, 67, 101, 173, 239, 265, 353, 364, 368, 371, 378, 434, 484-97, 517, 566, 612, 633, 759, 782, 1087, 1137, 1149
--iconoclasm in, 224, 326-40

tapestries, 1070, 1232, 1286
 see also , Croy Tapestry & Michelfeldt Tapestry
Tauler, Johannes, 1012
Ten Commandments, 37, 79, 147, 533, 536, 1200, 1214
tetragram, 759
Tetzel, Johann, 1206
Thomann, Grosshans, 782
"three godless painters," see Drei gottlose Maler
Tipschern, 1201
title pages, 529, 551, 561, 563
tombs, 499
Tons, Jan, 469
Torgau, 1141, 1147, 1157, 1196
--iconoclasm in, 243
Tortorel, Naeques, 748
Tory, Geofroy, 1120
Transylvania, 74, 101, 508

Trent, Council of, 47, 187-90, 212-13,
215-16, 302, 367
Treviso, Girolamo da, 661a
Tridentine Decrees, *see* Trent, Council
of
Trinity, 193, 634, 1049, 1057, 1167,
1179
Tschertte, Johannes, 163
Tseraerts, Jan, 469
Tucher family of Nuremberg, 1161
Turnhout, iconoclasm in, 268
Turks, 222

Ulm, 64, 404, 457, 1162
--iconoclasm in, 255, 259, 263
Utrecht, 157
--iconoclasm in, 276

Vadian (Mayor of St. Gall), 333
Valangin, iconoclasm in, 327
Vasas, Gustav, 1236
Vauzèle, Jean de, 218
Velde, Esias van de, 474
Veste Coburg, 637
Viret, Pierre, 242
Vischer, Peter, 656
Vogtherr, Heinrich the Elder, 531,
619, 1121-25
Vogtherr, Heinrich the Younger, 1124
Vos, Martin de, 1126-28

Waldeck, 253
wallpaintings, 394, 453, 1095, 1125,
1194-1214
Walter family of sculptors, 779
Weiditz, Hans, 629, 720, 788
Weigel, T.O., 601
Weimar, 922-4, 1159-60
Wessem, iconoclasm in, 275
Westfalia, 249
Wick, Johann Jakob, collection, 525,
592, 612-614
wild men, 690
William of Orange, 158
Wimpfen, 1125
witchcraft, 450, 833, 836-37, 854
Wittelsbach, 442
Wittenberg, 101, 104, 106-8, 110-11,

114, 134, 136, 254, 413, 435,
440, 544, 567, 577, 584, 767,
779, 880, 891, 902, 909, 926-27,
1058-59, 1155, 1227, 1268, 1316
--iconoclasm in, 104-114 *passim* , 134,
244
Wittenweiler's Ring , 709
Wolgemut, Michael, 251
Woudneel, 503
Württemberg, 438

Ypres, iconoclasm in, 272
Yverdon, 792

Zerbst, 544
--iconoclasm in, 254
Zündt, Matthias, 692
Zurich, 39, 62, 67, 96, 99, 102,
167-86 *passim* , 233, 487,
490-492, 494, 517, 528, 614,
619, 653, 826, 1166, 1218, 1243
--iconoclasm in, 95, 174, 326-27, 337,
339-40, 416
--Second Disputation, 62, 182, 186
Zwickau, 138
--iconoclasm in, 251
Zwingli, 23, 27, 34, 37, 39, 42, 51,
67, 95-96, 167-86, 326, 340, 353,
619, 684, 937, 1000, 1090, 1135,
1243, 1324
Zwinglisches Bett, 749